OXFORD–WARBURG STUDIES

General Editors

DENYS HAY *and* J. B. TRAPP

OXFORD–WARBURG STUDIES

The Conflict between Paganism and Christianity in the Fourth Century
Essays edited by A. D. MOMIGLIANO. 1963

Jacopo della Quercia's Fonte Gaia
By ANNE COFFIN HANSON. 1965

The Sistine Chapel before Michelangelo
By L. D. ETTLINGER. 1965

The Government of Florence under the Medici 1434–1494
By NICOLAI RUBINSTEIN. 1966

Spectacle, Pageantry, and Early Tudor Policy
By SYDNEY ANGLO. 1969

*Giotto and the Orators: Humanist Observers of Painting in Italy
and the discovery of Pictorial Composition*
By MICHAEL BAXANDALL. 1971

Raymond Lull and Lullism in Fourteenth-century France
By J. N. HILLGARTH. 1972

*The Manifold in Perception: Theories of Art from Kant
to Hildebrand*
By MICHAEL PODRO. 1972

The Figurae of Joachim of Fiore
By MARJORIE REEVES and BEATRICE HIRSCH-REICH. 1972

RENOVATION AND COUNTER-REFORMATION

VASARI AND DUKE COSIMO
IN STA MARIA NOVELLA AND
STA CROCE
1565–1577

MARCIA B. HALL

OXFORD
AT THE CLARENDON PRESS
1979

Oxford University Press, Walton Street, Oxford OX2 6DP

OXFORD LONDON GLASGOW
NEW YORK TORONTO MELBOURNE WELLINGTON
KUALA LUMPUR SINGAPORE JAKARTA HONG KONG TOKYO
DELHI BOMBAY CALCUTTA MADRAS KARACHI
NAIROBI DAR ES SALAAM CAPE TOWN

British Library Cataloguing in Publication Data
Hall, Marcia Brown
 Renovation and Counter-Reformation: Vasari and
 Duke Cosimo in Sta Maria Novella and Sta
 Croce, 1565-1577. - (Oxford-Warburg studies)
 Bibl. - Index.
 ISBN 0-19-817352-0
 I. Title 2. Series
 726'. 5'094551 NA5621.F5
 Santa Croce, Florence - History
 Santa Maria Novella, Florence - History

Printed in Great Britain
at the University Press, Oxford
by Eric Buckley
Printer to the University

per Carlo

because the preposition in the Italian
preserves the sense not merely of *for*
but also of *through, by means of,* and
even, in an important sense, *by*

PREFACE

THE centre of gravity of this study has shifted since it was begun some thirteen years ago as a doctoral dissertation at Harvard University. Initially, my interest was focused on the altar-pieces which would provide, I believed, a uniquely coherent framework in which to study the religious art of the Counter-Maniera generation of painters in Florence. My thinking and the terminology I adopted were shaped by the teaching of my adviser, S. J. Freedberg, who was then working on his book in the Pelican History of Art, *Painting in Italy, 1500–1600*.

I had only a vague suspicion when I selected the topic that another aspect of my training at Harvard might also prove indispensable. This was a seminar conducted jointly by James Ackerman and John Coolidge on Renaissance art in its social, political, economic, religious, and architectural context. I discovered *in mediis rebus* that the project to renovate Sta Maria Novella and Sta Croce provided an opportunity for this kind of contextual study, a far larger but also more broadly useful undertaking than I had foreseen. The implications of the renovation in terms of the Counter-Reformation dawned on me only slowly and were not yet fully formulated when I submitted my dissertation.

Though I and my patient editors have rewritten, amended, emended, extended, cut, revised, reorganized, corrected, clarified, compressed, and standardized the text, a dissertation is always, to some extent, a dissertation. Were I to undertake the project afresh today it would take a different form: less scrupulously documented, perhaps, but also less cumbersome. On the advice of my editors I have preserved the documentation as it was originally presented. It is our hope that such a body of material, of a rather different kind from what is usually assembled by art historians, may provide a model for comparison with other such large-scale projects. Much remains to be learned about methods of organizing patrons and artists and how they changed from one century or locality to another, and I believe this information will open new perspectives from which to view the art.

The methods used for this study are still regarded with scepticism by portions of the art historical community. The age of the Counter-Reformation has remained a largely unstudied lacuna in our knowledge, considered unworthy

of the art historian's attention, because it was not a period of great artistic creativity. James Ackerman has warned of the danger of 'studying inferior works by obscure masters . . . as documents for the investigation of an institution', rather than focusing upon works of the first quality. Having had the good fortune of observing his mind at work on such problems, however, I believe he would say that we are able to define a legitimate art historical enterprise more precisely. We have got things right side up so long as we are not asking: how do the phenomena of art history fit into social history? but rather, as this study intends: how does the history of the religious and social institutions of the Counter-Reformation illumine the art history?

While I enthusiastically adhere to the belief that artistic quality should be the prime criterion by which the art historian selects an object of study, I would contend that, in order to understand more deeply the achievements of greatness, we must also look at periods of decline. To understand the dynamic of periods of enormous creativity, we need to observe conditions under which such creativity dried up. To me, one of the most fascinating questions this study poses, but does not resolve, is: why did the renewal of painting at the end of the Cinquecento take place in Bologna, and not in Florence? I would argue that this is not solely attributable to the creative genius of the Carracci, as past generations of historians would have it, but to the changes taking place in the whole fabric of cultural life in those two cities.

One further aspect of this study requires comment. I chose to focus upon the altar-piece because I believed it to be the most sensitive artistic barometer of the turbulent decades of the late sixteenth century—the time of the third great iconoclastic crisis in the history of Christian art. In debating the role of the images in the churches, the clerics at the Council of Trent—like those in the first centuries of the Christian era and those in eighth-century Byzantium— were debating issues crucial to the artistic tradition. The compromise they evolved saved Western religious art from extinction, but not without sacrificing a measure of the freedom that artist and patron had previously enjoyed. The altar-piece is unique in that it must serve two masters, one private, one public and institutional. It must satisfy not only the patron who commissioned and paid for it, but it must also be an acceptable object of devotion to be housed in the church and to serve for the contemplation and instruction of the faithful. These two functions had coexisted without apparent friction until the period under discussion here. It was an altar-fresco, Michelangelo's *Last Judge-*

ment, that gave early warning of the gathering storm of criticism. The Decrees of the Council of Trent established procedures by which the Church, through the authority vested in the bishops over all the images in the churches of their dioceses, could exert a new measure of control. This inaugurated a new era in religious art, marked by a changed relationship between patron and artist, on the one hand, and the Church, on the other. How this relationship was worked out is one of the issues on which this study sheds some light. Much more will certainly need to be done before a clear understanding of this important subject emerges.

I have dealt with these two churches only, because the projects were conceived and executed together. Documentation on neither one is complete, but what I found on one church often filled in the picture outlined by the documents on the other. It has been my supposition, nowhere contradicted by the evidence I found, that there were no significant differences in the organizational structures or methods employed in the two churches. The altar-cycles in both churches, too, complemented one another, for they were executed by the same group of artists, and taken together they represent a significant sample of religious painting in post-Tridentine Florence.

The publication of this volume almost coincides with the four hundredth anniversary of the dedication of the new chapels in Sta Maria Novella in Lent, 1577/8. By this date, the work of renovation and construction of new chapels was virtually finished in both churches, although two or three chapels remained incomplete for several more years.

The reader will find the documentation on which the text is based divided into two sections. The documents which pertain to particular chapels have been incorporated in the Catalogue. Documents which pertain to the project as a whole are arranged chronologically in the Appendix. All the documentation has been either transcribed or checked by Dr. Gino Corti, for whose kindness and helpfulness over the years I am extremely grateful. A draft of the text has been read by Professor Malcolm Campbell, and Professor Ulrich Middeldorf has gone over the Catalogue. Their expertise, as well as the suggestions of friends and colleagues, has removed many, though I dare not presume all, of the book's deficiencies. Among my colleagues I recall the help of: Ludovico Borgo, Eve Borsook, Eugene Carroll, Janet Cox-Rearick, Samuel Y. Edgerton, Jr., John Hale, Ann Hanson, André Hayum, Christian von Holst, Eugene Johnson, Ulrich Krause, Nicolai Rubinstein, Edward Sanchez,

Gyde Shepherd, Randolph Starn, Ann Markham Schulz, and the late Walter Vitzthum. Maureen Pelta has helped me to correct the proofs.

In addition, I wish to acknowledge the support of the Fulbright Commission, and also of its superb direction, headed in Italy by Cipriana Scelba, which facilitated many aspects of my life when I was new to Italy and first beginning this study. Padre Cocci, at the church of Sta Croce, gave me access to the archive housed in the convent. The staff of I Tatti and both the directors, Myron and Sheila Gilmore, and the interim directors, Mason and Florence Hammond, created an environment conducive to creative scholarly work, and I remember my year as a Fellow (1971–2) and many summers there with great pleasure. The research for this project was undertaken in the mid-1960s; the text is based on a bibliography available up to 1972. In London and at the Warburg Institute, I wish to thank, in particular, three people: the late T. S. R. Boase, whose interest in Vasari I shared, and who first suggested that I submit my manuscript for this series; J. B. Trapp, whose editing improved my text; and E. H. Gombrich, who read the manuscript and recommended it for the series, and whose thoughtful response to material I have submitted to him on varied subjects over the years has never failed to give me fresh insights.

I have a debt to a special group, and they include some of the most beautiful people I know, whose care of our sons, Christopher Martin and Brian Starbuck, provided a loving substitute for their mother and freed me with confidence to carry on this work. Not only the book but, more importantly, the children are the better for their presence in our lives: Nancy Hughes, Mary Jo Peebles, Pirkko Kianta, Tarttu Kauramäki, Kaisli Rehn, Bruce Frankel, Giulietta Ceri, Joy Graham, Sam Edgerton, Jr., the late Peter Edgerton, Nicole Gaillard, Terri Ryan, Valerie Wunder, Lucia and Dave Peebles, Inger and Paul Peebles, Anna Hall, Edna Woodson, Frances Peebles, and John Ocheltree, and sometimes even Charles Hall.

Last, but most important, I thank my teachers: Helen Shearman, who first introduced me to the wonders of Florence twenty-two years ago; Mildred Brown, my first History of Art teacher at Holton-Arms School; the late Curtis Shell, who taught a whole generation of Wellesley students to see and whose generosity as a teacher set a high standard for the many who have followed in his steps; Fred Denbeaux, whose irreverence for the expected opened up the whole world of the history of ideas to me; John Coolidge, who taught me to take a second look, and to whose tough-minded brilliance I owe much; James

Ackerman, who better than any understood the painful process of learning to write, and whose continuing support has encouraged me; Detlef Heikamp, who among other kindnesses initiated me into the mysteries of the Archives; Ulrich Middeldorf, who has served me, like so many others, as a source of fresh ideas, of contacts with other scholars, and as a fount of learning; Sidney Freedberg, the imprint of whose mind is everywhere on these pages, a very great teacher, thinker, and dear friend.

The list is long. I have been well taught.

Flaine, Haute Savoie
August 1976

CONTENTS

LIST OF ILLUSTRATIONS

PLATES (*at end*)

FIGURES

LIST OF PHOTOGRAPHIC SOURCES

Alinari: 5 (Brogi), 7 (Brogi), 8, 9 (Brogi), 11, 16 (Anderson), 20, 21, 24, 25 (Brogi), 26 (Brogi), 30 (Brogi), 33, 40 (Brogi), 44 (Brogi), 46, 53, 54 (Brogi), 55 (Brogi), 59 (Brogi), 62, 76 (Brogi), 83 (Brogi), 86–8 (Brogi), 90 (Brogi), 93 (Brogi), 95, 98 (Brogi), 100 (Brogi), 104–5 (Brogi), 106, 109 (Brogi), 113 (Brogi).

Ashmolean Museum, Oxford: 61

Biblioteca Berenson, Villa I Tatti, Florence: 72, 85

Cabinet de Dessins, Louvre: 34, 65, 84

Documentation photographique de la Réunion des musées nationaux, Paris: 22

Gabinetto Fotografico, Soprintendenza alle Gallerie, Florence: 3, 4, 6, 12–15, 17–19, 23, 27–9, 35–6, 38, 39, 41–3, 45, 47–9, 51, 52, 56–8, 60, 63–4, 67–71, 74, 75, 77–82, 89, 91, 92, 94, 96, 97, 99, 101–3, 107–12.

Kunsthistorisches Institut, Florence: 1, 2, 10

Photo Gérondal, Lille: 31

Private collections: 32, 66

Staatliche Graphische Sammlung, Munich: 50

Studio Fotofast, Bologna: 37

Witt Library, Courtauld Institute, London: 73

LIST OF ABBREVIATIONS
AND WORKS CITED

The list that follows is confined to works referred to by author and short title in the footnotes. For further references see the following:

On the churches of Sta Maria Novella and Sta Croce:

Paatz, *Kirchen von Florenz*, vols. iii and i respectively.

On art and the Counter-Reformation:

Prodi, *Ricerche*; and E. Battisti, 'Reformation and Counter-Reformation', *Encyclopedia of World Art*, vol. xi, New York and London, 1966, cols. 894–916.

On Giorgio Vasari:

Barocchi, *Vasari pittore*; and T. S. R. Boase, *Giorgio Vasari* (The A. W. Mellon Lectures on the Fine Arts for 1972), Princeton University Press, 1977.

On individual artists:

Freedberg, *Painting in Italy, 1500–1600*

A. ABBREVIATIONS

The following abbreviations are used for archives and libraries:

A.S.F.	Florence, Archivio di Stato
A.S.Croce	Florence, Sta Croce, Archivio
A.S.M.N.	Florence, Sta Maria Novella, Archivio
B.N.F.	Florence, Biblioteca Nazionale Centrale

The following abbreviations are used for periodicals:

Art Bull.	*Art Bulletin*
Boll. d'Arte	*Bollettino d'Arte*
Burl.	*Burlington Magazine*
J.W.C.I.	*Journal of the Warburg and Courtauld Institutes*
Mitt. KHIF	*Mitteilungen des Kunsthistorischen Institutes in Florenz*
Riv. d'A.	*Rivista d'Arte*

B. WORKS CITED

Ackerman, James S., 'The Gesù in the Light of Contemporary Church Design', *Baroque Art: the Jesuit Contribution*, ed. Rudolf Wittkower and Irma Jaffe, New York, 1972, pp. 15–28.

Alpers, Svetlana, 'Ekphrasis and Aesthetic Attitudes in Vasari's *Lives*', *J.W.C.I.* xxiii (1960), 190–215.

Arnolds, Gunter, *Santi di Tito*, Arezzo, 1934.

Baldinucci, F., *Notizie de' professori del disegno da Cimabue in qua*, 6 vols., Florence, 1681–1728 (2nd edn., 10 vols., Florence, 1767–74).

Baldovinetti: refers to 'Memorie del convento, chiesa e confraternite di S. Maria Novella', collected by Giovanni di Poggio Baldovinetti, eighteenth century, B.N.F. Baldovinetti 124.

Barocchi, Paola, 'Itinerario di Giovambattista Naldini', *Arte Antica e Moderna*, xxxi (1965), 244–88.

——, *Vasari pittore*, Milan, 1964.

Berti, Luciano, 'Note brevi su inediti toscani: Santi di Tito', *Boll. d'Arte*, xxxvii (1952), 353–4.

——, *Il Principe dello Studiolo: Francesco I dei Medici e la fine del Rinascimento fiorentino*, Florence, 1967.

Biliotti, Modesto, 'Cronica pulcherrimae aedis S. Mariae Novellae de Florentia', sixteenth century, A.S.M.N.

Bocchi, F., *Le bellezze della città di Firenze*, Florence, 1591 (2nd edn., amplified by G. Cinelli, Florence, 1677).

Borghigiani, Vincenzo, 'Cronaca annalistica del convento di S. Maria Novella', 3 vols., eighteenth century, A.S.M.N.

Borghini, Raffaello, *Il Riposo*, Florence, 1584 (2nd edn., ed. G. Bottari, Florence, 1730; facsimile of 1584 edn., with bibliography and index, ed. M. Rosci, 2 vols., Milan, 1967).

Borromeo, Saint Carlo, *Instructiones fabricae et supellectilis ecclesiasticae*, 1577 (reprinted in P. Barocchi, ed., *Trattati d'arte del Cinquecento fra manierismo e controriforma*, vol. iii, Bari, 1962, pp. 1–113; English translation, G. J. Wigley, London, 1857).

Brookes, P. Cannon, 'Three notes on Maso da San Friano', *Burl.* cvii (1965), 193 ff.

Brown, J. Wood, *The Dominican Church of Santa Maria Novella at Florence*, Edinburgh, 1902.

Bucci, Mario, *Lo Studiolo di Francesco I (Forma e Colore*, x), Florence, 1965.

Canons and Decrees of the Council of Trent, original text and translation by H. J. Schroeder, O.P., St. Louis, 1941.

Carcereri, Luigi, *Cosimo Primo Granduca*, Verona, 3 vols., 1926–9.

Cheney, Iris H., 'Francesco Salviati (1510–1563)', dissertation, New York University, 1962.

——, 'Francesco Salviati's North Italian Journey', *Art Bull.* xlv (1963), 337–49.

Chiarelli, Renzo, 'Una biografia inedita di Sebastiano Vini, pittore veronese', *Scritti di storia dell'arte in onore di Mario Salmi*, vol. iii, Rome, 1963, pp. 133–45.

Cinelli, Giovanni: see Bocchi, Francesco.

Colnaghi, Sir Dominic Ellis, *A Dictionary of Florentine Painters*, London, 1928.

Daddi-Giovannozzi, Vera, 'L'Accademia fiorentina e l'Escuriale', *Riv. d'A.* xvii (1935), 423 ff.

Dejob, Charles, *De l'influence du Concile de Trente sur la littérature et les beaux-arts chez les peuples catholiques*, Paris, 1884.

Emiliani, Andrea, *Il Bronzino*, Busto Arsizio, 1960.

Fineschi, Vincenzio, 'Monumenti della chiesa di S. Maria Novella', eighteenth century, vol. i, A.S.M.N.; vols. ii and iii, B.N.F. E 5 777.

Florence, Gabinetto dei Disegni e delle Stampe degli Uffizi, *Mostra di disegni dei fondatori dell'Accademia delle Arti del Disegno*, catalogue by Paolo Barocchi, Adelaide Bianchini, Anna Forlani, and Mazzino Fossi, 1963.

——, *Mostra di disegni del Vasari e della sua cerchia*, catalogue by Paola Barocchi, 1964.

——, *Mostra di disegni di Alessandro Allori*, catalogue by Simona Lecchini Giovannoni, 1970.

Forlani Tempesti, Anna, 'Alcuni disegni di Giambattista Naldini', *Festschrift Ulrich Middeldorf*, Berlin, 1968, pp. 294 ff.

Freedberg, S. J., 'Observations on the Maniera', *Art Bull.* xlvii (1965), 187–97.

——, *Painting in Italy 1500–1600 (Pelican History of Art)*, Harmondsworth, 1970.

Frey, Karl, *Der literarische Nachlass Giorgio Vasari*, vol. i, Munich, 1923; vol. ii, ed. Herman-Walther Frey, Munich, 1930; vol. iii, *Neue Briefe von Giorgio Vasari*, ed. H.-W. Frey, Burg b.M., 1940.

Gilio, Giovanni Andrea, 'Dialogo degli errori de' pittori circa l'istorie' [1564], in P. Barocchi, ed., *Trattati d'arte del Cinquecento* . . . , vol. II, Bari, 1961.

Gombrich, E. H., 'Mannerism: the Historiographic Background', *The Renaissance and Mannerism (Studies in Western Art: Acts of the Twentieth International Congress of the History of Art, vol. ii)*, Princeton, 1963, pp. 163–73.

Hall, Marcia B., 'The Operation of Vasari's Workshop and the designs for S. Maria Novella and S. Croce', *Burl.* cxv (1973), 204–9.

——, 'The *Ponte* in S. Maria Novella', *J.W.C.I.* xxxvii (1974), 157–73.

——, 'The *Tramezzo* in Santa Croce, Florence, Reconstructed', *Art Bull.* lvi (1974), 325–41.

——, 'The *Tramezzo* in S. Croce and Domenico Veneziano's Fresco', *Burl.* cxiii (1970), 797–9.

Hauser, Arnold, *Mannerism*, London, 1965.

Hautecœur, Louis, 'Le Concile de Trente et l'art', *Il Concilio di Trento e la riforma tridentina: Atti del convegno storico internazionale* (Trent, September 1963), Rome, 1965, pp. 345–62.

L'interno della chiesa di S. Maria Novella dopo i restauri fatti nel 1861, Florence, 1861.

Isermeyer, Christian-Adolf, 'Die Capella Vasari und der Hochaltar in der Pieve von Arezzo', *Eine Gabe der Freunde für Carl Georg Heise*, Berlin, 1950, pp. 137 ff.

—— 'Il Vasari e il restauro delle chiese medievali', *Studi Vasariani: Atti del Convegno internazionale per il IV centenario della prima edizione delle 'Vite' del Vasari* , Florence, 1952, pp. 229–36.

——, 'Le chiese del Palladio in rapporto al culto', *Bollettino del Centro Internazionale di Studi di Architettura Andrea Palladio*, x (1968), 42–58.

Jedin, Hubert, 'La politica conciliare di Cosimo I', *Rivista storica italiana*, lxii (1950), 345–74, 477–96.

Lapini, Agostino, *Diario fiorentino di Agostino Lapini dal 252 al 1596*, ed. G. O. Corazzini, Florence, 1900.

Lewine, Milton, 'Roman Architectural Practice during Michelangelo's Maturity', *Stil und Überlieferung in der Kunst des Abendlandes (Acts of the 21st International Congress for the History of Art, ii, Bonn, 1964)*, Berlin, 1967, pp. 20–6.

Loyola, St. Ignatius, *The Spiritual Exercises*, ed. C. Lattey, S.J., St. Louis, 1928.

Mâle, Émile, *L'Art religieux après le Concile de Trente*, 1932 (republished as *L'Art religieux de la fin du XVIᵉ siècle*, Paris, 1951).

Marcucci, Luisa, 'Girolamo Macchietti disegnatore', *Mitt. KHIF* vii (1955), 121–32.

Mencherini, P. Saturnino, *S. Croce*, Florence, 1929.

Moisè, F., *S. Croce di Firenze: Illustrazione storico-artistica*, Florence, 1845.

Orlandi, Stefano, *'Necrologio' di S. Maria Novella*, 2 vols., Florence, 1955.

Orlandi-Borghigiani: refers to those sections of Borghigiani's chronicle published in Orlandi, 'Necrologio', ii. 397–404.

Paatz, Walter and Elisabeth, *Die Kirchen von Florenz: ein kunstgeschichtliches Handbuch*, 6 vols., Frankfurt am Main, 1940–54.

Paleotti, Gabriele, 'Discorso intorno alle imagini sacre e profane', in P. Barocchi, ed., *Trattati d'arte del Cinquecento . . .* , vol. ii, Bari, 1961.

Pouncey, Philip, 'Contributo a Girolamo Macchietti', *Boll. d'Arte*, ser. 4, vol. xlvii (1962), 237–40.

Prodi, Paolo, 'Ricerche sulla teorica delle arti figurative nella riforma cattolica', *Archivio italiano per la storia della pietà*, iv (1965), 123–212.

Richa, Giuseppe, *Notizie istoriche delle chiese fiorentine . . .* 10 vols., Florence, 1754–62; especially vol. i, on Sta Croce, 1754; vol. iii, on Sta Maria Novella, 1755.

Rosselli, Stefano, 'Sepoltuario fiorentino', 1657, A.S.F. MS. 624 (Sta Croce); MS. 625 (Sta Maria Novella).

Scoti-Bertinelli, Ugo, *Giorgio Vasari scrittore*, Pisa, 1905.

Sermartelli: refers to 'Sepoltuario della chiesa e convento di S. Maria Novella di Firenze', nineteenth-century copy of the 1617 original of prior Niccolò Sermartelli, A.S.F. MS. 812.

Settimanni, 'Diario fiorentino', sixteenth century, A.S.F. MS. 128.

Shearman, John, '*Maniera* as an Aesthetic Ideal', *The Renaissance and Mannerism* (*Studies in Western Art: Acts of the Twentieth International Congress of the History of Art*, vol. ii), Princeton, 1963, pp. 200–21. Reprinted in *Renaissance Art* (ed. Creighton Gilbert), New York, 1970, pp. 181–221.

——, *Mannerism*, London, 1967.

Sinibaldi, Giulia, 'Un disegno di Girolamo Macchietti', *Scritti di storia dell'arte in onore di Mario Salmi*, vol. iii, Rome, 1963, pp. 89 ff.

Smyth, Craig Hugh, 'Mannerism and Maniera', *Renaissance and Mannerism* (*Studies in Western Art: Acts of the Twentieth International Congress of the History of Art*, vol. ii), Princeton, 1963, pp. 174–99.

Vasari–Milanesi: refers to Vasari, Giorgio, *Le vite de' più eccellenti pittori, scultori ed architettori*, ed. Gaetano Milanesi, 9 vols., Florence, 1878–85.

Venturi, Adolfo, *Storia dell'arte italiana*, vol. ix, pts. v, vi, vii, Milan, 1934.

Vitzthum, Walter, Review of Paola Barocchi (q.v.) on Giorgio Vasari, in *Master Drawings*, iii (1965), 54–6.

——, *Lo Studiolo di Francesco I a Firenze* (*L'Arte Racconta*, xvi), Milan, 1965.

Waterhouse, Ellis K., *Italian Baroque Painting*, London, 1962.

Wittkower, Rudolf and Margot, *The Divine Michelangelo: The Florentine Academy's Homage on his Death in 1564*, London, 1964.

Zeri, Federico, *Pittura e Controriforma*, Turin, 1957.

I

Church Renovation in a Counter-Reformation Context

AS our understanding of the art of the second half of the Cinquecento has grown, the term 'Council of Trent' has disappeared from titles, to be replaced by the term 'Counter-Reformation'. Early studies of the influence of the Council of Trent left us with the exaggerated impression that sudden and fundamental changes occurred in the arts as soon as the Council closed in 1563. Recently, scholars have begun to recognize that the Counter-Reformation was a gradual process beginning in the 1530s, continuing and gathering momentum as the century proceeded. The more we learn about the Counter-Reformation the more Trent turns out to have been not so much the initiator of reform as the codifier of it.[1]

In church renovation a great deal of activity is discernible in the second half of the Cinquecento. No specific directives are to be found among the canons and decrees of the Council of Trent which might account for it. On the other hand, S. Carlo Borromeo published a treatise in 1577 which spelled out in very specific terms how a church should be designed. There can be no doubt that Borromeo's *Instructiones fabricae et supellectilis ecclesiasticae* reflect Tridentine attitudes. Borromeo, who was archbishop of Milan and was the nephew of Pope Paul IV, had played a decisive role in the closing session of the Council and had then given leadership to the group formulating the new Tridentine catechism.[2] Next, he had turned his attention to instructions on church design. Shaped as its principles were by the recent Council, his handbook carried enormous authority. Nevertheless, its contents were in no way novel. The

[1] Classic early studies include Dejob (1884) and Mâle's ground-breaking work (1932). For a recent statement of the case, see J. S. Ackerman, 'The Gesù'.

[2] An example of Borromeo's initiative in implementing reform in religious music has recently been documented (Lewis Lockwood, *The Counter-Reformation and the Masses of Vincenzo Ruffo*, Venice, 1970). In March 1565 Cardinal Borromeo ordered Vincenzo Ruffo, newly appointed choir-master of the Duomo in Milan, to compose a Mass in which the words would be as clearly intelligible as possible. The early date parallels in music the response of the Florentines in church renovation.

Florentine project which is the subject of this study anticipates many of S. Carlo Borromeo's directives, and it was begun twelve years before the *Instructiones* appeared. In fact, to take Florence as an example (but not to suggest that it was unique), renovation similar to that of Sta Maria Novella and Sta Croce was initiated in the Carmine, Ognissanti, and Sta Trinita, all before 1574.[3] In church renovation, as in many other areas, the codification succeeded a widely recognized need for reform.

The need for the reform of church plans was far more urgent than has hitherto been recognized. Many churches retained a form designed to serve an outmoded social situation, which enforced liturgical practices quite out of step with the religious needs of the times. At a moment when the Roman Catholic Church, responding to the attacks of Luther, was calling for greater involvement of the layman in the celebration of the Mass, many monastic churches still retained their original rood-screens and choir enclosures, thereby ensuring the separation of clergy and laymen.

In both Sta Maria Novella and Sta Croce the scale of these structures has been seriously underestimated. In Sta Maria Novella the *ponte,* as the rood-screen was nicknamed, was a two-storeyed barrier reaching up about fourteen feet. Vaulted on the underside, it was twenty-six and a half feet deep. Behind it, a second enclosure surrounded the friars' choir in the nave (see Fig. 1).[4] In Sta Croce the *tramezzo* crossed the middle of the church, as the name implies, but like the *ponte* it was a structure a half-bay deep (Fig. 2). It supported a second storey at a height of about sixteen feet and a superstructure rising above the floor to almost fifty feet.[5] Thus, for the layman attending Mass and stationed outside the rood-screen in the part of the church designated for him, the view of the priest at the high altar must have been almost entirely blocked. He could

[3] On 1 December 1566, even before the results of the work in Sta Maria Novella and Sta Croce could be realized, Sta Maria del Carmine appointed an architect to reorganize the church, and structural work was begun in 1568. The decision to transfer the monks' choir in Ognissanti had already been made when Vasari's *Vite* went to press in 1567, although the work there was not completed until 1582. Buontalenti was the architect of a similar renovation undertaken in *c.* 1574 in Sta Trinita. By 1600 virtually all the medieval rood-screens and choirs in Florence had been demolished or moved.

The evidence for precise dating of the work in the Carmine was found among the archives of the convent by P. Cannon Brookes (see Brookes, 'Maso da S. Friano', p. 196).

The clue for dating work in Ognissanti is provided by Vasari himself in the second edition of the *Vite* (Vasari–Milanesi iii. 311). Frescoes had just been transferred to the lateral walls of the church before the monks had decided to move the choir behind the high altar (Paatz, *Die Kirchen von Florenz*, iv. 431).

Information on the renovation in Sta Trinita was published by V. Giovannozzi, 'Ricerche su Bernardo Buontalenti', *Riv. d'A.* xv (1933), 299 ff. See also Paatz, op. cit. iv. 311.

[4] I have described the rood-screen in Sta Maria Novella in detail in 'The *Ponte* in S. Maria Novella'.

[5] The reconstruction of the *tramezzo* in Sta Croce is presented in my article, 'The *Tramezzo* in S. Croce, Reconstructed'.

only hear those words pronounced in a loud voice, and the chanting of the friars, and possibly, from certain angles, see the elevation of the host. He must have felt very remote indeed from the priest's actions on his behalf. It is not really surprising, in this context, to learn that the average Roman at this time received the sacrament of the Eucharist once a year, if that, at Easter.[6] It is even difficult to imagine how the Eucharist was administered to the layman in churches so designed.

Times had changed, however, since the epoch when the sanctity of the Eucharistic elements had been more highly regarded than the communion of the faithful, and when the inviolability of *clausura* had been given a higher priority than the spiritual involvement of the layman in the Mass. The Ordinances of Pope Paul III stress the importance of frequent communion.[7] The Council of Trent, too, which had concluded only shortly before the renovation project was initiated in Sta Maria Novella, was very much concerned to remedy this situation. A result of the Council just as significant as the body of doctrine it produced was a subtle shift of emphasis away from the medieval concentration on the clergy towards the individual layman. The decrees stressing repeatedly the importance of the layman's active role in the Mass bear witness to this.[8] Though the Decrees of Trent nowhere specifically state that monastic churches should be reorganized, it follows with ineluctable logic from the spirit of the Tridentine reforms.

The need for reform of church plan had long been recognized in some circles. Isermeyer has documented the interesting case of the Cassinese, a breakaway branch of the Benedictines, who had discussed the possibility of placing the monks' choir behind the high altar in Sta Giustina, Padua, as early as the 1470s. The abbot at that time decided in favour of the traditional arrangement, and the same decision was taken when a new church of Sta

[6] Information quoted by M. Lewine in his important article, 'Roman Architectural Practice during Michelangelo's Maturity'.

[7] Ibid., p. 24, quoted from L. von Pastor, *The History of the Popes, from the Close of the Middle Ages*, London, 1894–1953, xi. 150 f.

[8] This is implicit in the formulation given some of the doctrines, e.g. the grounds on which the pageantry of the Mass, which had been attacked by Luther, is defended. Such uses as mystical blessings, lights, incense, and vestments are justified not only because they emphasize the majesty of so great a sacrifice—the traditional and expected defence—but also because they 'excite the minds of the faithful, by those visible signs of religion and piety, to contemplation of those most sublime things which are hidden in this sacrifice' (*Canons and Decrees*, Session XXII, Chap. V).

A further indication of the new attitude is the reiterated recommendation that the layman make frequent communion (e.g. Session XIII, Chap. VIII; Session XXIII, Chap. XI). Even the conservative decision to preserve the Mass in which the priest alone communicates reveals the intention to reform, for the decree carries with it the statement that it is desirable and the wish of the Council that the faithful present should partake of the Eucharist at every Mass (Session XXII, Chap. VI).

Giustina was constructed in 1521. Beginning in the 1530s with Antonio da San Gallo's design for Montecassino and Giulio Romano's for S. Benedetto al Polirone, the Cassinese began placing the choir behind the high altar. The new system became an Order-wide policy which, because of the centralized organization of the Order, was carried out in virtually all the congregations before the end of the Cinquecento.[9] In Florence itself, Brunelleschi had transferred the choir of the canons behind the high altar in S. Lorenzo, and in Sta Maria Novella a new choir was constructed beyond the high altar after the Tornabuoni redecorated the walls of the *cappella maggiore*.

Numerous rood-screens built in the late Quattrocento and Cinquecento were so open in construction that the view of the high altar was scarcely obstructed. An interesting example of the kind of solution which was reached in various churches of Catholic Christendom around the middle of the Cinquecento occurs at St-Étienne du Mont in Paris.[10] When the church was built in the 1540s the choir was placed behind the high altar but the rood-screen was retained. Its design represents a compromise between the need to isolate the monks and the need of the congregation to see the Mass. Although it is deep enough to be vaulted underneath, its light and airy construction make it truly a screen, providing definition of the parts without obscuring the vista.

Giorgio Vasari, before he was assigned the task of renovating Sta Maria Novella and Sta Croce, had been engaged on a project to accomplish a very similar remodelling of his family parish church, the Pieve in Arezzo. It is interesting to note that the temper of the times apparently changed in provincial Arezzo in the decade between 1554 and 1564. In 1554 the bishop of Arezzo, Vasari's good friend, Benedetto Minerbetti, had tried to instigate a renovation of the Aretine Duomo, but the conservative clergy and the *Operai* were so adamant that the project had to be abandoned. A decade later, however, the conservative elements yielded and Vasari carried out his programme. Shortly

⁹ Isermeyer, 'Le chiese del Palladio', *passim*. Isermeyer ('Il Vasari') notes that, in the first plan for S. Lorenzo, Brunelleschi had placed the choir in the traditional position in the nave. He credits Cosimo de' Medici with instituting the innovative design of 1442. Lapini recorded in his diary that the new choir stalls in Sta Maria Novella had been built by Baccio d'Agnolo. It was probably not intended originally for the friars but rather for the *conversi* since as Brown, *The Dominican Church*, p. 132, points out there were only forty-two stalls, which were not sufficient to seat all the friars.

The stalls built by Vasari in the *cappella maggiore* merely added a second tier to Baccio d'Agnolo's choir. The eighteenth-century plan (Pl. 1) accurately represents the *cappella maggiore* as it was after Vasari's renovation. The first tier of stalls shown there accommodates forty-two.

¹⁰ Anthony Blunt, *Art and Architecture in France, 1500–1700* (Pelican History of Art), Harmondsworth, (1953), p. 80, n. 45, pl. 33, reproduces this rood-screen and tentatively attributes it to Philibert de l'Orme. For Italian examples of late, compromise screens, see my article, 'The *Ponte* in S. Maria Novella'.

after he had completed the work in the Pieve, Vasari undertook the project to renovate the two great Dominican and Franciscan churches of Florence.

In the 1568 edition of the *Vite,* he made a public announcement of the work that had been under way since 1565:

The Duke takes pleasure, not only in building palaces, cities, fortresses, ports, loggias, squares, gardens, fountains, villas, and other grand things useful to his people, but also, as befits a Catholic prince, in constructing and renewing churches, in imitation of King Solomon. Thus he recently had me remove from Sta Maria Novella the rood-screen (*tramezzo*) which destroyed its beauty, and make a richly decorated new choir behind the high altar so that the old choir, which had occupied a great part of the nave, could be removed. This makes it appear to be a beautiful new church, as it really is. And because things which lack order and good proportion cannot be entirely beautiful, he has ordered that chapels be made in one or two styles in the middle between the columns separating the bays of the aisles. Each bay is to have an altar and rich stone ornaments with new friezes to frame paintings, seven *braccia* high and five *braccia* wide, to be made according to the wishes of the chapel's patron. Thus, in one of these frameworks designed by me I have made for the most reverend Alessandro Strozzi, bishop of Volterra, my venerable and beloved patron, a crucified Christ according to the vision of St. Anselm, i.e. with the seven virtues without which we cannot mount the seven steps to Christ, and other *considerazioni* of the same saint. For the same church I painted a Resurrection of Christ in a similar framework as God inspired me. I did this for Messer Andrea Pasquali, the Duke's physician, and it pleased my dear friend very much.

The Duke has wanted the same thing to be done in the very large church of Sta Croce, that is, to remove the rood-screen, to transfer the choir behind the high altar, moving the high altar forward somewhat and placing on it a rich new tabernacle for the Holy Sacrament, ornamented in gold with scenes and figures. As in Sta Maria Novella, fourteen chapels are to be made along the walls, but at greater expense and with more ornament than in Sta Maria Novella, because this church is much larger. The paintings, including those of Salviati and Bronzino, are to represent all the principal mysteries of the Passion up to the Descent of the Holy Spirit. Having made the design of the chapels and the stone ornaments I have in hand for Messer Agnolo Biffoli, the general treasurer and my dear friend, a picture of the Descent of the Holy Spirit.[11]

This was by no means the only project Vasari had in hand during those years: since 1566 he had had constantly to balance the demands upon his time of not only one insistent patron, but two. For Duke Cosimo, who had been his continuing sponsor, he and his workshop were turning out the enormous murals for the Salone dei Cinquecento in the Palazzo Vecchio. For Pope Pius V the commission for a relatively modest altar-piece for the Pope's

11 Vasari–Milanesi vii. 709 ff.; author's translation.

native parish of Bosco Marengo had grown to gigantic proportions, involving a double-faced altar-piece with about thirty smaller pieces to make up the ensemble. Nor had the previous year, 1565, when the work in Sta Maria Novella had been initiated, been any less frenetic, for it was at that time that the elaborate preparations for the wedding of the Duke's son and successor, Francesco, to the Grand Duchess Johanna of Austria (Giovanna) were made. In addition to a city-wide clean-up campaign, there had been temporary decorations to be installed all over the town along the route of the couple's triumphal entry. And of course it was Vasari who designed and oversaw the execution of all this. In view of this hectic pace, and of the other major projects in which both Cosimo and Vasari were involved,[12] we may well question why they should wish to undertake yet another large enterprise at this time. It is true that the disastrous flood of 1557 had caused serious damage in Sta Croce.[13] Perhaps, as in 1966, this suggested the need for more extensive renewal. But we have no record of damage in Sta Maria Novella, and it was there that the project was initiated, not in Sta Croce. The wording of Vasari's description, as well as other evidence, indicates that Sta Maria Novella was the primary target of the project and Sta Croce the secondary.[14]

The damaged condition of Sta Croce, particularly the rood-screen, doubtless played some role in the decision to institute a major renovation. We must still ask why the Duke himself chose to sponsor such a large undertaking, involving not only the transfer of the choirs and demolition of the rood-screens but also new chapels in the aisles, especially at this particular time. Whatever else may have motivated him, Cosimo's personal political ambitions certainly played a vital part.

Throughout the 1560s Cosimo's policies were dictated by one overriding aim:[15] his determination to secure for himself and his progeny the title of Grand Duke, thereby elevating Tuscany above all the other duchies of Italy and making himself the equal of the crowned heads of Europe. At first he had

[12] Those other projects included the design and construction of the new buildings for the recently founded Order of the Knights of St. Stephen in the Piazza dei Cavalieri in Pisa, on which Vasari was engaged between 1562 and 1571. See Crivellucci, 'Giorgio Vasari e gli edifici dell'Ordine militare di S. Stefano in Pisa', *Studi Storici*, xvii–xix (1908–10).

[13] The level that the water reached in Sta Croce is known to have been slightly lower than in the 1966 flood. Description of the damage done to the Asini

Chapel (q.v. in Catalogue) suggests that it was similar in extent and character to that which we have recently experienced.

[14] See my article, 'The Operation of Vasari's Workshop'.

[15] Luigi Carcereri, *Cosimo Primo Granduca*, vol. iii, 1929, *passim*, persuasively demonstrated that this political ambition was the focus of Cosimo's thoughts and actions in his later life.

hoped for the crown of Italy from the Emperor, but he soon realized that political jealousies would prevent it, and turned all his attention to the papacy. He had had considerable difficulty maintaining smooth relations with the ferociously zealous reformer, Paul IV. For instance when, in 1559, Pope Paul had ordered the burning of all the books recently placed on the Index, Cosimo had at first attempted through his ambassador to convince the Pope to mitigate his severity. When it became clear that His Holiness was adamant and, further-more, was demanding immediate evidence of compliance with his command, Cosimo devised a scheme to save from destruction the great humanist libraries of Florence, including his own, and at the same time demonstrate his co-opera-tion with the papacy. In a private letter to his friend, Alessandro Strozzi, whom he had appointed one of the Inquisitors of Tuscany, Cosimo ordered that a great show be made of burning some books, after which the matter could be put aside and forgotten.[16] Cosimo must have been greatly relieved when, later that year, Pope Paul died and was succeeded by a distant Milanese relative of the Medici, whose election Cosimo had helped to secure. Although that impover-ished branch of the family had not previously been acknowledged by the Florentine Medici, Cosimo's relations with the papacy now reached the acme of intimacy and goodwill. One of the new Pope's first acts was to appoint Cosimo's second son, Giovanni, to the rank of Cardinal. A few years later, in 1563, when Giovanni died tragically of malarial fever, the Pope elevated his thirteen-year-old brother, Ferdinand, Cosimo's third son, to the Sacred College. During the pontificate of Pius IV a nuncio was sent to reside permanently in Florence, an honour never before bestowed on the city. Once, Duke Cosimo travelled to Rome and remained there for two months, spending much of the time with the Pope in intimate conversations which ranged over the whole gamut of problems facing Catholic Christendom. Cosimo must have felt himself to be very close indeed to the coveted crown. Any gesture, now, which would demonstrate his piety and his devotion to the spirit of the Council might evoke the desired response from the Pope, for Pius, while he was not the fiery reformer his predecessor Paul had been, was dedicated to the Council and to the renewal of the Church. Cosimo's entire conciliar policy of close co-operation with the Pope had, as Jedin points out, been aimed more at

[16] Many ancient authors (Hippocrates and Galen, for example) had been placed on the Index. The Duke had hoped to be able to persuade the Pope to limit the list to works dealing with faith and morals. When this failed, he instructed Strozzi, through Concini, that he wished that more demonstration than effect be produced, and that what he wanted was 'un falò per ostentazione'. A. Panella, 'L'introduzione a Firenze dell'Indice di Paolo IV', *Rivista storica degli archivi toscani*, i (1929), 11–25.

Rome than at Trent and always with an eye on the grand-ducal crown.[17] Unfortunately for Cosimo, Pius died in December 1565, a few weeks after the renovation of Sta Maria Novella was begun. Cosimo's attentive wooing had not been in vain, however, for he was finally awarded his crown by the succeeding Pope, Pius V, in December 1569.

Cosimo could not afford any errors of judgement in the game he was playing. He was not the man to rush into the vanguard on the basis of anything so ephemeral as the mood or spirit of the times. As soon as that spirit had been given explicit formulation in the Tridentine decrees, however, he was quick to act. He had evidently recognized that his patronage of the renovation of the great Dominican and Franciscan churches would set an example which the other monastic churches would feel compelled to follow. He was not only making a public demonstration of his devotion to the Tridentine spirit, but also leading the way in instituting the reform. Yet his political ambition and its ecclesiastical expression cannot fully account for this programme.

While Cosimo's purpose no doubt explains the immediate motivation, we must look elsewhere than to Trent for the sources of the Vasarian design. While it was Trent's new concern for the layman and the Duke's sympathy with Trent that lay behind the decision to undertake the project, the man who gave it its shape, Vasari, had quite different concerns, and they were neither chiefly liturgical nor political but aesthetic. What Vasari sought first and foremost was a unified space *à la Renaissance*. This is clear in the variously worded statements, by Vasari himself and by others, explaining why the renovation was being undertaken. In the passage from the *Vite* quoted above, Vasari blames the rood-screen for spoiling the beauty of Sta Maria Novella and claims that the removal has transformed it into a beautiful new church, 'una nuova chiesa bellissima'. By *new*, Vasari means to connote modern, up-to-date, in the style of today, the opposite of old, out-of-date, *passé*. Another description of the renovation in Sta Maria Novella (Appendix Doc. 2) refers to the *ponte* and the choir as structures that occupied the middle of the church, impeding the view of the whole and therefore marring the beauty of this magnificent temple. A contemporary witness, Settimanni, echoes Vasari when he records in his diary that they were removing the *ponte* in Sta Maria Novella which had 'spoiled all its beauty'.[18] The Renaissance man viewed the medieval church with

[17] See Jedin, 'La politica conciliare di Cosimo I', who reviews Cosimo's correspondence with his representative at Trent. [18] A.S.F. MS. 128, vol. iii, fo. 334[r].

Renaissance eyes: he saw the space as a unity, though its medieval architects had designed it in segments; he saw the *ponte* and choir as disruptive, though they were integral parts of the original design.

While the removal of the *tramezzi* and the transfer of the old choirs would do much to unify the space, the effect Vasari desired could not be achieved without also rebuilding the nave chapels. Here again the Renaissance judged the medieval by its own preferences. The heterogeneity and irregularity of these interiors, where each private chapel was a patron's castle the decoration of which was subject to no overall planning, must have seemed hopelessly old-fashioned to the Renaissance viewer. The accumulated chaos of three centuries of slow accretion in these naves must have been very disquieting. The Renaissance preferred a planned and ordered sequence of similar chapels such as Brunelleschi designed in Sto Spirito. In fact, Vasari had a number of precedents available to him in the matter of designing a succession of nave chapels. High Renaissance architects, when they turned their attention from the liturgically unfeasible central-plan church to the longitudinal plan, in several instances experimented with this idea. Both Antonio da San Gallo in remodelling Sto Spirito in Sassia after it was damaged in the Sack of Rome (1538–44), and either Jacopo Sansovino or San Gallo (or both) working in S. Marcello al Corso (*c.* 1519), designed a series of nave chapels. Palladio employed a similar sequence in S. Giorgio Maggiore (1566) and, of course, Vignola was to choose it for the design of the Gesù.

Not every visitor to Sta Maria Novella today realizes that what he sees there is not Vasari's church, but the product of an extensive renovation in the 1860s (Pl. 6). As I have shown elsewhere, it is possible to reconstruct its appearance as it was in the years following Vasari's renovation from drawings and engravings (Pls. 2, 3).[19] The first thing that strikes one in comparing Sta Maria Novella with Sta Croce is a surprising inconsistency in the style. The tabernacles in Sta Maria Novella were in a far more intricate and interwoven style than those in Sta Croce (Pls. 4, 5). We can account for this by an even more surprising discovery. Vasari himself was not the author of the tabernacle designs for Sta Croce; he had farmed out the task to Francesco da San Gallo (a fact he failed to mention in his description of the projects in the *Vite*). In

[19] The documentation proving that San Gallo was responsible for the design of the tabernacles in Sta Croce was published by the present author, in 'The Operation of Vasari's Workshop'. The appearance that Vasari gave Sta Maria Novella, which was completely undone in the nineteenth century, is discussed at greater length in that article.

both churches, however, the fundamental scheme is similar: an altar tabernacle to be placed in each bay of the nave in two alternating designs. We know from the documents that Vasari was the architect in charge of the project. We should assume, I believe, that Vasari made all the major decisions with respect to both churches, leaving to San Gallo only the task of working out a design which would fulfil all Vasari's specifications.

An earlier example of a solution similar to Vasari's is Peruzzi's design for S. Domenico, Siena. After a fire severely damaged the church in 1531, Peruzzi undertook a remodelling which, while it was never executed, might have been known to Vasari through the drawings that are still preserved.[20] On the other hand it could be that Vasari came upon a solution similar to that of Peruzzi in the course of working on a similar problem. Of particular interest to us is a plan (Pl. 13) and an elevation which corresponds to it (Pl. 12). The entrance at the façade is transformed into a rounded apse; the nave, divided into five recessed chapels, is closed off at the other end by a pair of projecting chapels. The bays, each about ten *braccia* wide, are separated from one another by large engaged columns. Within the bays are altar tabernacles, designed to contain a painting four *braccia* wide, with a window above. The general scheme of a series of nave chapels, unified in style and dimension, each containing a painting of the same size, is precisely that which Vasari adapted for Sta Maria Novella and Sta Croce (Pl. 7).

Francesco da San Gallo's tabernacles in Sta Croce resemble Peruzzi's more closely than do Vasari's in Sta Maria Novella. He used a similar bold classical form with alternating triangular and rounded pediments (Pl. 11, 12) (though he substituted the Composite order for Peruzzi's Ionic, extended the supporting columns to the floor without socles, and omitted the gigantic engaged columns Peruzzi used to separate the bays). Vasari, while employing a syntax similar to Peruzzi's, drew his vocabulary of form from Michelangelo. We are reminded of the compressed, tense style of Michelangelo's Medici Chapel and Laurentian Library.

Despite the similarity to Peruzzi in scheme, Vasari and San Gallo create a quite different effect. Peruzzi plainly was concerned to create a sequence of static spaces, as other drawings of the same series make still more clear.[21]

[20] This project and some of the drawings for it in the Uffizi were published by Gino Chierici, 'Baldassarre Peruzzi e la chiesa di S. Domenico a Siena', *Rassegna d'arte senese*, xvi (1923), 70–5.

[21] Peruzzi had also experimented with the idea of breaking the nave into three large domed bays closed off from one another by piers; Uffizi 339Aʳ, 340A.

Vasari, and San Gallo, probably following Vasari's directive, create a sense of movement proceeding down the church (Pl. 7). Unlike Sto Spirito (Florence), S. Marcello, or Sto Spirito in Sassia, where the chapels are recessed into the lateral wall, these project into the aisles. They delimit the lateral extension of the space, binding nave and aisles together, and create a strong perspective vista leading to the high altar.

The problem of unifying the chapels was greater in Sta Maria Novella and Sta Croce than in S. Domenico because the bays Vasari had to deal with were much longer than those designed by Peruzzi. Even with altar-pieces five *braccia* wide instead of Peruzzi's projected four *braccia,* the tabernacles in the Florentine churches could not nearly touch the limiting pilasters as Peruzzi had intended his to do. To draw the tabernacles together in Sta Maria Novella (and to compensate for the change in floor-level), Vasari implemented a nearly continuous two-step platform (Pl. 1). In Sta Croce there is some evidence that he would have liked to connect the tabernacles with a continuous cornice. We have a series of drawings by Cigoli in the Uffizi, dating from around the end of the century, which experiment with several methods for linking the nave altar tabernacles, e.g. by adding another whole series of smaller altars between the existing chapels (Pl. 15), or sculpture-filled niches (Pl. 14).[22] In either case the old and new altars are shown connected by a continuous cornice running the length of the nave. Nothing is known about this project—its date, its origin, whether any part of it was ever carried out—but there is an interesting precursor of it in the tomb Vasari had designed for Michelangelo. Above the bust of Michelangelo is a *Pietà* painted by Battista Naldini,[23] and above it a vast painted *baldacchino* which appears to be hanging from the base of the pilaster (Pl. 11). Behind the *baldacchino* is painted a simulated cornice which connects with the stone cornices of the flanking tabernacles. The concept of a continuous cornice was, in fact, carried out in Sta Croce, though we do not know when. Its presence in nineteenth-century engravings and photographs shows that when the widely-spaced tabernacles are connected in this manner the unification of space which Vasari sought is further enhanced

[22] See the catalogue of Cigoli's drawings, San Miniato, *Mostra del Cigoli e del suo ambiente,* Accademia degli Euteleti, 1959.

[23] The Inventory of Chapels in Sta Croce (A.S.F. Conv. Sopp. 92, vol. 362) describes this bay: 'La testa di detto Michelagnolo Buonarroti la fece Battista del Cavaliere. La Pittura dipinta nel quadro di sopra, col padiglione, angiolini et altro, la dipinse Batista del

Pont'Orme.' The simulated architecture is not mentioned specifically, but there is nothing else to which *et altro* could refer. It is highly unlikely that the architecture would have been painted in behind the *baldacchino* at some later date. The whole painted superstructure seems to have been conceived as a whole, not only spatially but also in colour.

(Pls. 10, 7).[24] Regardless of whether Cigoli's designs (and the later-executed cornice) were based on an intention of Vasari's which his death prevented him from carrying out, or whether they were part of a new project, the treatment given Michelangelo's tomb indicates that Vasari himself had turned to the idea of a continuous cornice as the connecting fibre he needed to create the desired impression.

In the interest of that unified effect, Vasari imposed a regularity which exceeded that of earlier experiments with a succession of side chapels. In those other plans by Brunelleschi, Sansovino, San Gallo, Palladio, and Vignola where the chapels are recessed into the lateral wall, there was ample opportunity for patron and artist to develop an individual design since there were three walls to each chapel. One tends to consider each chapel separately, and each was decorated independently. Even in the Florentine Sto Spirito and in Sto Spirito in Sassia, where the apsidal shape of the chapels gave them greater unity with the nave and less wall space, the plan of decoration varied greatly from one chapel to another. But in Vasari's design, tabernacles, altars, tombs, even frames are similar in every chapel. Each element was considered in terms of its function in the total architectural effect.

For example, in designing the shape and frames of the altar-pieces in Sta Croce, Vasari was faced with the problem of integrating into his cycle the pair of altar-pieces, already in place, by Salviati and Bronzino (Pls. 24, 25). One might well have expected him to base his own design on them, but on the contrary he chose to avoid the lunette-topped format employed there and selected instead the more architectural form of the rectangle. He also avoided the wide and highly ornamented frames which had been used on those two paintings of the high Maniera style. In contradistinction to his own usual preference for the elaborate and the ornate, Vasari chose a narrow, and rather simple, gilded frame (Pl. 5). By rejecting the pre-existing design he made it apparent that he was even more concerned with the relationship of the altar-pieces to one another and to their setting than in achieving absolute uniformity. Certainly the reason for his choice was that he wished to minimize the sense of sharp demarcation between the altar-pieces. Bronzino's and Salviati's paintings are defined more distinctly by their frames and they are more abstracted from their surroundings. Though it would be wrong to say of the Vasarian chapels

[24] The engraving of the interior of Sta Croce illustrated by Moisè (*S. Croce di Firenze*, 1845) also shows the continuous cornice.

that each unit is incomplete without the others, the sense that they belong together is overwhelming. What is important here is not the unique beauty of each individual chapel, but the effect of the series.

Vasari uses the side chapels as regular and like elements to bind and unify the space. They are indispensable in achieving his aesthetic end. It should be noted, however, that the proliferation of nave chapels was wholly consonant with the spirit of the reform codified at Trent. What better way to engage the layman actively in the liturgy than to make it accessible to him? When the Mass was performed in a nave chapel, instead of before the high altar, the worshipper was brought close to the celebrant physically and, therefore, psychologically. Even more relevant in this context, the altar-pieces in these nave chapels were likewise readily accessible to the layman, which was in keeping with the decrees of the Council asserting that sacred images had didactic value. The Jesuits, who were to take the van in the Counter-Reformation, went even further in affirming the value of images. They believed that the real use of a sacred painting was as a spur to mystical contemplation.

The technique developed by St. Ignatius Loyola and set forth in the *Spiritual Exercises* of 1540 reinstates mystical contemplation as a means of enriching the spiritual life. In the *Exercises* St. Ignatius instructs the exercitant to concentrate all his senses and focus his imagination on the subject selected for the day's meditation, e.g. hell. He is then instructed to see in his mind's eye the 'composition': the place; then to feel it: the heat of hell's fires; then to hear it: the shrieks of the damned in torment, and so on through the senses. By this means the exercitant is elevated to a mystical union with the subject of the meditation and thus to a fuller understanding of it.

For the untrained layman a representation of the scene provides a useful starting-point for meditation. Church decoration is thus elevated to a role of much greater importance. We cannot state with precision how long it was before St. Ignatius' concepts were first applied to sacred images. It is noteworthy, however, that a cycle of altar-pieces such as that introduced in Sta Croce was an excellent instrument for this kind of contemplation. The successive episodes of the Passion could be used to excite the layman's meditation on each phase of Christ's sacrifice.

The interests of Counter-Reformation and of architect coincide in the desirability of a series of nave chapels: the renovation, indeed, resulted from the interaction of liturgical and aesthetic considerations. The reiteration, by

the *Operai* of Sta Maria Novella, in a letter to the Duke, of the reasons for the undertaking documents its dual purpose. They affirm that it is for the greater ornamentation, *commodità,* beauty, and religious observance of the venerable church.[25] In all probability, the project would not have been initiated had it not been for the reform given definition at Trent. On the other hand, the need for reorganizing the interior provided the opportunity to create a 'most beautiful new church'. Trent did not invent any new forms. It was not a new idea, as we have already seen, to put the choir behind the high altar. Vasari himself had anticipated every element of the Florentine renovation when, a few years earlier, he had remodelled his family church in Arezzo.[26] While this indicates that Vasari, not Trent, must be credited with inventing the programme of these renovations, it supports my contention that the authority of the Council provided the impetus needed to realize the renovation.

It is not characteristically the nature of Councils to create radically new solutions, but rather to choose between conflicting alternatives. We are surprised to find that Trent's decrees on sacred images are brief and excessively generalized. We forget that the task of the Council had been to determine whether to accept or reject the iconoclasm of the radical Protestants, and that the decrees on sacred images were drawn up in this context. They contain no statement that in itself accounts for the change we observe in the religious art of the last third of the Cinquecento. We overlook the fact that the real importance of a Council is often the mood that results from it, as for example the ecumenical spirit generated by Vatican II which reversed, finally, the posture of confrontation between Roman Catholics and Protestants taken up at Trent.

The spirit of Trent, and therefore of the Counter-Reformation, has often been judged to have been harshly authoritarian. We must ask ourselves, if this be a true reflection of the spirit of its time, how were the decrees en-

[25] A copy of the letter is preserved in Baldovinetti, n.p., dated 5 October 1565. It runs in part:
'Illustrissimo, et Excellentissimo Signore Duca Cosimo.
'Atteso che l'Eccellenza V. Illustrissima, come quella che sempre attende a cose migliori, e più perfette è risoluta, che per maggiore Ornamento, commodità, e bellezza, e Religiosa Osservanza della Venerabile chiesa di S. Maria Novella si levi del mezzo di quella il Ponte, e il Coro, il quale secondo l'Ordine da lei dato si riducha nella Cappella Maggiore con tirar inanzi l'Altare, e l'altre sue Appartenze . . .'
[26] Isermeyer's research on Vasari's renovation of

medieval churches is extensive. His article 'Die Capella Vasari' documents the course of work in the Pieve, and shows that the plan corresponds closely to that adopted a few years later in renovating the Florentine churches. As Isermeyer points out, Vasari kept Cosimo fully informed about the progress of the Pieve. It was probably from contact with the Aretine project that our renovation grew, though we cannot know whether the conception of applying the plan to the Florentine churches originated with Vasari, or Cosimo, or some third party.

forced? I have found no evidence in this particular instance of imposition from above, but rather of immediate compliance with the spirit of Trent. There is no evidence of an order, originating with the ecclesiastical authorities, which required the removal of rood-screens and the transfer of choirs. Instead, we have found evidence that the practices codified by Trent were begun before the Council. Similar conclusions suggest themselves with regard to the style of the altar-pieces. We shall see that the style of the High Maniera, which was antipathetic to the Counter-Reformation, in large measure dissipated, and without any evidence of enforcement. Rather than an atmosphere of repression one seems to sense a new energy and a spirit of renewal in the last third of the century. It is as if the definitions of doctrine that Trent has provided dispel the mood of anxious uncertainty which had prevailed around mid century, and to which much of High Maniera art bears poignant witness. To a greater extent than is usually acknowledged, we may say that Trent met the psychological needs of Catholic Europe in its time. Perhaps in looking for the means of enforcing the new spirit we have overlooked the degree to which that spirit already pervaded the culture.

The renovation of Sta Maria Novella and Sta Croce took place in the context of the Counter-Reformation and is a significant expression of it. For the particular form of the project two individuals are responsible: it engaged the artistic personality of Vasari as deviser and executant in the service of Duke Cosimo, whose concerns included the consolidation of his power in Florence.

II

Realizing the Project

IMPLEMENTING a major renovation of two of Florence's principal
churches required powerful leadership. To co-ordinate such diverse ele-
ments as the property of the church, the patronage of the Duke, the plan
of Vasari, his chosen artists and artisans, the co-operation of the *Operai*, and
the participation of some thirty families as patrons of the private chapels needed
a highly organized bureaucracy. Only the Duke himself wielded this kind
of power in the Florentine duchy. The private patrons were to bear the ex-
pense of building the new chapels. However, had it been necessary to meet from
private sources the expenses of demolishing the rood-screens and old choirs
and replacing them with new structures, the *Opera* would not have been able
to find the money. Because only the ducal treasury could finance such an
enterprise, Cosimo agreed to make a payment to the *Opera,* which would then
dispense the funds as they were needed.

The plan for the renovation of Sta Maria Novella was probably drawn
up some time early in 1565. Contemporary and later documents frequently
refer to the order of the Duke stating that certain work was to be done in the
church. Copies containing its substance have been preserved, such as that
printed here (Appendix, Doc. 2), though the original document has not sur-
vived and its exact date is unknown. First were listed all the chapels, altars,
and tombs to be demolished. Included is the *ponte,* with its chapels, and the
old choir, with the altar attached to its wall. The presumed location of each
one mentioned is shown in Fig. 5. Then followed the project for rebuilding,
after everything that had been impeding the view of the whole had been
cleared away. Cosimo I wished that a new altar be placed in each of the bays
of the nave, just as Vasari says in the passage from the *Vite* quoted above in
Chapter I. It had been decided, the order stated, not to ask the consent of the
patrons of those chapels marked for demolition, but to seek new patrons who
would agree to construct chapels at their own expense in accordance with the
design of Vasari. The high altar was to be moved forward to make room for

a second tier of choir stalls behind. To replace the protection that the *ponte* had provided for the friars, a corridor running behind the transept chapels to the choir was to be built. By this route the friars would be able to go from the cloister to the *cappella maggiore* without being seen. In the space where the old choir had been, benches were to be placed for the worshippers. The organist was also to be provided with direct access from the sacristy to the organ. Four altars on the *ponte* were to be combined under one dedication in a single altar. The architect was to have the authority to transfer tombs, burial-places, or doors if necessary, so long as he accorded them equal or more honoured locations.

Actual work began in October 1565. On 12 September the prior of Sta Maria Novella, Frate Angiolo Malatesti, wrote to Duke Cosimo requesting that he forward the money for reordering the choir, high altar, 'etc.', in the church.[1] On 5 October the *Operai* wrote asking the Duke to give the order to the architect (i.e. Vasari) to begin executing the work.[2] Lapini records that about two weeks later, on 22 October, they began the demolition of the *ponte*. The following March the high altar was moved forward, and, a month later, they had completed the tearing out of the old choir in the nave.[3] Lapini remarks that the Dominicans were the first to accomplish this modernization, which was being planned for all the churches, and that everyone was very pleased to see these old structures go.[4] A dissenting opinion was recorded, however, by Settimanni, who remarked that some people who had enjoyed the privacy and quiet that the *ponte* afforded for personal devotions criticized its removal.[5]

By the following January the new choir stalls designed by Vasari were completed. The single tier of seats installed in the 1490s was retained and augmented by a second tier of thirty-eight seats (Pl. 9). The high altar had been moved forward about twelve feet[6] to the front of the *cappella maggiore,* so that although the high altar has undergone two renovations since that of Vasari its position today is probably that given it by him.

Meanwhile work had begun in Sta Croce. On 21 July 1566 the *Operai* reported to the Duke that they had removed the *tramezzo* and all the chapels

[1] A. S. F. Spogli, vol. 64 (Sta Maria Novella), pp. 364 ff., no. 1.

[2] This is the letter referred to and in part quoted above (Chapter I, p. 14 and n. 25).

[3] Lapini, *Diario*, entry dated 24 March 1565 (1566).

[4] Ibid., entry dated 23 April 1566.

[5] A.S.F. MS. 128, fo. 364ʳ.

[6] Lapini, *Diario*, p. 152, gave the figure 'circa 6 braccia'.

except that of the della Foresta (Fig. 2), which had the organ on top of it and was located on the cloister wall (Appendix, Doc. 3). In addition, they had lowered the choir wall to the point that His Excellency had indicated, except in one place on the north side where they had demolished a section of wall entirely to see how it would look. In fact, it had been necessary to remove the entire wall in places because the wood supporting the choir stalls was partially immured. Where the wall was torn out, however, everyone—especially the architects and experts whom they had consulted—noticed how much more beautiful the church appeared. The *Operai* then suggested to the Duke that they should transfer the friars' choir to the *cappella maggiore*, instead of simply leaving it in its old position in the middle of the nave and lowering the enclosing wall. By pulling forward the high altar and enlarging the steps to it, and by removing a small staircase which was no longer needed, almost four *braccia* could be gained in the *cappella maggiore*, which they estimated would be more than enough space to seat the sixty friars of the convent. They had tried it out, and not only was there space for all, but they could hear as well as they had been able to in the old choir. When the large polyptych was removed from the altar,[7] the *cappella maggiore* would appear larger and more handsome because the beautiful stained glass windows in the east wall could then be seen; the friars would also be able to see the elevation of the host. The altar-piece could be replaced with a ciborium[8] or a crucifix, like those in Sto Spirito, SS. Annunziata, and S. Pier Maggiore. They concluded the letter with a request that the Duke inform them of his wishes in this matter. A week later the ducal secretary returned the letter with the business-like note at the bottom: 'If the choir can be put in the *cappella maggiore*, remove it entirely from its present position.'

It had not been the original plan, apparently, to transfer the choir out of the nave. It may have been that in Sta Maria Novella the existence of choir stalls in the *cappella maggiore* suggested the possibility of moving the friars' choir entirely to that location. One suspects from the tone of this letter that the question of transferring the choir in Sta Croce had been discussed earlier and the decision left open. This document precludes the suspicion that the impetus for the alterations had actually been provided by some unseen higher ecclesiastical authority, implementing specific Counter-Reformation directives. It is

[7] This was a polyptych by Ugolino da Siena dating from *c.* 1330 (Paatz, *Die Kirchen von Florenz*, i. 602).

[8] The Council of Trent, in taking up the question of the reservation of the consecrated sacrament, had enunciated a doctrine which implicitly supported the use of ciboria for keeping the host on the high altar. Session 13, 'Canons on the Most Holy Sacrament of the Eucharist', Can. 7 (*Canons and Decrees*, p. 80).

clear that it was the Duke—in fact, as well as in name—who made the decisions with regard to the renovations, in consultation of course with the *Opera*. What is more, the decision as to what was to be done was made not in accordance with some pre-existent master plan but on the basis of the particular situation in the church.

The Duke apparently made a personal visit to Sta Croce a few weeks later, for Vasari reported on 18 August 1566 to his friend and collaborator, Vincenzo Borghini, that all was turning out very well there, that they were remaking much more there than in Sta Maria Novella, and that the Duke preferred it.[9] Perhaps it was at the time of this visit, in the first flush of pleasure at how successful the project was proving to be, that the Duke agreed to provide the marble for a new high altar, and to donate the ciborium mentioned earlier by the *Operai* but not mentioned in the ducal reply. Whenever it was that the promises were made, the Duke seems to have forgotten about them until reminded by the *Operai* the following February 1567 (Appendix, Doc. 4). They reported that the new choir had been finished and that Vasari had completed a *modello* of the new ciborium. The Duke was given the measurements for the altar table and informed that the friars would like to be able to hold services in the *cappella maggiore*. Again, the ducal secretary added the reply at the bottom of the original letter: 'It will be quarried and sent.' The ciborium, too, though not mentioned in the reply, was eventually donated by Duke Cosimo and, according to Lapini, put in place on 7 April 1569, where it was still to be found in the nineteenth century (Pl. 10).[10] It appears from these documents that the original plan called for fewer alterations in Sta Croce than in Sta Maria Novella, but that little by little this plan was expanded. Vasari's statement in the *Vite* that more was being spent on Sta Croce because it was much larger would seem to be an *ex post facto* rationalization.

In the same letter mentioning the Duke's visit to Sta Croce (18 August), Vasari reported that the construction of the Strozzi Chapel in Sta Maria Novella (Fig. 5) had begun and that the panel of the altar-piece was being gessoed. This was the first of the new chapels in either church. The patron for it, as well as for the other showpiece chapels, had been carefully chosen. When the project was announced at the end of the *Vite*, the names of the first three patrons were included. The Duke and his advisers evidently felt that if

[9] Frey ii. 272.
[10] This ciborium, of enormous scale and decorated with small painted panels, is at present being restored by the Soprintendenza and will be displayed in the Museo di Sta Croce. It was elaborated with lateral partitions and a cornice in the seventeenth century.

the project were given a good start and the example were set, other patrons would follow with a minimum of dissent. Accordingly those intimates of the Duke who would be most susceptible to the suggestion were given the opportunity to found the first of the new chapels. Alessandro Strozzi was selected for Sta Maria Novella. The Strozzi had long been associated with the church, and Alessandro was one of the Duke's closest friends. Cosimo had nominated him to one of the three posts of Inquisitor, and it was through him that the Duke had dealt in 1559 in the delicate problem of complying with the Pope's order to burn books placed on the Index (see p. 7). Then, shortly after work on the chapel in Sta Maria Novella was begun, Strozzi was appointed bishop of Volterra.

To found the first of the new chapels in Sta Croce (Fig. 6), Agnolo Biffoli was chosen. He was the Duke's own treasurer, was one of the *Operai* of Sta Croce, and had owned a tomb in the church. The deed for the chapel was drawn up in February 1567 and the altar-piece installed in October 1568 (see Catalogue, Sta Croce, Biffoli Chapel). Averardo Serristori, the Duke's ambassador to Rome, whose family already owned an altar in Sta Croce, was apparently also recruited as one of the founders of the project, but he died before his chapel could be built (see Catalogue, Sta Croce, Serristori Chapel).

The second chapel appropriated in Sta Maria Novella went to another man close to the Duke, Andrea Pasquali, his personal physician. There are several suggestions that the organizers of the project were anxious that he be one of the early patrons, perhaps because his family for many generations had had at least a tomb at the site of the new chapel. Certainly the organizers wished to suggest that venerable patrons were not being dispossessed, but that they were invited to participate and even expand their former presence by patronizing one of these fine new chapels. The chapel was evidently beyond Pasquali's means (see Catalogue, Sta Maria Novella, Pasquali Chapel). Vasari gave him a cut rate on the altar-piece, and the Duke himself presented a very large gift to Andrea shortly before he made the final decision to undertake the chapel. Andrea's inclusion of the Medici patron saints, Cosmas and Damian, who were also conveniently the patrons of the medical profession, represented in part an acknowledgement of the Duke's generosity. It may also be significant that no record of Pasquali's payment for the altar-piece can be found, although payments for minor expenses, such as making the wooden panel, are recorded. Perhaps the organizers made every effort to include him in order to demonstrate that

the project did not unjustly discriminate against previous patrons with modest resources.

At least one former patron in Sta Maria Novella followed the example set by Pasquali. Like Pasquali, he received a certain amount of preferential treatment. Girolamo Giuochi was a grocer who apparently objected when the *Opera* reported that his family was extinct (Appendix, Doc. 2, no. 2). He was allocated the site nearest that of his family's former chapel and he accordingly built the new chapel (Fig. 5). Grocer Girolamo, evidently childless and desirous of obtaining as much for his soul as possible with his hard-earned money, split the endowment between the Compagnia di S. Lorenzo, who became the patrons of the chapel, and the convent. The friars grudgingly accepted the scanty endowment, doubtless out of deference to Giuochi's ancestors (see Catalogue, Sta Maria Novella, Giuochi Chapel).

It was certainly to soften the harshness of the methods being used to realize the new series of chapels that these concessions were made to Pasquali and Giuochi. And Vasari, well aware of the propaganda value of the announcement in the *Vite,* timed the operation carefully, making sure that the project was launched with an impressive list of patrons already participating by publication date. The decision to demolish existing chapels and altars without seeking the consent of the owners was a bold step. It meant that the patrons were virtually dispossessed of rights established for them by their ancestors. The *Opera* alone did not possess sufficient power to accomplish such a measure. Only the Duke's prestige would suffice. As we shall see, when the time came to coerce a recalcitrant or lethargic patron, the *Operai* always acted in the name of the Duke. The *Operai* were, after all, only private citizens selected for life from among those who owned chapels and tombs in the church.[11] It was the Duke, however, who in effect selected the *Operai*. When a member of the *Opera*

[11] This is apparent in Sta Croce from two documents preserved in A. S. Croce, vol. 426. These are letters from the *Operai* to the Duke on the occasion of the death of Filippo Salviati (fo. 61) when Jacopo Salviati was elected to replace him, and when Biffoli died (fo. 70). The qualifications for membership are stated as residence in the quarter and ownership of a chapel or tomb in the church.

Those eligible for election at the time of Biffoli's death are listed: Mess. Marco delli Asini e Mess. Giovanni Battista suo figlº, Mess. Lorenzo di Piero Nicholini, Marabotto d'Antonio Rustichi, Giovanni di Jacopo Morelli, Benedetto Busini, Matteo Bonvanni, Pagolo di Giovanni Peruzi, Thommaso Spinelli, Agnolo Galilei, Agnolo Barberino, Giovambattista Guidacci, Ruberto Magalotti, Francesco Risaliti, and Bartolomeo di Lapo del Tovaglia. The following note is appended: 'Non vogliamo anchora manchare di fare noto a v. Alt., come tal grado è stato in chasa li Morelli più anni passati et così Mess. Lorenzo Nicholini ha havuto il padre, avolo e zio che sono stati di decto offitio a' tempi hodierni.'

We do not have a list of the *Operai* in Sta Maria Novella nor evidence of how they were selected. We know from a passing reference that Bartolomeo di Bernardo Gondi, a prominent patron in the church, was one of the *Operai* in 1569 (Appendix, Doc. 7).

died, the customary procedure (at least in Sta Croce) was for the nine survivors to draw up a list of those eligible to take his place. They would then forward the list to the Duke. By thus controlling the election of *Operai* the Duke could exercise considerable control over the physical character of the churches.

At the death of Agnolo Biffoli (22 November 1568)[12] the nine surviving *Operai* were: Alamanno de' Pazzi, Simone Corsi, Jacopo Salviati, Daniello degli Alberti, Lodovico Serristori, Giulio del Caccia, Piero Dini, Filippo dell'Antella, and Giovambattista Zati. Of the ten, six had already, or soon would, patronize one of the new chapels: Biffoli, Pazzi, Corsi, Serristori, Dini, Zati. In effect, then, the *Operai* were the patrons of the new chapels. Since they had a vested interest in the success of the project they could be expected to be enthusiastic backers. It is interesting, therefore, that from among their number came the most troublesome patrons, the dilatory Lodovico Serristori and the Alberti family. The Alberti are conspicuously absent from the list of patrons of new chapels, though the family had been perhaps the principal patrons of the church in former times. They had given the friars' choir in the nave, were the patrons of the *cappella maggiore,* and had no fewer than eleven tombs for the men of the family across the base of the steps to the *cappella maggiore* and two more for the women just outside the choir enclosure in the centre of the nave. But the choir had been demolished in the summer of 1566. There followed a lawsuit of great importance to the question of patrons' rights in churches.

The project to renovate Sta Maria Novella and Sta Croce was based upon a new conception of the role of the patron. Former patrons, like the Alberti, saw demolished what they had considered their property. In the case of tomb- and chapel-owners, they were given the option to build a new chapel on the same site, or were assigned a site near by (see Catalogue, Sta Croce, Asini Chapel, and Sta Maria Novella, Minerbetti Chapel). But these new chapels could not be designed or decorated according to the patrons' wishes, as had been done in former times. They had to be built according to a predetermined design. In Sta Croce, where the altars formed a cycle depicting Christ's Passion, even the subjects of the altar-pieces were pre-established. Pressure would be exerted to influence the patron's choice of artist as well (again, see Catalogue, Sta Maria Novella, Minerbetti Chapel). No longer was he free to decorate his chapel as he pleased, selecting his favourite architect and artists and commissioning his preferred painter to make an image of his name-saint

[12] A.S.F. Medici e Speziali 252 (Libro dei Morti, 1560–70), fo. 12ᵛ.

over the altar, spending as little or as much on the decoration as he saw fit. The medieval chapels had been considered private property. Those which were demolished in Sta Maria Novella are described as having been closed with wooden gates and locked with a key.[13] The degree to which the new chapels were regarded as public altars is indicated by the imposition of a cycle of subjects.

It is obvious that the situation had changed since the Quattrocento. We are told that Cosimo *pater patriae* had intended to carry out a renovation of S. Marco but that he did not succeed because the families who owned ancient rights to the chapels refused to surrender them. Duke Cosimo wielded more power than had his namesake, to be sure, but there is evidence of a steady erosion of the rights of private patrons in churches during this period.[14]

The Alberti went to court[15] when the *Opera* attempted to dispossess them entirely of the area where the choir had been (Appendix, Doc. 5). The arguments put forward by the *Opera,* which certainly reflect the judgement of the Duke, reveal how far he wished to push the revision of patronage rights in churches. Although the *Opera* lost, the conceptions voiced by them anticipate future developments. They had contended that 'things in churches' (*cose ecclesiastiche*) could not be possessed by the laity. They were rebutted by the Alberti on the grounds that every day sites for chapels and sepulchres in the churches were appropriated, and the fact that the patron actually possessed the site was proved by the fact that no other person could be buried there without his permission. The Alberti, argued the *Opera,* had been patrons of the choir,

[13] Orlandi–Borghigiani (p. 403) reports on this fact, quoting from the chronicle of Biliotti: 'Tutte le Cappelle sì del Ponte, che sparse per la Chiesa, erano concamerate, dice in latino il Biliotti, cioè alquanto sfondate, non per caso però nella muraglia, o poco se pure, a riserva di quelle della Crociata; ma per aggiunta di spallette di muro, ritto ai lati, ed arco sopra, con cancellata di legno da chiudere a chiave, ancora quelle della Crociata, eccettuata la sola Cappella maggiore, che non aveva cancello; ed ogni Cappella aveva un armadio, chiuso parimente a chiave, ove si tenevano gli arredi necessari per la medesima, quale armadio sarà stato allato, e questo probabilmente incavato nella muraglia.' Biliotti's description was apparently not entirely clear to Borghigiani, but he interpreted the earlier chronicler to say that each chapel had been recessed in the wall and closed with a gate, with a recessed cupboard in the wall beside it.

[14] Cosimo's abortive renovation of S. Marco is mentioned by both Filarete and Vespasiano da Bisticci, see Vasari–Milanesi, ii. 440–1. Louisa M. Bulman discusses similar issues in 'Artistic Patronage in SS. Annunziata, 1440–*c.* 1520', Ph.D. dissertation, University of London, 1971. When in the mid-fifteenth century it was decided to enlarge the church, the choice of a circular tribune was in part dictated, according to Bulman, by the presence of a chapel in the right transept belonging to the Falconieri family which blocked the possibility of extending the cruciform shape to the north. She reaches the conclusion that in SS. Annunziata patrons' rights of possession diminished in the course of the fifteenth century (Chap. II. 4). This coincides with the evidence presented here for the sixteenth century. It suggests that the prevailing view which assumes an opposite trend during this period may need revision.

[15] The verdict of the magistrate dated 26 August 1567 summarized the arguments that had been presented both by the *Opera* and the Alberti. The sentence followed about a week later (5 September 1567), and a copy was preserved among the records of the *Opera.* Moisè transcribed it (*S. Croce di Firenze*, pp. 126 f.), though without the prior document giving the verdict of the magistrate it was largely incomprehensible.

but when that choir was removed their rights ceased. The Alberti claimed that their rights were actually to the ground where the choir had been and to the empty pavement inside the stalls. They won their case by arguing that the tombs of men and women of the family would have been placed side by side and not—as they were—at the head and foot of the space, had it not been intended to designate that all the space between belonged to them. It was further argued that had the *Operai* been the proprietors, they would have appropriated the space for tombs as they had done in the rest of the church, and they would not have had to seek the permission of the Alberti to bury Francesco Sansoni in the middle of the choir enclosure, as the plaque on the tomb records that they did.[16] The final argument proving the Alberti's rights to all the ground where the choir enclosure had been *in tutto et per tutto,* and not only for the use of the choir, was that when the choir was being torn down they had buried a Cardinal of the family in the middle of this now disputed pavement and the *Opera* had raised no objection.

The *Opera*'s assertion that a site was appropriated only for a specific use, and that when that use ceased the site reverted to the *Opera,* was a very significant and portentous claim. On that basis they would have been able freely to demolish anything in the church without granting the patron further rights to the site. So long as a chapel dedicated to the title designated by the original patron was officiated as required in the endowment, the friars' obligation (signified by their acceptance of the endowment) would be fulfilled. A single altar could incorporate any number of dedications, as we shall see in the case of the Capponi altar in Sta Maria Novella, where the friars intended to include, in addition to that of Camilla Capponi, the dedications of three altars being demolished in the renovation (see Fig. 1).

While it had been stated in the plan for the renovation of Sta Maria Novella (Appendix, Doc. 2) that the architect had the right to transfer tombs, sepulchres, and doors, nothing had been said about altars and chapels. It required a papal bull to accomplish the transfer of the altar of the Immaculate Conception, which had been founded by Alfonso della Casa in 1492, from the nave in Sta Croce.[17] Even so, a lengthy dispute arose over the *Opera*'s intention to

[16] The tomb of Cardinal Sansoni, dated mid 1499, is still visible today in the centre of the nave of Sta Croce, and the inscription recording the permission granted by the Alberti is still legible.

[17] The bull was issued by Pope Pius V, dated 15 September 1570 (A.S.F. Conv. Sopp. 92, vol. 112, fos. 29 f.). The record of the dispute that ensued (cited in my article, 'The Operation of Vasari's Workshop') is also preserved (ibid., fos. 30 ff.).

remove it to a pier in the transept, because it was argued that the *Operai* were not according it an equally desirable location. Proof that ducal prestige was indispensable to the project comes, incidentally, from the grounds on which the *Opera* defended its intention. It based its case on the fact that the renovation project, which had been ordered by the Duke, made it necessary that the altar be moved because it disrupted the Passion cycle (see Catalogue, Sta Croce, Compagnia della SS. Concezione Chapel).

In view of the *Opera*'s difficulties in transferring a single altar when its action was contested, one wonders how firm was the legal basis for its treatment of the patrons of former chapels. Yet no one seems to have questioned it. The Asini, like the Serristori and all the others who had owned chapels or altars, received notice from the *Opera* that they could rebuild their family chapel at their own expense if they so chose. Although several branches of the family fought bitterly over rights in the new chapel, the decision to raze the original one seems to have been accepted without objection, even by Giovambatista Asini, the attorney who had argued the case against the *Opera* so effectively for the Alberti.

Similarly, in Sta Maria Novella, the Minerbetti had been informed of the impending destruction of their chapel under the *ponte* and were given first refusal on the adjacent site in the third bay of the right aisle. When they accepted, the Compagnia di Gesù Pellegrino and the Compagnia di Sta Maria della Croce al Tempio were, in turn, informed that the site of the tomb of Beata Villana, of which they were co-patrons, had been appropriated to the Minerbetti family, and that the sepulchre would have to be moved (Appendix, Doc. 7).

It may be that the Duke and the *Opera* had hoped with the Alberti case to establish that specific use was implicit in the allocation of a site, as they had argued before the *Magistrato Supremo*. Had they won, it would not even have been necessary, one must assume, to offer alternative sites to patrons of structures destined for demolition. What seems unjust, especially since to rebuild was a costly undertaking, is that if the patron refused the offer to rebuild the chapel, he then ceded his right to the site.

We know that the convent expected 300 florins for the endowment. This could be provided in a number of ways. Some (e.g. Corsi) donated a house to the convent, the rent of which represented a 5 per cent annual return on 300 florins. Others made an annual or semi-annual payment of equivalent

amount (*c.* 105 lire). The most common method was to deposit the sum in a bank as a trust, the interest to be paid to the convent, usually on a semi-annual basis. Whatever the method of payment, it was recorded in the account books of the convent kept for this purpose (Debitori/Creditori).[18] We know also that Vasari charged 200 florins to paint the altar-pieces for these chapels. (The discount of 50 florins he generously accorded Pasquali he made up on the general treasurer, Biffoli, who was charged 250). It is much more difficult to fix the cost of constructing the chapel and tomb, but it probably ran to another 300 to 400 florins. There were two cases in which patrons provided in their wills for a chapel to be built. Camilla Capponi designated that at least 400 florins be spent on building and decorating the chapel, including the altar-piece, in Sta Maria Novella; the endowment was provided separately. Andreuolo Zati left the munificent sum of 800 florins for a chapel in Sta Croce (including altar-piece), plus a sumptuous endowment. Zati had designated 400 florins for the endowment instead of the usual 300. If we assume that the amount set aside for construction was similarly extravagant, we can reduce the whole by a third, reaching a figure of 900 florins—300 for endowment, 600 for the painting, ornamentation, tomb, lamp, etc. Camilla Capponi, on the other hand, intended her 400 florins as the minimum figure, so that 500 or 600 florins might have been closer to the actual expenditure. Thus, in terms of total investment, one of the new chapels in either Sta Maria Novella or Sta Croce in the 1570s would probably have cost 800 or 900 florins, or between 5,600 and 6,300 lire (endowment, 300 florins; construction of chapel, 300 to 400 florins; altar-piece, 200 florins).

Such expense was too great for many of the former patrons to bear. Branches of the Serristori and Asini families are documented as having declared that they would not assume the full, or even partial, responsibility for rebuilding the family chapel. Others were doubtless put off by the abrupt circumscription of traditional patronage rights. But while the *Opera* was in the driver's box it was the Duke who held the reins. Virtually every decision was first referred to Cosimo. The *Opera* nominally controlled the appropriation of sites, but this was such a thin disguise that when the Compagnia di Gesù Pellegrino decided to petition to found one of the new chapels in Sta Maria Novella, they addressed

[18] All these methods of payment are reflected in the records of Sta Croce, which are quite complete and are properly cross-referenced with the volumes of *Ricordanze*. We observe that while values seem to hold steady throughout the last quarter of the sixteenth century, inflation is evident in the first years of the next century.

themselves directly to the Duke (Appendix, Doc. 7). When the young Zati failed after his eighteenth birthday to take action to found the chapel in Sta Croce, according to the terms of his father's will, the *Operai* wrote to the Duke explaining the situation and asking how they should proceed (Appendix, Doc. 6). When Cosimo replied that they should press the young man to fulfil his obligation, he gave the *Operai* their most effective weapon, namely, the right to speak in the Duke's name. After the death of Cosimo's good friend Averardo Serristori, the site of the proposed new family chapel languished untouched. Once again, the *Opera* sought the Duke's consent before taking action, in this case the razing of the former family altar so that the family would have no excuse for failing to begin the new chapel. Lodovico Serristori was informed in the name of the Duke that if he did not begin the chapel his family's site would be allocated to someone else (see Catalogue, Sta Croce, Serristori Chapel).

The Duke was so intimately connected with the project that, despite the high-handed treatment of patrons, there was no difficulty in recruiting them. A few who chose to participate had been associated with the churches for centuries. The Pazzi, for instance, were patrons of a new chapel in Sta Croce on the cloister wall next to the door leading to their other, more famous, chapel. In Sta Maria Novella the Gaddi, who had had an altar under the *ponte,* took possession of one of the large transept chapels. Lionardo Buonarroti was more or less obliged to be patron of one of the chapels adjacent to his famous uncle's sepulchre in Sta Croce, which was in the course of construction in those years. For the most part, however, the new patrons were the Duke's friends and the recipients of the honours that were his to bestow. For example, Giovambattista Ricasoli, who had been bishop of Cortona, was selected by Cosimo to be appointed bishop of Pistoia. Benedetto Minerbetti was both bishop of Arezzo and a member of a family long associated with Sta Maria Novella. Don Fabio Mondragone was an intimate of Prince Francesco until he fell from favour (see Catalogue, Sta Maria Novella, Mondragone–Vecchietti Chapel). The other new patrons included the most prominent families of Cosimo's Florence. The account of any important social event of these times will mention them. For example, among the list of fifty young Florentine noblemen selected to carry the *baldacchino* of Her Highness the Archduchess Giovanna when she entered Florence for her marriage to Francesco appear the names of Agostino Dini and our young delinquent, Alessandro Zati. There were also members of the Strozzi, Capponi, Pazzi, Minerbetti, Ricasoli, and

da Sommaia families.[19] Among the six senators who were chosen as special ambassadors by Duke Cosimo to convey his congratulations to Pope Pius V on his elevation were Averardo d'Antonio Serristori and Simone di Jacopo Corsi, as well as a member of the Strozzi family, Camillo.[20] Among the select group invited to accompany Cosimo to Rome for his coronation as Grand Duke were Giovanni da Sommaia, Jacopo Corsi, Agostino Dini, Cav. Andrea Minerbetti, and two members of the Capponi family, Neri and Cav. Vincenzo.[21] It is not surprising in view of the dependency of many of the patrons and their families upon the Duke's favour that he, through the mechanism of the *Opera,* had relatively little difficulty in managing them and bringing the series of chapels to a successful conclusion.

We would expect Vasari's administrative position in this project to be equal to and independent of that of the *Opera,* with him receiving orders directly from the Duke as the *Opera* did. There is a memorandum from Vasari to Matteo Benvenuti, the *provveditore* of the *Operai,* conveying the Grand Duke's wishes in several matters and summarizing the work to be done (Appendix, Doc. 14).[22] We are somewhat surprised that here Vasari is virtually conveying orders to the *Operai.* Clearly the *Operai* had an active responsibility in hiring and assigning workmen, in co-operation with the architect. Our document may represent not the usual procedure but an exceptional time-saving short cut, which had grown out of a conference the Duke had just held with Vasari; for Vasari's major administrative task was to handle relations between patrons and painters. There is no doubt that he played the primary role in the selection of artists. Borghini recalled in a letter to Vasari that one of the Minerbetti had striven hard to have the commission for their altar-piece awarded to Giovanni (presumably Stradano); the implication is that Vasari had had some unexpected difficulty getting the commission for Naldini, his personal choice (see Catalogue, Sta Maria Novella, Minerbetti Chapel).

After Vasari himself executed the first three altar-pieces (for Strozzi, 1567, Pasquali, 1568, and Biffoli, also in 1568), he evidently felt that the project was successfully launched and that the time had come to put into action a plan

[19] Recorded in his diary by Settimanni, vol. 3, fos. 335r and 335v.

[20] Ibid., fo. 359, entry dated 7 February 1565 (1566).

[21] Ibid., fo. 475r, entry dated December 1569.

[22] Vasari conveys the order to finish the gilded framework of Donatello's *Crucifix* which was to be placed in the Bardi Chapel (quoted by H. W. Janson, *Dona-*

tello, Princeton, 1957, p. 9). He also gives instructions concerning the Serristori Chapel (q.v. in Catalogue). The memorandum concludes with a *carte blanche* to move tombs as necessary—which should serve as a warning against inferring the location of other things from the placement of tombs today.

that must have been very dear to his heart. From now on, with only one exception, the altar-pieces would be painted by various members of the Accademia del Disegno. And the exception is the proverbial rule-proving one, because the artist, Sebastiano Vini, came from Pistoia and was therefore certainly the personal choice of the patron, Giovambattista Ricasoli, bishop of Pistoia. Since Ricasoli was a personal friend of Cosimo he would have been permitted to employ an outsider.

The Academy had only recently completed its first project, the funeral of Michelangelo, which had involved many of the same people as organizers and participants as did the altar cycles. Cosimo had been induced to grant nominal, and some financial, support. Vasari and Borghini had been the organizers of the event, while the Duke had merely been asked to approve their suggestions. As the Wittkowers admirably demonstrated in *The Divine Michelangelo,* a purpose of the funeral project, equal in importance to that of paying homage to a great colleague, was to elevate the status of the artist and the Academy in the eyes of society. Vasari was doubtless always alert for opportunities to solidify the gains made by the still nascent Academy. He must have been greatly pleased when in 1567 his Academy was requested by the Spanish court to give advice concerning the architects' plans for the Escorial.[23] The potential for propaganda afforded by the new altar cycles in Sta Maria Novella and Sta Croce could not have been overlooked by Vasari. To have the naves of two of the major churches in Florence adorned with altar-pieces by its young members would constitute a major triumph for the Academy.

Stradano, who was Vasari's oldest assistant, received the first commission for the Asini chapel. The ageing Bronzino, perhaps at the request of the patron, Niccolò Gaddi, painted the altar-piece for his transept chapel. By 1571–2 Stradano had fallen out of Vasari's favour, so that it was Vasari's next most faithful and experienced assistant, Naldini, who, having edged out Stradano, received the commissions for the Minerbetti altar-piece and also for the Mazzinghi Chapel a year later. At about the same time, Macchietti was asked to undertake the Giuochi altar-piece in Sta Maria Novella, and a year or two later the Risaliti altar-piece in Sta Croce. Two of the most promising artists in Florence, Santi di Tito and Alessandro Allori, both of whom had been more closely associated with Bronzino than with Vasari, were excluded from the early commissions. Santi probably received his first commission at the same

[23] Daddi-Giovannozzi, 'L'Accademia Fiorentina', pp. 423 ff.

time (*c.* 1573) as Jacopo Coppi, who was far less talented, received his (see Catalogue, Sta Croce, Medici Chapel, and Sta Maria Novella, Attavanti Chapel). Allori, despite his prominence on the Florentine scene, was invited only once to contribute to the original cycle and received his commission at about the same time as Alessandro del Barbiere, a much younger and less experienced artist, was granted his (*c.* 1574). (See Catalogue, Sta Maria Novella, Bracci Chapel, and Sta Croce, Corsi Chapel.)

It is possible that Vasari died before either Allori's or del Barbiere's commissions were awarded. The renovation of the two churches had moved well towards completion by the time Cosimo, and a few months later Vasari, died in 1574. In Sta Maria Novella, work on the Mondragone Chapel, abruptly curtailed by the patron's expulsion from Florence, would drag on for the rest of the century. Apart from that chapel, and the Bracci and Ricasoli Chapels, finished in 1575, the Chapel of the Compagnia di Gesù Pellegrino-Tempio, finished by Santi di Tito in 1576, and the da Sommaia Chapel, finished by Naldini in 1577, Vasari had seen the work there brought to completion. The new chapels were consecrated as a group by the bishop of Fiesole during Lent, 1577.[24]

Somewhat more remained to be done in Sta Croce, which had been begun later. The Risaliti, Pazzi, Corsi, Berti, and Zati Chapels were completed in the two years following Vasari's death. The troublesome Serristori Chapel, completion of which was protracted until 1613, was still only partially constructed in 1580 when the *Opera* wrote to Grand Duke Francesco to complain about it (see Catalogue, Sta Croce, Serristori Chapel). The altar of the Immaculate Conception continued also to plague the *Opera* until 1580, when the Compagnia della Concezione offered to build a chapel which corresponded to that of the Cavalcanti family opposite (see Catalogue, Sta Croce, Compagnia della SS. Concezione Chapel). The two chapels nearest the façade were not even appropriated until several years after Vasari's death. Construction on the Alamanneschi Chapel, the last site in Sta Croce, was begun on 18 January 1585, and the altar-piece by Santi di Tito was signed and dated 1588.

The ducal office proved indispensable to the project again and again. Of equal significance, however, was Cosimo's character and aesthetic taste. Sponsoring an enterprise such as this was entirely in keeping with his personality, for Cosimo, unlike his son, was genuinely pious. It is impossible to imagine the foppish Francesco, patron of the Studiolo, undertaking this project. As a

[24] Borghigiani, 'Cronaca', iii. 402.

matter of fact, when the *Operai* requested his directions on certain matters still unfinished at his father's death in 1574, Francesco peevishly replied that he did not wish to be bothered with this affair.[25]

Just how active Cosimo had been in initiating the project and how enthusiastically he supported it is difficult to assess. In the *Vite* Vasari certainly exaggerated the role of his benefactor to whom, after all, he had dedicated his book. Recent studies of Medici patronage by Chastel, Gombrich, and Wittkower have taught us to read with scepticism any passage in which Vasari attributed to one of the Medici a significant role as patron. Cosimo scarcely merited the comparison with the temple-builder, King Solomon, that Vasari bestowed upon him. In view of the fact that a good deal more of his energy and resources had gone into rebuilding his own houses, the Palazzo Vecchio and the Pitti, King David might have provided a more apt simile. The evidence also suggests that Cosimo could be rather lethargic toward the project, especially when it became time to demonstrate his interest with a gift. His terse directives, added at the bottom of letters from the *Operai,* could be interpreted as showing a lack of interest, though they might also be evidence of overwork and fatigue. It is well known that Cosimo's health and energy declined rapidly after the family tragedies of 1562. Nevertheless, he played a far more active role in this matter than in the funeral of Michelangelo, where the planning had been left entirely to the Academy.[26] In fairness to Vasari, it should be pointed out that there is a difference in the way he describes the Duke's role in the two projects. With respect to the obsequies, the Duke is shown to have co-operated with the suggestions made by Borghini, Vasari, and the other Academicians, but his role was not the formative one with which he is credited in the renovation projects. It has to be admitted, however, that Vasari had a different motive from his usual one of flattering Cosimo when he described Michelangelo's funeral, for if the Duke's role were exaggerated that of his beloved Academy might correspondingly diminish.

Whatever might have been Cosimo's part in conceiving the enterprise, or the degree of enthusiasm he had for it, it bears the distinctive mark of his personality. The very fact that it was a renovation and not the construction of a new church is characteristic of him. When one reviews Cosimo's building

[25] See Moisè, *S. Croce di Firenze*, p. 79. A recent reassessment of Francesco's personality by L. Berti (*Il Principe dello Studiolo*, 1967) confirms this view.

[26] Demonstrated by R. and M. Wittkower in their study of the funeral (*The Divine Michelangelo*). Compare the description of Michelangelo's funeral (Vasari–Milanesi vii. 287 ff.) with that of the renovation project.

projects—the rebuilding and redecoration of the Palazzo Vecchio, the completion and expansion of the Palazzo Pitti and the laying out of the Boboli Gardens, the restoration of the Villa di Castello—one notes a predilection for renovation rather than construction *de novo*. The grand style in which it is carried out is as characteristic of Cosimo as the *petite manière* is typical of his son and successor. Not only were Cosimo's money, power, and prestige essential to the undertaking, but his personal taste as well.

III

The Altar-piece before 1565

IN Vasari's description of his programme, quoted above (Chapter I, p. 5), he told how altar-pieces were to be made for the new side chapels and how he had already executed three of them. He was to paint three more himself by 1572. Two others, by Salviati and Bronzino, had been painted about the middle of the century, before the renovation work was undertaken. Artists selected by Vasari executed the remaining twenty, largely between 1569 and 1577. In all, twelve painters received commissions. Thus, from the point of view of the altar-pieces the enterprise represents a broad spectrum of participation in activity concentrated at a critical moment in the evolution of Mannerism, the decade between 1567 and 1577. The next chapter will deal with the work of the younger artists chosen by Vasari. In this chapter we will consider the Florentine solutions to the problem of the altar-piece offered in the period immediately preceding our project, particularly by Bronzino and Vasari.

Much has been written in recent years defining the style of what has come to be called the High Maniera, that is, the second phase of Mannerism emerging about 1540 in the art of the painters then reaching maturity.[1] In Florence the style was practised chiefly by Vasari, Bronzino, and intermittently by Salviati (whenever he returned from Rome to the city of his birth). An early artistic response to the Counter-Reformation movement, the Counter-Maniera, first recognized as a mid-century Roman phenomenon by Zeri, has also been given further definition. Its presence alongside Maniera as an alternative to it has been demonstrated by S. J. Freedberg in a widespread circle of artists in Italy who were either trained in Rome or travelled there after 1550. Among the artists who came into contact with the Roman Counter-Maniera were those who executed the altar-pieces for Sta Maria Novella and Sta Croce in the early seventies.

The altar-piece as a mode offers particular opportunity to study the Maniera–

[1] See contributions to the *Acts of the Twentieth International Congress of the History of Art*, vol. ii, especially by E. H. Gombrich, J. Shearman, and C. H. Smyth. See also Shearman's *Mannerism*; Freedberg, 'Observations on the Maniera', id., *Painting in Italy*; and Hauser, *Mannerism*. F. Zeri's *Pittura e Controriforma* contributed highly suggestive insights into the artistic situation in Rome at the middle of the century.

D

Counter-Maniera nexus in relation to the Counter-Reformation. It is a uniquely sensitive barometer of change in the religious climate. More than any other mode, the altar-piece depends upon the successful communication to the viewer of its content. If the altar-piece is to succeed as a religious image the artist must find the aesthetic form that will express an interpretation of the subject-matter. After brilliant success in the years of the High Renaissance, the altar-piece repeatedly failed to make effective communication. Raphael made what may well be the supreme synthesis of form and content in a High Renaissance altar-piece in his *Transfiguration* (Vatican, Pinacoteca, Pl. 16). His selection of a two-zoned structure for this subject was unorthodox, but the transfigured Christ alone would scarcely have provided that maximum dramatic intensity which Raphael sought in his late style. As its frequent appearance in Middle-Byzantine church decoration suggests, the event was readily and characteristically converted into a timeless devotional image. Raphael's inclusion in the lower zone of the contemporaneous event of Apostles attempting to heal the boy satisfied the aesthetic need for dramatic action. It also provided a narrative context for the devotional image, thereby presenting powerfully as coexistent the human and divine natures of Christ. The two-zoned format was the perfect vehicle to convey this content.

The synthesis of form and content that High Renaissance classicism had achieved dissolved in Florence even before 1520. The artist then shifted away from presenting an interpretation of the subject-matter as the primary content of his picture. Frequently in early Mannerism he substituted a highly charged emotional energy which has very little to do with the subject of the picture, as for example in Pontormo's *Sacra Conversazione* for S. Michele Visdomini (1518).[2] In his later *Deposition* for Sta Felicita (1526–8; Pl. 17), painted after the first violent outburst had subsided, his style moved towards a new consolidation. Here he presented a content of painful emotion, transfigured by extraordinary aesthetic effect, which is attached by only the most tenuous thread to the religious subject. The High Maniera altar-piece similarly slighted the religious content when it substituted *bellezza* and *grazia* for interpretation of the subject. From the point of view of the worshipper and the institution which commissions the altar-piece, the aesthetic is the *means* to a religious end, and not an end in itself. More than any other mode, the altar-piece is antipathetic to this kind of formalism.

[2] Reproduced in Freedberg, *Painting in Italy*, pl. 71.

The Counter-Maniera, as the name suggests, emerged in reaction to the Maniera and attempted to compensate for its deficiencies. Because the Maniera overweighted the aesthetic at the expense of the religious, the Counter-Maniera tended to deny altogether the aesthetic function of the altar-piece. Narrative, pure, simple, and direct, becomes the primary goal. That *bellezza* and *grazia* which the High Maniera regarded as the first priority of art is scarcely to be seen in Counter-Maniera works. In fact, it is the role of beauty in the religious work which particularly troubles Mannerism. The artists of the High Maniera found it difficult to synthesize *bellezza*, which since Leonardo had become ever more sensuous and sometimes even sensual, with the religious function. Until about 1520 the naïve confidence that the supernatural was no more, and no less, than the natural-made-more-beautiful (i.e. idealized) had undergirded High Renaissance religious art. When that confidence failed, beauty was severed from the divine. Cut loose from its traditional mooring in High Renaissance art, it floats about aimlessly in the Mannerist altar-piece, lacking any designated function.

The opposite face of this severance meant that the artist was also left without any means for representing the divine. There was no substitute readily available because the Cinquecento was not prepared to abandon the primary precept of Renaissance art that sacred history takes place, not in some other-worldly sphere (symbolized by a gold-leaf background), but in our space–time continuum. The crisis of Mannerism as regards the altar-piece might be expressed by the two-pronged question: if the supernatural cannot be represented in terms of the natural, how is religious art possible? and what is the function of beauty in religious art?

The various solutions attempted in the remainder of the century are partial, tentative, and ultimately unsuccessful. The germs of a positive solution present in Correggio's sensuous involvement of the spectator and in Venetian light were not recognized until many years had gone by. Even Michelangelo, while intensely aware of the problem, could not forge anything other than an intensely personal statement. His Rondanini *Pietà* (Milan, Castello Sforzesco) is perhaps the most poignant statement of the dilemma of religious artistic expression the century was to produce.

Bronzino, too, was conscious of the dilemma, but he was probably the only person with this awareness in Florence. Vasari does not seem to have been sensitive to the changes of mood which took place in his lifetime. The solution

to the problem of the altar-piece attempted by Bronzino and Vasari, which we will examine in this chapter, is certainly tentative, and it is characterized, above all, by the Maniera preference for complexity and paradox.

Vasari in his long artistic career was enormously prolific in many modes, including the altar-piece. His production in this genre, spanning his entire career from 1532 until his death in 1574, would constitute a major solution to the problem of the altar-piece in terms of sheer quantity alone. But it is significant also because of its widespread influence. Any painter reaching artistic maturity in Florence after the middle of the century had to come to terms with the Vasarian style, and, as most of the commissions in the last third of the century were for altar-pieces, this meant primarily coming to terms with Vasari's formula for painting an altar-piece. This formula was not fully evolved until around 1540, but once it had taken shape it underwent relatively little development. In the 1530s we see Vasari experimenting with aspects of the early Mannerist style that Rosso and Pontormo had formulated in the preceding decade. When in 1532 he came to paint an *Entombment* (Arezzo, Casa Vasari; Pl. 18), his first surviving altar-piece, he followed the lead of Rosso and of Baccio Bandinelli in representing an intensity of emotion far exceeding that possible within the classical style. Even at this early stage, however, Vasari revealed a characteristic which becomes the key to his mature style, for while borrowing from Rosso the anti-classical elements of impassioned mood, drama-tic light and idiosyncratic figure-types (cf. Rosso, *Pietà,* Borgo S. Sepolcro, Orfanelle, 1527–8),[3] he has revised his source in a way that foreshadows the Maniera precedence of graceful contour over expressive pose. Vasari's figures are more restrained and more self-consciously posturing to create an aesthetic effect than Rosso's.

In the *Deposition* (Arezzo, SS. Annunziata, 1536–7),[4] painted a few years later for S. Domenico in Arezzo, the same warring elements are present, but the balance has shifted in favour of Maniera *grazia.* Although the emotion is pitched in the same high key, the figures of the upper zone are manipulated into pos-tures determined more by an aesthetic criterion than by one of naturalness or expressiveness. And by 1540, the time of yet another version of the *Deposition* theme (Camaldoli, Arcicenobio),[5] the triumph of *grazia* is complete. Under Salviati's influence, perfervid emotionalism has given place to concern for

[3] Freedberg, *Painting in Italy*, pl. 83.

[4] Reproduced in Venturi, *Storia dell'arte italiana*, vol.

ix, pt. vi, fig. 166.

[5] Reproduced in Freedberg, *Painting in Italy*, pl. 189.

sheer formal beauty. The acid colour of the 1532 *Entombment* has been replaced by a palette of alluring, sensuous colour. Vasari is here consciously revising Rosso in a reclassicizing direction. The specificity of Vasari's setting and landscape implies a rejection of the unclassical abstracted realm of, for example, the Volterra *Deposition* (Pinacoteca, 1521).[6] Vasari has introduced Salviatesque ornament, conspicuously lacking in Rosso, which seems intended not only to allure the spectator but also to enhance the illusion of concrete reality. Emotion is masked. The figures have assumed the poses and gestures demanded by their roles, but there is no longer any sense of urgency.

Vasari's style here is more appropriate to his temperament than the impassioned mode with which he had experimented in the thirties. He was a man of many parts—historian, architect, courtier, organizer, painter—but not a man of great sensitivity. One suspects from reading his correspondence that he found it difficult to express emotion at all. In his exchange of letters with Vincenzo Borghini, which spanned many years, it is always Borghini who is the more open in his expressions of affection. Though it is clear that Vasari was closer to Borghini than to anyone else, including his wife, he was never able to reveal vulnerability even to him. Such a personality sought refuge behind masks which would conceal the emotion he could not allow himself to feel.

The aesthetic of Vasari's mature altar-piece style is not that of Rosso's and Pontormo's early Mannerism. A key to the difference is in Vasari's attitude toward the art of the High Renaissance, which is best revealed in the *Vite*.[7] He constructed the book round the biological metaphor in terms of which Giotto and the other artists of the Trecento represent infancy, or the initial stage of development. Brunelleschi, Donatello, and Masaccio represent youth; the culmination achieved in maturity is the art of Raphael and Michelangelo. His theoretical conviction that perfection had been achieved in the art of the *terza età* could not have failed to carry over to his practice of art. Thus, when he came to paint an altar-piece, he sought a classical prototype to emulate (e.g. *The Calling of Peter and Andrew*, finished in 1561 and eventually used as the altar-piece of the Aretine Badia,[8] which imitated Raphael's design for the tapestry). Where there was none, he designed his composition according to a formula deduced from his study of classical paintings. The primary actor or

[6] Ibid., pl. 79.

[7] On the design of the *Vite* and Vasari's philosophy of history see Svetlana Alpers's excellent 'Ekphrasis and Aesthetic Attitudes in Vasari's *Lives*'.

[8] Reproduced in Barocchi, *Vasari pittore*, fig. 39.

group must be placed in the centre and the other figures disposed symmetrically, the picture plane must be established by a figure or figures flattened against it and must never be violated; emotion must be restrained and must be expressed by appropriate pose and gesture, but such poses and gestures must have grace and beauty; contact with the viewer should not be sought. It is unfortunately true that Vasari tended to begin with the formula and seek a compositional solution that would conform with it, rather than beginning with his subject and developing an artistic representation of it. This inversion of ends and means accounts for the academic sterility of so much of Vasari's production. The effectiveness of the altar-piece suffered particularly from such a reversal of the priorities of style and expression. In the *Conversion of Saul* (Rome, S. Pietro in Montorio, *c.* 1551),[9] for example, one sees the curiously anti-dramatic effect which Vasari frequently produced in his effort to create *bellezza* and *grazia*.

One favourite device Vasari used when there was no direct prototype in High Renaissance painting for the subject he had in hand was to adapt the scheme of the devotional altar-piece. It had been frequently chosen by Raphael, Fra Bartolomeo, and Andrea del Sarto, most characteristically in *Sacre Conversazioni* and variations of that theme. Vasari adopted it, for instance, to represent the abstract theological concept of the *Immaculate Conception* (Florence, SS. Apostoli, 1540; Pl. 19). The Madonna takes the place regularly accorded to the devotional image, the centre of the upper zone. King David, Adam and Eve, and the other Old Testament inhabitants of Limbo, bound to the Tree of Knowledge round which the serpent is entwined, Vasari has disposed in the position of the saints who usually inhabit the lower zone and act as intermediaries between the worshipper and the image of the divinity above. It indicates how little change Vasari's style underwent in his lifetime that three decades later, when he came to design an altar-piece with a similar subject, *The Madonna of the Rosary* (Sta Maria Novella, Capponi Chapel, 1569; Pl. 33), he returned to this scheme.

On those occasions when Vasari was able to follow a classical prototype, there is frequently a considerable disparity between his model and his own emulative version. For example, he based the composition for his *Adoration of the Magi* (Rimini, S. Fortunato, 1547)[10] on Leonardo's famous underpainting (Florence, Uffizi Gallery).[11] He borrowed the motif of the centralized Madonna

 [9] Barocchi, *Vasari pittore*, fig. 43. [10] Ibid., colour pl. XV. [11] Freedberg, *Painting in Italy*, pl. 2.

and Child ringed by spectators, but he has enlarged the scale of the figures and compressed their spatial environment so that the effect is of crowding and disorder. The composition in Vasari's hands has become a complex pattern pressed against the picture plane, instead of Leonardo's carefully wrought projection of a rational space. The sense of wonder and awe, so beautifully expressed by Leonardo, has given place to a mood of vulgar, impatient, ogling curiosity.

In such a comparison as this we see very quickly what has been lost in the revision, but apparently Vasari and his contemporaries did not, or at least they did not acknowledge it consciously. They saw instead an increase of *grazia* and *bellezza*. Vasari again gives us the clue to his reasoning in the *Vite*. The perfection toward which art had been progressing, he says, was attained in the art of Raphael and Michelangelo. Their achievement was not like a beautiful flower, or the maturity of a man, doomed to fade and decline. Abandoning his biological metaphor, he goes on: what had been achieved by Raphael and Michelangelo was the perfection of *disegno,* the means of art. This perfected *disegno,* once discovered, became, as it were, a permanent possession, so that those who practised art in the wake of its discovery could employ it. As Vasari foresaw it, the artists of the *quarta età* (his contemporaries) could improve upon the art of the *terza età* in only one way: they could accomplish the same thing with greater facility. In this context he makes his infamous observation that what distinguishes the artists of his generation from their predecessors is that whereas in former times an artist took six years to complete a picture, his contemporaries could complete six in one year.[12] Vasari reasoned further that this facility enabled him to produce a greater quantity of beauty in a single picture. For this reason, at least ostensibly, he complicated his Leonardesque prototype, since the solution of a more difficult problem must necessarily produce a greater quantity of *bellezza* and *grazia*.

While this may be the intellectual explanation for the often bewildering complexity of design that Vasari offers his readers, and himself, there is a more profound, unconscious factor in Maniera art and culture which Vasari's explanation merely rationalizes. Repeatedly in Maniera altar-pieces we see the fragments of a synthesis which has failed to coalesce. The paradox which results from the juxtaposition of unrelated elements is the only statement it makes. The Maniera used many devices, notably including iconographic

[12] Vasari–Milanesi, iv. 13.

conceits and quotation, to enrich the meaning both aesthetically and religiously, but repeatedly this very complexity tends to obscure rather than to elucidate the significance of the subject-matter. This preference for complexity is nowhere better demonstrated than in Vasari's iconography.

In the same way that literature and history provided the material for the allegories of mural painting, theological literature provided the source for the programmes of altar-pieces. Perhaps even more than other modes the altar-piece became an illustration of the verbal programme. The *Immaculate Conception* (Pl. 19), for example, means very little, except in terms of the intellectual plan that lies behind it. The very choice of the subject, in which Vasari undoubtedly had a hand,[13] reveals the Maniera taste because it is a subject that is not susceptible to dramatic representation. Frequently, Vasari's pictures refuse communication except to those who have the key, in the form of the iconographical programme.

To convey another kind of veiled meaning Vasari depended frequently on the device of quotation, a self-conscious mannerism in any era when it occurs excessively. His reuse of a composition, such as his borrowing of Leonardo's *Adoration of the Magi* for his Rimini version, was a quotation which his visually sophisticated viewers could be expected to recognize. More specific instances of quotation, in which a figure is copied from another work of art and included virtually unchanged in a different context, occur as frequently in Maniera altar-pieces as in other modes. Only the intention to make reference to Michelangelo's *Pietà* (Rome, St. Peter's), for instance, can explain the curious posture of Vasari's Christ in his *Deposition* (Rome, Doria Gallery; Pl. 20). A highly sophisticated conversation among the *cognoscenti* could be carried on by means of quotations. Vasari's *Pietà* (Ravenna, Academy, 1548; Pl. 21) is a reply to—and, at the same time, a revision of—Bronzino's Besançon version (1545; Pl. 22) which, in turn, had quoted Michelangelo's *Pietà*. It is as though, in this age when the channels for direct communication between artist and viewer had become blocked, this kind of communication created a sense of communion. To recognize a quotation was to receive a coded message from the artist, unveiling another layer of meaning in his picture.

Quotation is a complex phenomenon, revealing the pathos of the Maniera mind. Ostensibly, the quoter pays homage to the original artist by reusing his

[13] The patron was Vasari's friend Bindo Altoviti. *Ricordo*, in Frey ii. 857; Barocchi, *Vasari pittore*, p. 116.

creation. At the same time, however, the quoter is demonstrating his own erudition. At a deeper level lies the fact that when something is quoted, the quoter need not take direct responsibility for it; he retains the appearance of being uncommitted. Just as so often literary quotations are used instead of the author's own words because he is embarrassed to express emotion, so the Maniera artist can evade representing emotion if, instead of creating his own Christ, he quotes Michelangelo's. At a still deeper level may be the fear that he cannot do it as well as it has been done before him.

Always beneath the surface of Vasari's *bravura* lurks the suspicion that he and his contemporaries are the epigones. Perhaps, after all, the perfection achieved by Raphael and Michelangelo was not being sustained. A constant vacillation between manic over-confidence and depressed self-denigration underlies Maniera art and culture. This is one of the tensions which Vasari's preference for paradox expresses. But it is a substitute for the expected content of the religious picture. He creates numerous multiple meanings that in themselves are disjunctive from the subject-matter: a quotation out of context, an iconographical programme which only restates the subject-matter more complexly. He devises an intellectual surrogate for devotional content. In his retrospective adulation of classicism he gives the first priority to style, which becomes an end in itself, displacing interpretation of the subject-matter. The real content is the complex form itself.

Agnolo Bronzino, unlike Vasari, responded with extreme sensitivity to the tensions and uncertainties of the religious climate in his time. His style shares the basic character of Vasari's, yet he was able to achieve in his religious art a tenuous synthesis which cohered until the pressures of the Counter-Maniera movement ruptured it. His *Pietà* (Besançon, Museum, 1545; Pl. 22), his earliest surviving altar-piece, came closer to a genuine synthesis of form and content than any work of religious art since Raphael's *Transfiguration* (Pl. 16). Even more than Vasari's, Bronzino's style was formed when he was apprenticed to Pontormo, at the time of the crisis of early Mannerism. Because the mature style demonstrated in the Besançon *Pietà* both resembles Pontormo's and departs from it, comparison with his master's treatment of the same theme in the Sta Felicita *Deposition* (1526–8; Pl. 17) immediately suggests itself. Bronzino's gleaming white, sculptured figures, as cold and as tangible as marble, are not the nervous, disembodied spirits inhabiting Pontormo's private world. Their setting, however, is the same abstracted sphere, purged of all the

particularities of the Crucifixion's time and place: the crosses, the two thieves, the tomb. Bronzino even offers a free quotation of his master in the figure of St. John supporting Christ's head, who resembles Pontormo's John carrying Christ's legs on his shoulder. The revision Bronzino makes of this figure is indicative, however, of the shift in his style to the High Maniera. Whereas Pontormo turned John's face outward, imploring the attention of the viewer in order to communicate his physical and psychic torment, Bronzino has eliminated John's physical discomfort by dropping his weight to his knees, and severs contact with the viewer by dropping his eyes to the floor. Thus the pose has been transformed into a posture of sorrowing affection. The emotional intensity of early Mannerism has been replaced by Maniera suppression.

The mood of Bronzino's scene, however, is no less bewildering than Pontormo's had been. While Pontormo's haunted faces astonish with their intensity, Bronzino's amaze with their lack of emotion. The participants seem scarcely grieved by the sight of the dead body of Jesus. Some converse politely among themselves, and their presence seems inappropriate, in their elegant and bejewelled garb. The painting itself is like a sparkling jewel, with gleaming flesh tones set off against the brilliant sapphire tonality that pervades the whole, and this, too, seems oddly precious and inappropriate to the subject. One wonders whether Bronzino could really have treated such a tragic event so trivially.

Only slowly do we begin to realize that Bronzino intended his picture to have a dimension of meaning beyond Pontormo's. It is only when we discover the figures flanking Christ holding the symbols of the Eucharist, the chalice and the veil, that Bronzino's curious handling of the *Deposition* (as he himself referred to it) begins to make sense. Like Andrea del Sarto (Pitti Gallery, 1524),[14] Bronzino has presented the body of Christ as the substance of the Eucharistic meal. To dwell upon the tragedy or sorrow of the event would have been inappropriate to the sacramental meaning. To satisfy both aspects of his subject Bronzino found it necessary to truncate the dramatization of the event, leaving it ambiguous and incomplete.

It would seem that he had additional reasons for curtailing the drama, however, because he has created more ambiguity than was absolutely necessary. Andrea del Sarto had rendered the setting at Calvary in detail and made the Eucharistic meaning explicit by placing chalice and Host conspicuously in the

[14] Freedberg, *Andrea del Sarto*, Cambridge, Mass., 1963, pl. 144; Shearman, *Andrea del Sarto*, Oxford, 1965, pl. 126.

foreground. Bronzino, however, has abstracted the setting and deliberately conceals the Eucharistic symbols, so that we do not immediately catch sight of the chalice or perceive that the angel is removing from Christ's body a veil like that used in the Mass to cover the Host. He has evidently intended that his viewer should be led by slow degrees to the second, sacramental meaning of his image, and only after pondering the incompleteness of the painting as a dramatization of the *Deposition*. By deliberately startling the viewer with the inadequacy of the dramatization, Bronzino makes a parallel in visual language to the idea that the meaning of the death of Jesus is incomplete when understood as event only; the second, sacramental meaning completes the first, partial one.

Bronzino has presented us with a world full of ambiguities: it is abstracted, yet intensely real; it is remote, yet palpable; it is tragic, yet exceedingly beautiful; it is a realm where the most sorrowful of events is not mourned. With such paradoxes Bronzino desired to lead his viewer to contemplate the paradoxical nature of his subject, which as historical event is tragic, but as symbol represents man's redemption. It is appropriate and a measure of his subtlety that in this context he should quote Michelangelo's Vatican *Pietà* in which Christ's beautiful body, more asleep than dead, reminds us not of his pain and suffering but of his sacrifice.

Thus the paradox which underlies so much Maniera religious art is transformed by Bronzino into an appropriate expression of the meaning of Christ's death in Christian theology. It is characteristic of Maniera art, which itself often substitutes aesthetic form for content, to see the form of the doctrine—paradox—as its content. The paradox, and not redemption, is the substance of Bronzino's statement. He despairs ultimately of actualizing the identity of scriptural and sacramental meaning. He can only present the two in tensional coexistence and hope that somehow the synthesis will be made.

For Bronzino, as for Vasari in his later years, neither the dramatization of a Biblical narrative without reference to its symbolic meaning, nor a devotional image, without reference to the historical reality of the event, was satisfactory. Both had to be expressed. His handling of the *Resurrection* (Florence, SS. Annunziata, *c.* 1549–52; Pl. 100) is similar to that of the Besançon *Pietà,* though it is slightly less successful than that magical picture. He again deliberately disrupts the drama. Bronzino's Christ, instead of bursting up out of the tomb, hovers a foot or so above the ground. Further to diminish the sense of dramatic climax, the two figures flanking Christ show no wonder or surprise at his

miraculous levitation, in contrast to the violent attitudes of the other witnesses. And the sheer sensuous beauty of one of them, the semi-nude boy standing at the left, seems as out of place here as had the beautifully adorned women in the Besançon *Pietà*. Again Bronzino allows the viewer to find explanation for the ambiguities he creates only slowly and after careful contemplation. The poise of these two figures is at last understood when one sees their wings, all but concealed in the shadows, and recognizes them as the angels who have opened the tomb. There is a *cartonetto* (Pl. 102)[15] for this altar-piece which reveals just how deliberate is the ambiguity of Christ's attitude. In it Bronzino shows Christ standing on a cushion of clouds, below which can be seen the claw-foot of the tomb. The effect is as of a pedestal on which Christ, now suddenly transformed into a devotional image, stands. Though the pedestal was eliminated in the final version, the effect of a devotional image superimposed on a dramatization of the Resurrection is retained. Bronzino's attempt here echoes the masterly synthesis of some classical altar-pieces, such as Raphael's *Transfiguration* (Pl. 16). But Bronzino's Christ is not, as Raphael's was, at the same time human and divine. The viewer must make an adjustment in the way he regards Bronzino's Christ to translate from one nature to the other. They exist in tension with one another as alternatives rather than as a unity. The very complexity which he sought defeats his purpose, for when he forces the dual meaning, both become less plausible. By arresting Christ's upward movement, the event is undercut; by creating a concrete narrative setting, the devotional image of God transcendent becomes place- and time-bound.

As in the *Pietà*, he has attempted to bring together multiple facets, but the final synthesis of the dual allusion is never made, though Bronzino comes tantalizingly close to synthesis. What results, as in many of Vasari's altar-pieces, is the juxtaposition of immiscible elements. It is perhaps the ultimate tragedy of the Maniera altar-piece that, for all its ability to comprehend ambiguity, it was incapable of resolution. The simple statement of faith based on conviction was no longer possible for this self-conscious generation. A true synthesis of form and content, such as that achieved by classicism, the style which the Maniera artists emulated above any other, forever eluded them.

In both these altar-pieces of Bronzino, the aesthetic effect is as dazzling as in any of his secular paintings. The startling impression of the *Venus, Cupid,*

[15] Uffizi 13843F. Published in Florence, Gabinetto dei Disegni . . . , *Mostra di disegni dei fondatori dell'Accademia delle Arti del Disegno*, no. 19.

Folly and Time (London, National Gallery)[16] is equalled by the sensual appeal of a figure like the angel of the *Resurrection* (Pl. 100) or the sensuous beauty of the elegantly ornamented women in the *Pietà* (Pl. 22); but in the London allegory, and many other Maniera easel paintings, sensuality is in large measure the content of the picture. Its presence in an altar-piece is more difficult to understand. Bronzino appears to use such incongruous elements to lure the spectator's attention. Once it has been gained, the aesthetic effect assumes a different function. It conveys the viewer to a state of aesthetic delight similar to religious exultation. Just how the former translated into the latter, Bronzino and his contemporaries seem to have despaired of comprehending, but they hoped that somehow one would ignite the other.

More than Bronzino, who always intended meaning in his interpretation of the subject-matter, Salviati depended almost entirely upon aesthetic effect to generate a devotional attitude in the viewer. One suspects that religious subjects were not particularly sympathetic to this great practitioner of Maniera, for he painted relatively few altar-pieces. In his *Deposition* for Sta Croce (Dini Chapel, 1548; Pl. 24), he appears not to have concerned himself at all with the dramatization, but solely with the aesthetic effect. Instead of seeking the viewer's empathetic identification with the participants in the drama, as the artist of an altar-piece traditionally does, Salviati seeks an aesthetic response as a substitute. The painting does not attempt to re-enact the event of the *Deposition*: the people and the actions in it have very little to do with the lowering of Christ's body from the cross. The intention would seem to be to depict a *grazia*, a *bellezza*, and a *venustà* that will excite in the viewer a sense of exultation which may transform itself into a religious response.

There is very little certainty in Maniera religious art. The abstruse and abstracting process by which the Maniera altar-piece could fulfil its devotional function was barely comprehensible even to the most religiously sensitive of the artists who practised it, such as Bronzino. The potential for exploitation and abuse was enormous, while the potential for effective communication was small indeed. It is not surprising under these conditions to find a reaction taking shape. The shape it took we have come to call the Counter-Maniera.

The shift in Bronzino's style is at first very subtle and scarcely discernible. He is documented as having visited Rome for a month in 1548,[17] but the

[16] Reproduced in Freedberg, *Painting in Italy*, pl. 183.

[17] Janet Cox Rearick has gathered the documentation on this troublesome problem. See her forthcoming study of Bronzino's chapel for Eleonora of Toledo in the Palazzo Vecchio.

Resurrection, commissioned in that year though not completed until 1552, reveals virtually no impact of Roman Counter-Maniera. The *Christ in Limbo* (Sta Croce, Zanchini Chapel; Pl. 25), finished in the same year, is in many ways similar to the *Resurrection.* One sees the same basis of design: a pattern of marble-like flesh tones playing against the sparkle of the other colours. The brilliantly lighted *Venus Pudica* figure to the right of Christ not only resembles the angel in the *Resurrection* but performs the same function of capturing the viewer's attention. Another device startles the viewer into an attentive attitude. At the right of Christ's feet Bronzino has portrayed a strikingly beautiful and frigidly alluring contemporary lady who looks outward. The spectator's confidence that this must be a portrait-likeness falters, however, when he discovers the same face seeking his eye at the same level from another part of the picture (far left). A fraternal twin of the *Venus Pudica,* seen from a slightly different angle, appears below her sister at the lower edge. The features of the bearded old man to the left behind Christ are echoed in his double, standing beside him. Faces which by their particularity would seem to be intended to enhance the plausibility of the event, when doubled serve instead, paradoxically, to undercut it. Surrounded as he is by those who entreat him to redeem them, the Christ is not only the pivot of the dramatic action but he resembles also, as in Bronzino's earlier altar-pieces, the image in a devotional scheme. In his intent to create complex dual meanings and in the self-conscious quest for aesthetic effect, Bronzino reveals that he is still pursuing the same goals with similar means as in the earlier altar-pieces. It is clear that there is no renunciation of the *bella maniera* here.

Yet there is a new note of urgency in the expression not seen before. The spectator's point of view is not directly opposite Christ; Christ's lower body is strangely foreshortened unless we imagine that it is seen from below. This is part of the reason we regard him as a devotional image. The spectator, then, must be standing below the bottom of the picture among the souls who clamber up, entreating Christ to redeem them. *Venus Pudica*'s sister hauls up out of the spectator's space a woman whose head and arm only have become visible. The woman on the right who commands our attention with her glance points to Christ's foot, our focal point and the centre of a radiating circle of imploring arms. The identification of the viewer with those who must beg for redemptive grace is explicit. For the first time, Bronzino has violated, as early Mannerism had done, the classical principle of the self-containment of the

picture. He insists upon what had previously been artfully concealed, namely, the implication of his subject for his viewer. This is the first hint in his art that I have found of the insistence upon the significance of the religious image that characterized the Counter-Reformation.

Close examination of the copy of the Besançon *Pietà*, made by order of Duke Cosimo to replace the original in the chapel of Eleonora of Toledo (Florence, Palazzo Vecchio, 1552; Pl. 23), reveals further hints of the impending renunciation of the *bella maniera*. Even though it was obviously executed from the original cartoon one notes a subtle shift away from the poise of the Besançon version (Pl. 22). It is slightly more turbulent, the shadows are sharper and more harsh. In the faces, enigmatic serenity has hardened into painful sorrow. The Madonna, who in the earlier version had looked yearningly but with comprehension into her dead son's face, now regards him with bitter grief. The ambivalence in the emotion, which had served so well to suggest the veiled sacramental meaning, has been lost. Something of the fervour of the Counter-Maniera can already be discerned here.

It is clear that what had disrupted Bronzino's style in the fifties had developed into a genuine crisis in the following years, for in his *Deposition* (Florence, Accademia; Pl. 53), signed and dated 1561, we see a style which has undergone essential revision.[18] Aesthetic effect is no longer sought; the flesh tones have lost their allure; colour is no longer decorative, designed to delight by its sheer ornamental appeal, but has become merely descriptive. In place of the enigmatic calm that was so enticing in the Besançon version of the subject, faces here show a tortured anguish, exceeding by far the somewhat heightened intensity discernible in 1552. Whereas in the early fifties Bronzino was only toying with aspects of Counter-Maniera style, in the *Deposition* he has adopted it full-fledged. The urgency of communication barely perceptible in the *Christ in Limbo* is raised to a high key here. The dead Christ, in huge scale, is pressed up against the picture plane as if to present it with maximal intensity. But Bronzino seems intent on impressing the tragedy of the event upon his viewer, for the pathetically limp and graceless body is shown again, being lowered from the cross in the background. Perhaps the most telling index of Bronzino's state of mind is given by the two boys in the lower corners of the picture, both of whom point to the dead Christ and look directly into the

[18] The *Noli Me Tangere* (Paris, Louvre) originally for Sto Spirito, probably painted in the late fifties, resembles the *Christ in Limbo* in lighting and plastic effect and in psychological tenor. Its manner, relatively less impassioned than that of the Academy *Deposition*, suggests that it preceded that painting.

spectator's eye. The boy on the left holds the spear and sponge, symbols of Christ's suffering, the boy on the right lets fall from his hand several of the thirty pieces of silver. The implication is unmistakable and carries the involvement of spectator, broached in the *Christ in Limbo,* to new psychological depth: Bronzino's viewer stands accused of personal guilt for Christ's suffering and his perpetual betrayal.

In the background of Bronzino's increasing adherence to the Counter-Maniera were the religious upheavals which were taking place within the Church. Two events of 1559 signal the change of mood. As we have seen, Pope Paul IV ordered the burning of books placed on the Index, including many ancient authors: an action symbolic of an at least temporary triumph of puritanism. That this puritanism would affect the visual arts was made clear when breeches were applied to Michelangelo's nudes in the Sistine *Last Judgment.*

Not only Bronzino, but also his principal pupil, Alessandro Allori, shows evidence at the time of undergoing a crisis of style. Allori was studying in Rome in the later 1550s and was therefore in contact with the Counter-Maniera at its source. The catalyst of crisis in his style, however, appears to have been a reappraisal of Michelangelo's *Last Judgment* in the light of Counter-Maniera fervour. Despite the fact that it had drawn the fire of the Counter-Reformers, certain aspects of Michelangelo's great fresco, above all its sobriety and its sense of urgency, were compatible with the spirit of reform. Allori's *Deposition* (Florence, Museo di Sta Croce, 1560; Pl. 89), based upon Salviati's version in Sta Croce (Pl. 24), retained much from the *bella maniera.* But its colour, which is dark and sombre, contrasts strikingly with the gay, *changeant* brilliance of the Salviati. In spite of its mannered grace, which would seem to imply an exclusive concern with formal values, Allori's picture has greater intensity and seriousness because of the difference in tonality. In his preliminary sketch for the composition (Uffizi 10318F),[19] Alessandro departed from his usual drawing style, which was derived from Bronzino's, to emulate Michelangelo's. The melancholy tonality of the *Last Judgment,* so much more in keeping with the spirit of the times, must have seemed more appropriate to Allori than the aestheticism of Salviati's colouring.

In his frescoes of about the same time for SS. Annunziata (Pl. 88), Allori

[19] Simona Lecchini Giovannoni (Florence, Gabinetto dei Disegni . . . , *Mostra di disegni di Allessandro Allori,* no. 7) correctly associates the drawing with the altar-piece in the Museo di Sta Croce.

Borghini tells us that the painting was to be seen in the Chapel of the Compagnia del Gesù under Sta Croce (*Il Riposo,* p. 624).

demonstrated still more clearly his preoccupation with the *Last Judgment*: over the altar of the Montauto Chapel[20] he painted excerpts from Michelangelo's fresco. It is symptomatic, however, of the mood of the time that he extracted sections from the scenes of the damned only; two figures at the top of the fresco stand for the elect. At the bottom, pulling himself out of the lower reaches of hell, the artist has represented his own likeness. The frescoes on the side walls, while original creations of Allori, are fraught with quotations and paraphrases of Michelangelo. The colour here is not so sombre as in the altar wall fresco, which, like Michelangelo's, is dominated by dark neutralized greens and browns. Bright passages emerge from the neutral background. Even so, the tonality in no way recalls Bronzino's, nor do the types. Allori had not been willing to follow Bronzino, apparently, in his all-out renunciation of his own earlier style. Sensing the need for a somewhat greater intensity, he had turned to the *Last Judgment* for an alternative model of style. Thus, what had been the closest possible relation between master and pupil had been disrupted in the chaotic transition from Maniera to Counter-Maniera.

In 1564 Bronzino painted an *Adoration of the Shepherds,* at Duke Cosimo's behest, for S. Stefano in Pisa (*in situ*; Pl. 55). Crowded with contorted figures in tense, strained postures, it is not a very successful work. The joy and serenity which belong to the subject, and were to be found in his earlier small-scale version (Budapest, Museum, *c.* 1540),[21] are missing altogether. Where there had previously been carefully controlled order, there is now confusion. The sense of mystery, of ambiguity, of concealed meaning that had engaged the viewer of the earlier altar-pieces has vanished. The tenuous synthesis that Bronzino had achieved in his classic phase has been shattered. He no longer has the power to suspend multiple complex meanings in the web of his aesthetic form. In repudiating *grazia* and *bellezza* he has abandoned the means by which to create his kind of subtle allusion, and in embracing the idiom of urgency his pictures take on a ponderous religiosity. It is ironic that it should have been not Vasari but Bronzino upon whom the burden of Counter-Maniera fell, for Bronzino had approached far closer than Vasari the kind of significant religious expression that the Counter-Reformation was now demanding.

[20] Allori's works, originally decorating three walls of the fourth chapel, are now divided: the *Last Judgment* is now to be seen in the third chapel (Paatz, *Die Kirchen von Florenz*, i. 110, 130).

[21] Catalogued and reproduced in Emiliani, *Il Bronzino*, pl. 30, but without reference to Borghini's description of it (Borghini, *Il Riposo*, 1586, p. 535). Borghini tells us Bronzino made a small painting of the subject for Antonio Salviati and that it was later engraved. An engraving of the picture now in Budapest was made by G. B. del Cavaliere in 1565 (British Museum 1874-6-13-621).

Once Bronzino and Allori had abandoned it, there was no major painter in Florence practising the *bella maniera* except Vasari. Virtually no reflection of the Counter-Maniera can be seen in his style, but because Vasari invested relatively little of his personal feelings in his artistic creations, this is not surprising. As I have suggested above, his artistic method was that of production rather than of creation, and this became more true in his later years as he became increasingly burdened with work. Having amassed a repertory of poses, his procedure was to select the forms appropriate to the design he had in hand and to arrange them in a composition. The extent to which Vasari was out of step with the changing mood of the sixties is revealed in the series of comments he wrote on journeys to Rome in 1566 and 1567. He remarked to his old friend Borghini in a letter dated 14 April 1566[22] that he had seen almost everything there was to see of the work of the present generation, but that he did not like any of it. (This is an odd remark for the man who believed that perfection had already been achieved and practised in his own generation.) From this generalization Vasari excepted, significantly, Salviati, which shows that what he was looking at and rejecting was the art of the Counter-Maniera. Salviati, who had died three years previously, was almost the only major painter in Rome who had continued practising the *bella maniera* unaltered into the 1560s. A year later, when Vasari returned to Rome, he wrote back complaining about the changes that had occurred there. Rome, he said, had fallen on very distressing times, her former splendour replaced by a parsimonious life-style. Everyone was garbed in a very mediocre manner, and simplicity seemed to be the word of the day. In fact, if Christ loved poverty and Rome wished to follow him, she could scarcely do better, for she was well on her way to beggary.[23] Vasari had written to Borghini the previous day that nothing was being built, that the stonecutters, masons, carpenters, painters, and sculptors had no employment. Nothing at all was going on, and things were going from bad to worse.[24] In a letter to Prince Francesco, Vasari reported on two antique fauns which he had found for sale: 'Since they will be using benedictions here more than statues and one can't eat marble, I believe they might be secured for less than a hundred scudi each.'[25] When we recall that Vasari charged his customers 200 scudi for an altar-piece, we realize that the market for the antique must indeed have taken a downward plunge. Vasari attributed the new puri-

[22] Frey ii. 229. [23] Letter to Concini, 15 March 1567; Frey ii. 324 f.
[24] 14 March 1567; Frey ii. 322. [25] 13 March 1567; Frey ii. 318.

tanical fashion to Pope Pius V: 'If this pope lives long there can be no doubt that
statues will be going begging in Rome and many such things will be thrown
on the market.' Pius V was certainly the antithesis of the flamboyant, pleasure-
loving princes of the Renaissance Church whom Vasari preferred. He lived
an exemplary moral life, often spending hours praying and meditating on the
Passion, sometimes weeping prostrate before the Blessed Sacrament. He could
even be seen going about Rome barefoot, carrying a monstrance.

The Rome Vasari described with ill-disguised disgust was post-Tridentine
Rome. The conditions he described in the art world were the result of the new
ordering of priorities the Church had laid out for herself. But Vasari's attitude
was certainly not unanimously held, even among painters. Bronzino's earnest
espousal of the Counter-Maniera—and Allori's following suit—shows that
artists too were aware of the failure of Maniera religious art.

A permanent change had taken place in the preceding years in the Church's
attitude toward church decoration. It was enunciated clearly in Gilio's treatise
on the errors of the artists, published in 1564. Examining art not from the
point of view of its artistic merits but in terms of how well it fulfilled its devo-
tional function, he gave voice to the new criteria for church decoration. The
sense that the beleaguered Church must make maximum use of its resources
led to the notion that art in the churches must serve not art first, but religion.
The Church's sponsorship of art had always been based upon the confidence
that the beauty of art not only reflected the beauty of God's good creation but
also assisted in creating the devotional attitude.

Now, in the wake of Maniera abuses, that confidence had failed. What had
taken hold in its place was the suspicion that aesthetic beauty could only
distract the worshipper from the real subject of the representation. When
Gilio attacked Sebastiano del Piombo's *Flagellation* (Rome, S. Pietro in Mon-
torio), it was on the grounds that the artist had made Christ powerful as an
excuse for demonstrating his artistic virtuosity; had he really wished to show
la forza d'arte, Gilio said, he would have shown a broken, suffering, and humili-
ated Christ. This would have presented a real challenge to the artistic imagina-
tion. What Gilio's puritanical literalism failed to concede to the artist was the
right to interpret his subject, a right which the Maniera artist had all too fre-
quently abrogated. Gilio demanded the illustration of a scriptural text rather
than a creative artistic invention.

The failure of the Maniera to deal adequately with the devotional function of

religious art had set off a reaction in the Church. That reaction, because it was a response to abuses, or a misunderstanding of efforts by such a sensitive and subtle painter as Bronzino, was extreme. But it was the mood of post-Tridentine culture to consolidate. The task of the Church now was to fight, not only to hold together the still faithful churches but to regain territory lost to the Protestants. She had attention and energy only for this single, supreme, serious goal. Asceticism was necessary, as it is for any nation fighting a war or struggling for its survival. The preciosity, ornamentalism, involution of Maniera ratiocination was out of keeping with this spirit. Thus sympathy with reform rapidly spread. The altar-pieces of our project, begun in 1565, were inevitably affected by it.

IV

The Altar-piece after 1565

THE artists Vasari selected to paint the remaining nineteen altar-pieces
of the project (when he, Bronzino, and Salviati had reserved their nine)
were not of the same generation as their Maniera elders. Six of the nine
selected were born in 1535 or after. Only Jacopo Coppi and the Fleming
Stradano, both born in 1523, and the Veronese Sebastiano Vini, born *c.* 1528,
had reached artistic maturity when the Maniera was in full bloom. As for
the other six, just at the time their own styles were consolidating, the Counter-
Maniera was emerging. At least four of these six—Santi di Tito, Alessandro
Allori, Battista Naldini, and Girolamo Macchietti—studied in Rome in the
late fifties or early sixties. For them the new reserve and the new piety being
practised in the papal city had an authority which marked it as the wave of the
future. This experience, however, was only one stage in their artistic training.
Either before the Roman journey or afterwards, most of them assisted Vasari
in his vast *bottega*. The somewhat older Stradano had been working in the
Palazzo Vecchio with Vasari since at least 1561. According to Borghini, the
young Macchietti had assisted Vasari there for six years before going to Rome.[1]
Naldini joined the shop on his return to Florence, and contributed to the
decoration of ceiling (1563–5) and walls (1565–72) of the Salone dei Cinque-
cento.[2] Alessandro del Barbiere, who had evidently not studied in Rome
earlier, was given that opportunity when in the winter of 1571 he assisted Vasari
there.[3] Jacopo Coppi apparently worked at the Vatican with Vasari the follow-
ing year.[4] Even Sebastiano Vini, who was in most respects an outsider, had
assisted in the preparations for the arrival of Prince Francesco's bride, directed

[1] Though Vasari does not mention in the *Vite* that
Macchietti had worked with him in the Palazzo Vecchio,
his invitation to Macchietti to join him in Rome in 1573
(Frey ii. 741) lends credence to Borghini's statement.

[2] Naldini's portrait appears along with Stradano's
and Jacopo Zucchi's on the ceiling of the Salone. In
describing the iconography of the ceiling in the *Ragiona-
mento* (Vasari–Milanesi viii. 219), Vasari identified the
three portraits besides his own: 'Il primo è Batista
Naldini, l'altro è Giovanni Strada, e l'ultimo è Iacopo
Zucchi, i quali sono giovani nella professione molto
intendenti, e mi hanno aiutato a dipignere ed a condurre
quest'opera a perfezione, che senza l'aiuto loro non
avrei condotto in una età.' Reproduced in Barocchi,
Vasari pittore, fig. 84.

[3] See Frey ii. 565 f. and Barocchi, *Vasari pittore*, p. 70.

[4] Frey ii. 631, 650.

by Vasari, in 1565.[5] Those others who were not closely associated with Vasari—Allori and Santi di Tito—had been pupils of Bronzino in the fifties before his conversion to the Counter-Maniera. Only Andrea del Minga who, like Macchietti, had been a pupil of Ridolfo Ghirlandaio, but of whom we know very little else, apparently never worked for Vasari or with Bronzino. Thus for most of these painters, experience of the Counter-Maniera formed a critical episode in their artistic development, but it was necessarily tempered by the sway that the Maniera continued to hold in Florence in the person of Vasari. For while he made certain concessions in the 1560s to the new spirit, his style remained essentially Maniera. The style of these artists is therefore by no means identical with Roman Counter-Maniera, but it is also by no means identical with the Maniera that preceded it.

The project to decorate the Studiolo of Francesco in the Palazzo Vecchio is in several respects the secular counterpart of our altar-piece enterprise. Both were directed by Vasari. All the artists who contributed to the altar-piece project (except Vini) had taken part in the decoration of the Studiolo. Both projects were conceived as a team effort in which many artists took part within a predetermined iconographical and formal framework. In comparing the style of the two, one finds that in the Studiolo more of the Maniera is retained, and the reason for this difference would seem to be in the diverse functions of the two projects. The very use to which the cabinets of the Studiolo were to be put—storage for precious objects—lent itself favourably to the preciosity of Maniera style, and the allegorical subjects were compatible with Maniera preference for complexity. The meaning of the panels as symbols for materials, not as narrative or event, released the artists to exercise their fantasy in creating a realm remote from reality in the fashion of the Maniera. The style of the altar-piece is, on the contrary, far less abstract, precious, fantastical, abstruse either than the immediately previous Florentine altar-pieces or than the Studiolo. But this is only what we might expect. Because of its religious nature the altar-piece project reflected more immediately the spirit of the Counter-Reformation. It is both significant and no accident that the majority of commissions in Florence in the last quarter of the century were for religious subjects. The Studiolo by its very nature was antipathetic to the new spirit.

[5] Vini helped with the temporary decorations for the Salone del Cinquecento. On 17 June 1565 Vasari wrote to V. Borghini that the new recruits had arrived and had helped with this work: 'Et la sala son già le XII tele tirate inanzi, i telai fatti, la sala chiusa; et lunedì si lavorerano perché è venuto già quel Viniziano, quel Pistolese, overo Veronese . . .' (Frey ii. 188). Mellini tells us in his description of the wedding preparations that 'Bastiano Veronese' painted the scenes of Fiesole and Pistoia (Mellini in Vasari–Milanesi viii. 621).

The artists who participated in our project include all the principal painters in Florence in the last quarter of the sixteenth century, except Francesco Poppi. And although two of the altar-pieces were executed by artists who remain insignificant (Vini and del Minga), eleven of the nineteen were painted by the three major painters of the time: Santi di Tito, the most progressive artist then in Florence, executed five of them; Naldini painted four; and Allori one. In terms of quality, therefore, the project is significant. It is also significant as the earliest statement of these younger artists, who were to dominate the Florentine artistic scene in the remaining years of the century. In many instances the commission to make one of these altar-pieces was the first or second opportunity these artists were given to create independently a major public work in Florence. Of the nineteen altar-pieces commissioned from them, sixteen were executed in the eight years between 1569 and 1577; two were executed in the 1580s; and one after 1600. Thus by 1577 almost 90 per cent of the altar-pieces were completed. This gives us a remarkably varied but also compressed impression of the state of Florentine painting in the 1570s. For all these reasons, the cycles of altar-pieces in Sta Maria Novella and Sta Croce make up the principal example of the Florentine Counter-Maniera, though by no means its sole expression.

If anyone were to doubt that the style practised by these younger artists deliberately departed from that of their artistic parents, he need only read Raffaello Borghini's *Il Riposo* to be convinced. The *Riposo,* published in 1584, was written when the cycles in Sta Maria Novella and Sta Croce were largely finished, and reflects artistic taste at the time these artists were working. Borghini establishes two sets of criteria, one religious, one aesthetic, by which the work of art should be judged. He divides his book into four *libri,* of which the last two are devoted to biographies of Florentine artists. In *Libro I* he first enunciates the religious criteria, then discusses all the sixteenth-century paintings in the major Florentine churches in terms of them. In *Libro II* he follows a similar plan, discussing each of the works a second time to evaluate how well it fulfils his aesthetic requirements. The redundancy of the organization reflects the tension between the religious and the aesthetic function of the work of art that existed at this time.

Borghini counsels the artist to observe three rules when he comes to paint a sacred image: (1) He must paint an invention derived from Holy Scripture, simply and purely, as the Evangelists and the Holy Fathers of the Church

have written, so that the illiterate will receive the sacred mysteries faithfully translated. (2) The artist should make additions only after careful consideration and with good judgement so as to avoid major inappropriatenesses. (3) The artist must always paint with propriety, reverence, and devotion so that the viewer will not be moved to lasciviousness but rather to repentance.[6]

These norms sound strikingly like those enunciated by certain other critics at about this time, for example, Gilio, and we associate them with the Counter-Reformation movement. We need to ask, however, how these new criteria for religious art were being communicated to the art critic. In the past we have imagined a very authoritarian situation in which ecclesiastical authority dictated to the artist. But when we search for an explicit prescription it proves elusive. We find only the most general sort of statement in the Decrees on Art of the Council of Trent which hardly tell us more than that the Church regarded the principal function of the sacred image to be didactic. While this is echoed in the reason Borghini gives for requiring simple narrative,[7] the specific call for narrative is nowhere to be found among the decrees. As Federigo Zeri has pointed out,[8] the general guide-lines provided by Trent quickly crystallized into precise norms in the atmosphere which emanated from the Council. Clerics like Gilio, Archbishop Carlo Borromeo in Milan, and Bishop Gabriele Paleotti in Bologna examine art from a generally similar point of view. Paleotti,[9] who published a book similar to Borghini's two years earlier, made it explicit that the Council had provided the impetus for his *Discorso* (1582) by quoting on the frontispiece the Council's charge to the bishops that they should assure the propriety of the images in their own dioceses. In Florence, however, the publication applying Counter-Reformation norms to recent religious art was not penned by a cleric, but by a layman. This and other factors indicate, I believe, more broad-based support and less authoritarian imposition in the reform of religious art than we have been supposing. Borghini's book is interesting because as a layman he has at least as much concern for aesthetic matters as for ecclesiastical propriety. Borghini's first rule, calling for fidelity

[6] Borghini, *Il Riposo*, 1584, pp. 77 f.

[7] Borghini even mentions Gilio at one point. Ibid., p. 82. [8] *Pittura e Controriforma*, pp. 23 f.

[9] Paleotti, in *Trattati d'arte del Cinquecento* . . . , ii. 118. The passage Paleotti quoted reads: '. . . all superstitions shall be removed, all filthy quest for gain eliminated, and all lasciviousness avoided, so that images shall not be painted and adorned with a seductive charm . . .

Finally, such zeal and care should be exhibited by the bishops with regard to these things that nothing may appear that is disorderly or unbecoming and confusedly arranged, nothing that is profane, nothing disrespectful; since holiness becometh the house of God.' Paolo Prodi has given a thorough analysis of Paleotti's important treatise in his 'Ricerche sulla teorica delle arti figurative', especially pp. 140–76.

to Scripture, means to him that those subjects, so dear to the heart of the Maniera artists, that attempt to combine Biblical narrative with theological doctrine are not acceptable. Allori's *Deposition* (Sta Maria Nuova; Pl. 94), a re-evocation of his master Bronzino, is vehemently attacked for not showing the lowering of Christ's body from the cross, as is the business of a *Deposition*.[10] Vasari is accused of greatly altering the scriptural account by adding saints who were not yet born to his *Resurrection* (Sta Maria Novella, Pasquali Chapel; Pl. 30). Naldini is censured for including similar saints in his *Assumption* (Carmine; Pl. 61), though Borghini acknowledges that in this case the fault lay largely with the patron.[11] A distinction between two types of sacred image, devotional and narrative, is made explicit in the comparison of two altar-pieces by Rosso. The *Sacra Conversazione* (now Pitti Gallery, formerly Sto Spirito)[12] is acceptable as a devotional altar-piece because it intends to show saints worshipping the Madonna and Child, which can take place at any time in history, and to put them before the viewer for his contemplation. On the other hand, Rosso's *Marriage of the Virgin* (S. Lorenzo)[13] Borghini condemns on the same basis as Vasari's and Naldini's pictures because here an event is depicted as taking place before saints who could not have witnessed it. Rosso should not have attempted to combine the two types of altar-piece. Borghini makes it clear that they must be kept distinct.

Borghini objects, too, to the precedence that *grazia* was often accorded over accurate representation. Painters are repeatedly taken to task for not representing the suffering of Christ. Borghini finds fault with the beautified, more asleep than dead Christ, so frequently represented by Maniera artists in their *Depositions* (e.g. Salviati, Sta Croce, Dini Chapel; Pl. 24), and repeated by those artists of the younger generation such as Naldini (Sta Maria Novella, Minerbetti Chapel; Pl. 54) who retained a devotion to Maniera *grazia*.[14]

He applies his exhortation to conformity with Scripture even to incidental details. Bronzino is criticized for including two additional women in his *Noli Me Tangere* (Sto Spirito).[15] Vasari is censured for making his Madonna appear too youthful in his *Descent of the Holy Spirit* (Sta Croce, Biffoli Chapel; Pl. 36). Borghini even finds fault with Naldini, not for excluding the ox and ass from his *Nativity* (Sta Maria Novella, Mazzinghi Chapel; Pl. 56), but for giving them

[10] Borghini, *Il Riposo*, 1584, p. 104.
[11] Ibid., pp. 114 f.
[12] Reproduced in P. Barocchi, *Il Rosso Fiorentino*, Rome, 1950, fig. 23.

[13] Reproduced in Freedberg, *Painting in Italy*, pl. 80.
[14] Borghini, *Il Riposo*, 1584, p. 113.
[15] Ibid.; reproduced in Emiliani, *Bronzino*, pl. 95. The painting is now in the Louvre.

insufficient prominence. In his *Purification of the Virgin* (Sta Maria Novella, da Sommaia Chapel; Pl. 62) Naldini's angel is accused of looking more like a baby and, since he has no wings, of being seemingly in danger of plummeting to the ground.[16] It is clear from a remark like this that Borghini's concern is not only for literal adherence to Scripture but for plausibility as well. By thus insisting that the laws of nature must be applied, he rejects the kind of fantastical abstraction the Maniera had so often invented. The taste of his time found no virtue in the complex multiple meanings the Maniera artist had sought.

In applying his third criterion, Borghini's criticism is often made on moralistic grounds. Mention of Bronzino's *Christ in Limbo* (Sta Croce, Zanchini Chapel; Pl. 25) provides the occasion for a discourse upon the impropriety of lascivious figures in any public place because 'they set a bad example and induce vain thoughts'.[17] The puritanical fear, fostered by Trent, that the representation of corporeal beauty would distract the worshipper with wanton thoughts may be the basis for the frequently reiterated criticism that the figure of Christ does not sufficiently reveal his suffering. Not only men and women but also children and cherubs must be chastely garbed to remove the slightest opportunity for the devil to tempt us, says one of Borghini's spokesmen in discussing Allori's *Christ and the Samaritan Woman* (Sta Maria Novella, Bracci Chapel; Pl. 90). Bronzino's angel standing beside the tomb in his *Resurrection* (SS. Annunziata; Pl. 100), which had indeed caught our eye, is condemned as lascivious; but because Borghini cannot deny its sheer aesthetic magic he is forced into an uncomfortable position. At this point his two sets of criteria, one functional, one formal, come into direct conflict. He must reject such a figure on the grounds that it is inappropriate in an altar-piece, but he goes on to say that he would be delighted to have so beautiful and delicate a figure in his house.[18] The very qualities which distinguish the painting as a work of art make it unacceptable as a church decoration.

Just as Borghini's application of his criteria for *pittura sacra* reveals a reaction against Maniera religious art, so his aesthetic is unmistakably post-Maniera. In fact, though he is careful in discussing each painting to mix praise with his criticisms, he is hard put to it to find any positive comment on works of the Maniera artists. Concerning Pontormo's frescoes in the choir of S. Lorenzo (now destroyed), the kindest remark he is able to muster is that he cannot understand how such a formerly fine artist could have lost himself so com-

[16] Borghini, *Il Riposo*, 1584, p. 102. [17] Ibid., p. 110. [18] Ibid., p. 116.

pletely as Jacopo has in his last work.[19] Borghini censures all three of Vasari's paintings in Sta Maria Novella, and, unable to find a single good word for those in Sta Croce, he interrupts his tour round that church to remark that Vasari has executed one painting he likes and to wish that his others were as good as the *Immaculate Conception,* across the town in SS. Apostoli (Pl. 19).[20] His approbation of it must have been solely on aesthetic grounds, however. In *Libro I* he had expressed doubts about the desirability of representing the subject at all, because it had no basis in Scripture.[21]

He instructs artists specifically to avoid many of the conventions the Maniera painters had depended upon. Artists are warned against making figures which are over-muscular, such as the Maniera emulators of Michelangelo were wont to create, or figures which are excessively soft and delicate.[22] The kind of complexly compacted intertwining of figures practised by the Maniera, Borghini rejects as confusing. The artist should paint as many figures as possible in their entirety,[23] he says, and when Stradano represents half-figures in the foreground of his *Ascension* (Sta Croce, Asini Chapel; Pl. 43), Borghini objects. Coppi, who because he was slightly older had retained much of the Maniera in his style—as had Stradano—is criticized for overlapping figures and obscuring the legs of one in his *Ecce Homo* (Sta Croce, Zati Chapel; Pl. 48). The Maniera habit of making patterns with the limbs of figures and concealing parts arbitrarily was antipathetic to Borghini's taste.

Borghini's rejection of the aesthetic of Maniera art is not total. He demands the glowing colour, the gracefully posed figures, and the beautifully rendered textures of the Maniera, and he criticizes any lapse from these standards. His criticism reveals an ambivalent attitude towards Santi di Tito's efforts to reform Maniera. He is conspicuously silent about those elements in Santi's style which contained the seeds of revolution against it. However, when Santi moves in the direction of abandoning the Maniera altogether and of reinstating direct response to the central action, rendered in purely descriptive colour (as the Carracci were to do), Borghini recognizes the value of his innovation and praises his compositions (in *Libro I*) with fewer reservations than he applied to anyone else. In *Libro II,* however, he criticizes the colour of those same paintings as dull. Although he frequently objects to artificialities of pose in Maniera pictures, he reverses his condemnation in *Libro I* and applauds in *Libro II* Naldini's Christ in his *Deposition* (Sta Maria Novella, Minerbetti Chapel; Pl. 54),

[19] Ibid., pp. 195 f.　　[20] Ibid., p. 118.　　[21] Ibid., p. 102.　　[22] Ibid., p. 181.　　[23] Ibid., p. 177.

which retains from the Maniera much of the sense of a conscious striving after grace. Even when a painting is fully satisfactory in terms of the rendering of the scriptural story, as he finds Bronzino's last work, the *Raising of Jairus' Daughter* (Sta Maria Novella, Gaddi Chapel; Pl. 59), to be, he takes the artist to task for its artistic deficiencies.

In many cases the judgements made in *Libro I* on the merits of a work as *pittura sacra* conflict with those made on it as a work of art. It is interesting to isolate the few paintings that meet with complete approval on both grounds. They are distinguished by conformity with Borghini's three criteria for sacred art and by clarity of form: e.g. Barbiere's *Flagellation* (Sta Croce, Corsi Chapel; Pl. 83); Santi di Tito's *Tobias and the Angel* for S. Marco (now in Paris, St-Eustache; Pl. 107);[24] Allori's *Christ and the Adulteress* (Sto Spirito; Pl. 93); Macchietti's *Adoration of the Magi* (S. Lorenzo; Pl. 75). Borghini gives preference to neither set of criteria. They are two hurdles, both of which the artist must clear. His criticism suggests that the situation in Florence was somewhat different from that in Rome at this time, where the aesthetic requirements of *pittura sacra* were frequently subordinated to the interest of illustrating the Scriptures.

Vasari adjusted his style very little in the 1560s to the new conditions. One can observe that his colour becomes somewhat more subdued and that there is a diminution of the kind of *grazia* and *morbidezza* which might be considered sensuous, but, as his letters from Rome indicate, he was not in sympathy with the Counter-Reformation. The revision of his style of painting was made in the same spirit as the revision he made in his remarks on Sogliani in the *Vite*. Eugenio Battisti has pointed out that, in the 1550 edition, Vasari scoffed at the popularity of what he considered Sogliani's simplistic art: 'He was popularly acclaimed because he depicted pious and devotional scenes, as is the practice of hypocrites.' For the 1568 edition, in deference to the new mood, Vasari changed this to read: 'His manner was popular because he depicted religious scenes as such scenes are liked by those who, without appreciating the fine points of art and certain mannerisms, like things that are forthright, easy, gentle and graceful.'[25] He leaves little doubt by this statement that he remained an intransigent *manierista*.

The six altar-pieces which Vasari undertook to launch the project embody the

[24] Exhibited in Paris, Chapelle de la Sorbonne, *Trésors d'art des églises de Paris*, 1956, no. 42, where the provenance was traced to Vienna. Paatz (*Die Kirchen von Florenz*, iii. 43) had identified the Paris picture with the altar-piece of this subject by Santi di Tito, formerly in the church of S. Marco. He failed to note that it was mentioned by Borghini in 1584 (*Il Riposo*, 1584, p. 194).

[25] *Encyclopedia of World Art*, vol. xi, col. 911.

Maniera style, despite the apparent effort on his part, no doubt motivated by the mood of the Counter-Reformation, to make serious and significant religious statements. In all three of the works for Sta Maria Novella, executed first, he either selected a subject which was devotional, not narrative, in nature, or else he treated a narrative in such a way as to add a devotional dimension to it. Borghini criticized precisely this practice two decades later, but at the time Vasari was painting the new norms for *pittura sacra* had not yet crystallized. It must have appeared to him that by attempting the more difficult religious statement he might best answer the reformers' demand for more devout religious art.

The altar-piece which initiated the series in Sta Maria Novella was for the Strozzi Chapel (1567; Pl. 27). Here Vasari chose to represent, not the simple dramatic event of the *Crucifixion,* or even the simple devotional image of the *Crucified Christ,* but an intellectual invention, the *Crucifixion as seen in a Vision of St. Anselm.* By translating a traditional subject into a more sophisticated form, Vasari liberated himself from the constricting bonds of representing concrete reality. In a world beyond the laws of gravity and rational space, the action becomes a complex ornamental pattern of movement filling the picture plane and thereby creating the much-sought *bellezza* and *grazia.* Vasari was able to evade altogether the kind of direct expression of emotion which the Crucifixion would seem to require, but which he and the other Maniera artists found so distasteful. He substituted, as he so often did, an intellectual conception. Just what that conceit was, however, not even the patron, who was a learned bishop, could keep in mind. When the altar-piece was exhibited Strozzi wrote to Vasari asking him to explain the iconography again, because it was so complex he had all but forgotten it (see Catalogue, Sta Maria Novella, Strozzi Chapel). It is interesting that Borghini, usually quite accurate about the subject of religious paintings, referred to this picture, in both his discussions of it, merely as a *Christ on the Cross.* This would seem to indicate that he was completely unaware of its complex iconography.

When Vasari came to paint the *Resurrection* for the Pasquali Chapel (Pl. 30), the following year, he again eschewed the simple narrative treatment. By introducing in the foreground that tier of saints Borghini was to object to, he transformed it into a devotional altar-piece. The saints, who include Andrea Pasquali's name-saint and the patrons of the medical profession he practised (Cosmas and Damian), worship the Resurrected Lord, who serves at the same

time as the centre of an interrupted dramatic narrative and as a devotional image. Undoubtedly Vasari had in mind Bronzino's version of the same subject of two decades before and, like Bronzino, intended to combine the two aspects of the subject—the Resurrection as an event in sacred history, and the Risen Lord as an article of faith. What occurs instead, as Borghini pointed out, is that the interposition of medieval saints undercuts the plausibility of the Biblical event. Rather than adding a further dimension, Vasari has unwittingly generated, as happens often in Florentine Maniera pictures, two non-convergent paths of meaning.

Borghini's niggling remarks are an index of how remote his criteria were from Vasari's concerns. He found fault with the foreground saints on aesthetic grounds because their position is ambiguous, neither standing nor kneeling. He was completely out of sympathy with Vasari's concern to fill every part of the panel with visual interest, and looked instead for clear and plausible treatment of space.

The *Madonna of the Rosary* (1569) for Camilla Capponi and the Compagnia della Rosario (Pl. 33), the last of Vasari's contributions to the cycle in Sta Maria Novella, while not executed by him, bears the distinctive mark of his mind in the design. The abstract subject, probably selected by the patron, required treatment as a devotional image. Vasari's incorporation of the traditional conception of the Madonna della Misericordia, by quoting Rosso Fiorentino's design (Pl. 34), provided the kind of multiple allusion Vasari delighted in. But what would be the supremely subtle and complex quotation is the use Vasari seems to have made here of a compositional recollection of Masaccio's *Trinity*. The subjects are related: just as the Trinity represents the dispensation of God's grace through Christ's redeeming death, the Madonna of the Rosary is the intercessory channel through which man can reach God. This similarity would seem to be entirely fortuitous until we recall that Vasari's painting was designed to take the place of the *Trinity*. The friars, probably mindful of their obligation to officiate *in perpetuo* at the altar dedicated to the Trinity, ordered Vasari to include the Trinity, as well as St. Vincent and St. Ignatius, in his altar-piece.[26] Perhaps the necessity of making reference to the Trinity suggested to Vasari the conceit of 'quoting' Masaccio's composition.[27] Such a complex ratiocination, implausible in any earlier era, was characteristic of the mind of

[26] Biliotti, 'Cronica', fo. 54E, transcribed by H. Geisenheimer, 'Di alcune pitture fiorentine eseguite intorno al 1570', *Arte e storia*, xxvi (1907), 19.

[27] See Appendix, Doc. 2, nos. 15 and 16 for the chapels of St. Ignatius and St. Vincent Ferrer, which were both slated for demolition.

the Maniera artist for whom, as we have seen, meaning existed primarily in this kind of veiled allusion.

In Sta Croce a narrative treatment was dictated by the Passion cycle. Nevertheless, Vasari continued to employ complicated iconographical programmes even though the very existence of further meanings in these pictures is sometimes concealed. The *Descent of the Holy Spirit* for the Biffoli Chapel opened the series in 1568 (Pl. 36). To the casual observer it appears to be a straightforward narrative, and one would not suspect that each of the angels above had been carefully devised to represent one of the gifts of the Holy Spirit. Don Vincenzo Borghini must have spent considerable time working out the scheme (see Catalogue, Sta Croce, Biffoli Chapel), to which Vasari closely adhered. Even the execution of this otherwise dull work indicates that it was this upper zone with its cryptic meaning that interested Vasari, for it is the only portion showing any liveliness. He has tended, in accordance with his personal preference, to shift the interest of the picture away from the titular event, which is not so much dramatized as diagrammed, to the arcane iconography.

The altar-piece executed after a four-year interval for the Guidacci Chapel, the *Incredulity of Thomas* (1572; Pl. 39), is probably the most successful of the six Vasari made. Comparison of the painting with the preparatory sketch shows, however, that between them he had recourse to that standard repertory of types and poses on which he increasingly depended (Pl. 41). The sketch shows a liveliness in the poses of the figures which is lost in the painting. For example, Peter's gesture of shocked surprise and Thomas's animated, almost vulgar, curiosity appear in the painting as stock gestures from the Vasarian vocabulary. The allegories above, a pair of vivacious putti in the sketch, have become staid and awkward ladies in the painting, so laden with intellectual baggage that they can no longer float convincingly on their clouds. Comparison with other paintings reveals that at this stage Vasari was dealing with prefabricated interchangeable parts. If one juxtaposes the head of the youthful St. John here (in profile at the right edge) with representations of St. John in two other late altar-pieces, the Badia *Assumption of the Virgin* (Pl. 38) and the Carmine *Crucifixion* (Pl. 26), it is clear that Vasari used the same model in each case, either in the form of a study or of a mental image.

The *Christ on the Way to Calvary* for the Buonarroti Chapel (Sta Croce; Pl. 40) was executed at this same time, but (contrary to Vincenzo Borghini's judgement) it is notably less successful, particularly in the treatment of space.

Vasari has adapted a model designed in a horizontal format, but has apparently been unwilling to omit a single detail. He has compressed the winding procession, ill suited to the vertical format, so that the figures are pushed together and piled in layers, filling every inch of panel. The setting, which at least suggested space in the *modello,* is obscured in the final painted version, and this is only in small part due to the panel's present dirty condition. With his quite arbitrary application of highlight, Vasari has plunged the background into deep shadow. Especially in this work his composition resembles those late antique sarcophagi which are the source of many of the Maniera conventions.[28] The figures in the lowest zone maintain the plane, as in a sculptural relief. The figures behind, arranged more or less in tiers, emerge with decreasing clarity, as if in lower relief.

Borghini held all three of these altar-pieces in very low esteem. He railed against the faults of the least offensive, the *Thomas,* and refused to discuss the other two. The heart of his criticism is that he finds a want of grace and artifice in Vasari's later work. Objecting to the conventions of the Maniera, he wished to preserve its aestheticism. It is no wonder that he found Vasari's late works despicable, since in them the Maniera conventions are retained, but—partly because of the Reform, partly because of excessive haste—grace is expunged.

Although almost every one of the young artists was in some sense Vasari's pupil, it is noteworthy that not one pursued the conventions of Vasari's style in Florence in the 1570s. Giovanni Stradano and Jacopo Coppi, the two older artists, resemble Vasari and the Maniera in their styles more than any of the others, and they were to be berated by Borghini for it. Stradano, the first artist except Vasari himself to receive a commission for the project, painted his *Ascension* for Sta Croce (Asini Chapel, 1569; Pl. 43) the year after Vasari had initiated the cycle there with his *Descent of the Holy Spirit.* The contrast of manner with his *Crucifixion* (SS. Annunziata; Pl. 44), executed at the same time, reveals that in the *Ascension* Stradano was at pains to accommodate his style to Vasari's for the sake of the unity of the project. In the *Crucifixion* his Flemish temperament and background expressed itself freely in the macabre details of the dragon and a skeleton chained to the foot of the cross, and in the unrestrained contortion of the thieves. In contrast, the *Ascension* is marked by a tranquil sterility. Stradano was undoubtedly aware that Vasari did not esteem the

[28] C. H. Smyth pointed out the similarity between late antique and Maniera conventions of posture, gesture, and composition ('Mannerism and Maniera', *passim*).

Flemish elements in his style. Vincenzo Borghini had remarked to Vasari in a letter in 1564 that one of the small panels for the Aretine Pieve executed by Stradano would have to be retouched because it had too much of a Flemish air about it (Pl. 51).[29] In the same vein, Borghini would later report to Vasari that Stradano's rectangular panel for the Studiolo was being badly received and that people considered it ludicrous, though he had done better in the oval.[30] Comparison of the two panels makes it clear that it was the Flemish particularity of his style that people objected to. Thus, when he came to paint an altar-piece for Vasari's cycles, he sought to repress his Flemishness, and the result is dry and lifeless.

His composition of the *Ascension* follows the Vasarian formula in that it treats a dramatic event in a two-zoned devotional scheme. The immobile figure of Christ, centred in the upper zone, surrounded by an aureole and a choir of heavenly angels, is adored by the symmetrically disposed Madonna and rigidified Apostles below. Genre details, such as those that enliven the *Crucifixion,* are excluded here. The only activity is that conveyed by the stock Vasarian gestures of the spectators. Their vapid faces betray no emotion; their response to Christ's miraculous levitation is so restrained as to be unexpressed. In the interest of Italianizing his style Stradano has curbed the ability, derived from his Flemish background, to create highly individual physiognomies. The faces here are all of the same square-jawed type, with long noses and rosebud mouths. The colour is of a dry, pinkish tonality ranging from pallid reds to purples. Here, too, Stradano appears to have been emulating Vasari, for the colour of his *Crucifixion* is considerably more vibrant.

The same restraint is observable in Stradano's other altar-piece for the project, the *Baptism of Christ* for Sta Maria Novella (Baccelli Chapel, *c.* 1572; Pl. 45). In the same year he executed the *Expulsion from the Temple* (Sto Spirito; Pl. 46), and here again the contrast between his manner in it and in his painting for the project is striking. The vitality and the observed genre details which enliven the *Expulsion* are not to be seen in the *Baptism*. Only in the trio of portrait heads (probably of the patrons), behind at the right, do we find any liveliness. In both the altar-pieces where Stradano felt free to work in his own style—the *Crucifixion* and the *Expulsion*—his figures break through the picture plane, and in the latter even spill into our space; but in the works for the

[29] Letter dated 22 March 1564; Frey ii. 64.
[30] Stradano's rectangle represented the *Glass Factory* (reproduced in Vitzthum, *Studiolo*, p. 39), and his oval

Circe transforming the Companions of Ulysses (reproduced in Bucci, *Studiolo*, pl. 13).

project he has scrupulously observed Vasari's cardinal rule of planarity. His figures all appear uncomfortable at being frozen in enforced conformity.

Though Stradano showed a marked willingness to adopt the conventional-ized postures of Vasari, his is not the full-fledged Maniera style. He eschewed, for example, the intricate interweaving of figures and the arbitrary light that obscures as much as it reveals. Whereas Vasari's compositions are bewilder-ingly convoluted, his are simple to the point of being dull. Jacopo Coppi, like Stradano, retained much of the Maniera. However, it is not primarily in Vasarian postures that his style recalls the High Maniera. Rather it is in his manner of treating the subject-matter. In his *Ecce Homo* (Sta Croce, Zati Chapel, 1576; Pl. 48) he chose to represent the scene frontally so that Christ, at the top of the stairs with Pilate, is so diminished in scale that he cannot dominate the scene. But Coppi has made it evident that he is not primarily interested in the narrative, for he has placed Christ in the shadow, and has shifted the spot-light to the prominent foreground figures who ignore him and carry on their own animated discussions. One suspects that some kind of allegorical signifi-cance was conveyed here in the manner of the High Maniera. This representation of multiple, concurrent but unrelated activities; the lack of focus; the disen-gagement of the figures from the event, and their contortion; even the fascination with ornamental details derived from Salviati, and his master, Carlo Portelli, are all remnants of the Maniera.

Even more indicative of Coppi's Maniera frame of mind is the treatment he gave to his altar-piece for Sta Maria Novella (*Christ in Glory with Saints*, Attavanti Chapel, 1574; Pl. 47). Borghini viewed it as an example of the kind of subject which should not be painted. On the one hand, it did not make sense as a *Triumph of Christ*; on the other, if it represented *St. Vincent Contemplating the Mystery of Christ Triumphant*, there was no reason for including St. Verdiana, who lived many years later. This type of combined subject recalls the High Maniera. Coppi did very little further work in Florence—at least work that is now known[31]—and he seems to have dropped into sufficient obscurity for Borghini not to feel it incumbent on him to include his biography in *Il Riposo*.

After the project was under way, the artists felt less constrained than had

[31] Coppi executed an altar-piece dated 1579 for S. Salvatore, Bologna, and painted the frescoes in the tribune of S. Pietro in Vincoli, Rome. Though Col-naghi (*Dictionary*) records that he was appointed consul of the Accademia del Disegno three times between 1581 and 1585, only the *Descent of the Holy Spirit* in S. Niccolò is known to have been painted by him in those years (see Paatz, *Die Kirchen von Florenz*, iv. 367).

Stradano to temper their styles to accord with Vasari's. Coppi's kind of Maniera, for instance, depends more upon Rosso and Carlo Portelli than upon Vasari. Despite this, there is a formal character to the altar-pieces that lends itself to generalization. This would seem to result more from a common background in the Florentine artistic milieu than from the kind of conscientious imitation of Vasari that Stradano had attempted. The altar-piece of Sebastiano Vini, who was not a Florentine, differs noticeably from the others (as Borghini noted) and serves to highlight their similarities. Trained in Verona, Vini spent most of his artistic life in Pistoia. Before he painted the *Conversion of Saul* for Sta Maria Novella (Ricasoli Chapel, *c.* 1575; Pl. 49), his contact with Florentine artistic circles seems to have been limited to his brief involvement in the temporary decorations for the Palazzo Vecchio. Whereas the other artists in their altar-pieces characteristically fill the lower picture surface, Vini has created a central void there which strikes a discordant note. The Florentines tend to place the central figures about one-third above the lower edge and to fill the lower corners with repoussoir or kneeling figures. Vini's isolated Saul at the bottom of the picture breaks with this convention. Vini has used the traditional two-zone organization with the image of the divinity above, which the Florentines increasingly avoided. Whereas the Florentines tended to evade climactic drama, Vini, emulating his model, Michelangelo, represented the scene as intensely dramatic. Vini used a light background which contrasts with the dark field of most of the other altar-pieces in the series, and his figures are smaller in relation to the size of the panel. Furthermore, he was not interested in the kind of graceful aesthetic effect that the Florentines inherited from their Maniera predecessors. There is none of that languid grace in his painting that pervades the other works of the series.

To each of these generalizations there is, of course, an exception. Macchietti and Santi di Tito designed compositions along a line diagonal to the picture plane (*Martyrdom of St. Lawrence*, Sta Maria Novella, Giuochi Chapel; Pl. 76; and *Supper at Emmaus*, Sta Croce, Berti Chapel; Pl. 104). Naldini introduced an upper zone into his *Nativity* (Sta Maria Novella, Mazzinghi Chapel; Pl. 56). Santi di Tito regularly used light backgrounds and eventually renounced aestheticism altogether. Nevertheless, the altar-pieces resemble one another enough to create a continuity in the series which Vini's work, emerging from Emilian circles and much more dependent upon Michelangelo than was fashionable in Florence in the 1570s, disrupts.

Battista Naldini (1537–91), who contributed four altar-pieces to the project, appears to have made very little accommodation to Vasari's style when he undertook the *Deposition* (Sta Maria Novella, Minerbetti Chapel, 1572; Pl. 54). A pupil of Pontormo in his last years, Naldini derived at least as much of his personal manner from the Pontormo–Bronzino line as from Vasari, whom he had assisted since his return from Rome about 1564.[32] Naldini chose not one of Vasari's versions but Bronzino's late *Deposition* (1561; Pl. 53) as the source of his composition, although he made significant revision of it. Whereas Bronzino, with his genius for inventing tension-creating ambiguities, had represented Christ twice in temporally successive events, Naldini resolved this troubling ambiguity simply by representing the cross of the Crucifixion empty between the two crucified thieves, who strongly resemble Bronzino's. By moving the figure of Christ back from the picture plane and excluding the accusing figures in the lower corners he has also abolished the sense of desperate urgency which Bronzino had sought. One might well expect the younger artists to retreat from the expressionistic crisis Bronzino was experiencing at the time he painted the *Deposition*. Bronzino himself had achieved a kind of resolution by the time he painted the *Raising of Jairus' Daughter* (Sta Maria Novella, Gaddi Chapel, 1572; Pl. 59), though it amounted to little more than a negation of artistic values. Naldini, however, did not simply revive his master's *bella maniera* from the years before Bronzino's espousal of the Counter-Maniera. While there are elements of that style to be found here, the mood is altogether different. Naldini has withdrawn from the disturbing ambivalence of the Maniera into a rarefied, abstracted realm. Bronzino had represented an abstracted world, but it was inhabited by sculptural figures emitting a strong sense of physical presence. Naldini's figures are gentle shadows, moving silently in a world where emotion scarcely exists. The sense of remoteness is achieved in part by the application of Correggesque colour and *sfumatura* which Battista must have learned in Rome. They distinguish his style in the Studiolo[33] and in his earlier *Christ on the Way to Calvary* (Badia, 1566; Pl. 52) from that of his Florentine colleagues. The gentle pastel colours and diffused light create an aura as of a dream-world which intrudes only peripherally upon our consciousness. The sense of the tragedy of the event is minimized by the ingratiating colour scheme

[32] Naldini became a member of the Accademia del Disegno in 1564 and assisted with the decorations for Michelangelo's funeral (Colnaghi, *Dictionary*, p. 188).

[33] Naldini's panels for the Studiolo were the *Allegory of Dreams*, reproduced in Bucci, *Studiolo*, pl. 14; and the *Gathering of Ambergris*, reproduced in Freedberg, *Painting in Italy*, pl. 273.

and the sensuous appeal of the textures. Rather than pressing itself upon the observer as Bronzino's picture had done, Naldini's recedes almost to another world.

When, in the following year, Naldini painted his *Nativity* (Sta Maria Novella, Mazzinghi Chapel; Pl. 56), he again turned to Bronzino for his prototype, the altar-piece for S. Stefano in Pisa (Pl. 55) and made a similar revision of it. Although Naldini preserved the basic scheme, he greatly simplified it, reducing the figures from twenty-three to nine. Concrete elements of setting and landscape, which make a scene seem familiar to us, were shunned by Naldini, who preferred to create the sense of a semi-reality barely accessible to us. Accordingly, the upper zone, where God and his angels burst in—a device usually avoided by Naldini and his Counter-Maniera colleagues—has been enlarged to occupy the area where Bronzino had represented a very tangible Tuscan landscape. None of the figures look out at us in either of these altar-pieces for Sta Maria Novella. Not only do they avoid establishing psychological contact with the viewer, they retain from the Maniera the characteristic isolation from one another. Their agitated movements and stagy gestures—another remnant of the *bella maniera*—are intended to create an air of excitement, but their lack of interrelatedness, either formal or psychological, creates instead a curious silence. The intentional ambiguities of the Maniera prototypes have been carefully excluded, but no other content has been substituted, so that what results is a dramatization which is not dramatic.

At some time in the mid-seventies Naldini undertook to complete an altar-piece for the Carmine left unfinished by Maso da San Friano at his death in 1571. It was a task in which Naldini was more circumscribed by the conditions imposed on him than usual, so that the work which resulted was, in Borghini's opinion, not entirely successful. The altar-piece, along with the other two Naldini painted for that cycle, was destroyed in the eighteenth-century fire in the Carmine, but Naldini's *modello* has been preserved and was recently acquired by the Ashmolean Museum (Pl. 61). Also preserved is Maso's sketch for the composition (dated 1565, Uffizi 602S; Pl. 60). The subject was the Assumption, but in the foreground appear Saints Helen and Agnes. Borghini claimed to know at first hand that this unfortunate combination of subjects had been dictated by the patron.[34] Naldini, working on the picture perhaps

[34] Borghini, *Il Riposo*, 1584, p. 115. P. Cannon Brookes, 'Maso da S. Friano', connected the Oxford *modello* with the Carmine commission and reproduced Maso's sketch (p. 194, fig. 32).

a decade after Maso had first designed it, may have been more sensitive to the kind of criticism that Borghini was to make, for he has evidently attempted to integrate the two ladies into the composition far more than Maso had done. He breaks the eye contact with the viewer, moves Helen's cross around to the spectator's side, and turns the two saints inward to form part of the circle of witnesses. Perhaps also at the request of the patron, the Virgin has been inserted into the handsome void Maso had left at the centre. Despite his awareness of Counter-Reformation demands with respect to subject-matter, Naldini demonstrates here his preference for certain Maniera artificialities of style. His figures are more mannered in pose and gesture than Maso's and he has shifted the composition quite intentionally to fill the picture plane.

In the *Purification of the Virgin* (Sta Maria Novella, da Sommaia Chapel, 1577; Pl. 62), Naldini chose to follow a Vasarian prototype (Naples, Capodimonte, 1544; Preparatory sketch, Pl. 65). As in the earlier altar-pieces, he has simplified the composition and reduced the number of figures, expelling even the priests, so that the festal activity of Vasari's version has given way to a hushed silence. This choice of source would seem to be symptomatic, for in this painting we note also an academicism which approximates to that of Vasari's late style, and is evident earlier neither in Naldini's Sta Maria Novella altar-pieces nor in the Carmine *modello*. The treatment is markedly less impressionistic, the forms harder and more distinctly defined—tending even towards petrification. The figures have more substance than previously. The function of colour has shifted away from the decorative towards the descriptive; the pretty pastels of the earlier works have been somewhat neutralized here. The lighting is consistent and clarifying, not the arbitrary, evocative illumination of his earlier works. These stylistic changes may well have been motivated by some expression of the Counter-Reformation, for they move in the direction favoured by it of making figures and their environment more tangible and the narrative more plausible. Nothing, however, has been gained in terms of dramatization. Naldini has merely exchanged the ephemeral delicacy of his early works for a solidity which borders on the pedestrian. Possibly, as Barocchi has suggested, the presence in Florence since 1575 of Federigo Zuccaro and the example of post-Tridentine academic pedestrianism set by his decorations for the Duomo cupola accounts for the classicistic turn in Naldini's style.

Naldini executed the fourth of his altar-pieces for the project (*Entombment*, Sta Croce, da Verrazzano Chapel, 1583; Pl. 67) after his return from a second

QTY.		YOUR REF.
1	HALL MARCIA BROWN - RENOVATION AND COUNTER-REFORMATION [OXFORD-WARBURG STUDIES]	B032917&x 20/10/77

THE SCOTT LIBRARY
PROCESSING DEPARTMENT V.N 1186
YORK UNIVERSITY
4700 KEELE ST.
DOWNSVIEW 463
ONTARIO
CANADA M3J 1P3

OUR REF:
4730'1635/000
81210127/11
0 19 817352 0

REPORT OF RESERVATION
TIME LIMIT EXCEEDED
IN THE EVENT OF A QUERY, PLEASE RETURN THIS SLIP

prolonged visit to Rome, probably in 1580–1.[35] We note a curious revival of the rosy atmospheric handling characteristic of the early pictures, inspired perhaps by his own earlier treatment of the subject in Sta Maria Novella, incongruously combined with passages in which the crude manner of Balducci is discernible. Naldini relied increasingly upon this pupil's assistance, and occasionally entrusted to him the execution of an entire work, such as the immediately subsequent altar-piece for S. Niccolò (*Purification of the Virgin*, 1585).

The culmination of his later style (and that of the Florentine Counter-Maniera) is to be seen in his works of the mid- and later eighties, particularly the familiar *Calling of Matthew* (1588, signed and dated; Pl. 74) and a *modello* for it (Pl. 73) done in competition with Poppi and Allori for the Salviati Chapel in S. Marco, where all three altar-pieces are still to be found. Of the same date must be the *modello* for a *Resurrection of Lazarus* (present location unknown; Pl. 72).[36] The direction already set in the Sta Maria Novella *Purification of the Virgin* (Pl. 62) before the Roman journey, but strangely departed from in the Sta Croce *Entombment* (Pl. 67), is now re-established and pursued. In both these works space has been lucidly organized in stages with conveniently placed steps as in the *Purification*—unlike the compressed *Entombment*. This device enabled the artist to place Christ high, dominating the action with a powerful gesture. Columns on lofty bases extend space beyond the frame, and balustrades permit the artist to insert spectators into otherwise dead space. These architectural devices had appeared much earlier on the Florentine scene, for example in Macchietti's *Martyrdom of St. Lawrence* (Sta Maria Novella, Giuochi Chapel, 1573; Pl. 76) and, though they were originally derived from Venice, Naldini had probably learned them at second hand. We find in both these pictures the broad, hard, classicistic figures first observed in the *Purification of the Virgin*. Instead of the pastel values of his colour in the decade between 1566 and 1576, we see in the *Calling of Matthew* intense primary hues rising out of the dark background. Instead of the dreamy, glowing illumination, a strong light

[35] Barocchi ('Itinerario') reproduces several of Naldini's works executed during this second trip to Rome. Since the only year before 1585 in which Naldini's taxes are not recorded as having been paid to the Accademia del Disegno is 1580, it would seem likely that this is the date of his trip to Rome. As payments were made on 1 February 1579/80 and on 15 July 1581, Naldini could have been absent for a period of almost eighteen months. (A.S.F. Accademia del Disegno, vol. 101 (Entrata e Uscita), fos. 56ᵛ, 62ᵛ.)

[36] This work was reproduced in the catalogue of the Spinelli sale, 1928. Borghini does not mention a *Resurrection of Lazarus* by Naldini. It may well have been executed shortly after the publication of *Il Riposo* in the second half of the 1580s.

contrasting with deep black shadows enhances the drama. Naldini has overcome the deficiency in dramatization that had characterized his earlier works. He has embraced a style which, if less aesthetically appealing, is better suited to the kind of scriptural illustration the Counter-Reformation required. Nevertheless, his style remains essentially Mannerist. He continued to construct a composition, as the Maniera had, from a series of academic figure-studies made in the studio and then combined artfully together (Pls. 63, 64, 68–71).[37] Almost as much in his late as in his earlier style, *grazia* and *bellezza* were the primary values to which narrative took second place. These artificial constructs were a bondage preventing Naldini from making that open-minded confrontation with the dramatic demands of the subject which was essential if a wholehearted renewal of art was to take place.

Girolamo Macchietti (*c.* 1535–92) was surely one of the most gifted of the artists who contributed to the project, yet we know little about his life. In his *Martyrdom of St. Lawrence* (Sta Maria Novella, Giuochi Chapel, 1573; Pl. 76), for example, influence from Venice is everywhere apparent. The balustrade already mentioned, the courtly dwarf, the brocaded tapestry draped around the columns, all bespeak enthusiasm for the art of Titian and Veronese. The obvious Florentine prototype for this subject was Bronzino's monumental fresco for the Church of S. Lorenzo, unveiled only a few years before.[38] Macchietti conspicuously rejected a composition based upon this very Maniera work, and chose instead a design which closely resembles Titian's treatment of the subject in the Church of the Gesuiti.[39] Yet we have no documentation of a journey to Venice.

There was opportunity for such an experience, however, because Macchietti executed few known works between his return from Rome in 1564 and the Studiolo panels of 1571–2. After his six years with Vasari (1556–62) and two years in Rome, he had returned to Florence and had assisted in Michelangelo's funeral. By the time he executed the Studiolo panels,[40] he had become acutely aware of the possibilities of spatial composition; and this awareness was still

[37] Barocchi ('Itinerario') has brought together numerous drawings for the *Calling of Matthew* which show that studies, usually in red chalk from a model in the studio, were made for virtually every figure in the composition. We have found almost as exhaustive sets of studies for the altar-pieces in this project (see especially Catalogue, Sta Croce, da Verrazzano Chapel).

[38] Bronzino's fresco is reproduced in Emiliani, *Bron-*

zino, pl. 92.

[39] Titian's altar-piece is reproduced in Harold E. Wethey, *The Paintings of Titian*, vol. i, London, 1969, pl. 178.

[40] Macchietti painted in the Studiolo *Medea rejuvenating Aeson* (reproduced in Bucci, *Studiolo*, pl. 24); and the *Baths of Pozzuoli* (reproduced ibid., pl. 23).

alive, if slightly diminished in intensity, when he designed his altar-piece for Sta Maria Novella.

This new conception of space might be due not to Venetian influence but to that of Macchietti's friend, the elusive Mirabello Cavalori, with whom Macchietti had collaborated on some frescoes for the Capuchin church outside Florence some time between 1564 and 1567.[41] Cavalori displayed a remarkable sensitivity to space and light in his panels for the Studiolo,[42] but so few of his works survive that we cannot fix the source or date of it. It is, therefore, difficult to assess what his supposed influence on Macchietti might have been. It appears, however, that Macchietti's interest in spatial composition post-dated his collaboration with Cavalori, since the *Adoration of the Magi* (S. Lorenzo, 1568; Pl. 75), which was painted after the Capuchin frescoes, reveals very little concern with problems of space. Instead, he drew upon his Roman experience and modelled his conception on a design from the workshop of Taddeo Zuccaro, a source he was to use again in his *Trinity* (Sta Croce, Risaliti Chapel, 1575; Pl. 79).[43] A trip to Venice might be postulated for the year 1569, between the *Adoration* and the Studiolo panels.[44]

The two extra-Florentine artistic influences seen in Macchietti's works (derived either first hand or through some unspecified intermediary), Zuccaro and Titian–Veronese, provided him with the means to liberate his style from Vasari and the Florentine Maniera. Thus by using a source other than Bronzino for his *Martyrdom of St. Lawrence* he could make a post-Maniera statement. In contrast to Bronzino's strictly planar composition, Macchietti placed St. Lawrence along a space-creating diagonal. For the multitudinous meaning-laden

[41] Vasari mentions these frescoes in his biography of Macchietti and Cavalori (Vasari–Milanesi vii. 613), saying that they had been finished several years before he was writing.

[42] Cavalori contributed to the Studiolo the *Sacrifice of Lavinia* (reproduced in Vitzthum, *Studiolo*, p. 23); and the *Wool Factory* (reproduced in Freedberg, *Painting in Italy*, pl. 200).

[43] Taddeo's design survives today in two forms: his panel painting, in the Fitzwilliam Museum, Cambridge, which Macchietti might have seen during his stay in Rome, and a fresco by Federigo painted in 1564–5, in the Grimani Chapel in S. Francesco della Vigna, Venice. It may be that Macchietti became familiar with the design through Federigo, who stopped in Florence on his return to Rome after completing the frescoes to assist the members of Vasari's workshop, including Macchietti, in preparing the decorations for the wedding of Francesco de' Medici and Giovanna. See J. A. Gere,

'Two panel-pictures by Taddeo Zuccaro', in *Burl.* cv (1963), 363–7; and id., 'Two of Taddeo Zuccaro's last commissions, completed by Federigo Zuccaro: I. The Pucci Chapel in S. Trinità dei Monti; II. The High Altar-piece in S. Lorenzo in Damaso', in *Burl.* cviii (1966), 286–93, 341–5.

[44] Marcucci ('Girolamo Macchietti disegnatore', p. 123) established that the S. Lorenzo altar-piece was finished by 1568, when it was praised by Benvenuto Cellini. Cellini and Macchietti were evidently good friends, for Cellini bequeathed his studio to Macchietti in his testament (see *Ricordi, prose e poesie di B. C. . . . in seguito della Vita del Medesimo*, ed. F. Tassi, vol. iii, Florence, 1829, p. 254).

Freedberg (*Painting in Italy*, p. 512, n. 9) believes that there is evidence of knowledge of Venice already in the 1568 *Adoration of the Magi* and that Macchietti's journey should therefore be dated earlier.

quotations from Michelangelo and other sources that Bronzino had employed, Macchietti substituted figures which have no latent iconographical significance, in poses more congruent with the narrative. The irrational ambiguities of Bronzino's version have been avoided and attention focused on the narrative. Yet Macchietti's version is scarcely more dramatic than Bronzino's. His delight in beautiful effect, while derived largely from Venice and therefore different in kind from the Maniera artist's, is nevertheless similar in undercutting the painful horror of the martyrdom. And the drama is by no means enhanced by including among the witnesses the placid, earnest, bourgeois faces of the grocer–patron Girolamo Giuochi and his wife.

Immediately after the altar-piece was installed, Macchietti departed for a visit to France.[45] Unfortunately, we have no record of what he did there.

Macchietti's other altar-piece for the project, the *Trinity* of 1575 for Sta Croce (Risaliti Chapel), is known only through drawings (both for it and of it; Pls. 79, 80). Nevertheless, one can observe enough to see that he departed abruptly in this painting from the experiments with spatial environment that had interested him in immediately prior works. As again in the succeeding *St. Lawrence in Glory* (Empoli, Collegiata, 1577; Pl. 82), the action has been transferred to the spaceless realm of vision, with only a minimal suggestion of terrestrial setting. Light continues to play an important role, making the vision tangible; but the delicate, luminescent forms, though still visible—at least in the drawing for the dead Christ—have hardened, much as Naldini's did at this time. One suspects that, like Naldini, Macchietti has fallen under the influence, not of Allori as Marcucci claimed, but of Federigo Zuccaro as Freedberg suggested.[46] With this shift, the promise of renewal that Macchietti's art had held was frustrated. The experiments—with the diagonal, with texture, with naturalistic setting—had moved, however briefly, in the direction of reforming and revitalizing the Maniera. In the *Trinity,* Macchietti tended toward a flight from naturalism to the visionary realm, but one could have argued that the subject left him little choice. The tendency became pattern, however, with the *Madonna of the Girdle* (Florence, Sta Agata) and the Empoli *St. Lawrence.* The sense of exploration and of visual delight has departed.

[45] A.S.F. Accademia del Disegno, vol. 123 (Debitori/ Creditori per conto di tasse), fo. 32ᵛ: 'andò in Francia adì di giugnio 1573'. He stayed in Paris for 15 months according to an entry on the following folio (fo. 33ʳ): 'E più si fa buoni al detto I. dua s. diesi per esere stato a Parisi qui[n]disi mesi a lavorare.'

[46] Marcucci, 'Girolamo Macchietti disegnatore', p. 131; Freedberg, *Painting in Italy,* p. 426. The *St. Lawrence in Glory* was put in place on 2 November 1577 (Venturi, *Storia dell'arte italiana,* vol. ix, pt. v, p. 292).

Macchietti himself departed from Tuscany in 1578 for southern Italy. He returned only briefly in 1584 before leaving again to work at El Escorial.[47]

Alessandro Fei, called del Barbiere (1543–92), was probably the youngest of the artists who participated in the project, and it would seem to have been for this reason that he was given only one rather late commission, that for the *Flagellation* (Sta Croce, Corsi Chapel, 1575; Pl. 83). Barbiere's altar-piece is qualitatively among the best, and he seems to have been a favourite of Borghini, who listed many works, especially frescoes, by him in his biography.[48] Few survive that can today be identified.

It is evident from his compositions and from his manner of drawing (Pls. 84, 85) that his primary stylistic source was Andrea del Sarto. Although Andrea had died more than a decade before Alessandro was born, Barbiere, like many of his contemporaries, leap-frogged his masters and immediate predecessors to draw upon Andrea, Pontormo, and Rosso. Allori and Santi di Tito frequently returned to Andrea del Sarto for a compositional idea. The influence of Rosso is very apparent, not only in Jacopo Coppi's (Pls. 47, 48) but also in Francesco Poppi's imitation of his idiosyncratic figure types. This is most evident in drawing styles. One is not surprised that Pontormo should have influenced his pupil Naldini, but that Naldini, like Barbiere, should have chosen also to emulate Andrea del Sarto's red-chalk manner is surprising. Macchietti's delicate touch resembles Pontormo's, too, though he was never his pupil as far as we know (Pls. 78, 80).

What seems to have appealed to Barbiere was Andrea's direct narrative style. He has less of the Maniera in him than Stradano, Coppi, Naldini, or even Macchietti. The action is presented boldly at the frontal plane, with no ornamental space-filling figures below and in front of Christ and his flagellators. The remaining half of the height Alessandro has filled with monumental architecture, reminiscent of Venice (as with other artists that have been discussed) and perhaps derived from the authoritative example of Macchietti's altar-piece in Sta Maria Novella, finished just two years previously (Pl. 76). The panel's present dirty condition makes it difficult to assess the treatment of light and space, but one suspects that were it cleaned the perspective vista of columns and arches behind Christ (a naturalization of the truncated column traditionally

[47] The records of the Accademia del Disegno (A.S.F. vol. 101, fo. 79) document his absence from Florence: 'Da Girolamo di Francesco Macchietti pittore quattro lire soldi tredici denari quattro sono per resto di sua tassa insino a tutto ottobre 1584 d si computò cinque anni che era stato fuori dello stato di S.A. L.4-13-4.'

[48] Borghini, *Il Riposo*, 1584, pp. 632 ff.

represented) would open up an impressively spacious setting. Like Macchietti in the early seventies, Barbiere has eliminated many of the Maniera conventions and substituted for its circumlocutory syntax a robust declarative statement. It may have been from Maso da San Friano, whom Barbiere had assisted, that he derived both his inclination to a post-Maniera aesthetic and his respect for Andrea del Sarto.

Alessandro apparently left Florence in 1579 and did not return until 1583, perhaps recalled by the commission, described by Borghini, to decorate the Albizzi Chapel in S. Pier Maggiore.[49] The *Assumption* altar-piece for that chapel has unfortunately disappeared, and with it the only major evidence of Barbiere's later stylistic development.

We know less about Andrea del Minga (1535/40–1596) than about any other artist who worked on the project. In addition to his *Agony in the Garden* (Sta Croce, Pazzi Chapel, 1574–8; Pl. 86) only four of his works are known: a pair of pictures representing the *Creation of Eve* and the *Expulsion from Eden* (Pitti Gallery), said to have been executed on Bandinelli's design, an oval for the Studiolo representing *Deucalion and Pyrrha*, and a late altar-piece. According to Colnaghi, Andrea and his brother Francesco were expelled from the Accademia del Disegno in January 1571 (1572) on the grounds that their activities as tax-collectors were not appropriate to the dignity of that body.[50] The altar-piece for Sta Croce is the only painting by Andrea that Borghini mentions, but he twice repeats the rumour that Andrea had been assisted by Stefano Pieri in the colours, by the Flemish artist Giovanni Ponsi in the landscape, and in the composition by Giambologna. This sounds like the kind of tale which might have been devised to explain the embarrassingly fine performance of an artist whom the Academy had expelled from its ranks. The painting, which resembles in style Andrea's other known works, is remarkable for its handsome landscape and warm, glowing colour. The landscape bears a close resemblance to that of his Studiolo panel.[51] The figures, the weakest part of his work, show the same rubbery anatomy that afflicted his *Deucalion and Pyrrha*. His sleeping Apostles, forming a kind of foreground frieze, have the graceful proportions and convoluted posturing of the Maniera. The soft, warm colours, especially in the robes of the Apostles and the romantic luxuriance of the landscape, create a mood of sylvan serenity. Like many of his Florentine contemporaries, Andrea

[49] Borghini, *Il Riposo*, 1584, pp. 636 f. Barbiere paid no taxes to the Accademia del Disegno between June 1578 and 1583 (A.S.F. vol. 138 (Entrata e Uscita del Vanto ed altro), fo. 4ᵛ).

[50] Colnaghi, *Dictionary*, p. 74.

[51] Andrea's *Deucalion and Pyrrha* is reproduced in Vitzthum, *Studiolo*, p. 36.

has treated an intensely dramatic subject with such dreamlike remoteness that it seems barely real.

It is impossible to trace Andrea's activities after he completed this commission, since he was no longer a member of the Academy and does not appear among its records, and Borghini gives no biography of him. He makes a final appearance, however, in a late altar-piece for Sta Felicita (*Assumption*, 1589; Pl. 87)[52] of decidedly pedestrian character. In its return to the stereotyped two-zone devotional type it documents the loss of vitality and interest in experiment which afflicted so many of the Florentine painters toward the end of the century. With very little experimentation going on around them, even among the most talented and progressive artists, painters like Minga, who in the seventies had reflected the vitality of their colleagues, retreated into retrospective formulas.

Alessandro Allori (1535–1607) increasingly departed from the Michelangelesque brand of Counter-Maniera he had brought back from Rome in the early sixties, but he never endorsed his master Bronzino's late manner. There is a marked contrast between the return to Maniera that marks the style of Allori's Studiolo panels,[53] and Bronzino's own purged and desiccated Maniera of the contemporary *Raising of Jairus' Daughter* (Pl. 59). Allori revived Bronzino's style of the forties, simplifying it to accommodate it to the mood of the seventies. He, more perhaps than any of the other younger artists, was satisfied to work entirely within the Florentine tradition. Only once do we find him turning to Venice for inspiration, and that turns out to have been the briefest possible infidelity. His *Sacra Conversazione* for Sta Maria Nuova (now in the Accademia; Pl. 92), painted in the same year as his *Christ and the Samaritan Woman* for Sta Maria Novella (Bracci Chapel, 1575; Pl. 90), is quintessentially Florentine. The format of a *Sacra Conversazione* in an architectural setting recalls the Florentine High Renaissance, particularly Andrea del Sarto, and Allori's picture has that quality of modest grandeur which distinguishes the classical style in Florence from the rhetorical manner it assumed in Rome.

In the early seventies, Allori's style tended to take on the character of his compositional prototype. *The Ten Thousand Martyrs* (Sto Spirito, 1574),[54] for

[52] Documentary evidence for the attribution of this altar-piece to Andrea del Minga was discovered by P. C. Hamilton ('Andrea del Minga's *Assunta* in S. Felicita', *Mitt. KHIF* xiv (1969–70), 466).

[53] Allori painted for the Studiolo the *Pearl Fishers* (reproduced in Bucci, *Studiolo*, pl. 16); and *Cleopatra's*

Feast (reproduced in Venturi, *Storia dell'arte italiana*, vol. ix, pt. vi, fig. 54, and in Bucci, *Studiolo*, pl. 18, detail only).

[54] Reproduced in Venturi, *Storia dell'arte italiana*, vol. ix, pt. vi, fig. 57.

example, is far more Mannerist than the other altar-pieces of this date, doubtless because Allori had in mind Perino del Vaga's design for the fresco in the church of the Camaldoli.[55] Increasingly as he gained maturity, Allori's style, purged of all residue of Maniera contortion and complexity, was a distillate of rhythmic grace with all trace of emotion refined away. In his *Christ and the Samaritan Woman* the encounter between the protagonists is scarcely dramatized at all, but partakes of that silence that pervades all Allori's paintings. All emotion is avoided, just as the exchange of glances between Christ and the woman is avoided. Much of Bronzino's sensuous beauty is evident—too much in Borghini's opinion—but Allori appears to have renounced, for the moment at least, Bronzino's precious ornamental colour, possibly out of deference to the Counter-Reformation. Despite his perfunctory bow to the current puritanism, Allori's style remained in its essence aesthetical. Though he had shed the manifestly offensive elements of Bronzino's *maniera*, he had assumed unaltered his master's artificial mode of vision and supplemented it with whatever he could learn from Salviati. Though his paintings faithfully represent the elements of the scriptural text, the events take place in the same remote realm depicted in Minga's *Agony in the Garden* (Pl. 86), or in Naldini's earlier works (Pls. 52, 54, 56), or in Macchietti's later ones (Pl. 82). The atmosphere his figures breathe is so rarefied as to be insufficient to sustain life. While conforming to the letter of the Counter-Reformation's dicta, his creations have little or no power to convince. Yet Allori was perhaps the most prolific and successful artist of his time in Florence. The attraction of his pictures lies not in the rendering of the content but in their highly appealing formal character.

For a brief moment in the later seventies Allori seemed to have moved in the direction of a revitalizing naturalism. The setting of *Christ and the Adulteress* (Sto Spirito, 1577; Pl. 93) (very similar to that of Barbiere's *Flagellation* of 1575; Pl. 83) reveals that Tintoretto's two paintings of St. Mark (*Abduction of the Body of St. Mark*, Venice, Accademia, and the *Finding of the Body of St. Mark*, Milan, Brera, commissioned in 1562) had impressed Allori profoundly. He achieves an eloquent isolation of the Adulteress by his use of the perspective vista and the void in which she stands, with a noteworthy lack of conventionalized grace and prettiness. It turned out to have been only a momentary inspiration, however, for the conventionalized grace reappeared in the *Deposi-*

[55] Perino del Vaga's design for the *Martyrdom of the Ten Thousand* has been preserved in several copies. One, probably by Vasari, is in the Fogg Art Museum, Cambridge, Mass.

tion (Sta Maria Nuova, 1578; Pl. 94) along with an unexpected revival of Maniera complexity. Whereas still in 1577 he appeared to have abandoned certain elements of Bronzino's aestheticism, in the charming *Annunciation* (Accademia; Pl. 95) of 1579 he has warmly embraced the decorative manner. His colour is now decidedly ornamental, more pastel than Bronzino's, conveying none of the master's sense of repressed emotional excitement. The mood he evokes is of a vision made palpable—but only barely.

His *Christ in Limbo* for the Salviati chapel in S. Marco (1584–8; Pl. 96) demands comparison with Bronzino's version, of the middle of the century (Pl. 25). Allori has turned the scene, which in Bronzino had been on one level a stern *memento mori*, into a visionary tableau. Christ is draped with a beautiful brocade, the colour is dominated by an ethereal blue, the expression of emotion is gentle to the point of sentimentality. Allori continued to retreat from contact with our world. In his *Sacrifice of Isaac* (S. Niccolò; Pl. 97) he employed a composition derived from Andrea del Sarto,[56] as he often did. It is symptomatic, however, that whereas Andrea's Isaac had sought the spectator's eye at the moment of his greatest anguish, Allori's Isaac looks away. Eventually Allori ceased attempting to synthesize the real world and the spiritual realm. In the *Vision of St. Hyacinth*, made in 1596 to replace Vasari's altar-piece in the Strozzi Chapel (Sta Maria Novella; Pl. 98), he covered the entire surface of the picture with the vision. The kneeling St. Hyacinth appears in the lower left, looking as if he were part of his own vision. All the figures share the expression of disoriented transport. Even when the subject is dramatic, as in the miraculous *Raising of Lazarus* (Montepulciano, S. Agostino, 1593),[57] Allori's witnesses respond with the same entranced languor as the actors in the *Vision*. Allori, in effect acknowledging that Mannerism could not resolve the fundamental problem of the altar-piece, has made no attempt to relate or distinguish between the natural and the supernatural realms.

Santi di Tito (1536–1603) came into more intimate and more sustained contact with the emerging Counter-Maniera during his stay in Rome than any of the other artists, and it had, therefore, a more profound influence upon his style. When he returned to Florence he was not absorbed into the Vasarian workshop as Naldini had been. Given the opportunity to paint a *Nativity* (S. Giuseppe; Pl. 99) in the mid-sixties, he presented in it his anti-Maniera

[56] Andrea del Sarto's *Sacrifice of Isaac* is reproduced by Freedberg, *Andrea del Sarto*, Cambridge, Mass., 1963, pls. 190–1; and by J. Shearman, *Andrea del Sarto*, Oxford, 1965, pl. 146.

[57] The date is given by Venturi, *Storia dell'arte italiana*, who reproduces it, vol. ix, pt. vi, fig. 56.

manifesto. Its naturalism is like a premonition of Caravaggio. The simple peasant types, the pastoral mood, the rustic setting amount to an emphatic rejection of the artificial style of the Maniera. By the time he came to execute the *Resurrection* (Sta Croce, Medici Chapel, *c.* 1574; Pl. 101), he had developed an interest in the decorative effect of colour, ornamentation, and textured materials much as Macchietti did at about this time (Pl. 76). The source for his new appreciation of visual effect could have been a *rapprochement* with the Maniera. Beginning with the panels for the Studiolo, Santi's works evinced Bronzino's influence. He took Bronzino's *Resurrection* (SS. Annunziata; Pl. 100) as the starting-point for his own, though he revised it in such a way as to create an altogether different mood. With only minor adjustments to the composition, Santi expunged the deliberate ambiguity in Christ's posture and its symbolic significance. The Christ no longer hovers, but flies upward wrapped in swirling drapery. In contrast to the pervasive glow Bronzino had used to minimize the transient, Santi's bright, sunrise light catches the figures in a fleeting moment. The essence of the drama is that in another instant everything will have changed. The palpable forms persuade us of the actuality of the event. Santi, unlike Bronzino, offers no invitation to contemplation, or to doubt, no opportunity for pondering that violation of rationality the doctrine of the Resurrection perpetrates. The principle underlying Santi's approach, and the Counter-Reformation's, is that we cannot doubt what we ourselves witness. Thus Christ and the angels of the upper zone are as tangible and as realistic as the inhabitants of the natural world below.

Also in conformity with the new taste, Santi has avoided the sensual nudes of his Bronzinesque prototype. He does not forgo the opportunity to allure the viewer with sensuous effect, however. His figures have a robust, rather than a sensual beauty, but they are nevertheless pretty. Ornamental details of the type Salviati delighted in (Pl. 24) can be seen in the weapons of the soldiers. While his colour scheme is not based, as Bronzino's was, on the contrast of beautiful flesh-tones and blue, the many *changeant* tones make his palette extremely appealing. The brightness, warmth, and clarity of his colour contribute to the impression of palpability which he sought.

It is probable that much of the interest in optical effect here is derived not so much from Bronzino and the Maniera as from Venice.[58] We have observed

[58] Berti ('Santi di Tito', pp. 353 f.) discovered the date on the fresco and noted the Venetian influence. He stated, without specifying what documentary evidence he was referring to, that Santi could have made a trip to Venice in the second half of 1571 and the first half of 1572. Presumably the evidence Berti relied on was

that the lighting is not like Bronzino's; in its dramatic character, the way it creates volume and space and enhances the texture of fabrics, it is much more like Venice. The *Supper at Emmaus* (Sta Croce, Berti Chapel; Pl. 104) of 1574 has a specifically Venetian cast. Composed along a receding diagonal, as was Macchietti's *Martyrdom of St. Lawrence* (Pl. 76), finished the previous year, it is conspicuously more spatial than Santi's works or those of his contemporaries had been until this time. The rough-hewn types of the earlier *Nativity* have re-entered (Pl. 99), appropriately as the ingenuous disciples eating with Christ. But their surroundings have become far more elegant in a Veronesque way.

Santi now combined a highly accomplished aesthetic effect with both the ability, gained with maturity, to compose a powerfully coherent composition, and the will to naturalistic narrative. This combination can be seen in several other works which must date from this time; for example, the impressive *Baptism of Christ* (Corsini Gallery).[59] *Tobias and the Angel* (Paris, St-Eustache; Pl. 107) has the elegance of the High Renaissance designs to which Santi often returned for inspiration. Both compact and rich, it is liberated from Maniera artifice. Although in the *Raising of Lazarus* (Sta Maria Novella, Compagnia di Gesù Pellegrino-Tempio Chapel, 1576; Pl. 105) we note some diminishing of brilliant optical effects, perhaps due in part to the picture's condition, the priority of narrative is reasserted, and if anything reinforced. Santi depicts the miracle as so thoroughly credible that its historicity cannot be doubted, but he goes so far in this direction that he is in danger of making the event seem not merely plausible, but commonplace.

In spite of this defect, Santi's style approached in the seventies the kind of revolution which the Carracci were to begin in Bologna in the eighties. Though he is often naïve and rather blunt, we discover in his style the potential for renewal. This potential is given only rudimentary expression and is not realized, but it is a possibility which is not present in the style of the Counter-Maniera because of its continuing dependence upon the Maniera it denies. Santi soon abandoned the experiment, however, failing either to recognize its potential or to receive any encouragement. Borghini, as we have seen, does not single out Santi di Tito for the distinguished talent that he had, because Maniera aestheticism remained Borghini's preference. Santi had painted a number of fine works in the decade before Borghini published *Il Riposo*. They include the

the records of the Accademia del Disegno. From these we learn that Santi was certainly in Florence from October 1572 to 1573, when he himself kept these records.

We note also that he paid his *tasse* on 1 June 1572.

[59] Discussed and reproduced in E. K. Waterhouse, *Italian Baroque Painting*, pl. 129.

Incredulity of Thomas (Borgo S. Sepolcro, Cathedral),[60] the *Entry into Jerusalem* (now Accademia); *Peter and John Healing* (Città di Castello, Pinacoteca) and probably the *Annunciation*[61] and the *Deposition* for S. Biagio, Scrofiano (Pl. 108). In general, they show the same high standard of narrative composition and a drifting away from the visual excitement that distinguished the two altar-pieces in Sta Croce and the other works presumed to have been painted at the same time. Santi's recollection of the Venetian experience seems to have dimmed little by little and, regrettably, to have faded away. Borghini's attitude may well have reflected that of the Florentine public, for we note that many of Santi's commissions came from churches in the hinterland of Tuscany. Most significant of all, Francesco, who became Grand Duke on the death of his father in 1574, favoured with his patronage not the experimental and progressive Santi, but the reactionary Allori.

Some time shortly after the publication of the *Riposo,* Santi largely gave up the attempt to dramatize a narrative and turned his attention to the devotional format. The works in this genre are often so static in character that they seem to emulate the Quattrocento (e.g. Dicomano, *Madonna of the Rosary;*[62] Borgo San Sepolcro, Pinacoteca, *St. Nicholas of Tolentino,* 1588;[63] Volterra, S. Girolamo, *Immaculate Conception.*[64] Although he never embraced the ornamental manner of Allori and Naldini, his paintings are at times far more elegant than at others. It would seem to depend to some extent, at least, on the picture's destination. When he painted for a provincial public he would use rustic types in a provincial setting (e.g. Prato, Sto Spirito, *Descent of the Holy Spirit,* 1593), but his altar-piece for the sophisticated and urbane public who would see his work in Sta Croce is quite different.

The soldiers in the otherwise austerely simple *Crucifixion* for Sta Croce (Alamanneschi Chapel, 1588; Pl. 109), however, are animated in elegant pose and are richly garbed. In all other respects the picture approaches a devotional image. No particular moment of the Crucifixion is represented. Neither Christ, nor the thieves, nor Jesus's friends express any emotion. In an unusually complete sequence of compositional sketches we can observe Santi evolving his design for the lower half (Pls. 110–12). It is curious that he passed from the more animated to the more contemplative as he replaced the fainting Virgin of the earlier design with the perfectly undemonstrative, almost placid,

60 Reproduced in H. Voss, *Die Malerei der Spätrenaissance in Rom und Florenz,* Berlin, 1920, vol. ii, fig. 149.
61 Reproduced in Arnolds, *Santi di Tito,* pl. XXX.
62 Ibid., pl. XXXVIII.
63 Ibid., pl. XLI.
64 Ibid., pl. XLII.

Madonna and John of the final version. Santi clearly preferred to risk being dull than to risk being over-complicated.

The handsome *Annunciation* Santi executed for the chapel in Sta Maria Novella which Mondragone had sold to Bernardo Vecchietti is said to have been his last work and is therefore dated *c.* 1602 (Pl. 113). As most of his paintings of the eighties and nineties had been, it is simple, uncluttered, and direct. The brilliant light emitted by the Holy Spirit creates a dramatic effect, however, surpassing that of his immediately preceding works. It even recalls the zenith of Santi's career in the seventies when, under the influence of Venice, he had created such an effectively dramatic work as the *Resurrection* (Pl. 101). Much depends upon the upper zone; below, the figures are almost as stolid as those of the *Crucifixion*. Again, Santi has made the supernatural thoroughly plausible; his Gabriel stands firmly on the ground, distinguished as an angelic being only by his wings and halo. We are reminded once more of the Carracci, and must ask why they were able to generate a fresh beginning in such an unlikely place as Bologna, which had very little artistic tradition, and subsequently in Rome, while Santi's style remained an isolated local phenomenon.

Perhaps what was lacking in Florence was above all else the creative atmosphere and the patronage to nurture revolution. What characterized Annibale Carracci's art was often irreverence towards the past. Just as he resolved the problem of how to paint a ceiling after Michelangelo's Sistine Chapel by treating pagan gods with jovial mockery in his Farnese decoration,[65] so he was able to confront the problem of the altar-piece with a freshness that engendered new solutions. The elements of a new solution are undoubtedly present in Santi's style, but the cultural climate which at the beginning of the century had produced Raphael and Michelangelo seemed no longer to contain the same generative powers. Santi di Tito did not find in the Florence of the last quarter of the Cinquecento those conditions—the excitement, the enthusiastic reception by an appreciative public, the monumental commissions from the State and from private sources—that had created the opportunity for the masters of the High Renaissance to transform their art into a truly great expression of human cognition and human aspiration.

[65] As demonstrated in Charles Dempsey's delightful article '*Et nos cedamus amori*: Observations on the Farnese Gallery', in *Art Bull.* l (1968), 363–74.

V

Conclusion

ALTHOUGH we cannot reconstruct exactly the means by which the project of renewing Sta Maria Novella and Sta Croce first took shape, one thing is certain: it would not have been initiated had not several forces arisen more or less simultaneously and converged to make the project desirable and to catalyse its conception. Even prior to Vasari's invention of the plan to remodel the Pieve at Arezzo, the need, both liturgical and aesthetic, to modernize medieval churches had been felt. Nevertheless, had it not been for the creative imagination and organizing leadership that Vasari provided, the project might not have been conceived. And had not Cosimo regarded grand acts of patronage as essential to his role it would most certainly never have passed the planning stage. To be sure, within little more than a decade after the Florentine undertaking had been initiated, firm incentive for such renovation was provided by the publication of S. Carlo Borromeo's *Instructiones fabricae et supellectilis ecclesiae* in 1577. Those that had been responsible for the Florentine renovation must have read it with considerable satisfaction, for what had been done in Florence conformed in item after item to the archbishop's prescriptions. He prescribed that the high altar should be visible from all the parts of the church and should therefore be raised on steps (as Hautecœur has noted, this necessitated the demolition of rood-screens[1]). He specified that the choir should be behind the high altar. He recommended that the Host be reserved on the high altar in a ciborium decorated with scenes from the Passion. We recall that Vasari designed a ciborium for Sta Croce; one assumes that the reason a similar one was not made for Sta Maria Novella lay in the fact that the double-faced altar-piece for the high altar by Ghirlandaio was still relatively new, having been completed at the beginning of the Cinquecento. Finally, S. Carlo laid it down that supplementary altars in a church with three aisles should be placed along the lateral walls. S. Carlo's volume was a welcome guide to anyone concerned with bringing up to date a church interior or

[1] See his article, 'Le Concile de Trente' ,p. 356.

with building a new church, and it hastened the spate of renovations that swept away virtually all the old rood-screens in the last quarter of the sixteenth century.

The leadership Florence had asserted in its swift response to the new requirements in church design and its evolution of a new manner of altar-piece was not sustained, however. As we have seen, the painters who at times seemed ready to forge exciting new expressions of religious ideas slipped one by one into obscurity, many absenting themselves from Florence for long periods or departing, never to return. Despite the promise that Santi di Tito, Naldini, and Macchietti had held out in the 1570s, the leadership in painting passed, quite unpredictably, to Bologna.

Why to Bologna? We may well ask. Paolo Prodi,[2] posing this question, has suggested that the conjectures made more than a half-century ago by Reymond, but subsequently neglected, may contain the essence of the answer. According to Reymond, the Bolognese school rose from being decidedly second-rank to the acknowledged leadership not only of Italy but of Europe because it came to incarnate the spirit of the Counter-Reformation. The schools of painting which flourished in the first half of the sixteenth century were deeply penetrated with the secular spirit of the Renaissance, and could not offer to the post-Tridentine church the kind of Christian art it required. Bologna, on the contrary, appeared open to these new needs, above all because of the active presence there of a tradition of university study and of theological-philosophical thought. The Bolognese were the best prepared to become un-ambiguously Christian again. They concerned themselves above everything else with conceiving their Christian subjects in the most Christian way possible, and they considered the most essential law of art that of making all their forms coincide with the expression of ideas.

The opposite face of Reymond's hypothesis would be the inference that Florence's very primacy as a cradle of Renaissance art made it more difficult for her to accommodate to the Reform. We have seen how the critic Borghini is torn between espousing the new norms on the one hand, and clinging retro-spectively to the aesthetic of a previous era. It is obvious that no new solution to the problem of the altar-piece could be generated from such conflict. The Bolognese critic, Bishop Paleotti, while enunciating many of the same

[2] Prodi, before devoting most of his article to Bishop Paleotti's *Discorso*, gives an excellent survey of the literature on the relationship between Counter-Reformation and art ('Ricerche sulla teorica', pp. 123–40). The article of Reymond cited by Prodi is 'École bolonaise', *Revue des deux mondes*, lv (1910), 109–27.

principles as Borghini, does so with an unwavering conviction, a consistency, and an energy in sharp contrast with Borghini's vacillations. There is in Paleotti the sense of a new beginning; in Borghini, it is more a matter of having recovered the right path after the previous generation had temporarily lost the way. Unlike Borghini's, Paleotti's work is not, as Prodi points out, a collection of rules, prohibitions, and obligations, but rather a *colloquium* with the representatives of an art which he loves and which he desires to reform, but from inside, in spirit. Borghini's is a superficial application of formulated rules which does not regard first and foremost the spirit of the work of art but the letter of Counter-Reformation criticism. This sort of criticism does not constitute the kind of fresh rethinking that can challenge the artist to find new solutions.

There is the same indecision in the work of the Florentine painters. Artist after artist, after making an impressive fresh start, abruptly changes direction. Macchietti withdraws from his Venice-inspired manner about 1577 and drifts off into the sphere of visions. At about the same time Naldini abandons his highly individual painterly *sfumato* for a more lucid, and more heavy-handed, manner. Allori in the 1560s, after pursuing a Michelangelesque style, reverts to the model of his Maniera training. Then again in the 1570s he seems to embrace a boldly spatial treatment which promises monumentality, and then abruptly abandons it. Above all, Santi di Tito produces fine works born of a synthesis of simple and direct narrative with handsome sensuous effect in the 1570s, before retreating increasingly into timeless, static, devotional representations. And, like a dim echo, lesser artists like Andrea del Minga follow his example.

The Florentine painters cling to the past, again like Borghini, seeking precedent and model in the Florentines of the High Renaissance and then adapting that solution to the new conditions. The Carracci learned from the past, of course, but they drew upon it in a different way from the Florentines. Aware of the need to put sensuous beauty to work again in the altar-piece, they drew upon Titian's atmosphere and rich colouring and on Correggio's *sfumato*. They attacked anew and found a solution to the problem of the spectator's relationship to the sacred image, calling upon him now to participate with all his senses in the visionary image set before him. Bronzino had experimented with a more personal and intense involvement of the spectator in his Counter-Maniera altar-pieces of the fifties and sixties, but it had been a purely cerebral

involvement. The Florentines attempted to represent visionary reality from time to time, but they made it so remote and so ethereal that it lacked the power to convince, and they did not relate the visionary world to the physical one. In the Carracci's pictures a supernatural reality every bit as plausible as the natural world breaks into the terrestrial sphere. For the Florentines the past was a legacy to be treasured respectfully and extended. The Carracci had a much less reverent attitude toward the past. The Bolognese, after all, had no such tradition, and so the authority of the past was relativized. They could select and reject and combine from the past with a ruthlessness that earned for them at one time the designation 'eclectic'.

Not only the artists and the critics but also the patrons in Florence were unprepared for seeking a new beginning. It is an indication that Florence was not the atmosphere in which to regenerate reform that Allori, whose art was distinguished by its formal character and not by its rendering of subject-matter, held the most honoured position among the artists of his generation.

What we can observe developing in Vasari's and related projects that has significance for the future is the consolidation of power. In terms of social history the two decades of collaboration between Vasari and Cosimo are an important episode in the transfer of patronage from private to official sources. In this project the initiative for patronage comes from the government in the person of Duke Cosimo, and not primarily from the private citizen. Despite Vasari's efforts to make us believe that this had been true a century earlier when Lorenzo the Magnificent had held office, we now recognize that this had not been so and that Duke Cosimo was really the first Medici to undertake such large-scale patronage of the arts. And the private patron could not for long keep pace. Cosimo held, of course, vast fiscal superiority. With the coffers of the Florentine duchy at his disposal he could undertake projects of a scale no private person, and few institutions, could afford. In addition, he wielded enormous influence, not only through the prestige of his office but also through established mechanisms such as his control of the *Operai* of the churches. We have observed how the chapel patron's freedom was reduced in our project, how he was no longer permitted to choose his own design (or in Sta Croce the very subject of his altar-piece), or even to decide how much he wished to spend. These decisions were all made for him when the over-all scheme was devised. The private families to a much greater extent than ever before were asked to buy a pre-packaged unit. Only in Sto Spirito had any comparable scheme existed,

and there the private patrons had not been overshadowed, as they were in the Dominican and Franciscan churches, by an official super-patron.

The artist-manager, in the person of Vasari, was now in control of a considerably larger operation than previously. The artists of the altar-pieces were not functioning as members of Vasari's workshop in the traditional sense: they were each commissioned individually and they signed their works as their own. Yet their freedom was scarcely greater than that of an experienced workshop assistant. Vasari had, after all, turned over the preliminary designing of parts of the Salone del Cinquecento in the Palazzo Vecchio to Naldini and Stradano when they were part of his *bottega*.[3] In our project, Vasari or his appointed deputy predetermined almost every aspect, leaving the painters only the task of designing their own compositions. And, as we have seen demonstrated by the conspicuousness of Sebastiano Vini's nonconformity, even in style there was a strict consistency in the altar-pieces. Not only were such things as size and shape—ordinarily left to the painter himself to determine—dictated by the over-all plan, but even the scale of the figures in relation to the size of the panel is uniform throughout the series. What is important in this project is the effect of the whole, and it is this to which many individuals make a contribution. This is as true for the patrons as for the painters. It is a team effort, and what is produced is larger than any single artist, even working with his *bottega,* could normally have effected.

This constitutes a new way of regarding the work of art. It had been common at the time of the High Renaissance to consider a chapel as an entity and to co-ordinate all elements, architectural, sculptural, and pictorial, to create a harmonious and self-consistent effect without regard for the rest of the church. The outstanding example is Raphael's treatment of the Chigi Chapel in Sta Maria del Popolo in Rome. A similar conception is represented by the Capponi Chapel in Sta Felicita in Florence, where Pontormo not only created the altar-piece but decorated the walls and ceiling in fresco as well. In those other sixteenth-century cycles of lateral chapels we have mentioned by San Gallo, Sansovino, and Vignola, the chapels, being recessed into the lateral wall, permit a very individual treatment. As we have noted, one tends to

[3] Sketches by Naldini which can be connected with the walls of the Salone have been published by P. Barocchi (*Mostra di disegni del Vasari e della sua cerchia*, Uffizi, Gabinetto Disegni 631F, 7064F, 119 Orn.) and A. Forlani Tempesti ('Alcuni disegni di Giambattista Naldini'). Sketches for the ceiling were recognized as Stradano's by the late Walter Vitzthum, in *Master Drawings*, iii (1965). 54–6. See my 'The Operation of Vasari's Workshop', p. 208, n. 24.

consider each of these chapels separately and each was decorated individually. The decorative scheme of each three-walled unit was devised by the artist according to the specifications of the patron. Vasari, however, regarded the chapels as integral parts of the over-all scheme. The autonomy of the individual unit has been diminished for the sake of the total plan.

Vasari's design does not focus upon the single monument but aims rather at transforming the whole environment of the worshipper. The artist is no longer the creator of a single masterpiece, but is now a collaborator with others to create a series which in its sum encompasses the whole space. There is, certainly, in this conception something of Vasari's notion that the only way to improve upon the High Renaissance is quantitatively to accomplish more. Twenty-eight altar-pieces by his team of artists seemed to Vasari almost twenty-eight times better than Raphael's Chigi Chapel. But the scheme also anticipates Baroque ideas of total decoration. Vasari uses painting, sculpture, architecture—as Bernini was to do on an expanded scale—to shape the spectator's space.

The work is not only greater quantitatively, but because it unfolds serially it encompasses time as well as space. Vasari seems very much interested in effects of movement in his architecture. He had designed the Uffizi, for example, to be seen end-on, so that he concerned himself with the profile of the elements more than with their appearance if one were able to stand back and observe the façade as an entity in the traditional manner. The parts—columns, window aediculae, cornice—are designed to be seen in terms of the perspective vista which the vantage-point at the entrance of the Palazzo Vecchio offers (Pl. 8). To make an elevation or to show a part of the Uffizi façade and point out the monotonous repetition of unvaried elements is to do violence to Vasari's architectural intent. Similarly, the altar tabernacles in our churches which project boldly into the aisles are planned to be seen as a series in profile (Pl. 7). It was doubtless with this in mind that he designed the Sta Maria Novella tabernacles to be identical in exterior form, varying only in interior design (Pls. 2, 3). The continuity would strike the visitor as he entered the door of the church, the rhythmic alternation in the design would appear as he proceeded down the nave, regarding each tabernacle head-on. The effect of Vasari's architecture is difficult to judge today because the tabernacles in Sta Croce, designed by San Gallo, vary more in contour than Vasari's owing to the alternation of round and triangular pediments—and of course Vasari's own tabernacles in Sta Maria Novella have been demolished.

Vasari had less regard in his architecture for the individual element than his predecessors, just as he had less regard for the significance of an individual painting, or an individual painter, or an individual patron. He thought in terms of the whole, all too often without paying sufficient attention to the quality of the parts. The art factory which he managed was based upon the provocative principle that the work of art must not be a static entity put before the spectator's eyes for his mind's contemplation, but an experience through which the spectator moves under the artist's direction. This principle went beyond Renaissance thinking and prepared the way for the exuberant, all-encompassing monumentality of the Baroque.

CATALOGUE OF CHAPELS

INTRODUCTORY NOTE

THE chapels are arranged according to their location in Vasari's time, those of Sta Maria Novella preceding those of Sta Croce. I have followed the now standard guidebook order in progressing anticlockwise, along the right aisle towards the high altar then back along the left aisle away from the high altar, in spite of the fact that in Sta Croce this route disrupts the progression of the altars in the Passion cycle. In Vasari's time one was expected to proceed clockwise, beginning in the chapel nearest to the high altar in the right aisle and ending in the bay opposite in the left aisle.

The Catalogue of Chapels cannot, within the scope of this study, present an exhaustive history of each of the chapels. I have indicated sixteenth-century changes of decoration and patronage subsequent to Vasari's renovation. I have also attempted to sketch the history prior to Vasari's time, where I have found documentation not known to Paatz, whose definitive book this Catalogue is intended to supplement.

Each entry, with very few exceptions, contains what is known of the following material in this order:

Patron's family name as title of entry
Artist, title, and date completed of the altar-piece
Present location of the altar-piece
Inscriptions on the painting

Patron's relation to Duke Cosimo
Documentation on the bay prior to Vasari's renovation
Documentation on the Vasarian chapel, presented chronologically, as available from:
 Vasari's correspondence
 Archival records of the *Opera* (Sta Croce only)
 Payments for the chapel or altar-piece
 Endowment of the chapel
Subsequent history of the chapel
Iconography
Attribution and/or dating, in instances where these are not fully known
Preparatory studies
Raffaello Borghini's commentary in *Il Riposo* (1584).

A NOTE ON THE SOURCES

The body of documentation falls roughly into four categories:

(1) Documents on the church and chapels of Sta Maria Novella before Vasari.

On this topic there is a considerable amount of material, published and unpublished. In addition to the books preserved in the Archivio di Stato, Firenze, Conventi Soppressi 102 (Sta Maria Novella), much has been published in J. Wood Brown, *The Dominican Church of Santa Maria Novella at Florence* (1902), and by the late Padre Stefano Orlandi in his '*Necrologio*' *di S. Maria Novella* (1955). The chronicles of Biliotti and Borghigiani, preserved in the library of Sta Maria Novella, contain a great deal of valuable material culled from earlier records, now lost.

(2) Documents on the church and chapels of Sta Croce before the Vasarian renovation.

Early records of Sta Croce are scant indeed because almost all the archive was destroyed by the great flood of 1557. Very little can be found on the pre-Vasarian chapels other than the Inventory of Chapels of 1439, which I have presented in the six versions known to me as Document 1 in the Appendix.

(3) Documents on the chapels in Sta Maria Novella founded and decorated in the Vasarian project.

Within each entry I have quoted *in extenso* the earliest document providing the essential information about the Vasarian chapel (patron, dedication of the chapel, date completed). Usually this is the note of the endowment kept by the friars in their books of *Ricordanze*. Where this record is lacking in Sta Maria Novella, the *Sepoltuario* of 1617 (Sermartelli, A.S.F. MS. 812), which is based upon inventories and other records of the monastery that are no longer extant, is quoted.

Unfortunately, there are no records of the *Opera* nor are the relevant volumes of accounts, the Debitori/Creditori, preserved.

(4) Documents on the chapels in Sta Croce founded and decorated in the Vasarian project.

I have been able to use not only the two volumes of *Ricordanze* which cover the entire sixteenth century, but also the volumes of Debitori/Creditori with which they are cross-referenced. All are preserved in A.S.F. Conv. Sopp. 92 (Sta Croce). In the terminology of the cross-references:

vol. 133 (1496–1589) = Ricordanze Segnato A
vol. 134 (1580–1700) = Ricordanze Segnato B
vol. 71 (Deb./Cred. 1558–83) = Campione Giallo Segnato C
vol. 72 (Deb./Cred. 1583–1603) = Campione Azzurro Segnato D

I have not published the records from the Debitori/Creditori as they are tediously repetitious, of interest only to the specialist in a certain kind of economic problem, and readily

available and easily legible to him. I have preserved the cross-references from the *Ricordi*, so that these records can be more easily located. When the record of the endowment is lacking in these books, I have quoted from the Inventory of Chapels (vol. 362), made originally in *c.* 1590 and with later additions in a different hand.[1] Other versions of this useful document can be found in A.S.F. MS. 618; Conv. Sopp. 92, vol. 175; Conv. Sopp. 92, vol. 112, fos. 65–8. A fifth version was found and published by Mencherini in his book *S. Croce*.

In addition, it is not generally known even to scholars in Florence that whatever records of the *Opera* have survived have been preserved in the library of Sta Croce. These books, which Moisè studied and on which he based his book *S. Croce di Firenze* (1845), though they post-date the flood of 1557, contain a great deal of neglected documentation for the late sixteenth century, as well as for the seventeenth, eighteenth, and nineteenth centuries.

In some instances in both churches the original document of endowment, always more detailed than the *Ricordo* in the friars' books, has been quoted because it gives useful additional information.

I began my search in the archives expecting to find the commissions for the altar-pieces and the records of agreements between patrons and the artistic establishment. I systematically collected the names of the notaries who had drawn up the document of endowment as given in the *Ricordi* and checked their books for other documents concerning the same patron and chapel. This lengthy procedure failed to turn up a single document of the type I was seeking, so that I was eventually forced to the conclusion that no such document had been drawn up and notarized. What I have been able to learn about the costs and other arrangements involved in founding one of the chapels in this project was obtained from the wills of the several patrons who obliged their legatee to make the foundation.[2]

[1] The inventory can be dated between 1588 and 1592. The *terminus a quo* is established by the inclusion in the original hand of Santi di Tito's *Crucifixion* for the Alamanneschi Chapel; the *terminus ad quem* is revealed by the notation in a later hand of the substitution of Cigoli's *Trinity* for Macchietti's in the Risaliti Chapel.

[2] I have followed Dr. Corti's system of adding accents and modern punctuation to the documents published for the first time here. In the case of R. Borghini's *Il Riposo* I have used the more readily comprehensible text of the 1730 edition with accents added and punctuation modernized, but I have cited page references to the standard 1584 edition. Where I have quoted from Frey's edition of Vasari's correspondence I have added modern accents and substituted *v* for *u*.

STA MARIA NOVELLA

MONDRAGONE-VECCHIETTI CHAPEL

Santi di Tito, *Annunciation* (After 1591) (Pl. 113) *In situ*

Don Fabio Arazzola Aragona, Marchese di Mondragone, was an intimate friend of Principe Francesco and was said to have served as intermediary between Francesco and his mistress, Bianca Cappello. He is identified as 'Maestro di Camera' by Baldinucci.[1] He commissioned Ammanati to build him a palace (which still bears his name), and its construction was begun in February 1567/8, as Lapini tells us.[2] It was probably shortly thereafter that he acquired the chapel in Sta Maria Novella which had been allocated to Guaspare da Lama in the Quattrocento and decorated by Botticelli with the *Adoration of the Magi*, which is today in the Uffizi. This chapel had passed in the Cinquecento to the Fedini family,[3] from whom, according to Borghigiani, Mondragone bought it. He proceeded to demolish the old chapel, transferring the painting and marble to a chapel he had had built in his new palace, and began construction of the new chapel in Sta Maria Novella. However, as Borghigiani, quoting from a contemporary writer, Firenzuola, tells us:

Accadde, che cascò in disgrazia del Serenissimo Gran Duca, et essendo sbandito, vendé il suo palazzo a Zanobi Carnesecchi, e la Cappella di chiesa cominciata e non finita la vendé a Messer Bernardo Vecchietti, il quale per ancora non ci ha principiato cos'alcuna=fin qui il Firenz.ª questo scriveva del 1572.[4]

This date does not appear to be accurate, because Lapini has the following entry under the date 12 August 1575: '. . . il gran duca Francesco fe' intendere a Mandragone spagnuolo, già suo favoritissimo, che per tutto settembre prossimo futuro avessi sgombero del suo stato, avendo prima pagato tutti quelli avevono avere da lui.'[5]

The notes to Lapini give one explanation for Mondragone's fall from favour. In 1572 the king of Spain had asked the regent Francesco for a loan of 800,000 scudi, as security for which he offered Port'Ercole. The prince boasted about what he considered a sure acquisition to his friend Mondragone, who then wrote to the Spanish king concerning it. When the king withdrew his request for the loan, Francesco learned of the reason and expelled Mondragone from the state of Florence.[6]

Santi di Tito's painting is not mentioned by either Borghini (1584) or Bocchi (1591). According to Cinelli (1677) it was Santi's last work, and it is therefore generally dated 1602/3. Cinelli also stated that the angel of the Annunciation is a portrait of Virgilio Carnesecchi,[7] but on what basis, is not clear.

[1] Baldinucci, *Notizie de' professori*, vol. vii (1770), p. 9.

[2] Lapini, *Diario*, p. 157.

[3] Borghigiani says that it was sold to the Fedini ('Cronaca', iii. 393); Biliotti and the other sources say they do not know how the Fedini family acquired it (Biliotti, 'Cronica', 17ᵛ).

[4] Borghigiani, 'Cronaca', iii. 393. Biliotti says Mondragone removed the Botticelli altar in 1574 ('Cronica', 17ᵛ). Substantially the same story is related by Baldovinetti (n.p.).

[5] Lapini, *Diario*, p. 188.

[6] Ibid., p. 157, n. 2. [7] Cinelli, p. 240.

There is no apparent explanation for the lapse of almost thirty years before the chapel was provided with an altar. Though Bernardo Vecchietti seems to have acquired the chapel in the mid-1570s he did not resume work on it for a number of years.

Santi's last painting is also the last altar-piece of these cycles to be completed. Unlike a number of his other late works which were completed by his son Tiberio, this painting appears to have been executed entirely by Santi himself.

GIUOCHI-COMPAGNIA DI S. LORENZO CHAPEL

Girolamo Macchietti, *Martyrdom of St. Lawrence* (Pl. 76) *In situ*

Inscribed in lower right beside soldier's foot: 'HIER. MACHIETTI FLOR. FACIEBAT MDLXXIII'

Cionetto de' Giuochi in his will, dated 1372, instructed his heirs and executors, Cesare and Jacopo di Gherardo, and Giovanni and Taddeo di Franceschino, that a family chapel should be founded in Sta Maria Novella. On 24 June 1396, Jacopo di Gherardo Giuochi instructed in his will, drawn up in Paris, that the wish of Cionetto must be carried out. On 25 August 1399 the Chapter was convened by the Prior, Fra' Ubertino degli Albizzi, for the purpose of appropriating space in the church for the Giuochi Chapel, to be dedicated to the Virgin and St. Lawrence. They granted for this purpose an area of eight and a half *braccia* by seven and a half *braccia* at the bottom of the church in the right aisle.[1]

Vasari states that Giottino had painted in fresco a St. Cosmas and St. Damian in the Giuochi Chapel in Sta Maria Novella: '. . . entrando in chiesa per la porta a man destra, nella facciata dinanzi'.[2] Possibly this fresco belonged to a chapel inside the façade wall beside the site where the da Lama chapel was later placed. Vasari describes the site so specifically that he must have seen it.

We read in the plan for renovating the church (Appendix, Doc. 2) that the Giuochi family had been reported to be extinct, and their chapel was therefore to be destroyed and the site reallocated. The *Opera*'s research had not, apparently, been exhaustive, because the books of the convent record the endowment of the new chapel in 1576 by one Girolamo Giuochi:

Ricordo come insino addì primo di febraio 1575. Il padre priore Maestro Thomaso Boninsegni et il padre sindaco frat'Antonio da Lamole presono da Raffaello Carraresi F170 di moneta per un legato fatto a nostro convento da Girolamo Giuochi, per suo testamento rogato ser Cosimo Cappelli sotto il 9 di Agosto 1574 con obligo di dir ogni giorno in perpetuo una messa al suo altar di S. Lorenzo . . .[3]

The *Ricordo* goes on to say that the convent had decided to accept this obligation in spite of the fact that 'pareva poco emolumento per tal carico'. Comparison with the endow-

[1] Orlandi, '*Necrologio*', ii. 174 f.; in his biography of the Prior Albizzi.

[2] Vasari–Milanesi, i. 625; repeated in Brown, *The*

Dominican Church, p. 116.

[3] A.S.F. Conv. Sopp. 102, vol. 90, fo. 46ᵛ.

ments made by the owners of the other chapels indicates that the *frati* would normally expect 300 florins. The will of Girolamo Giuochi reveals that he had divided the endowment between the convent and the Compagnia di S. Lorenzo. This testament also explains how the chapel passed into the possession of the Company of St. Lawrence, to which both Brown and Paatz mistakenly ascribe the construction of the chapel.[4]

Girolamo di Carlo Giuochi, pizzicagnolo

. . . Item iure legati ut supra reliquit societati Sancti Laurentii in Palco penes conventum Sancte Marie Novelle, florenos 150 similes, cum hoc onere scilicet quod quolibet anno in die sequenti post festivitatem sancti Laurentii celebrari faciant . . . in capellania seu super altare dicti testatoris quod habet in dicta ecclesia Sancte Marie Novelle, unum officium mortuorum . . . et quod gerant curam dicte cappellanie seu altaris quod habet dictus testator in dicta ecclesia . . . et ordinavit in perpetuitate et eorum cure et prudentie dictam cappellaniam seu altaris commisit et recommendavit, in cuius sepolcro sepelli possint subcessores heredes dicti testatoris et alii dicti testatoris coniuncti, secundum libitum hominum dicte societatis . . .[1]

Macchietti must have been at work on this altar-piece in January 1572/3, when Vasari wrote to Don Vincenzo Borghini asking him to find out whether Naldini or Poppi or Macchietti could come to Rome to assist him with the frescoes for the Sala Regia. Borghini replied that both Naldini and Macchietti were busy, and that Macchietti had already been paid for two paintings which he could not abandon.[6] The altar-piece was finished and installed by 23 May 1573, when Borghini wrote to Vasari that he had seen it and the new one by Naldini (see next entry).[7]

Raffaello Borghini praised this painting as not only Macchietti's best, but also as one of the best pictures which had recently been painted.[8] In relation to his criteria of appropriateness, the altar-piece measures up very well. Each of the figures expresses the right emotion, especially St. Lawrence, who accepts his martyrdom devoutly.[9]

There is a study for the torso of St. Lawrence in the Uffizi (Pl. 78).[10] The medium of red chalk, Macchietti's favourite, is reminiscent of the late Pontormo, who also made careful studies of his figures, but with a far quicker, surer stroke than Macchietti's cautious, studied one. The technique of shading with fine, soft strokes within a firmly determined outline is very similar to Bronzino's. Bronzinesque, too, is the effect of a hard surface. The surprising characteristic of this drawing is that it was made in order to study the effect of light; the modelling in a Bronzino or a Pontormo drawing had an expressive function, rather than being the academic study of naturalistic details. This un-Florentine interest in

[4] Brown, *The Dominican Church*, p. 116; Paatz, *Die Kirchen von Florenz*, iii. 702.

[5] A.S.F. Notarile Moderno, 1379 (Cosimo Cappelli, 1572–7), fos. 123–5.

[6] 'Parlai a Girolamo del Crocifissaio, che è ne' medesimi termini, che è pagato già dell'opera di due tavole — et è stato malato un pezzo, in modo che non può, e mi ha mostro che molto volentieri sarebbe venuto et servitovi, se non fussi obligato in questo tempo, et mi ha ragionato degli huomini che ci son qui che potessino venir a aiutarvi, ma non come maestri

(ché di questo non havete bisogno) ma come per opere.' Frey, ii. 744.

[7] 'Giovedì si scoprì in Santa Maria Novella 2 tavole: Girolamo del Crocifissaio: vago colorito più che di maestro. Quella di Batista più fondata et dà piacere agli intendenti et quellaltra a manco; et così credo, se ben non l'ho veduta, et anche così intendo.' Ibid., p. 789.

[8] Borghini, *Il Riposo*, 1584, p. 605.

[9] Ibid., p. 100.

[10] 6925F. 120 × 130 cm, red chalk on white paper.

light, which has been carefully studied throughout the painting, is further evidence of Macchietti's familiarity with the Venetian school. However, the way he creates his effects of light with pastel *changeant* colour is not Venetian but altogether Florentine, and Mannerist.

Borghini's approval of Macchietti's painting extends to its artistic features. He praises the composition, the poses of the figures, the colours, the perspective, and particularly the figure of the king. His criticism is limited to the rather Maniera soldier in the right foreground, and to a detail of colour:

> . . . ma quel soldato, che è innanzi, sembra, anzi che no, troppo lungo : e secondo le regole, che voi ne deste, che i colori più chiari voglion esser dati alle figure, che sono più innanzi, il panno giallo del Re viene a esser colorito troppo fiero, avendo avanti a sé un soldato, che ha le calze gialle, di colore più oscuro.[11]

The only other criticism of Macchietti's painting is made at least partly in jest. One of Borghini's spokesmen expresses surprise that Girolamo should have placed a portrait of himself among the infidels, since if they should discover that he was a Christian '. . . mal per lui!'[12] The figure to which he refers, on the far right, closely resembles Macchietti's self-portrait drawing in the Uffizi,[13] which is done in the Zuccaresque medium of red and black chalk (Pl. 77).

MAZZINGHI CHAPEL
Battista Naldini, *Nativity of Christ* (1573) (Pl. 56) *In situ*

The Mazzinghi family, though no longer prominent in sixteenth-century Florentine society, appear to have been patrons in Sta Maria Novella at least as early as the Quattrocento. The chapel which was established during Vasari's time by the Baccelli family (q.v.) contained a Quattrocento tomb of the Mazzinghi family which was preserved by the Baccelli. This fact suggests that the two families were related, and that during Vasari's reorganization both branches decided to found chapels. Sermartelli gives the earliest account of this chapel and its prior history:

> L'altare de' Mazzinghi fu eretto da Ugolino di Jacopo Mazzinghi l'anno 1575 sotto il titolo DD. Septem Angelorum Principibus, et D. Jacopo Interciso insieme colla finestra, che gli è sopra, nel qual luogo innanzi alla racommodazione della chiesa era un altare antico eretto a S. Maurizio Martire da Messer Guidone da Campi gran Contestabile del Comune di Firenze, nel quale fu dipinto detto santo insieme con altri Martiri l'anno 1305 dal valente artefice Bruno Pittore fiorentino d'ordine del sopradetto capitano; il quale è sotterrato appié del nuovo altare lungo il muro dalla

[11] Borghini, *Il Riposo*, 1584, p. 197.
[12] Ibid., p. 100.
[13] Uffizi 1088F, published by Marcucci ('Girolamo Macchietti disegnatore'), who mistakenly gives the number as 1088S. She dates it 'before 1577'. 253 × 121 cm. Marcucci also published Uffizi 980S as a study by Macchietti for this altar-piece. This must be rejected

both as the work of Macchietti and as a study for this painting.

Louvre 10250 has been noted by C. Monbeig-Goguel (Louvre, Cabinet de dessins, *Vasari et son temps*, Paris, 1972, n. 42) as derived from Macchietti's composition, but she correctly remarks that the sketch does not resemble Macchietti in style.

banda dell'altar maggiore in un deposito di macigno come al suo tempo sentirete, seguitando per ora l'ordine delli altari . . .[1]

It seems likely that the Mazzinghi had possessed this chapel before Vasari's renovations, but the exact date at which they acquired it is not known.

Paatz reports that the painting was illegibly dated 1573. It must have been this altar-piece that Vincenzo Borghini referred to in his response to Vasari's request that someone come to Rome to help him with the Sala Regia frescoes:

Quanto a Batista: egli harebbe voglia di venire, ma questa tavola, che coloro lo martoriano et non lo lasciano vivere, e egli ha promesso questo corpus domini darla fatta et vi ha messo mano e finita quasi d'abbozzare et hora comincierà a finire, lo 'mpedirà secondo me tanto che per questo tempo che mi scrivete non veggo modo che e' possa servirvi. Credo ben doppo questa tavola et altri pochi lavori, che ha fra mano et si spediranno a un tratto, habbia in disegno di servirvi tutto et in ogni cosa et luogo.[2]

Thus we know that the Mazzinghi picture followed the Minerbetti commission (see next entry) at an interval of almost exactly a year; it was sketched out in January, and we know that it was finished according to plan by Corpus Christi, for Borghini reported that he had seen the two new altar-pieces in Sta Maria Novella, this one and Macchietti's, on 23 May.[3]

Naldini has attempted to combine two subjects, doubtless at the request of the patron, who dedicated his altar to St. James and the Seven Archangels, not to the Nativity. The newborn Child is adored by the Madonna, Joseph, and, in the background, shepherds. Kneeling in the foreground are represented a bishop, and two saints in the garb of shepherds, in a format reminiscent of the standard devotional altar-piece depicting the Madonna and Child adored by saints. This attempt to combine a dramatization of the Nativity with the *Sacra Conversazione* was criticized by Raffaello Borghini, as we might expect:

Depigner non vi si doveano i due apostoli ed il vescovo, che vi si veggono, perché quando il Salvador del mondo nacque, non vi erano apostoli né vescovi, né vi potevan essere, non essendo ancora tai gradi in cognizione delle genti, non che ordinati gli abiti.[4]

The altar-piece is at present very dirty. The composition has been obscured almost entirely in the middle ground, but the artist made a compositional sketch (Pl. 57) which he followed closely.[5] Here we can see the architecture of the hut, and the ox and ass,[6] which are lost from sight in the painting. A red-chalk study from life for the saint in the lower left (Pl. 58)[7] shows that figure in the position he had assumed in the sketch. Apparently in order to give more space to the bishop behind, the saint was shifted to a profile pose in the painting.

[1] Sermartelli, p. 54. Baldovinetti (n.p.) and Orlandi–Borghigiani, ii. 398 give concurring descriptions. Vasari mentions these frescoes and says that Buffalmacco assisted his brother (Vasari–Milanesi, i. 515; cited in Brown, *The Dominican Church*, p. 117). According to Brown (ibid.), and following him Paatz (*Die Kirchen von Florenz*, iii. 703), the dedication of the chapel after 1565 was to St. Michael and St. James.

[2] Dated 17 January 1572/3. Frey, ii. 744.

[3] 23 May 1573. Ibid., p. 789.

[4] Borghini, *Il Riposo*, 1584, p. 101.

[5] Uffizi 705F. Published by Smyth in 'Mannerism and Maniera', fig. 26. Pen, 410 × 275 mm.

[6] Borghini complained that the position given these animals was not sufficiently prominent (*Il Riposo*, 1584, p. 101).

[7] Uffizi 7474F. Red and black chalk, 340 × 190 mm.

Judging in terms of artistic merit, Raffaello Borghini found this the least successful of the three Naldinis in Sta Maria Novella:

. . . ma questa disposizione di Natività pare a molti nuova, ed a gran pena per tale, da chi vi pon ben mente, si conosce: il bambino mi sembra alquanto grande, siccome ancora le ginocchia de' santi, che sono innanzi, ed eziandio quelle degli agnoli sono così grosse e ne' panni ravvolte, che pajono gonfiate.[8]

DA SOMMAIA CHAPEL

Battista Naldini, *Purification of the Virgin* (Pl. 62) *In situ*

[Signature and date, 1577, now illegible]

Prior to Vasari's renovation, the main entrance to the church had been the door located at the north end of this bay. As we read in Doc. 2 of our Appendix this door was walled up; the resulting chapel was allocated to Senator Giovanni da Sommaia, whose father, Giro-lamo di Francesco, had also been a senator.[1] As was true of most of the patrons of these chapels, he was favoured by Duke Cosimo, and members of his family frequently appear among those selected by the Duke for special functions, e.g. Giovanni accompanied Cosimo to Rome for his coronation as Grand Duke.[2]

Sermartelli is the earliest source providing information on the founding of this chapel: 'Altare della Famiglia de' Sommai eretto dal Senatore Giovanni di Girolamo l'anno 1577 sotto il titolo della Purificazione della Madonna, insieme colla finestra, nel vetro della quale è l'Arme di questa Famiglia . . .'[3] He goes on to say that there was a tomb in front of the chapel dated 1585, bearing in addition the Guicciardini arms of Giovanni's wife.

For his iconography, Naldini has turned this time to Vasari, who had claimed in the *Vite* that his Naples *Purification* presented this event in a new way (preparatory sketch, Pl. 65).[4] Naldini, like Vasari, chose as the central action the moment when Mary hands the Child to the old man Simeon. The aged prophetess, Anna, who in Vasari's version kneeled in the lower left, establishes the picture plane, introducing us to the Child with her point-ing finger. She has been moved back and turned away to break her visual contact with the spectator. Naldini has taken over from Vasari almost without change the physical setting of the Temple.

A pair of studies for the seated female figure in the lower right show us how Naldini prepared a picture. The first is a sketch, made from a model in the studio, in which he worked out the pose and roughed in the drapery (Pl. 64).[5] Then he turned his sheet over and made a careful study of the model's head (Pl. 63).[6] This study was incorporated,

[8] Borghini, *Il Riposo*, 1584, pp. 197 f.

[1] Baldovinetti (n.p.). [2] See Chapter II, p. 28.
[3] Sermartelli, p. 53. [4] Vasari–Milanesi, vii. 675.

[5] Uffizi 7447F verso. Red, black, and white chalks. Identified on the mount by Paola Barocchi as a study for this altar-piece. 275 × 200 mm.
[6] Uffizi 7447F recto.

virtually unchanged, in the composition, except for the addition of an elaborate *coiffure* to change the figure's sex. Two more studies for the figure of Anna are preserved.[7] Battista, who evidently loved to draw, probably made studies such as these for every major figure in a painting. This method of work accounts for the isolation of his figures and the lack of communication or interaction among them, for when the various studies were pieced together in the final composition very few, if any, accommodations were made. Though originally conceived as a whole, the composition was broken down into single-figure units in the course of preparation and never regained its unity. Such a method was well suited to an introverted personality like Naldini because it provided him with the means for avoiding the expression of emotion.

A small *modello* provided him with the opportunity to assess the ensemble effect of the individual studies. In this case, happily, the *modello* has been preserved (Pl. 66), and we find that it resembles the altar-piece very closely in all but the painting technique.[8] Naldini has used the looser, freer, more painterly style visible in his earlier works (e.g. Florence, Badia, *Christ on the Way to Calvary*).

Borghini's comments are very brief. He remarks that the painting seems 'assai bene osservata'.[9] In discussing its artistic features he admits to a preference for this painting over the Mazzinghi *Nativity*, especially in its composition; however, he likes it less than the Minerbetti *Deposition*.[10]

MINERBETTI CHAPEL
Battista Naldini, *Deposition* (Pl. 54) *In situ*
Inscribed on vase, lower right: '1572 BATISTA NALDINI'

The original Minerbetti Chapel had belonged to the family since the beginning of the Trecento, at least. The will of Maso di Ruggerino Minerbetti, dated 6 November 1308, stated that he wished to be buried in Sta Maria Novella at the foot of the altar of St. Thomas of Canterbury,[1] which had been built by his family.[2] This chapel was located in the lower tier of chapels on the *ponte* in the right aisle immediately beyond the steps (see Fig. 1). Orlandi–Borghigiani describes its position thus: 'Saliti appunti gli scalini cominciava la impostatura ed appoggio della muraglia maestra delle volte del Ponte. Lì subito accosto v'era sotto al detto Ponte la Cappella di S. Tommaso di Cantuaria della Famiglia de' Minerbetti.'[3] When it was decided that the rood-screen should be removed, the Minerbetti were apparently given the same option as were the Asini, who owned a chapel on the rood-screen in Sta Croce (see Asini Chapel, below), of losing their family chapel altogether,

[7] Uffizi 7502F, red chalk, 240 × 165 mm. Identified on the mount by L.M. (Luisa Marcucci) as a study for this altar-piece. Uffizi 7501F, red and black chalk, 330 × 231 mm. Identified by P. Barocchi.

[8] Panel, 413 × 286 mm, Private collection. Michael Hirst kindly brought it to my attention.

[9] Borghini, *Il Riposo*, 1584, p. 102.

[10] Ibid., p. 198. He also complains that the foreground figures have oversized knees.

[1] Paatz, *Die Kirchen von Florenz*, iii. 703, incorrectly stated that the chapel was dedicated to St. Thomas Aquinas. [2] Orlandi, 'Necrologio', i. 415.
[3] Orlandi–Borghigiani, ii. 398.

or of building a new one according to Vasari's design. Because of their past patronage they (like the Asini) were apparently offered first refusal on the nave chapel nearest their former chapel, which was the fourth bay in the right aisle—notwithstanding the fact that the tomb of Giovanni da Salerno was at that time located there (see Appendix, Doc. 2). The patrons of the tomb were simply advised that it would have to be moved (see Compagnie di Gesù Pellegrino-Tempio Chapel, below). The Minerbetti family tombs were transferred from the rood-screen chapel to the new one.[4]

There is no mention in the extant records of the convent of the founding or endowment of this chapel. It is clear, however, from Vasari's correspondence that, as one would expect, his own bishop and close friend Benedetto Minerbetti, bishop of Arezzo, was primarily responsible for the chapel. About Christmas 1570 Vasari was in Rome working in the Sala Regia and anxious to have some assistance so that the work might go faster. Naldini had been expected to help, but he was working not only on his panels for the Studiolo but also on this altar-piece for the Minerbetti Chapel. Vincenzo Borghini wrote on 23 December 1570: 'Batista sollecita et lavora dì et notte et dì di lavoro et dì di festa, et ha più voglia di venire che voi che e' venga; ma la tavola è grande e vacci su molte centinaia di pennellate et vi doverà scriver da sé.'[5] A few weeks later Borghini reported again, somewhat too optimistically as it turned out, on Naldini's progress: 'Batista sollecita e penso che di questa altra settimana harà finito ogni cosa . . .'[6] About a week later, however, after Benedetto Minerbetti's timely arrival in Florence, Borghini began to realize the facts of the matter, and wrote to Vasari that he was beginning to doubt that Battista would be able to get away, in spite of his progress on the Studiolo panel:

Credo vi sia ancora o vi andrà domane quella di Batista, et come il Principe vi sarà stato, vi saprò dir qual cosa. Il qual Batista vi dovette scriver hieri che que' Minerbetti et il vostro vescovo, che ha mandat' uno a posta qui e datoli la 2ª paga de' danari, lo serron forte e vogliono che e' metta mano a finir hora, et trovandosi obligato loro per scritta et osservando essi dalla parte loro, veggo mal modo che e' possa tirarsi indietro di non osservar anch'egli quel che ha promesso; onde comincio a dubitar forte del poter lui venire, che a me dispiace et allui molto più, ma i patti rompon le leggi, etc.[7]

A few days later, on 25 January 1570/1, Minerbetti addressed Vasari on the same subject, and scolded him for trying to steal away Naldini, who, he said, had already made commitments which first had to be fulfilled:

Molto Magnifico messer Giorgio dilettissimo
Io son venuto in Firenze con licenza di N.S. a terminar questa mia lite della iurisditione, se così piacerà a Dio et loro d. A[ltezze]; né prima son giunto, che io ho trovato sollevato Gianbatista pittore, per esserli stata fatta molta instantia dal signor spedalingo [Borghini] a nome vostro, che egli se ne venga costà. Messer Giorgio mio, questi non sono i patti. Egli ha imposta la tavola, ha quasi la metà del pagamento; e se ce lo levate di qua, la tavola si finirà tardi, et quei padri di Santa Maria Novella con molta ragione si dorranno di noi. Vi prego, che non procuriate questo

[4] Paatz, *Die Kirchen von Florenz*, iii. 703. [5] Frey, ii. 557.
[6] Dated 12 January 1570/1; ibid., p. 561. [7] Dated 21 January 1570/1; ibid., p. 564.

disordine et vogliate bene a questo vescovo, che è tutto vostro et prega sempre per la vostra salute et consolatione.[8]

Vasari was evidently extremely annoyed at Naldini's show of independence, and a lengthy correspondence ensued in which Borghini attempted to justify Naldini without further offending Vasari. Minerbetti made his contribution towards mollifying Vasari with the following letter written on 24 February 1570/1:

Io ragionerò più volentieri a bocca con voi, se però io viverò tanto, del caso di Giovan Batista pittore, sopra di che tanto risentimento fate, che per lettera, et per hora mi contenterò solo di ricordarvi quel che voi stesso affermate, che voi me lo deste. Ad instantia vostra l'accettai, alla vostra informatione et fede di sufficenza si allogò la tavola; et se questa non ci si fosse interposta, non se li dava questo carico. Et oltre a questo vi ridurrò a memoria, che poichè avevi disegnato di condurlo costà, me lo concedeste: perché egli mi sbrigasse di questa ansietà di veder a' mei dì, che possono essere pochi, finita quella cappella. Se hora adunque io mi interpongo con ragione o no, che egli non venga et attenda a lavorare, ne faccio giudice quel mio tanto caro messer Giorgio Vasari. Se lo conoscete o vedeste mai, domandatevelo et rispondetemi quel che vi risponde. El resto discorrerò a boccha, quando che sia.[9]

In the course of defending Naldini to Vasari, Borghini made a reference to the history of the commission. He said that 'un dì quel Minerbetti, che ha certe albagie, ha cerco per ogni via di dar questa tavola a maestro Giovanni',[10] referring, of course, to Stradano. It had been, no doubt, thanks to the persuasive power of Vasari, who felt at this time that Stradano was not coming up to the standard of his bottega,[11] that the Minerbetti awarded the commission to Giorgio's (then) favourite pupil, Naldini.

In evaluating the iconography, Borghini puts two contradictory appraisals into the mouths of his commentators. Vecchietti opens by remarking that he likes the painting, but he would have liked it better if Christ had showed more evidence of his suffering. Here Christ looks as if he has just emerged from the bath, instead of having been brought down from the cross. Michelozzi reminds his friend that the Marys washed Christ's body and rubbed it with precious ointment, and that it was this that Naldini had desired to depict.[12] In commenting upon the formal qualities, Borghini calls this Naldini's best work. He praises the artistry of the composition, the postures of the figures, the beautiful body of Christ, and the colour. His only criticism is of the swollen knees of the lady in the left corner.[13]

Two preparatory drawings are in the Uffizi, one a study from life for the central group, the other a life study for the Christ.[14]

[8] Paatz, *Die Kirchen von Florenz*, iii. 564–5.

[9] Ibid., p. 574.

[10] In a letter dated 15 February 1570/1; ibid., p. 570.

[11] A few months later (4 May 1571) Vasari wrote to Francesco de' Medici praising the work of Jacopo (Zucchi), Battista (Naldini), Francesco da Poppi, and Sandro del Barbiere, but of 'maestro Giovanni Stradano, fiammingo' he said he did not want to speak because Stradano had been away from the workshop for some time, and this was becoming evident in his style. Ibid., p. 583.

[12] Borghini, *Il Riposo*, 1584, p. 103: '. . . dico che mi piace; ma molto più mi piacerebbe quando il corpo del Cristo avesse più del flagellato e del morto, che egli non ha; ché così par piuttosto un corpo uscito del bagno, che sconfitto della croce. Ricordatevi (disse il Michelozzo) che le Marie il lavarono e l'unsero con preziosi unguenti; ed il Naldino l'ha fatto così dilicato, per dimostrarloci quando fu lavato ed unto.'

[13] Ibid., p. 198.

[14] Uffizi 879E and 7531F. Published by P. Barocchi, 'Itinerario', pl. 100c, d.

COMPAGNIA DI GESÙ PELLEGRINO-TEMPIO CHAPEL

Santi di Tito, *Raising of Lazarus* (Pl. 105) First bay, left aisle

Inscribed on edge of tomb beside Lazarus: 'SANTI DI TITO TITI F. 1576'

The Compagnia di Gesù Pellegrino and the Compagnia di Sta Maria della Croce al Tempio were two lay associations, which according to Document 5 of our Appendix were jointly the patrons of the tomb of Beata Villana, sculpted in the Quattrocento by Bernardo Rossellino and his workshop. The Compagnia di Gesù Pellegrino had been a large and prosperous confraternity in the Trecento and Quattrocento and had owned a succession of chapels in the cloister area of Sta Maria Novella for its meetings.[1] The last was the chapel along the exterior wall of the left transept, opposite the present Gaddi Chapel but opening from the cloister side.[2] Since Vasari's plan of renovation (see Appendix, Doc. 2) called for this area to be converted to a passageway for the friars, connecting cloister and choir, the chapel of the Compagnia di Gesù Pellegrino was marked for destruction.

This accounts in part for the desire of that Compagnia to found a chapel in the church, but in addition our document makes it clear that the Minerbetti were being assigned the chapel in which the tomb of Beata Villana had been located, alongside the tomb of Giovanni da Salerno (bay 4, right aisle).[3] Thus the Compagnie were being forced to find a new location for the tomb. We read in Document 2 that in March 1569 the Compagnia di Gesù Pellegrino requested the Duke that it be allocated the chapel opposite that of St. Catherine, or one elsewhere, either with the Compagnia del Tempio or alone. Later in that same year the tomb was moved to the sacristy and then in 1570 was installed in the chapel of the Compagnie.[4] The prior history of this bay remained obscure until the publication by Orlandi of the excerpts from Borghigiani's *Cronica annalistica*, in which a chapel belonging to the Gaddi is described following mention of the Minerbetti Chapel on the *ponte*: 'Dove adesso è la porta del fianco, o poco più là sotto al medesimo Ponte, . . . vi stava un Altare posticcio, e la famiglia de' Gaddi vi faceva cantar delle Messe . . .'[5] Thus it was not the case, as Brown believed, that this fifth bay had been allocated to the Compagnie in the fifteenth century, nor that Fra Angelico's *Entombment* (Museo di S. Marco, 58) was painted for this altar.[6]

The subject of the Raising of Lazarus was doubtless selected because it was the function of the Compagnia del Tempio to administer the last rites to the condemned.[7] Since the classic subject representing man's victory over death, Christ's Resurrection, had already

[1] Fineschi, 'Monumenti', p. iv, records a large marble tondo inscribed 'Collegii Salvatoris Peregrini' and dated 1485 in the last bay of the left aisle, '. . . situata dal pilastro che fa cantonata per andare alla sacrestia'.

[2] Paatz, *Die Kirchen von Florenz*, iii. 692.

[3] Orlandi–Borghigiani, among others, records the tombs in this location (ii. 398).

[4] Sermartelli, p. 49. The transfer was made on 20 November 1570.

[5] Op. cit. Brown, *The Dominican Church*, p. 122, had mistakenly placed this chapel on the choir wall.

[6] Pope-Hennessey (*Fra Angelico*, London, 1952, p. 176) seems to be correct in his view that this painting was commissioned for the church of Sta Maria della Croce al Tempio rather than for Sta Maria Novella.

[7] Brown, *The Dominican Church*, p. 122.

been depicted across the aisle in the Pasquali Chapel, the Raising of Lazarus was an appropriate alternative.

The basis for Santi's composition seems to be a design by the Zuccari which can be seen in a fresco by Federigo in the Grimani Chapel, S. Francesco della Vigna, Venice. A preparatory drawing for that fresco is in Florence.[8] From the Zuccari are borrowed the motifs of Christ, flanked by the kneeling Mary and Martha; the figures who climb up the columns for a better view; and the distinctive manner of treating the traditional detail of the turbaned man who covers his nose against the stench.

Santi's approach to the problem of the altar-piece here is very similar to the point of view which Raffaello Borghini was to enunciate a few years later, so it is not surprising to find that Borghini praises his painting *qua* altar-piece:

. . . la qual pittura mi par molto bella, molto osservata, e molto onesta. Voi dite vero (rispose il Vecchietto) ed a me piace molto, perché veggo in essa ben posta la storia sagra: veggo riverenza e divozione, e le cose dell'artefice proprio molto bene accomodate.[9]

Also, in terms of its artistic qualities, Borghini approves Santi's renunciation of the Maniera style, except that he finds fault with the plainness of the colour:

Il Lazzero risuscitato è di Santi Titi (seguitò il Sirigatto) e giudico, che questa sia una bella tavola; perciocché le figure hanno molto del vivo, e le teste sono bellissime, gli atti molto convenevoli, ed è copiosa d'ordinanza, veggendovisi figure di più sorte, prospettive e paesi. Sì, ma voi tacete di dire (soggiunse il Michelozzo) che il colorito non è troppo commendabile.[10]

RICASOLI CHAPEL

Sebastiano Vini, *Conversion of Saul* (1575) (Pl. 49) Sacristy

Before the Vasarian renovation this bay had been occupied by the tomb of Bartolomeo Rimbertini, bishop of Cortona, who died in 1466,[1] and by the door opening into the Cappella della Pura. Opposite, on the wall of the choir, had been an altar originally dedicated to the Virgin and St. Lawrence by Fra Domenico Pantaleoni (*c.* 1375). The dedication was later changed to the Annunciation, and this chapel became the burial-place of the friars.[2]

The tomb and the chapel were removed in the Vasarian renovation (see Appendix Doc. 2) and a new chapel was constructed by Giovanni Battista Ricasoli, bishop of Pistoia. We have no record of the endowment of this chapel, but Borghigiani, apparently using sources which are now lost, records that the construction of the chapel was entirely finished in 1572, and that in September 1575, after Bishop Ricasoli had already died, the painting of the *Conversion of Saul* was put in place.[3] The diarist Settimanni records Ricasoli's

[8] The fresco has been reproduced by W. R. Rearick, 'Battista Franco and the Grimani Chapel', *Saggi e memorie di storia dell'arte*, ii (1958–9), fig. 13. J. A. Gere catalogued the drawing (797F) in Florence, Uffizi, *Mostra di disegni degli Zuccari*, 1966, no. 44 (fig. 32).

[9] Borghini, *Il Riposo*, 1584, p. 106.

[10] Ibid., p. 198.

[1] Orlandi–Borghigiani, ii. 399; Orlandi, '*Necrologio*', i. 170. Brown, *The Dominican Church*, p. 123, incorrectly placed the Pantaleoni Chapel on the exterior wall of the aisle.

[2] Orlandi, '*Necrologio*', i. 588 ff.; Orlandi–Borghigiani, ii. 404.

[3] Borghigiani, 'Cronaca', iii. 395: 'Seguita la Cappella

death on 23 February 1572/3 and the fact that he was to be buried in the Ricasoli Chapel in Sta Maria Novella; he also mentions that Bishop Ricasoli had been a great favourite and intimate of the Medici house.[4]

This first Ricasoli patron and altar-piece have been all but forgotten by modern scholars, who have overlooked Borghini's description of this chapel as it was in 1584. Five years later the endowment of the Ricasoli Chapel is recorded, but with a dedication to St. Raymond.[5] Subsequently, Vini's altar painting was replaced by the painting we see in this site today, Ligozzi's *St. Raymond Raising the Dead Child* (Pl. 106). Commissioned, according to Borghigiani, by Raffaello delle Colombe, Prior of the convent,[6] Vini's painting was removed to the refectory where it was to be found in 1730, when its provenance and correct attribution were still known.[7] In 1755, however, Richa records a *Conversion of Saul* in the sacristy (where it still is today), which he attributes to the school of Paolo Veronese.[8] Fineschi describes it, still in the sacristy, as by 'Sebastiano da Cortona, pupil of Paolo Veronese';[9] this attribution is repeated by Fantozzi in 1842,[10] and (with a question mark) by Paatz, who dates it in the early seventeenth century;[11] Venturi calls it Jacopo Ligozzi.[12] Only Colnaghi correctly identified the artist as 'Sebastiano di Giovan Piero Vini or dal Vino'.[13]

Though Vini was born in Verona (*c.* 1528), he spent most of his life in Pistoia, where he was married in 1548.[14] His only appearance on the Florentine scene was as one of Vasari's numerous assistants in 1565 in the rush to make ready the Palazzo Vecchio for the arrival of Francesco and his bride.[15] One wonders why the altar-piece, finished and put in place in 1575, should have been removed and replaced a few decades later. Raffaello Borghini's criticism of Vini's painting provides a clue to the possible explanation. He says he does not want to discuss it because 'mi pare di maniera molto lontana dall'altre, e da non doversi

della Conversione di S. Paolo, edificata da M. Giovanni Batista de' Ricasoli, Vescovo di Pistoia, la quale fù finita perfettamente quanto alla muraglia l'Anno 1572. E poi doppo morte di Monsignore l'Anno 1575 adì [lacuna] di Settembre fù messa la tavola, nella quale vi è dipinto S. Paolo, quando fù convertito da Gesù Cristo, che gli apparse per la via di Damasco, e fù dipinto a Pistoia . . .'

4 A.S.F. MS. 128, vol. 3, fo. 595ᵛ.

5 'Andrea Ricasoli l'anno 1589 dotò la sua cappella di S. Raimondo dandoci scudi 500 quali si rinvestino con altri denari nel Podere della Pecciolina con obbligo d'una messa cantata l'anno e una messa ogni mattina . . .' Notary: Panfilio Guerrini. A.S.F. Conv. Sopp. 102, vol. 106 (n.p.). I am indebted to Edward Sanchez for this reference.

6 Notes to Borghini, 1730 edn., p. 81.

7 'Circa l'Anno 1620, più o meno, il P.N.F. Raffaello delle Colombe fece fare per mano del Ligozzi la tavola di S. Raimondo, e con permissione de' Signori Ricasoli la collocò a detto Altare, con transportare la vecchia tavola della Conversione di Paolo dentro al Refettorio sopra la porta di fianco dove è stata per molti anni.

Finalmente nell'ultimo ornamento della Sacrestia è stata ivi trasferita dal Refettorio, e posta allata al fine-strone laterale di detta Sagrestia.' Borghigiani, 'Cronaca', iii. 396.

Borghigiani's assertion that the Ligozzi was commissioned by Raffaello delle Colombe is lent credence by the inclusion of a pigeon (*colombo*) in the upper left corner of Ligozzi's painting. It is not clear whether the chapel passed out of the possession of the Ricasoli at this time, which is very unlikely since it was richly endowed in 1589, or whether the Prior's connection with the painting was other than as the chapel's patron.

8 Richa, *Notizie istoriche*, iii. 45.

9 Vincenzo Fineschi, *Il Forestiero istruito in S. Maria Novella di Firenze*, Firenze, 1790, p. 34.

10 Fantozzi, *Guida di Firenze*, Firenze, 1842, p. 514.

11 Paatz, *Die Kirchen von Florenz*, iii. 715.

12 Venturi, *Storia dell'arte italiana*, vol. ix, pt. vii, p. 481.

13 Colnaghi, *Dictionary*, p. 280.

14 For the details of his life see, in addition to Thieme-Becker, R. Chiarelli, 'Una biografia inedita di Sebastiano Vini'.

15 See p. 53, above.

fra quelle annoverare'.[16] It is unquestionably true that Vini's painting is in a different style
from the others and that it strikes a discordant note among the relatively harmonious
works of the Academy. Bishop Ricasoli's heirs may well have removed Vini's picture for
this reason. It is clear from Ligozzi's painting, in which St. Raymond's miracle is performed
before an altar representing the *Conversion of Saul*, that the generation which replaced the
bishop's altar-piece did not wish to discredit him or to quarrel with his choice of dedica-
tion, but only with his choice of painter.

A preparatory drawing for the lower zone exists in Munich under the attribution of
Lelio Orsi (Pl. 50).[17] The style of the drawing reveals more dramatically than the painting
how un-Florentine were Vini's training and tradition.

GADDI CHAPEL

Agnolo Bronzino, *The Raising of Jairus' Daughter* (Pl. 59) *In situ*

Prior to the Vasarian renovation, the Gaddi family had been the patrons of a chapel in
the first bay of the right aisle, which finally in 1569 was allocated to the Compagnie di
Gesù Pellegrino e Tempio for their chapel (q.v.).

The transept chapel had belonged to the Falconi family who had dedicated it to St.
Dominic. Not long after the removal of the rood-screen, on 11 October 1566, Francesco
di Niccolò Falconi ceded the chapel to Niccolò Gaddi for reasons stated in the deed:

> Cum hoc sit quod Franciscus quondam Falconis Nichole de Falconibus, civis florentinus,
> habeat unam cappellaniam in ecclesia Sancte Marie Novelle de Florentia sub titolo Sancti Dominici
> . . . Et cum dicta cappellania propter antiquitatem de presenti non reperiatur ornata tabulis et
> picturis prout deceret in ecclesia celebri et insigni prout est ipsa ecclesia Sancte Marie Novelle in
> civitate Florentie, et etiam plurimum indigeat aliis ad divinum cultum necessariis, et propterea
> divinus cultus in eadem cappellania plerumque omictatur et minuatur et in ea cristifidelium devotio
> plurimum refrigescat, ipseque Franciscus propter inhabilitatem, cum sit gravatus filiis et aliis
> oneribus, non possit neque valeat ipsam restaurare, ornare et manutenere ut deceret. Et quod
> Mag.cus Dominus Niccolaus de Gaddis miles Sancti Iacobi de spata, zelo devotionis summopere
> cupiat, si eadem cappellania sibi daretur et concederetur, illam ad laudem et honorem omnipo-
> tentis Dei et in divini cultus in eadem ecclesia augumentum pulcriorem reddere et decenter ornare,
> manutenere et conservare.[1]

It would appear that in the course of the renovation the *Operai* informed the Falconi that
they must either undertake to redecorate their chapel, or cede the site to others. Gaddi,
offered the same option on his nave chapel, apparently decided that he would prefer the
much larger transept chapel.

For the architectural decoration of the chapel Gaddi employed Giovanni Antonio
Dosio, but Bronzino's painting, which is generally considered to be his last work before
he died in 1572, must have been commissioned before the architectural decoration was

[16] Borghini, *Il Riposo*, 1584, p. 106. [17] State Graphic Collection, 3099.
[1] A.S.F. Notarile Antecosimiano, H288 (ser Francesco Rossini, 1565–8).

even planned.[2] The altar-piece has the same dimensions as those for the Vasarian taber-
nacles in the nave and therefore would seem to have been conceived as part of the Vasarian
project. Perhaps only after having conformed with the *Opera*'s requirement that the altar-
piece resemble the others in the project was Gaddi free to decorate the walls and the vault
as he wished.

The chapel was not endowed until 1591, at which time Niccolò provided the liberal sum
of 45 scudi annually, and dedicated the chapel to St. Jerome.[3]

Bronzino's last work is startlingly dissimilar from his earlier works, even those from
the previous decade of crisis. Here the artist seems intent upon demonstrating his ability
to paint in conformity with the new criteria being applied to altar-pieces. As Raffaello
Borghini put it: 'Egli fece cotesta tavola in sua vecchiezza (disse il Michelozzo) e forse
così onesta, per purgar la fama della lascivia, che nell'altre sue opere si aveva acquistata.'[4]

From Borghini's point of view, this was the only religious work of Bronzino's that had
any merit. He praises the faithfulness to Scripture, the modesty of the figures, the composi-
tion, and above all, the reverence and devotion with which it must have been painted.[5]

Bronzino has indeed followed the scriptural story religiously. Only the family of the
dead girl, Christ, and his three favourite Apostles are represented in the room, because
Christ had dismissed the crowd that had gathered. Christ, who is not even designated by
a halo, stands in the centre and presents the resuscitated girl to her mother and her father,
who has dropped to his knees. On the ground are the symbols of death—the urn, the
candles, and the book—which are contrasted with the serving woman who enters at the
right with food, the symbol of life. Behind on the left are the musicians with their flute,
mentioned in Matt. 9 : 23. Overhead is a figure identified for us by Borghini as Fame
blowing her trumpet, to represent Matt. 9 : 26: 'And the fame thereof went abroad into all
that land.' No additions have been made by the artist.

In commenting upon the work's style, on the other hand, Borghini had several criti-
cisms to make:

Nella bella cappella del Cavaliere Gaddi, la tavola . . . è di mano del Bronzino lavorata con molta
diligenza, con buona ordinanza, e con bellissimo colorito, e spezialmente la madre della fanciulla
mi pare bonissima figura. Voi dite vero (rispose il Michelozzo) perché come buono oratore solo
quelle cose lodate, che fanno al proposito vostro per difesa de' pittori; ma quelle, che vi potrebbono
arrecare qualche impedimento, cercate sotto silenzio di passarle; come sarebbe a dire, che il Cristo
non posa bene, che il braccio manco ha grandissima disgrazia, e che l'Arcisinagogo non fa molto
buona attitudine.[6]

It is probable, as several critics have already suggested, that the ageing Bronzino left
most of the execution to his workshop.[7]

[2] Paatz, *Die Kirchen von Florenz*, iii. 712.

[3] 'Il Cavaliere Niccolò Gaddi dotò la sua cappella di
S. Girolamo l'anno 1591 e lasciò che gli sua eredi . . . in
perpetuo al Convento come fanno Scudi quarantacinque
l'anno . . .' A.S.F. Conv. Sopp. 102, vol. 106 (n.p.).

[4] Borghini, *Il Riposo*, 1584, p. 92.

[5] Ibid., pp. 91 f.

[6] Ibid., p. 199.

[7] See Emiliani, *Il Bronzino*, no. 98.

STROZZI CHAPEL

Giorgio Vasari, *Crucifixion According to St. Anselm* (1567) (Pl. 27) Sacristy

The first of the new chapels to be finished was that of Alessandro Strozzi, who was appointed bishop of Volterra shortly after work on the chapel was begun. Strozzi was an intimate friend of the Duke, and had been appointed Inquisitor by him.[1]

None of the sources are clear about the earlier history of this bay. Sermartelli refers to 'L'altare ultimo di questa nave, prima eretto a S. Pietro Martire dal Reverendissimo Messer Alessandro Strozzi Vescovo di Volterra'.[2] He was apparently confusing Strozzi's chapel with the miraculous tabernacle directly opposite on the exterior wall of the choir, which was dedicated to St. Peter Martyr.[3] Paatz, too, says that this chapel had been dedicated to St. Peter Martyr, implying that it was at that time in the possession of some other family.[4] Brown correctly states that we have no record of an early appropriation of the west wall of this chapel.[5] Borghigiani's source, however, says: 'Subito voltato il canto, secondo alcuni scrittori, v'era l'Altare eretto e dedicato a S. Maria Maddalena Penitente dal Vescovo di Fiesole Maestro Iacopo Altoviti, assai devoto di detta Santa.'[6] Beside it was Altoviti's tomb which Sermartelli tells us was dated 1416. Where the tomb of Beato Giovanni da Salerno is today, i.e. at the north end of the next bay, was that of Messer Andrea da Panzano, Podestà di Firenze. Sermartelli does not agree with this description,[7] which, however, corresponds with the order of these monuments (all demolished by Vasari), as they are described in Document 2 of our Appendix (see also Fig. 1).

The chapel and painting are referred to a number of times in Vasari's correspondence, enabling us to follow their progress. On 18 August 1566 Vasari wrote to Vincenzo Borghini: '. . . È finita di legniame la tavola di messer Alexandro Strozzi, che s'ingessa; e la cappella di pietra si [è] cominciata.'[8] Shortly thereafter, on 3 September, Vasari wrote to Borghini that he had spoken to Strozzi, presumably about certain questions concerning his painting.[9] On 20 October 1566 the bishop wrote a very accommodating letter to Vasari concerning the prices of the chapel and painting:

Magnifico Messer Giorgio mio

Io vi porto sempre nel cuore et non vorrei essere con esso voi troppo indiscreto. Quanto alle spese sapete, dove havete a ire. Quanto poi al premio vostro vi dico, facciate il medesimo, perché io darò ordine, che voi siate satisfatto. La fede, ho in voi, è grandissima et causa questa sicurtà con esso voi. Desidero, che l'opera vadia a buon viaggio, et son contento più l'un di che l'altro di honorar Iddio et quella chiesa con questa opera pia, et tanto più per le vostre mani, havendovi conosciuto et virtuoso et amorevole.[10]

By the following February the painting was nearly finished, as is revealed by another letter from Strozzi in answer to a letter (now lost) from Vasari, who was in Rome:

[1] See p. 20 above.
[2] Sermartelli, p. 69.
[3] Ibid., p. 17, and Orlandi–Borghigiani, ii. 403.
[4] Paatz, *Die Kirchen von Florenz*, iii. 716. He cites no source for this statement.
[5] Brown, *The Dominican Church*, p. 124.

[6] Orlandi–Borghigiani, ii. 401.
[7] Sermartelli, p. 68.
[8] Frey, ii. 272.
[9] Ibid., pp. 275 f.
[10] Ibid., p. 280.

Magnifico Signor mio

Io ho ricevuta la vostra di 18 et per quella ho inteso l'andata vostra di Roma insieme con la cagione et vi veggho tanto occupato con papi et cardinali, che io giudicherei farvi torto, se con questa mia io vi dessi molestia . . . Et ho grande piacere di havere inteso per la vostra et poi da Lorenzo, mio nipote, che è venuto qui, che la tavola non solamente sia inanzi et quasi che finita, ma ancora che l'habbia a saddisfare assai, et che l'habbia a essere riputata degnia d'uno maestro perfettissimo, come siate voi. Et in quanto a questa parte io non ho mai dubitato punto, sapendo, chi voi siate; ma stavo bene sorpreso, si la inventione fussi per piaceri o no. Ma poi che voi mi scrivete, che l'è stata lodata dallo eccellentissimo Signor Duca, essendo il giuditio di Sua Eccellentia tanto buono, ancora di questo ne rimangho contentissimo et lascerò la cura a voi di dichiararla al popolo, perché io l'ho quasi che dimenticata et non me ne ricordo. Et si voi alla vostra tornata verrete di qua, l'harò molto caro; et quando pure vi fussi scommodo il venire, non mancate di metterla in opera sanza altra mia commessione, perché il tutto rimetto in voi liberamente, sapendo, che da voi et da la virtù vostra non uscirà mai cosa che non stia bene. Mi dice Lorenzo, mio nipote, che l'ordine, che havete lasciato, si tirerà inanzi; et non mancherà cosa nessuna.[11]

Meanwhile work was continuing on the construction of the chapel: Vasari, still in Rome, wrote on 8 March to Borghini: '. . . et arò caro ch'ella cavalchi a spasso fino a Santa Maria Novella et vegha a che termine, e come torna la cappella degli Strozzi, e mi avisi . . .'[12] By July, a little less than a year after it was begun, the chapel was completed, and Vasari entered the payment in his *Ricordanze*:

Ricordo come del mese di Luglio [1567] per la festa del Corpo di Cristo si messe su, che era fatta quell'anno una tavola nella chiesa di Santa Maria Novella di Fiorenza, dov'è una scala che le virtù conducano l'uomo per fretta a Cristo Crocifisso fatta a Monsignor Alessandro Strozzi, Vescovo di Volterra, che la pigliò scudi duegento d'oro in oro 200.[13]

On 2 March 1594/5 the Grand Duchess Cristina, wife of Ferdinand, wrote to the Cardinal of Cracow requesting that he send her a relic of the Polish Dominican, St. Hyacinth, whose cult she wished to encourage in Florence. The Cardinal complied by sending her the saint's arm-bone, which she then gave to the Strozzi family to be placed in their chapel in Sta Maria Novella. A marble tabernacle enclosing the relic was to be placed under the Strozzi altar.[14] Alesso di Camillo then rededicated the chapel to St. Hyacinth, and commissioned Alessandro Allori to paint a new altar-piece, the *Vision of St. Hyacinth*, which is dated the following year, 1596 (Pl. 98).[15] Vasari's painting was taken down and, according to Borghigiani, was placed in the refectory until the eighteenth century, when it was transferred to its present location in the sacristy.[16]

Vasari's painting represents Christ on the cross surrounded by allegories of the virtues. There is a preparatory drawing in which the artist has labelled each of the allegories (Pl. 28).[17] Vasari described the altar-piece in the *Vite* as '. . . a Christ on the Cross, as seen

[11] Ibid., p. 295, dated 26 February 1566/7.
[12] Ibid., p. 313.
[13] Vasari's *Ricordanze*, entered in July 1567. Ibid., p. 879.
[14] P. M. C. Becchi and H. Geisenheimer, 'Per la storia del culto di S. Giacinto in Firenze', *Il Rosario* (January 1907), pp. 17 ff.

[15] Uffizi 10280F was first recognized by Geisenheimer (ibid.) as a preparatory drawing for this altar-piece. It was exhibited as no. 70 (fig. 31) in the recent *Mostra di disegni di A. Allori*, Florence, Gabinetto Disegni . . . , 1970. [16] Borghigiani, 'Cronaca', iii. 397.
[17] Uffizi 624F, pen and watercolour, 458 × 333 mm. Both drawings for this altar-piece were exhibited in the

by St. Anselm, with the seven Virtues, without which we cannot mount the seven steps to Jesus Christ, and other circumstances of the same vision.'[18] The staircase can be seen on the lower right. Unfortunately, however, no one has found the passage in St. Anselm's writings on which Vasari and Borghini based the iconography, so that it is not possible to explain most of the activities depicted. The composition is an elaboration of a *Crucifixion*, such as the one Vasari painted for the Botti Chapel in Sta Maria del Carmine a few years earlier (Pl. 26). The mourning Magdalen at the foot of the cross in the Carmine version has been transformed into an allegory of Humility.

A compositional sketch (Uffizi 623F; Pl. 29) shows the extent to which Vasari conceived his composition in terms of linear pattern. Indications of setting have been excluded, as well as lighting, details of modelling, and so forth. With rapid pen-strokes the artist has worked out the design, using only the linear outlines of the figures and such props as are essential to the composition.

Vasari's preoccupation with his *invenzione* and his lack of interest in naturalism lead him into awkward juxtapositions in the lowest tier of figures. Though these difficulties already exist in the sketch, they are compounded in the painting because the artist has moved several of these figures up flat against the frontal plane of the picture and added several more figures behind.

Today the painting can only be seen from a distance of about thirty feet, but its condition appears to be poor. Examination of the photograph indicates that the figures of the lower zone have been overpainted by a rather crude hand (especially the drapery of the woman in the lower left corner). The colour in the present condition of the painting is dry and metallic.

Raffaello Borghini did not object to Vasari's invention as such, but he remarked that the Virtues in the sky around the cross should have been depicted with wings.[19] In commenting upon the artistic quality of the picture, he said he thought Christ's arms were too long: 'Ed a me pare (disse il Michelozzo) che il Cristo abbia le braccia troppo tirate; perciò giudicherei tal'attitudine non aver molto del naturale.'[20]

COMPAGNIA DI STA CATERINA DA SIENA CHAPEL

The chapel of this Compagnia had been in the lower zone of the *ponte* next to that of the Castiglioni. Sermartelli describes its history:

Accanto a detta cappella [Castiglioni] c'era quella di S. Marco eretta da' Frati, la quale da Fra' Zanobi di Guasconi allora Priore di questo luogo fu concessa a Vermiglio Alfani l'anno 1365, il quale levatogli il primo titolo l'eresse di nuovo a S. Marco evangelista, essendo stata la prima volta dedicata a S. Tommaso d'Aquino, dove in quella fece un magnifico sepolcro, il quale poi colla sepoltura di questa casata ch'era a piè delli scaglioni; ... e questa degli Alfani per essere stata

Mostra di disegni del Vasari e della sua cerchia, Florence, Gabinetto Disegni . . . , 1964 (nos. 39 and 40). The other drawing is Uffizi 623F, pen, lightly scored in black chalk, 390 × 270 mm.

[18] Vasari–Milanesi, vii. 710.
[19] Borghini, *Il Riposo*, 1584, pp. 89 f.
[20] Ibid., p. 199.

concessa da' Frati dopo la morte del Fondatore alle Donne della Compagnia di S. Caterina da Siena, la quale è stata dopo trasferita sotto l'organo per abellimento della chiesa.[1]

Brown believed mistakenly that this had been where the Altoviti Chapel had been located (see Strozzi Chapel, above) and that it had passed from the Alfani to the Altoviti.[2]

The chapel under the organ was probably the least desirable in the church. There is no evidence that an altar painting by the Vasarian school was ever commissioned, or even planned. Borghini, in his tour round the church, makes no mention of this chapel, and the scanty records of the Compagnia preserved in the Archivio di Stato reveal nothing.

The tomb of Giovanni da Salerno, which had been in the fourth bay of the right aisle (Minerbetti Chapel), was transferred to this bay in 1571.[3] Vincenzio Danti was commissioned to make a relief for the tomb, for which payments are recorded in the books of Sta Maria Novella.[4]

PASQUALI CHAPEL

Giorgio Vasari, *Resurrection with Saints* (1568) (Pl. 30) *In situ*

Inscribed on plaque held by two *putti*, middle foreground: 'VICTIME PASCHALI'

Andrea Pasquali was the Duke's personal physician and a friend as well. Along with Strozzi's, his was one of the first chapels to be begun. The Duke strongly encouraged his desire to renew his ancient family chapel, even to the point of subsidizing the undertaking, as is revealed by a letter from Vasari to Borghini, dated 18 August 1566: '. . . Maestro Andrea à a[v]uto il luogo, et spetto fargli aver la gratia che non paghi il sito, che 'l Duca l'à rimesso a me, et vol far la cappella risoluto, né gli dà noia balzello . . .'[1]

It is interesting to note that a few months earlier, on 1 March 1565/6, Duke Cosimo made a *donativo* of 2,000 scudi (or about 14,000 lire) to Pasquali, and that this was a matter of sufficient note to be recorded by Settimanni in his diary.[2]

A later letter, this one from Borghini to Vasari (28 January 1566/7) discussed certain questions of iconography:

Maestro Andrea Pasquali mi parlò et si contenta del disegno et rimette a voi et a me il tutto; et a me sadisfà quello che ho veduto. Darei bene la man ritta a San Cosimo et San Damiano, poi che per uso commune è introdotto, che questo luogo si dia a chi ha il Titolo della cappella, non ostante altri privilegi o priminenze [*sic*]; et è bene, ne facciate un disegno il più finito che si può, sì per quello effetto che voi mi dicesti, sì perché egli lo desidera, ed è bene che e' rimanga sadisfatto. Pensava, per che que' soldati [che] di necessità vengon nel mezzo, luogo che negli altari dove si dice messa non mi piaque mai, per che gli occhi nel levare il Sacramento non vorrei percotessino in questa tal veduta, se e' vi si potesse riparare in qualche modo, che havesse buona invenzione et conforme insieme al vero; et mentre ch'io penso, mi è occorso, che nel punto della resurrecttione venne un gran tremoto, et venn' un'angelo da cielo, che aperse et si pose a sedere su 'l monimento:

[1] Sermartelli, p. 17.
[2] Brown, *The Dominican Church*, pp. 123–4.
[3] Sermartelli, p. 49.
[4] A.S.F. Conv. Sopp. 102, Appendix vol. 33 (Entrata e Uscita), and Appendix vol. 60 (Debitori e Creditori).

[1] Frey, ii. 272.
[2] A.S.F. MS. 128, vol. 3, fo. 361[v].

Se questo si potesse accommodare, che con la persona et con lo splendore occuperebbe il luogo del mezzo et coprirrebbe una parte di que' soldati et una particella, che se ne vedesse, non darebbe tanta noia a un pezzo, come vederne tanto numero. Voi ci penserete et farete quel che giudicate meglio et vi ricorderete di vestire riccamente que' medici. Del resto ragionaremo a bocca.[3]

As we can see from the painting, Vasari followed Borghini's advice, changing the design to include the angel in the tomb.

A couple of months later Vasari was in Rome, under heavy new burdens of work for the Pope. He wrote to Borghini on 1 March 1566/7 directing him to greet Maestro Andrea Pasquali. Apparently he wished to reassure Pasquali that, though occupied at present with other matters, he had not forgotten him.[4]

The painting must have been delayed in execution, because Vasari did not record his receipt of payment for it until the end of the year 1568. Here, as before, Pasquali received special treatment: a *sconto* of 25 per cent. 'Ricordo come adì ultimo di Decembre si messe su la tavola di Maestro Andrea Pasquali in Santa Maria Novella, alta braccia 7, largha 4; con la resuretione di Cristo et 4 santi. Costò scudi 200; ma non volsi da lui più che scudi 150.'[5] Geisenheimer found no record of payment for the altar-piece among the records of the Pasquali family.[6]

The endowment is recorded a year later:

Ricordo oggi questo dì 20 di Dicembre 1569 come havendo il magnifico et eccellente Dottore maestro Andrea di maestro Giovanni Pasquali, medico fisico, fatto una Cappella nella nostra Chiesa, intitolata S.to Cosimo e Sancto Damiano, et volendo dotarla . . . Et per tal causa dette et donò al Convento, in recompensa de' sopradetti oblighi, lire dumilacento, come a entrata segnata B a c. 19, alle quale L. 2,100 se gli oblighi una casa posta nella via de' Cenni . . . contratto rogato ser Buonaccorso di Lorenzo Buonaccorsi detto dì.[7]

The appropriation of this chapel to the Pasquali family is an old one, as is proved by the record of an old tomb which Rosselli says was covered over by the stairs of the new altar, but which was inscribed: 'SEP. DE PASQUALIBUS PRO NATIS, AMICIS ET SERVIS EORUM'.[8] Andrea's own tomb was placed in front of the chapel.

One source (Orlandi–Borghigiani) states that the original location of the Guasconi chapel (see Compagnia di Sta Caterina Chapel) was in this bay, but that when it was ceded to the Alfani family (in 1365) and the dedication changed to St. Mark it was transferred to the *ponte*.[9]

Vasari has represented Christ's Resurrection from the tomb in the middle and upper zones, while in the foreground he has interposed as witnesses to the event four saints who can be identified as SS. Cosmas and Damian, patrons of the medical profession as well as of the Medici, St. John the Baptist, and the patron's name-saint, the Apostle Andrew.[10]

[3] Frey, ii. 291.

[4] Ibid., ii. 304.

[5] Vasari's *Ricordi*, ibid., ii. 880.

[6] H. Geisenheimer, 'Di alcune pitture fiorentine eseguite intorno al 1570', *Arte e storia*, xxvi (1907), 18 f.

[7] A.S.F. Conv. Sopp. 102, vol. 90, fo. 37[r–v]. An abbreviated record of this contract appears also in vol. 106 (n.p.).

[8] A.S.F. MS. 621, p. 687, paragraph 17. (Also in Sermartelli, p. 65.)

[9] Orlandi–Borghigiani, ii. 401.

[10] He is identified as St. Andrew in R. Borghini's discussion of the painting (see below).

The inscription is of course a pun on the patron's name, and the patron himself was portrayed, according to Biliotti, in red kneeling to the right of Christ.[11]

In *Il Riposo*, Borghini quite correctly criticized Vasari's double subject on the grounds that it undercut the historicity of the Resurrection by abstracting it from its setting in time and space. He objected that it did not follow the Scriptures, and that the inclusion of the four saints as though they were actually present at the event was confusing to the unschooled:

In questa pittura (disse il Vecchietto) molto mi pare alterata la sacra invenzione; percioché quando il Signor nostro risuscitò, non vi era presente alcuno degli apostoli; onde io non so quei quattro quel che vi si facciano, se non far credere a gl'ignoranti (che più là che la pittura non guardano) che altramente passasse la bisogna di quello, che nelle carte sante si legge: e s'egli fosse stato veduto dagli apostoli nel risuscitare, non accadeva poi, che egli apparisse alla Maddalena, a Cleofas, e a Luca, e a tutti gli apostoli insieme: le quai tutte cose grandissimi misteri, come i sacri teologi sanno, in sé contengono. Gli agnoli poi, che egli ha fatto intorno al Redentor del mondo, per arricchire l'opera sua, estimerei che vi potessero stare; conciossiacosaché dove è Dio, sieno gli angeli: e così il rimanente della tavola mi pare assai bene osservata.[12]

The preliminary sketch which Don Vincenzo Borghini showed to the patron in January 1566/7 has been lost. The Lille drawing (Pl. 31)[13] represents a later version to which the angel in the tomb, suggested by Borghini, has been added. The upper and lower zones of this sketch are executed in very different manners. The lower zone appears to be Vasari's tracing or a hastily-made copy of another of his drawings or possibly Naldini's tracing of Vasari; the much firmer, heavily reworked stroke of the upper zone is unmistakable as Naldini's energetic pen-work. It seems that Vasari himself made a rather careful compositional sketch (which is now lost) of the lower zone, incorporating Borghini's suggestion for the iconography of the centre, then copied it and turned over to Naldini the designing of the upper zone. The pupil's design was revised by the master when he made the final *modello* (Pl. 32),[14] which corresponds in every detail to the final painting: the graceful pose of Naldini's Christ is superseded by a reversed quotation of the Christ in Michelangelo's *Last Judgment*—to the detriment of the composition, as Borghini noted in his commentary upon the artistic qualities of the altar-piece: 'Mi piace tutto quel che voi dite (rispose il Michelozzo) ma l'attitudine del Cristo mi pare alquanto sforzata.' Borghini also criticized the ambiguity in the pose of the two flanking saints: 'Santo Andrea e San Damiano, secondoché si dice, a rispetto del piano, dove posano i due santi, che sono innanzi non sembrano né dritti, né inginocchioni; perché essendo dritti su quel piano, sarebbono corti di gambe, ed essendo ginocchioni, apparirebbono troppo alti.'[15] In the drawing it is clear that the two saints are standing and that they are, as Borghini says, too short. In order to

[11] Geisenheimer, op. cit., p. 19.

[12] Borghini, *Il Riposo*, 1584, pp. 93 f.

[13] Musée Wicar, Lille, no. 901. Published by P. Barocchi (*Vasari pittore*, no. 94) as Vasari.

[14] I am indebted to the late Walter Vitzthum for pointing out this drawing to me. It was exhibited in Indianapolis (*Pontormo to Greco*, 1954, no. 60) as Bene-

detto Caliari; and in Notre Dame (*The Age of Vasari*, 1970, no. D47). It is now in a private collection in New York City. It is executed in pen and bistre with bistre wash, heightened with white, on tinted paper measuring 421 × 267 mm.

[15] Borghini, *Il Riposo*, 1584, pp. 199 f.

conceal their poor proportions in the painting, Vasari has obscured their legs in shadows so that it is impossible to determine at what depth they are standing. Because the position of Christ and his heavenly entourage depends upon the placement of the two saints, and their position is ambiguous, the entire spatial organization is insecure.

The execution of the upper zone appears to be by Vasari himself. The figures of the four saints in the lower zone, however, are drier in handling, revealing the intervention of Jacopo Zucchi (cf. Capponi–Compagnia del Rosario Chapel, below).

CAPPONI–COMPAGNIA DEL ROSARIO CHAPEL
Giorgio Vasari and Jacopo Zucchi, *Madonna of the Rosary* (1569) (Pl. 33)
Right transept, opposite Gaddi Chapel

This bay contained Masaccio's famous fresco of the *Trinity*, which was covered over in the Vasarian renovation. There had also been a door at the north end of the bay, but it is not mentioned in the record of changes made under Vasari's direction (see Appendix, Doc. 2) and may therefore already have been walled up. The exact date or manner in which the Capponi family acquired the chapel is not known, but Camilla Capponi's will, drawn up on 4 August 1568, gave instructions for the founding and decoration of this chapel.[1] The *Ricordo* from the books of the convent gives the substance of the testament:

Ricordo oggi questo dì 25 di Novembre 1568 come morse la bona memoria di madonna Camilla vedova donna fu di ser Piero Arrighetti et figliuola di messer Piero di Reccho Capponi quale per suo ultimo testamento lasciò herede universale il nostro Convento di Santa Maria Novella, rogato per ser Iacopo Nocchi sotto dì 4 d'agosto 1568 . . .

. . . Ancora lasciò che il Convento fussi obbligato a far fare una Cappella di pietre conce in un Arco della chiesa a comodo loro, simile all'altre fatte et da farsi, con la Tavola del S^mo Rosario, nella quale vuole si spenda da lire 2800 piccioli almanco et quel più parrà a frati et Convento, et questo fra 18 mesi, quali debbino cominciare a correre ogni volta sarà riscosso un Credito di lire 2450 piccioli che debbe havere detta heredità e sua heredi da Benedetto delli Alessandri, il che non facendo lascia sua herede universale lo spedale di S. Maria Nuova, come in detto testamento si dice. Et per dote di detta Cappella lasciò un Credito di Monte delle paghe di sette per cento di f. 266, quale canta in Madonna Camilla de' Capponi donna fu di Pagolo Giuntini. Ancora in detto testamento dispone et aplica in dote alla sudetta Cappella lire 70 piccioli, quale la Compagnia di S. Piero Maggiore era obligata pagare ciascuno anno a uno studente di questo Convento per conto d'una donagione fattali più tempo fa del Podere di Aiuolo, con detto carico et obligho, et questo considerato che è superfluo lasciare a particulari vivendo osservantemente. Et tal dote lasciò al Convento con obligho di far celebrare ogni mattina perpetuamente una messa a detta cappella del Rosario per l'anima di detta.[2]

The wording of the testament, which does not specify the position of the chapel or make reference to 'la sua cappella', suggests that perhaps the site had not previously been allocated, and that it was assigned to Camilla after her death.

The chapel was nearly finished sixteen months after Camilla's death, for we read: 'Nota

[1] A.S.F. Notarile Antecosimiano, N184 (1568), fos. 108 ff. [2] A.S.F. Conv. Sopp. 102, vol. 90, fos. 35ᵛ–36ʳ.

come e Conci della Cappella del SS.^{mo} Rosario furno fatti et murati adì 20 di Marzo di dett'anno, come a Debitori e Creditori Segnato A a c. 151.'³

At the end of 1569 Vasari recorded the completion of the painting and the receipt of his payment of 200 florins from the executor of Camilla's will, the Prior of Sta Maria Novella:

Ricordo, come alla fine di questo anno si finì la tavola del Rosario, che andò nella chiesa di Santa Maria Novella, alta braccia 7, largha quatro, pel Reverendo Padre Fra Angelo Malatesti da Pistoia, priore di detto convento; con un tondo di sopra; con putti, che getton rose. Ebesi per pagamento di detto tavola scudi dugento che sene dà cento a Iacopino . . scudi 100.⁴

Although this was among the first of the new chapels to be undertaken, it was not given the same special treatment that the Strozzi and Pasquali Chapels had received. No doubt because the patron, already in her grave, was in no position to complain, Vasari turned over the execution of the picture to a member of his shop, Jacopo ('Iacopino') Zucchi, who received half the payment.

The painting was installed and the chapel brought to completion in May 1570: 'Di più sotto dì [lacuna] di Maggio 1570 fu messo in opera la Tavola con suo ornamento, et compito detta Cappella, come a detto libro Debitori et Creditori Segnato A a c. 153.'⁵

It is not clear how or when the chapel passed to the Compagnia del Rosario, but the facts that (1) the confraternity is not mentioned in Camilla Capponi's will, and (2) according to Fineschi, the Capponi arms were to be seen on the altar table and in the window above, while those of the confraternity were on the tabernacle,⁶ would seem to indicate that the chapel did at some time actually belong to Camilla Capponi's estate, and was not originally constructed for the confraternity by Donna Camilla.⁷

The choice of subject for the altar-piece is unusual at this early date, though the theme was to enjoy a wide popularity in the next two decades owing to the ascription of the victory against the Turks at Lepanto on 7 October 1571 to the Madonna of the Rosary. The Rosary had always been associated with the Dominicans, having been revealed by the Madonna to St. Dominic himself in 1208 as an aid against the heresy of the Albigenses. Thus Vasari has represented St. Dominic kneeling beside the Madonna and gratefully kissing her hand, from which he has just received the rosary he holds. Above her head is strung a giant rosary, supported by *putti* and angels, on which are depicted the fifteen mysteries of the rosary.⁸ Beginning with the bead nearest the Christ child and running to the upper left corner are the five Joyful Mysteries of the Incarnation: Annunciation,

³ Ibid.

⁴ Vasari's *ricordi*, no. 348; Frey, ii. 881. The *tondo* with *putti* throwing roses still exists in good condition in the Capitolo del Nocentino behind the refectory (mentioned but not identified by Paatz, *Die Kirchen von Florenz*, iii. 727). The original position of the *tondo* is not clear, because the bottom of the window above the altar came within a couple of feet of the tabernacle. Vasari describes it as being *above the altar-piece*, but since the *tondo* measures at least 24 in. in diameter it is difficult to imagine where it might have been placed.

⁵ A.S.F. Conv. Sopp. 102, vol. 90, fo. 36ᵛ.

⁶ A.S.F. MS. 892, fo. 64. I am indebted for this reference to Mr. Ulrich Krause.

⁷ According to Paatz, *Die Kirchen von Florenz*, iii. 795 n. 219, the painting remained in its original location until 1906, when it was moved to its present location in the right transept.

⁸ Mary Ann Graeve, 'The Stone of Unction in Caravaggio's Painting for the Chiesa Nuova', *Art Bull.*, xl (1958), 223 ff.

Visitation, Nativity, Circumcision, Christ among the Doctors. Balancing them on the other side, moving toward the upper right corner, are the five Sorrowful Mysteries of the Passion: Agony in the Garden, Flagellation, Crowning with Thorns, Carrying the Cross, Crucifixion. Placed horizontally across the picture are the five Glorious Mysteries: Resurrection, Ascension, Descent of the Holy Spirit, Assumption, Coronation of the Virgin. The bead representing the Descent of the Holy Spirit is appropriately centred above the Madonna's head, directly below the Dove and God the Father. Vasari's placement of the Madonna of the Rosary between the worshippers below and God the Father above symbolizes her role as intercessor. For the figure of the Madonna the artist has cleverly adapted the iconography of a different but analogous type, the Madonna della Misericordia. The two types have in common the quality of compassion as the primary attribute of the Virgin. Beneath her cloak are crowded numerous figures, including seven haloed saints, only one of whom—St. Catherine of Siena in nun's habit at the left—can be identified.

For his composition, Vasari turned to the artist who had profoundly affected him at the beginning of his career, Rosso Fiorentino. Vasari used Rosso's beautiful drawing for the *Madonna della Misericordia* (now in the Louvre: Pl. 34),[9] which is a devotional scheme, as the core of his composition, even lifting several of the figures of the worshippers directly from Rosso's design, and then elaborated upon it. His composition alludes also to Masaccio's *Trinity* fresco, which was covered over by this altar-piece.[10] Vasari certainly designed the altar-piece himself, probably in consultation with Borghini on matters of theology and iconography. The execution, however, appears to be entirely by the hand of Jacopo Zucchi. The characteristics of Zucchi's style can be studied in his panel for the Studiolo, *The Gold Mine*, of a year or two later (Pl. 35). Here a nervous energy animates the figures and even overflows into their garments; it distorts the shapes of objects into curvilinear patterns, as for instance the labourers' hats, or into sharp angles, as in the folds of the drapery. He uses a strong, bright light and very dark shadows. His preference for clarity of forms distinguishes him from his colleagues in Vasari's *bottega*, Naldini and Poppi, both of whom soften and diffuse their colours with their chiaroscuro. Those same characteristics can be seen in the *Rosary* altar-piece, especially if we make allowance for the inevitable tightening-up of a youthful artist when he approaches his first large-scale works. The composition is fragmented by the nervous activity of the figures. The drapery, which is handled in a rather dry, texture-less manner, falls into the same V-folds that we see in the Studiolo panel. The strongly lighted areas contrast sharply with the black-filled shadows, though the impression of clearly delineated forms is diminished by the present condition of the painting, which needs cleaning.

In commenting upon this painting *qua* altar-piece, Raffaello Borghini approved both of the subject and its treatment. After a lengthy review of the history of the rosary prayer, he remarks, '. . . non mi par che si possa se non molto lodare l'invenzione'.[11] In terms of its

[9] Louvre 1579. I am grateful to Professor Eugene Carroll for pointing out this connection to me.
[10] See above, p. 114.
[11] Borghini, *Il Riposo*, 1584, p. 96.

artistic qualities, he praises the composition, the figure of the Madonna, and the colour, criticizing only one detail: 'Ogni cosa mi soddisfà (rispose il Michelozzo) fuorché quella donna, che è quivi a basso dinanzi, la quale ha un braccio, che poco più grande che fosse, sarebbe disdicevole a un gigante.'[12]

BRACCI CHAPEL

Alessandro Allori, *Christ and the Samaritan Woman* (Pl. 90) *In situ*

Inscribed on step on which child is seated: 'ALEXANDER ALLO. CI. FLO. FACIEB. A.D. MDLXXV'

Borghigiani, quoting Firenzuola, gives the most complete account of the founding of this chapel:

> Ne segue la Cappella della Sammaritana eretta di nuovo ove prima era l'altare di S. Ignazio Martiro della Casata Benintendi: fu fatta a spesa di M. Antonio Bracci, e M. Noferi suo fratello circa l'anno 1570. La Tavola fu posta nel 1575 dipinta da Alessandro Allori detto il Bronzino. Fu dedicato detto Altare da' Benefattori a S. Antonino Arcivescovo di Firenze; non ha dote.[1]

I have found no record of the founding or endowment of the chapel in the books of the convent; Borghini (1584), however, in mentioning Allori's painting, refers to the chapel of M. Anton Bracci.[2]

Sermartelli (1617) confirms that the Benintendi Chapel had been in this bay: 'Nel qual luogo fu già un altro altare con un monumento appiè di quello eretto dalla famiglia de' Benintendi sotto il titolo di S. Ignazio, che nel raccomodare la chiesa fu levato via, e rifattovi di nuovo secondo l'ordine di quelli altri dal soprariferito Noferi Bracci.'[3] This is the same chapel mentioned in Document 2 of our Appendix, which was demolished in Vasari's renovations. Brown is correct, it appears, in stating that there were two altars in this bay,[4] though this was probably for only five to ten years, between 1560 and the time that the Benintendi Chapel was demolished.

Borghini objects to the figure of the Samaritan woman from the point of view both of propriety and of artistic quality:

> Questa è degna di considerazione, e molto vaga (soggiunse il Vecchietto) e mi par veramente, che l'istoria sia bene osservata, e l'altre parti convenevolmente rappresentate; comeché alcuno dica, che la Sammaritana e il fanciullo sieno figure troppo morbide e lascive.
>
> A questo si può rispondere (replicò il Sirigatto) che la Sammaritana è nell'abito lascivo, in cui ella andava avanti che conoscesse il vero Iddio: e che al fanciullo è men disconvenevole la morbidezza, che all'uomo; perché l'età puerile molto meno destar suole il sensitivo appetito.

Valori goes on to say that since temptation is both so great and so subtle, it is better for the artist to clothe modestly all the figures in a sacred painting, including children and cherubs.[5]

[12] Ibid., p. 200.

[1] Borghigiani, 'Cronaca', iii. 392.
[2] Borghini, *Il Riposo*, 1584, p. 625.

[3] Sermartelli, p. 63. See also Orlandi–Borghigiani, ii. 402.
[4] Brown, *The Dominican Church*, p. 118.
[5] Borghini, *Il Riposo*, 1584, pp. 96 f.

In discussing the artistic merits of the painting, Borghini makes essentially the same criticism from a different point of view:

La tavola, dove è effigiata la Sammaritana (disse il Sirigatto) che parla al Salvadore del mondo, è di Alessandro Allori, con ordinanza molto ben composta, la femmina molto vaga, il fanciullo bellissima testa, e dilicate membra, il paese ben accomodato, ed il colorito non si può disiderare il migliore.

Cotesta tavola (soggiunse il Michelozzo) è molto vaga, ed ha una certa maestà, che piace e diletta assai; ma a considerarla poi partitamente, vi si vede qual cosa, che pur dà noia a molti, come la testa di Cristo, per esser di cera fosca: e la Sammaritana, comeché sia leggiadra figura, nondimeno non può col braccio manco far l'effetto di coprirsi la poppa manca, siccome dimostra, e malagevolmente può sostener la secchia, che non cada, avendola appogiata sopra la gamba, che posa, e leggiermente tenendola colle mani.[6]

As one would expect, there are many things about the painting which Borghini likes: the simple composition, the landscape, the colour and, above all, its faithfulness to the Scriptures. In the middle ground we see the figures of the Apostles approaching from the city, where, according to John 4, they had gone to get food. John uses this event, in which Christ asks the woman for water, as an introduction to the discussion of the water of life, but Allori avoids this and any other theological implication, and represents the scene solely for its narrative value.

A preparatory drawing for the left part of the painting, scored for transfer, is preserved in the Uffizi (Pl. 91).[7] Another study of this subject, very similar to the painting, may have been made for a private devotional painting on a smaller scale.[8] In this version the drama has been greatly strengthened, for the woman does not avert her eyes demurely but looks directly at Christ.

BACCELLI CHAPEL
Giovanni Stradano, *Baptism of Christ* (c. 1572) (Pl. 45) Sacristy

There is very little information about this chapel. Our earliest source is Sermartelli (1617):

Nella nave di verso il convento, altare primo, quando si vien di fuora della Famiglia de' Baccelli con monumento appiè della stessa Famiglia; e finestra sopra a detto altare fatta da medesimi Baccelli, come dall'arme loro messa nell'Invetriata si vede.

Fu questo altare eretto da Piero e Baccio Baccelli l'anno del Signore 1572[1] sotto al titolo del Battesimo, la tavola del quale fù dipinta da Giovanni Stradense Fiamingo. Il monumento che

[6] Borghini, *Il Riposo*, 1584, pp. 200 f.

[7] Uffizi 10317F. Black chalk, 418×250 mm, published by S. Lecchino Giovannoni, *Mostra di disegni di Alessandro Allori*, Florence, Gabinetto Disegni . . . , 1970, no. 26. She also mentions that Uffizi 18418F is a study for the Samaritan woman's arm.

[8] Uffizi, 18475F. Black chalk, 390×260 mm. There is evidence on the drawing that the artist traced this design on to another sheet: the outlines are incised,

and the back of the sheet has been covered with black chalk to transfer the lines. Allori not infrequently used this method of copying his own designs.

[1] Sermartelli undoubtedly took this date from the tomb inscription (see below), so that it may not represent the exact date of the painting, though Firenzuola gave the same date (Orlandi–Borghigiani, ii. 400).

innanzi al detto altare si vede, non era quivi, ma sibbene fu dal luogo suo levato e messo quivi per accompagnare l'altare, nel quale oltre all'Insegna di questa Famiglia ci sono due iscrizioni, una antica, e l'altra moderna, come qui sotto si vede.[2]

In the old tomb was interred a member of the Mazzinghi family: 's. CIRCUMSPECTI VIRI MICHAELIS BENIS SPINELLI DE MAZZINGHIS, CIVIS, ET MERCATORIS FLORENTINI, ET NEPOTIS ET SUORUM DESCENDENTIUM, QUI OBIIT DIE 12 SEPT. A.D. 1430.'[3] Added to this inscription on the *chiusino* of the old tomb[4] was this modern inscription of the Baccelli family: 'PETRUS ET BACCIUS BACCELLII, SEPULCRUM A MAJORIBUS SUIS CONDITUM SIBI POSTERISQUE INSTAURARUNT AN. SAL. 1572.'[5] Since the old tomb was preserved and the inscriptions appear together, it is clear that the chapel must first have belonged to the Mazzinghi and passed from them to a branch of the family called Baccelli.[6]

The endowment of the chapel was recorded not by its founders, but by one of their sons, Tommaso di Piero Baccelli, in the year 1616. A house was consigned to the convent, the rent of which was intended as perpetual endowment of the chapel.[7] Borghigiani stated that, except for the tomb of Antonio Strozzi, this bay was empty.[8]

The original altar-piece, Stradano's *Baptism of Christ*, was still in its place at the time the 1730 edition of Borghini appeared,[9] but by Richa's time (1754)[10] it had been moved to the sacristy, where it can still be found; in its place over the altar the Ricci family had put a *Crucifixion of St. Catherine* by Romanelli. Santi di Tito's *Raising of Lazarus* is at present in this bay.

Raffaello Borghini makes the portraits in this painting the occasion to attack patrons who require artists to make inclusions in their paintings which are not appropriate to the subject-matter.[11] In terms of its style, Borghini is obviously troubled by Stradano's awkwardnesses:

Il Battesimo di Cristo ne vien ora di Giovanni Strada (disse il Sirigatto) dove oltre all'ordinanza ben considerata, ed al vaghissimo colorito, si vede un bellissimo paese, con acque molto naturali, ed in cielo un vivo splendore, e tre teste ritratte dal naturale assai buone. Certo che il paese è molto bello e vago (rispose il Michelozzo) ma la testa dell'agnolo vestito di giallo, e quella dell'altro agnolo, che tiene quel panno in mano, hanno poco grazia: ed il torso del Cristo, anzi che no, pare ad alcuni alquanto corto.[12]

[2] Sermartelli, p. 60.

[3] Fineschi, 'Monumenti della chiesa di S. Maria Novella', gives this inscription, with the date incorrectly transcribed 1421 (fo. 13ᵛ).

[4] Ibid.

[5] Sermartelli, p. 62.

[6] Brown, *The Dominican Church*, p. 117, citing Fineschi as his source, asserted that the prior allocation of this bay had been to the Mazzinghi, and Paatz (*Die Kirchen von Florenz*, iii. 717) followed Brown. Sermartelli's statement (written a century and a half before Fineschi) that the Mazzinghi tomb was *moved to* this bay from some other (undetermined) position causes me to question whether this bay actually belonged to the Mazzinghi. In any case there is no mention among the early sources of a chapel here, and none was listed among those demolished in Vasari's renovation. (See Appendix, Doc. 2.)

[7] A.S.F. Conv. Sopp. 102, vol. 106 (n.p.).

[8] Orlandi–Borghigiani, ii. 402.

[9] Borghini, *Il Riposo*, 1730, p. 74.

[10] Richa, *Notizie istoriche*, iii. 45.

[11] Borghini, *Il Riposo*, 1584, pp. 97 ff.

[12] Ibid., p. 201.

ATTAVANTI CHAPEL

Jacopo Coppi, *Christ in Glory with Saints* (Pl. 47) Right aisle, fifth bay

Inscribed at bottom on plaque: 'IACOBUS COPPI[US?] MDL[XXIIII?]' [partially covered by frame]

A chapel on the façade between the doors was erected by the Friars in dedication to St. Vincent Ferrer. The altar-panel (subject unknown) was later removed to the first cloister and replaced by a fresco of the *Annunciation*,[1] whether because of a change in the chapel's allocation or not we do not know. The dedication, however, appears not to have been changed, because it is described in the list of chapels demolished in Vasari's renovation as 'La Cappella antica di S. Vincenzio Fererrio' (Appendix, Doc. 2).

The will of Pandolfo di Giovanni Attavanti, drawn up in September 1574, describes his chapel and his reasons for founding it:

Item atteso come esso testatore per honore di Dio et salute dell'anima sua et per gratia havuta dalla buona memoria del Gran Duca Cosimo, come appare per il partito fatto de' SS. Operai di S. Maria Novella di quel tempo ha fatto edificare nella detta chiesa di S. Maria Novella una cappella intitolata di S. Vincenzio e S. Agnol Raffaello . . .[2]

The old dedication to St. Vincent Ferrer, as given by Borghigiani, was retained, possibly because the convent so stipulated. Sermartelli, however, states that the old chapel had been dedicated to 'S. Verdiana Vergine avocata di questa casa', and that *this* dedication was retained in the Attavanti chapel.[3] Though Pandolfo himself contradicts Sermartelli by not mentioning St. Verdiana, the fact that she is represented in her nun's habit (together with St. Vincent and the Archangel Raphael) at the right of the painting, and is identified by Raffaello Borghini,[4] indicates that there must have been an altar or shrine dedicated to her which was also incorporated into the new chapel.

Coppi's painting is signed and dated, but the last digits of the date are concealed behind the frame today. Sermartelli, however, specifies a date for it of 1574,[5] and we can safely assume that he read this date on the painting. The endowment of 18 florins to be paid annually by Pandolfo's heirs is recorded on 21 November 1576 in the books of Sta Maria Novella.[6]

Richa recorded that Coppi's painting was at his time still in its original position, but that the figure of St. Vincent had been repainted: '. . . già dal Meglio effigiato per il Martire, ma in S. Vincenzio Confessore da moderno pennello trasmutato.'[7] Evidently the dedication of the chapel had been changed, but no change in ownership had taken place, because Richa still refers to it as the Attavanti Chapel. When the doors were renovated in 1861 Coppi's painting was moved to its present location in the fifth bay of the right aisle, and the Vasarian tabernacle was demolished.[8]

[1] Orlandi–Borghigiani, ii. 402.
[2] A.S.F. Notarile Moderno 1052 (1574), fo. 16r–v.
[3] Sermartelli, p. 58.
[4] Borghini, *Il Riposo*, 1584, p. 99.

[5] Sermartelli, p. 58.
[6] A.S.F. Conv. Sopp. 102, vol. 92, fo. 44v.
[7] Richa, *Notizie istoriche*, iii. 72.
[8] *L'interno della chiesa di S. Maria Novella*, p. 14.

The lower zone of the painting represents the Archangel Raphael standing on the left, St. Vincent in the centre (the two titular saints mentioned in the patron Attavanti's will), and on the right, in nun's attire, St. Verdiana, to whom the chapel had previously been dedicated. The Archangel is flanked by the blind Tobit and his son Tobias (recognizable by the fish and the little dog at his feet), forming a group of three on the left. Interspersed between the saints in the lower zone are figures unrelated to any of the saints and, if Borghini is correct, representing portrait likenesses of the patron and his family.[9]

The difficulty Coppi had in arranging three unrelated figures in a unified composition is evident, but the awkwardness of the composition, its lack of drama and emotion are inherent in the requirements of the patron and are not altogether attributable to the artist's ineptitude. Borghini says that when painters are forced to represent together in one painting *cose disconvenevoli*, '. . . la colpa degli errori di questa tavola venisse da' padroni di essa.' Having made this point, he cannot say anything complimentary about Coppi's artistry:

Digrazia (soggiunse incontanente il Michelozzo) lasciate dire a me quel ch'io ne ho inteso sopra questa; perciocché la gamba del Cristo, che va indietro, non pare che possa stare: ed il torso della femmina, che ha appresso di sé il bambino, non si ritrova, ed il vecchio, che è innanzi ha la man manca storpiata: ed in somma si conclude che in tutta sia poco disegno.[10]

[9] Borghini, *Il Riposo*, 1584, p. 99. [10] Ibid., pp. 201 f.

STA CROCE

DINI CHAPEL

Francesco Salviati, *Deposition* (1548) (Pl. 24) Museo di Sta Croce

Vasari, whose biography of his friend Salviati is both detailed and accurate, indicates that this was the last painting made by Francesco before his departure from Florence for Rome[1] (dated by Iris Cheney September 1548).[2] Vasari also states, however, that the picture was commissioned by Giovanni and Piero Dini after the death of their father,[3] the date of which a source quoted by Richa incorrectly gave as 9 May 1548.[4] Paatz claimed that he had read 1547 on the tombstone in Sta Croce.[5] In fact Agostino did not die until 10 May 1552[6] and must have commissioned the painting himself.

The endowment of the chapel was provided for in Agostino's will: 16 florins 'per ofitiatura della loro cappella, e f. 4 simili per dua ofiti di morti per l'anima sua . . .'[7] In 1556 there was litigation involving the property that had been purchased as endowment for the chapel.[8] It appears that the Dini estate lost the suit, because there is a note on 6 May 1560 stating that the annual payment of 16 florins should be collected to maintain the chapel.[9]

The painting was removed from the church and transferred to its present location in the Museo di Sta Croce in the late nineteenth century.[10]

Along with its pendant, Bronzino's slightly later painting (1552; Pl. 25) for the Zanchini Chapel, this altar-piece was made before the idea of remodelling the interior of the church had taken shape. The Vasarian cycle was fitted round these two pre-existing chapels with only one violation of chronology: the sequence moves from the Alamanneschi *Crucifixion* through the Dini *Deposition* and the Zanchini *Descent into Limbo*, then returns to a *Deposition-Entombment* scene in the da Verrazzano chapel. The Bronzino and Salviati altar-pieces differ from the others in that they were designed for lunette-topped frames. Though Bronzino's painting is larger than Salviati's and their ornate frames are not identical, they are sufficiently similar to make it clear that they were considered as a pair from their inception and were conceived in relation to one another.

Raffaello Borghini was drawn to this painting in spite of its Maniera composition, because of the sheer beauty of the execution. He remarks that though Christ's body should

[1] Vasari–Milanesi, vii. 29 f.
[2] Cheney, 'Francesco Salviati', pp. 207 f.
[3] Vasari–Milanesi, vii. 29.
[4] Richa, *Notizie istoriche*, i. 100.
[5] Paatz, *Die Kirchen von Florenz*, i. 677, n. 491.
[6] A.S.F. Conv. Sopp. 92, vol. 128. I owe this information to Edward Sanchez.
[7] A.S.F. Conv. Sopp. 92, vol. 71, fo. 99.
[8] A.S.F. Conv. Sopp. 92, vol. 133, fo. 149[r–v] contains a contract drawn up by the convent and signed

by Giovanni and Piero Dini, dated 10 October 1556, in which they agree: '. . . durante detto piato si obbligano detti Dini paghare al detto Convento e frati, per ciascuno anno, scudi ventidua di lire 7, ufitiando detti frati . . .' [9] Ibid., fo. 167[v].
[10] Paatz, *Die Kirchen von Florenz*, i. 593. This painting and Bronzino's *Christ in Limbo* were severely damaged when the Museo di Sta Croce was flooded in November 1966. The restored paintings will eventually be returned for public display.

show more signs of suffering, Scripture has been observed and the women are devout and chaste, in contrast to Bronzino's[11] (see Zanchini Chapel). In judging its artistic merits, he criticizes the liberties that Salviati has taken with human form and gesture for the sake of his aesthetic effects:

Parmi molto bella (rispose il Michelozzo) nondimeno vi è qualcosa, che non finisce di piacere, come l'attitudine della Maddalena, la quale par che faccia piuttosto un atto di scherzo, che di dolore: e la Madonna è così grande sedendo, come una delle Marie, che l'è dritta a lato, e pur posano i piedi sopra un medesimo piano; talché, se la Vergine si drizzasse, sarebbe di sproporzionata grandezza, rispetto all'altre donne, che vi sono, ed arriverebbe colla testa a mezzo il corpo del Cristo; nell'altre parti mi par molto degna d'essere lodata.[12]

ALAMANNESCHI CHAPEL
Santi di Tito, *Crucifixion* (Pl. 109) *In situ*
Inscribed in right corner below soldier's foot: 'SANTI TITI F. 1588.'

The date inscribed on the picture was misread *1568* by Arnolds, and the error was repeated by Paatz.[1] This would have made it one of the earliest chapels completed in Sta Croce, whereas in fact it was the last save one (the Serristori Chapel). Lapini records the date on which work was begun on this chapel:

A dì 18 di detto gennaio [1583/4], in mercoledì, si gittorno i fondamenti della cappella posta in Santa Croce di Firenze, che è quella che è accanto a la [sepoltura] di Michelangnolo Buonarroti, di verso la porta di fianco, verso la piazza: quale è stata l'ultima che si è fabricata per le nave, che è delli Alamanneschi . . . così questa delli Alamanneschi è stata l'ultima a fabricarsi giù per le navi.[2]

The discovery of the correct date of the painting explains why it is conspicuously missing from Raffaello Borghini's thorough discussion of these altar-pieces in 1584. Bocchi (1591) is the earliest source to record the painting.[3]

The Alamanneschi name appears in the records of Sta Croce throughout the sixteenth century,[4] but the endowment of the chapel is not recorded until 1608, although the contract for it was made in 1594.

9 di Maggio 1608

Ricordo come siamo ubbligati celebrare dua uffizi con trenta messe piane l'anno in perpetuo, che uno del mese di Maggio et l'altro del mese di 9bre come che si vede allo stratto di sagrestia in detti mesi per l'anima di messer Francescho e Filippo Alamanneschi per lor Padre, Madre [etc.] . . . con carico di più di celebrare ugni mattina alla lor' Cappella una messa con l'oratione de' Morti quando sarà giorno che si possa dire . . . come appare per Contratto Rogato per mano di messer Orazio Macchanti sotto dì 3 di dicembre 1594.[5]

[11] Borghini, *Il Riposo*, 1584, p. 110.
[12] Ibid., pp. 186 f.

[1] Arnolds, *Santi di Tito*, pp. 26, 79; Paatz, *Die Kirchen von Florenz*, i. 549. [2] Lapini, *Diario*, p. 229.
[3] Bocchi, *Le bellezze*, p. 159.
[4] In 1509 Boccaccio di Alamanno Alamanneschi had

made a contract with the convent, which was renewed in 1570 by Francesco and Filippo di Ruberto and Alberto di Francesco di Filippo Alamanneschi, but without any mention of a chapel. A.S.F. Conv. Sopp. 92, vol. 133, fo. 223; the endowment account can be found in vol. 71, fo. 230.
[5] A.S.F. Conv. Sopp. 92, vol. 134, fo. 107.

The altar was decorated with the Alamanneschi arms in the centre, with the arms of the Adimari on one side and those of the Cavicciuli on the other. The tomb at the foot of the altar bears the inscription: 'FRANCISCUS ET FILIPPUS ALAMANNESCHI CAVIC-CIULI ADIMARI ROBERTI FILIORUM A.D. 1585.'[6]

This chapel may have been allocated during the second half of the Quattrocento because there were frescoes by Domenico Ghirlandaio here representing the life of S. Paolino.[7] The name of the patron is not known.

Three compositional sketches show Santi developing the plan of the soldiers on the right of his painting. In the first (Pl. 110),[8] the artist has represented the Madonna in her traditional swoon, supported by John and the Magdalen. On the right, one soldier is climbing on the ladder, probably, but not certainly, down from the cross. Two other soldiers, back to back, counterbalance the Madonna group. Evidently Santi found this design unsatisfactory because of the imbalance created by the single ladder at the right edge; so in another drawing (Pl. 111)[9] he put the ladder in the arms of the soldier facing away, introduced a second ladder at the base of the other thief's cross, and transferred the Magdalen to the middle, where she kneels at the foot of Christ's cross. The Madonna, having lost half her support, now stands upright. The design, by utilizing depth, introduces variety into the heights of the heads and unifies the two zones more successfully. On the verso of this drawing (Pl. 112) Santi reversed the two soldiers, placing the one with his back to us at the outer edge, as we see it in the painting; instead of the unwieldy ladder, he introduced the mounted soldier. Other changes were made before the final version. Evidently feeling that the Madonna should show more emotion than does the quiet stalwart figure standing beside John, he transformed that figure into another of the Marys, and introduced the Madonna behind the Magdalen. The fact that this change was made so late explains the unlikely iconography in which the Madonna appears in the background, scarcely visible and obscured by shadow. As he appears finally, the soldier at the right presents a single touch of elegance in an otherwise rustic scene. He alone is animated, his drapery swirling in motion. His grace and garb and reversed pose suggest a Zuccaresque prototype.

BUONARROTI CHAPEL
Giorgio Vasari, *Christ on the Way to Calvary* (1572) (Pl. 40) *In situ*

The site of the Buonarroti Chapel was determined by the location of Michelangelo's tomb, which had been placed between the first and second bays in the right aisle. Work on

[6] A.S.F. MS. 618, fo. 80, and MS. 624 (Rosselli), vol. i, p. 271.
[7] Vasari-Milanesi iii. 255; Paatz, *Die Kirchen von Florenz*, i. 595. This chapel is not mentioned in the Inventory of 1439.
[8] Uffizi 773F. Pen and watercolour, heightened with white, traces of black chalk, blue paper, 361×251 mm.
[9] Uffizi 771F. Pen and watercolour, heightened with white, traces of black chalk, blue paper, 357×231 mm. Verso: pen, traces of black chalk. A red-chalk study for the figure of John is also preserved in the Uffizi (7618F), 405×243 mm.

the tomb had begun under Vasari's direction shortly after the funeral in 1564. The decision to add a chapel to the tomb must have been made shortly after the plan to renovate the church took shape; we know from a note written to himself on the back of a letter that in 1568 Vasari had already accepted the commission to paint this altar-piece for Lionardo Buonarroti.[1] The delay of more than four years before the painting was completed was due, doubtless, to Vasari's overcrowded schedule; and since Michelangelo's nephew had shown little enthusiasm even for the tomb project (above all, when the time came to pay), we can suppose that the patron was not exerting pressure to get the painting completed and that Vasari found it easy to put other things first.

The preparation of the panel was under way in June 1572, for at that time Vasari wrote to Lionardo requesting that he pay 37 scudi for 'making the frame for his painting which was to go in S. Croce'.[2] Two months later he wrote again, asking for a payment of ten scudi for the cost of the gold for gilding the frame.[3] By the time another two months had elapsed Vasari had nearly finished the execution of the panel: in his letter to Borghini on 18 October he remarked that he intended to finish both the *Incredulity of Thomas* for the Guidacci Chapel (Pl. 39) and the Buonarroti picture in time to get them installed for All Saints' Day.[4] Only a week later, on 25 October, he reported to Don Vincenzo that both paintings were finished.[5] On Hallowe'en he wrote to Lionardo rendering his final bill:

Magnifico messer Lionardo signor mio. Per conto della tavola della vostra cappella di S. Croce per conto del legname è questo che s'è pagato a Nisgii legnaiolo alla Nighittosa scudi diciotto e soldi sedici che tanto hanno pagato la loro e Guidacci al detto scudi 18.16.

Però la S.V. pagherà e detti danari al sig. Spedalingo degl'Innocenti e a conto della tavola scudi dugento d'oro in oro a ogni vostro piacere e la tavola vi sarà consegnata da ser Pietro mio fratello a ogni vostro piacere e comodo: e mi vi raccomando.[6]

The next day Vasari, who was about to depart for Rome, wrote to Borghini that he should expect payment from both Guidacci and Buonarroti.[7] On 20 December Borghini informed Vasari in Rome that he had finally received payment from Lionardo. He goes on to comment upon the two new altar-pieces which he had only just seen *in situ*:

Hiersera fui in Santa Croce et vidi su tutte le due nuove tavole; et parmi che tornino molto bene, et quella del Buonarroti anche un po' meglio, che la historia credo ne sia cagione, ché del resto sono d'un medesimo maestro; et anche era da sera et quella di San Tommaso ha dirimpetto que' lumi et vi batteva il sole, che gli danno un po' di noia, et bisogna correr costi per certi versi a poterla veder bene; ma questi altri vi diranno qualcosa, ché io ho nelle cose vostre gli occhiali che mostrono bene tutto; et per anchora non ho dato in persone che ne habbino parlato, ché non si sa anchora: alla prima festa si saprà qualche cosa.[8]

Vasari has adapted for his altar-piece an iconography that was designed for a horizontal format. The procession to Calvary as it is represented in a *modello* of the 1520s from the Roman circle[9] is very similar, even in detail, to Vasari's version. This design, its source—

[1] Frey, ii. 407. [2] 21 June 1572. Ibid., p. 687. [7] Ibid., pp. 715–16. [8] Ibid., p. 734.
[3] 23 August 1572. Ibid., p. 698. [9] British Museum 1885–7–11–267, attributed to
[4] Ibid., p. 705. Rosso Fiorentino, reproduced in K. Kusenberg, *Le*
[5] Ibid., p. 710. [6] Ibid., p. 715. *Rosso*, Paris, 1931, pl. LX, attributed to Léonard Thiry.

which was probably northern, perhaps Dürer—or a derivative, may have been Vasari's source.

Vasari has made several alterations in adapting his source. The soldier in the foreground of the drawing, whipping and kicking the fallen Christ, has been moved to the side in Vasari's version, and for his violent gesture an elegant *contrapposto* has been substituted. Vasari has also adjusted Christ's pose to one with greater poise which better maintains the plane. He has eliminated Christ's expression of agony, and turned his attention to Veronica. Thus nothing of the Saviour's suffering and humiliation is given expression in Vasari's version.

One is not surprised to find that it is precisely Vasari's alterations of his Mannerist prototype of which Raffaello Borghini disapproves:

Digrazia bastivi l'aver detto infino a qui (suggiunse tosto il Michelozzo) perchè non vi si vede ordinanza, che buona sia; anzi le figure pajono attacate insieme: e la Maddalena, la Madonna, e San Giovanni par che facciano alle braccia: Cristo non mostra affetto nel portar la Croce, e si volge a Santa Veronica con troppa fierezza: ed i cavalli, che vi sono, non hanno molto disegno.[10]

There is a handsome pen-and-wash drawing for this altar-piece in the Uffizi (Pl. 42).[11] As is so often the case with Vasari, the drawing has a freshness and freedom that has become frozen and hard in the painting.

ZATI CHAPEL
Jacopo Coppi, *Ecce Homo* (Pl. 48) *In situ*
Inscribed in centre at lower edge: 'IACOPII COPI OPVS MDLXXVI'.
Appendix, Doc. 6 and Doc. 16.

In his will, drawn up on 12 August 1551 and notarized by ser Piero Gemmari, Andreuolo di Niccolò Zati left 1,200 florins to his son, Alessandro, instructing him that when he reached the age of 18 he should found a chapel in Sta Croce, for which he was to spend 800 florins on the painting, ornamentation, tomb, lamp, and similar items, and the remaining 400 florins on the endowment of the chapel. On 10 July 1565, when Alessandro was already well past his eighteenth birthday, he was called before the ecclesiastical authorities for failing to execute his father's will. At this time he was given four years in which to construct the chapel; if by 1569 he had not done so, he would be fined 200 florins, which would be added to the endowment of the chapel.[1]

On 6 February 1568/9, the *Operai* wrote to the Duke reviewing these facts, advising him that they had not been able to induce Alessandro to begin construction of the chapel, and asking the Duke how they should proceed. He replied that they should continue to press Zati to fulfil his obligation (Appendix, Doc. 6).

[10] Borghini, *Il Riposo*, 1584, p. 191.
[11] Uffizi 1190E. 320 × 241 mm, squared. Published in: Florence, Gabinetto Disegni . . . , *Mostra di disegni dei fondatori dell'Accademia delle Arti del Disegno*, 1963, no.

37, fig. 24.

[1] This contract was notarized by Ser Agnolo del Favilla.

In February 1571 an account was opened in Alessandro's name, into which he was obliged to pay 20 florins per annum for the celebration of masses in his chapel.[2] This represented 5 per cent interest on the 400 florins which were to be given as endowment. At this time the construction of the chapel seems to have been completed. Upon completion of the painting, the friars would maintain the lighted lamp at their own expense.

In 1576 the painting was finished, and on 5 July 1577 Alessandro deposited in the bank 300 of the 400 florins which he owed for the endowment. On 18 June 1581 the remaining 100 florins had still not been paid. At this time, undoubtedly in response to the demands of the convent that he make payment immediately, Zati asked that another four years be granted him in which to complete the endowment. An agreement was drawn up by the convent and signed by Zati (Appendix, Doc. 16), which provided that by the end of the four-year period he should have paid the remaining 100 florins of the endowment, in addition to half the fine imposed upon him in 1565, making a total of 200 florins.[3] (The other half of the fine was remitted.) If at the end of the four years he had still not paid the endowment, he would then be charged interest of 5 per cent per annum for as long as he failed to pay.

The Inventory of Chapels which stated that the endowment was 300 florins indicates that Alessandro did not conform to the terms of this agreement either:

Alla Cappella de' Zati intitolata S. Andrea et S. Niccolò, anchor che vi sia dipinto l'Ecce Homo, fondata da Alessandro d'Andreuolo Zati per lascio di detto Andreuolo suo padre; et vi s'ha a dire ogni mattina messa, per l'anima di detto Andreuolo et di madonna Ginevra de' Gondi sua seconda donna. Et ci lasciò f. 300 di l. 7 l'uno, messi sul Monte della Pietà. La tavola la dipinse Iacobo di Coppo, detto Iacopino di Meglio.[4]

Mencherini, on the basis of a Quattrocento note that there were some Zati banners in the church,[5] believed that the Zati had owned a chapel on the *tramezzo* which was destroyed in 1566;[6] Paatz also makes this assumption.[7] However, no chapel belonging to the Zati family is mentioned in the 1439 Inventory of Chapels, and it would appear from Andreuolo's desire, expressed in his will, to found a chapel that no Zati Chapel existed in 1551.

In view of its *retardataire* style, it is to be expected that the anti-Maniera Borghini would censure Coppi's altar-piece. He suggests that it be passed by without comment.[8] Subsequently in his discussion of style, however, he unrestrainedly unleashes his disdain:

Quella che segue è di Jacopo di Meglio, dove si vede Cristo da Pilato mostrato al popolo (disse il Sirigatto) e mi sembra molto copiosa. Sì, ma la copia (rispose il Michelozzo) genera fastidio, perché è di disposizione male ordinata, secondoché dicono quei che intendono, l'architettura confusa, le femmine senza grazia, il Cristo posa male, e le gambe di quella figura vestita di giallo, che è innanzi, non si ritrovano, e particolarmente la gamba destra non pare che esca del suo busto e tutta la figura è di membra disunita . . .[9]

[2] A.S.F. Conv. Sopp. 92, vol. 71, fo. 248.
[3] This agreement is recorded in the account books of the convent in vol. 71, fo. 336.
[4] A.S.F. Conv. Sopp. 92, vol. 362.
[5] Rosselli (MS. 624) also cites this note.

[6] Mencherini, *S. Croce*, p. 27.
[7] Paatz, *Die Kirchen von Florenz*, i. 594.
[8] Borghini, *Il Riposo*, 1584, p. 111.
[9] Ibid., pp. 190 f.

CORSI CHAPEL

Alessandro del Barbiere, *Flagellation of Christ* (Pl. 83) *In situ*

Inscribed on base of column, to the right of Christ's foot: 'ALEXANDRO DEL BARBIERE
DE FEI MDLXXV'

This chapel already belonged to the Corsi family in 1571, which is the date on the Corsi
Tomb in front of the chapel.[1] In 1573 'Simone e Antonio fratelli di Iacopo de Corsi' de-
posited 100 florins in the Uffiziali di Monte, the income of which was to be paid to Sta
Croce for the celebration of masses 'alla loro Cappella'; the payment of 14 lire 12 soldi
each year from 1574 to 1580 is recorded.[2] Though the chapel must have been finished by
1575 when the painting is dated, the formal endowment was not made until 1579:

> Ricordo come sotto dì 8 di Luglio 1579, e magnifici Simone et Antonio di Iacopo di Simone Corsi
> tanto in nome loro che delle rede di Bardo e Giovanni lor fratelli buone memorie ci ànno dato una
> casa posta nel popolo di santa Lucia sul Prato nella via detta Palazzuolo per dota della loro Cappella
> posta nella nostra chiesa al presente la 3ᵃ a man ritta dove è nella tavola l'immagine di nostro
> Signore flagellato alla colonna con obrigo . . . [etc.] come per contratto rogato ser Agniolo del
> Favilla sotto el sopradetto dì al quale si abbi relazione et la detta casa, è apigionata per f. 22 di l. 7
> piccioli.[3]

This chapel and the Pazzi Chapel next to it were the site of the great Orcagna frescoes
which were covered over in Vasari's renovation. Fragments of the *Triumph of Death* were
discovered behind the Pazzi altar in 1911, and fragments of the *Last Judgment* and of *Hell*
were found behind the Corsi altar in 1942. In 1958, remnants of the upper band of frescoes
were uncovered, and the following year all the fragments were removed and eventually
installed in the Museo di Sta Croce.[4]

Barbiere's single contribution to these cycles is qualitatively among the best; and to
judge by his few surviving works it is his own masterpiece, as Borghini commented.[5]
His figure of Christ was influenced by Sebastiano del Piombo's fresco in S. Pietro in Mon-
torio, which Alessandro would have come to know during the months that he worked in
Rome in 1571 assisting Vasari on the chapels in the Vatican.[6] Alessandro's Christ has the
same long-torsoed, heavily muscled body, but he stands more nearly upright. The flagel-
lators, however, do not resemble Sebastiano's dancing figures, but stand much more
solidly. The flagellator on the right has been magnified in importance, so that he shares
the spotlight equally with Christ. As his model for this figure, Barbiere has turned to his

[1] A.S.F. MS. 618, p. 78; also Rosselli (MS. 624),
p. 273.

[2] A.S.F. Conv. Sopp. 92, vol. 71, fo. 259. This same
transaction is also recorded in the *Ricordanze*, vol. 133,
fo. 249.

[3] A.S.F. Conv. Sopp. 92, vol. 133, fo. 305ᵛ. As is
recorded in the margin of this document, the account
can be found in 'Campione Giallo Segnato C' (vol. 71),
fo. 321.

[4] Richard Offner, *A Corpus of Florentine Painting*,

Section IV, vol. i, New York, 1962, pp. 54–6.

[5] Borghini, *Il Riposo*, 1584, p. 634: 'In Santa Croce
alla cappella de' Corsi la tavola, in cui si vede Cristo
alla colonna con molte figure benissimo accomodate,
ed una prospettiva fatta con arte grandissima: ed è
divero quest'opera degna di considerazione, per esser
bene osservata in ogni parte, e la migliore, che abbia
fatto Alessandro . . .'

[6] See Vasari's letter to Francesco de' Medici, dated
10 February 1570/1 (Frey, ii. 565 f.).

favourite source, Andrea del Sarto—in this case, to the Scalzo fresco of the beheading of John the Baptist. Like Andrea's executioner, Barbiere's flagellator is seen from the back, has the same broad-based stance, and the same partially bared back and bare legs.

Two preparatory drawings reveal the extent of Barbiere's dependence upon Andrea del Sarto. In the Louvre study from the Baldinucci collection (Pl. 84),[7] Barbiere has handled the red chalk in a manner which closely resembles Andrea's. He uses the same rapid strokes, reworking repeatedly, to fix the outline; broad parallel strokes suffice to suggest shading or the background. Barbiere's style is cruder than the master's, almost a parody of it. It lacks Andrea's freedom and flexibility, and often becomes tight and hard. A black-chalk drawing (Pl. 85), which was attributed to Rustici in the collection of its last known owner, is a study for the flagellator at the right, squared for transfer.[8] Here again we see Barbiere's derivative Sartesque style, his tendency to insist upon the outline, giving only schematic indications of the modelling and of interior contours. The curious nubbly *pentimenti* of the flagellator's left hand are Barbiere's signature.

Barbiere's narrative treatment of his subject was appealing to the anti-Maniera author of *Il Riposo*. Borghini complimented the painting for its scriptural accuracy and for its beautiful architecture and figures, criticizing only the figure of Christ for not showing more evidence of the flagellation.[9] In terms of its artistic merits, Borghini has nothing but good to say:

Questa di Cristo alla colonna (soggiunse il Sirigatto) è d'Alessandro del Barbiere, in cui potete vedere una dispozione ben ordinata, l'attitudini convenevoli, le membra a' loro luoghi bene accomodate, i colori vaghi, e la prospettiva, con bell'ordine fuggendo in dentro, porge all'occhio diletto. Di vero che vi si veggono molte parti ben osservate (disse il Michelozzo) e tutta insieme mi piace assai.[10]

PAZZI CHAPEL
Andrea del Minga, *The Agony in the Garden* (1574/8) (Pl. 86) *In situ*
Inscribed at the left: 'AND. MINGHI'

The Pazzi tomb in front of the chapel is inscribed 1571.[1] The endowment was given by Alamanno de' Pazzi in a codicil to his will dated 21 February 1573/4; the record of the

[7] No. 198. Red chalk, 173 × 211 mm. This drawing was published in the exhibition catalogue, *Dessins florentins de la collection de Filippo Baldinucci (1625–96)*, Paris, Louvre, 1958, no. 21; and in the recent catalogue by Catherine Monbeig-Goguel, *Vasari et son temps*, Paris, Louvre, 1972, no. 28.

[8] Formerly in the possession of the dealer Franz Koenigs in Munich; present location not known. The close relationship in style to Sarto is witnessed by the fact that Berenson had noted on the photograph of the drawing an attribution to the school of Andrea del Sarto (I Tatti Photograph Collection).

[9] Borghini, *Il Riposo*, 1584, pp. 111 f. 'A me piace molto (rispose il Vecchietto) sì per l'invenzione delle sacre carte, come per la propria del pittore, che l'ha d'una bella architettura e di molte figure arricchita; ma più divozione darebbe, quando il corpo del Cristo i lividi delle battiture di quei manigoldi dimostrasse.'

[10] Ibid., p. 190.

[1] A.S.F. MS. 618, p. 77; also Rosselli (MS. 624), p. 273.

Convent in establishing an account of this endowment speaks of the chapel as though it were still under construction:

Rede di Alamanno di Antonio de' Pazzi deon dare f. 300 di moneta per lascio di detto Alamanno acciò possiamo uffiziare la Cappella che fece in nostra Chiesa da rispendersi da noi infra 18 mesi in beni stabili et non gli havendo noi rispesi in detto tempo 6 mesi poi dopo detti 18 mesi che sono 2 anni, gli possino rispendere dette Rede et non potendo ciò fare le dette Rede che gli hanno in mano et gli hanno a tenere finché non si rispondono in beni stabili, sieno obbligate dette Rede depositarli sul Monte della Pietà di Firenze per rispenderli quando occasione si porgerà e tutto è per dote di detta sua Cappella; et perchè detto Alamanno passò all'altra vita il dì primo di Marzo 1573, detto dì comincia il tempo di detti denari, et in mentre gli tengono dette Rede sono obbligate darcene li 5 per cento l'anno acciò possiamo eseguire il Testamento, che siamo obbligati ogni mattina celebrarvi una messa et ogn'anno il dì di S. Antonio di Gennaio celebrarvi un uffizio de' morti con 30 messe o vero la vigilia di detto S. Antonio come per suo codicillo rogato ser Francesco di ser Giovanbattista di Giordano in dì 21 di Febraio 1573, come al libro Ricordanze A, 249.[2]

On 16 February 1578/9 Girolamo de' Pazzi, Alamanno's son, deposited 300 florins in the Monte di Pietà.[3]

This bay, and not that of the Serristori Chapel, was the site of the della Foresta Chapel (see Fig. 2). The *ricordo* of an agreement made with Bernardo di Francesco della Foresta on 12 February 1589/90 concerning the maintenance of a lighted lamp, describes the position and history of the della Foresta Chapel precisely:

. . . sua cappella ch'era sotto il Tramezzo della nostra Chiesa a canto alla Capella de' Cavalcanti dov'è hoggi la Cappella di M. Alamanno de' Pazzi, ma per ordine del Serenissimo Cosimo Gran Duca di Toscana l'anno 1565 detto Tramezzo fu levato et la detta Cappella ancor fu levata via . . .[4]

Rosselli (and Moisè and Paatz following him) mistakenly describe this chapel as being in the Serristori bay.[5]

It may be that the Pazzi were originally assigned the third bay in this aisle and that Vasari himself expected to paint the altar-piece. We know that he had on his mind an *Ecce Homo* for Alamanno de' Pazzi in September 1568;[6] whether it was to be for Sta Croce we cannot be sure. Alamanno's death in February 1574, followed a few months later by Vasari's own demise, put an end to this plan, if indeed it had not already been abandoned when Pazzi was assigned the fifth bay, and the commission was open. On the basis of the documents cited above, the altar-piece would seem to have been executed between 1574 and 1578, so that the approximate date of 1575 assigned to it by Paatz[7] is substantially correct.

[2] A.S.F. Conv. Sopp. 92, vol. 71, fo. 258. The *ricordo* of this same endowment can be found in vol. 133, fos. 249 f., as the cross-reference quoted here indicates. Also recorded in vol. 343, fo. 114r.

[3] A.S.F. Conv. Sopp. 92, vol. 112, fo. 66v. Moisè (*S. Croce di Firenze*, p. 140) gives the amount as 200 ducats.

[4] A.S.F. Conv. Sopp. 92, vol. 72, fo. 193r. This agreement can be found in A.S.F. Notarile Moderno, no. 4608 (Ser Antonio Biagini, 12 February 1589/90),

fo. 120, but the position of the chapel is not specified.

[5] See Hall, 'The *Tramezzo* in Santa Croce, Florence, Reconstructed', p. 325, n. 4.

[6] Vasari noted on the back of a letter dated 19 September 1568 a list of pictures he had to paint. Third on the list is: 'per Alamano de papi [*sic*; probably misread by Frey] Ecce Homo'. Frey, ii. 407.

[7] Paatz, *Die Kirchen von Florenz*, i. 551.

According to Colnaghi,[8] Andrea del Minga and his brother Francesco were expelled from the Accademia del Disegno in January 1571/2.[9] It is peculiar that an artist of so little experience, who had been adjudged unworthy of belonging to his professional fraternity, should have been granted the commission for the altar-piece of the Pazzi family. This lends credence to the hypothesis that Vasari himself had intended to execute the altar-piece, since it is entirely unlikely that he would have allowed one rejected from his Academy into the privileged circle of those adorning the naves of these churches. It may be evidence of the breakdown of the Academy's efficacy after Vasari's death that Andrea received the commission.

Had it not been for the undermining effect of the rumour, then current in Florence, that Andrea had been given substantial assistance by three other artists,[10] Borghini would perhaps have expressed his approval at greater length than he did. He indicates, however, that he considers this work to be very well done and well observed;[11] it should be praised, and Andrea as well if, contrary to report, he was responsible.[12]

A drawing, said to be a *primo pensiero* for this altar-piece, has been published.[13] Since there are no other drawings known to be by Minga, and because the drawing differs considerably from the finished work, it is impossible to make a final judgement on the attribution. If this drawing is by Andrea, it shows him to be a mediocre draftsman. If the drawing is related to the painting, the artist must have decided after studying it to move Christ and the angel to the left so that the approaching soldiers could come upon him from behind. The disposition of the sleeping Apostles had also to be changed to readjust the balance.

CAVALCANTI CHAPEL

Though the Cavalcanti Chapel is not listed in the 1439 Inventory of Chapels (Appendix, Doc. 1) we assume that Donatello's *Annunciation* tabernacle already existed at that time.[1]

[8] Colnaghi, pp. 74 f.

[9] The discovery of Andrea's account for the payment of his dues in the records of the Accademia del Disegno (A.S.F. vol. 123, fos. 3, 71) confirms Colnaghi's statements:

f. 3

Andrea di Marioto del Mi(n)ga pitore de' dare...
E de' dare L. tredici, dicho lire tredici, da l'anno, ci(o)è da novembre 1571 fino a maggio 1578, ci(o)è di anni sei e mesi sei, a ragione di L. dua l'anno di sua tassa
――――――――L. 13――

f. 71 +YHS M.ª MDLXXVIII
Andrea di Mariotto del

f. 3

Andrea di Marioto p(ittore) de' avere...
E de' avere lire sedici s. 10, per tanti posto debitore per resto di sua tassa sino a maggio 1578, in questo dare a c. 71――――――――
――――――――L. 16. 10

f. 71
(no entry)

Mingha de' dare lire sedici s. 10 per resto di sua tassa sino a maggio 1578, come in questo avere a c. 3 fu già raso di nostra academia
――――――――― L. 16. 10

[10] Borghini, *Il Riposo*, 1584, p. 111. See above, p. 76.
[11] Borghini, *Il Riposo*, 1584, p. 111.
[12] Ibid., p. 190.
[13] Florence, Gabinetto Disegni e Stampe degli Uffizi, *Mostra . . . dell'Accademia del Disegno*, no. 92. Entry written by Adelaide Bianchini. Uffizi 1089F. 397× 282 mm, pen and bistre on bistre-washed paper.

[1] H. W. Janson, *The Sculpture of Donatello*, Princeton, 1957, il. 103 ff., dates it *c*. 1428–33. Possibly the Cavalcanti, like the Serristori next to them (see next entry), did not found and endow a *chapel* in the Quattrocento.

Vasari records in his *Vite* that he had transferred Domenico Veneziano's fresco of *St. Francis and St. Jerome* from the *tramezzo* to the aisle wall in this bay of the church (where it remained until modern times when it was removed to the Museo di Sta Croce). I have recently been able to reconstruct the position of the fresco as having been on the reverse side of the wall where the della Foresta Chapel was.[2]

Paatz, mistakenly believing that *tramezzo* meant choir wall, assumed that the Cavalcanti Chapel was on the choir wall and that not only the fresco but also Donatello's tabernacle had been transferred.[3] As Janson also concluded, there is no reason to believe that the Donatello has ever been moved.

As a result of the Vasarian remodelling, the Cavalcanti were called upon to endow their chapel, which was done by Francesco di Matteo Cavalcanti in his will drawn up on 5 July 1576, notarized by ser Luca Bandocci.[4]

When in 1581 the ecclesiastical authorities informed the *Operai* of a plan to remove the altar of the Immaculate Conception and place it under the organ where the door was and is today, the *Operai* objected strenuously in a letter to the Grand Duke Francesco, claiming that it would be necessary to reorganize the bay opposite as well (see Appendix, Doc. 15). According to the *Operai*, the Cavalcanti altar would have to displace the door in the centre and small doors be put in beside the chapels. This would, among other things, disrupt the carefully planned programme of the Passion cycle by introducing the *Annunciation* between the *Last Supper* (Serristori) and *The Agony in the Garden*. We can infer from this, and from paragraph 5 added at the end of our document, that the Cavalcanti *Annunciation* was at that time located off-centre in this bay, as it is today.

SERRISTORI CHAPEL

Ristoro Serristori stated in his will in 1559 (Appendix, Doc. 8) that there was already a Serristori family altar in Sta Croce near the door leading into the cloister ('nella quale chiesa già ha fatto uno altare nel muro propinquo alla porta di detta chiesa').[1] This altar is not mentioned in the 1439 Inventory of Chapels, probably because it was only an altar and not a chapel; Rosselli mentions a tomb in this bay bearing the date 20 August 1400.[2] It was Ristoro's intention to erect a chapel at the site of the family altar and for this purpose he left 300 florins, of which 200 florins were to be used for the endowment. However, when the ducal project to renovate all the chapels was announced a few years later,

[2] Fig. 2, no. 20, shows the location of the della Foresta Chapel. To view Domenico Veneziano's fresco one would have had to stand on the choir side of the *tramezzo* facing the façade. See my article, 'The *Tramezzo* in S. Croce, Florence, Reconstructed'. The presumed position of the fresco has been corrected with respect to my earlier publication, 'The *Tramezzo* in S. Croce and Domenico Veneziano's Fresco'.

[3] Paatz, *Die Kirchen von Florenz*, i. 594.

[4] A.S.F. Conv. Sopp. 92, vol. 133, fo. 272ʳ. The account can be found in vol. 71 (Debitori/Creditori), fo. 301. The will can also be found among the records of the notary, but it does not give any further information about the chapel.

[1] A. S. Croce, vol. 426, fo. 7. The will is dated 21 August 1559 and notarized by ser Niccolò Parenti.

[2] MS. 624, p. 274.

Ristoro's heirs were evidently disinclined to spend a sum amounting to about three times as much as Ristoro had provided.

At this time another branch of the family apparently took over responsibility for the chapel. Averardo Serristori, who was a friend of the duke's and his ambassador to Rome, must have agreed to construct the chapel, for in September, 1568, Vasari made a note that the *Last Supper* for Averardo Serristori was to be painted.[3] Averardo died shortly thereafter, and apparently his heirs also were unwilling to construct the chapel. At this point the *Operai* turned to a third branch of the family, and offered Lodovico di Francesco Serristori the opportunity to build a family chapel according to the design prescribed by the *Opera*. Lodovico wrote back to the *Opera* on 19 May 1569 (Appendix, Doc. 8), saying that he could not give up this site, which had always belonged to his family, and that he would gladly construct the new chapel himself, provided the heirs of Ristoro would give him the necessary permission.

It was nearly two years before Lodovico wrote again to the *Opera* (15 March 1570/1), and even then the question whether the other branch would cede it to him did not seem to be finally decided. Nevertheless, Lodovico requested the *Opera* to appropriate the site to him.[4]

Construction of the chapel still did not get under way, however, and the *Opera* began to lose patience with the protracted negotiations. The following December Vasari conveyed to the *Operai* the grand-ducal decision that the old Serristori altar should be removed so that Lodovico would have no excuse for failing to begin the new chapel. They were ordered to give Lodovico the ultimatum that if he had not begun the chapel within a certain time, the site would be allocated to someone else (Appendix, Doc. 14).

The chapel was finally begun under the patronage of several members of the family, but construction was interrupted by the failure of certain parties to meet the expenses. In an undated document the 'Reverendissimo Monsignor Lodovico di Francesco Serristori' and a certain Francesco di Alessandro Serristori informed the *Operai* of their willingness, past and present, to pay their share of the expenses, and urged the *Operai* to use more forceful measures to compel their relatives to fulfil their responsibilities.[5]

Finally on 20 April 1580 the *Operai* wrote to the Grand Duke, pointing out that the chapel was still unfinished and that it was an eyesore. They asked for permission again to threaten the Serristori that, if they did not bring it to completion within a short time, the

[3] Frey, ii. 407.

[4] 'Lodovico Serristori ad voi Signori Operai di Santa Croce domanda il sito de' Serristori in detta chiesa perché se li suoi parenti non volessino fabbricar la cappella, egli medeximo lo farà, et vi prega a farne partito secondo gli ordini in lui, come in persona che vi ha interesso, et circa le circustanzie di farli libero detto sito da altri altari o sepolcri o altro se ne tratterà in prima audienza. Di casa, addì 15 di marzo 1570. Lodovico Serristori mano propria.' A. S. Croce, vol. 426, fo. 5.

[5] '. . . Et dissero et dicono che loro et ciascuno di loro furno et sono stati per il passato, come ancora al presente sono pronti et parati a concorrere alla spesa che si deve fare nella cappella da farsi nella chiesa di Santa Croce della città di Firenze per la famiglia de' Serristori, o per dir meglio da finirsi, et si offeriscano a concorrere come di sopra a ogni rata e parte che toccasse loro et a ciascuno di loro, per la concorrente quantità della detta spesa per le cause di che di sopra; et domandorno et domandano che per le Signorie Vostre si constringhino gli altri della famiglia de' Serristori qualli non volessino spontaneamente concorrere a detta spesa . . .' A. S. Croce, vol. 429 (n.p.).

site would be allocated to someone else.[6] A few weeks later, on 5 May, Lodovico wrote to the *Opera* saying that he was willing to finish the chapel alone if the *Opera* should so decide.[7]

This chapel was designed to contain the first altar of the cycle, namely the *Last Supper*. We know that this was still the intention of the *Opera* in 1581 when it is mentioned in a letter discussing the cycle (Appendix, Doc. 15). In 1591 Bocchi stated that a painting representing this event was in progress, but he did not identify the artist.[8] At some time after this the subject was changed to *Christ's Entry into Jerusalem*, and Ludovico Cigoli began the painting which now hangs over the altar. Cigoli left it unfinished when he departed for Rome in 1604; it was completed after his death in 1613 by his pupil, Bilivert.[9]

This bay was the original site of Alfonso della Casa's altar dedicated to the Immaculate Conception (q.v.). As Francesco da San Gallo testified on 9 November 1571, it became necessary to move della Casa's altar when the chapel was conceded to Lodovico Serristori. Since della Casa's altar is described as being beside the Bruni Tomb ('secus sepulchrum quondam Leonardi de Aretio'),[10] it must have been placed where today we find Rossini's monument. The first Serristori altar, which, we remember, was described as *near* ('propinquo'), but not as *next to* ('accanto') the door to the cloister, must have been beside della Casa's altar. The della Foresta Chapel was not in this bay, as Rosselli, Moisè, and Paatz believed, but in the bay of the Pazzi Chapel (q.v.).

RISALITI CHAPEL
[Girolamo Macchietti, *Trinity* (*c.* 1575)] Lost

In 1575, Tommaso Risaliti had a chapel constructed on the wall to the left of the door to the Salviati Chapel where today we find the funeral monument of Luigi Cherubini.

6 'Serenissimo Gran Duca. Gli operai di Sᵗᵃ Croce di Firenze reverentemente expongano a V.A.S. come la cappella de' Serristori è ancora nell'essere che è stata per il passato né si vede che pensino di dargli fine. Et perché l'imperfectione di quella dà molto brutezza alla chiesa oltre al'occupare che altri non la finisca et conduca a perfectione erano di parere di fargli un precepto che se infra un tempo conveniente non davano ordine di finirla si darebbe ad altri. Ma perché se gli sono fatti per altri tempi più precetti simili et di poi non si è venuto al'executione d'essi però desidererebbano fargli questo per ultimo et peremptorio quando fussi con buona gratia di V.A.S. per poterlo in caso di contrafactione exeguire. Hanno giudicato farlo prima intendere a quella per poter poi senz'altro exeguirlo quando con suo rescritto ne dia il placet. Dio la feliciti et lungo tempo conservi felicissimo. Di Firenze. Il dì 20 d'Aprile 1580.'
'Di S.A.S. [Grand Duke's reply, in another hand]. Faccianli un precetto con tempo conveniente. Giovanbattista Concini 28 d'Aprile '80.' A. S. Croce, vol. 429, fo. 33.
7 'Io Lodovico Serristori per causa del precetto fatto li Signori operai di Santa Croce per la fine della fabrica della Cappella de' Serristori, son pronto a dar per mio pro a quel che manca, sempre che li Signori Operai haranno dichiarato se io debbo far solo o in compagnia, offerendomi finire tutto solo se così dichiareranno, questo dì 5 di maggio 1580. Exhibita die 5 maii 1580.' A. S. Croce, vol. 429 (n.p.).
8 Bocchi, *Le bellezze*, p. 152: 'Cappella adunque che è de' Serristori si dee porre una tavola, dove è dipinta l'ultima Cena, che fece Cristo con gli Apostoli: la quale, perché ancora non è condotta a fine, ci dà occasione di procedere innanzi.'
9 Paatz, *Die Kirchen von Florenz*, i. 552. See also San Miniato, *Mostra del Cigoli e del suo ambiente*, 1959; Mario Bucci, 'Biografia', p. 34.
10 A.S.F. Conv. Sopp. 92, vol. 112, fos. 30 ff. 'Magister Franciscus magistri Iuliani de Sancto Gallo . . . dixit quod ad effectum construendi cappellaniam concessam Domino Ludovico de Serristoris, opus est altare de quo in articulo removere, quia inter Cappellas hedificatas nullum altare potest remanere, et remanendo ordo Architecture deperiret in dedecus tam magni ornamenti, et iudicaretur et arbitraretur per quemlibet virum et expertum de predictis notitiam et scientiam habentibus.'

Strictly speaking, this altar was not a part of the project directed by Vasari to decorate the nave of the church, but was added subsequently. The chapel was tucked round the corner so that it actually faced out into the left transept. In terms of iconography, too, the Trinity, while it is a logical addition to the programme, is not integral to the story of Passion and Triumph unfolded in the altars beginning with the events of Holy Week and proceeding to a culmination in the descent of the Holy Spirit at Pentecost. Nevertheless, the architecture was designed to be very much in keeping with the Vasari–San Gallo tabernacles in the nave, as we can see from the drawing of the chapel published by Sinibaldi (Pl. 79). The last tabernacle on the left nearest the altar, that of the Biffoli Chapel, is capped with a rounded pediment; the alternating design proceeds around the corner to the Risaliti Chapel where the tabernacle is capped with a triangular pediment. San Gallo's original design is taken over and only slightly adapted: because the altar and the tabernacle were to be smaller than those of the nave, the columns were made more slender and, to be proportional, had to stop at the height of the altar table instead of extending all the way to the floor. Clearly the chapel was made to conform as closely as possible to the design and the programme of the others. Both Paatz and, in greatly expanded form, Sinibaldi tell us the basic facts regarding the history of the chapel. As one sees in the drawing, there was a plaque in the chapel inscribed with all the pertinent information: 'THOMAS RISALITI JO[HANNIS] F[ILIUS] IND[IVIDUAE] TRIN[ITATI] PRO SE SUISQ[UE] D[EDICAVIT]'; 'ANNO SAL[UTIS] ET BEATISS[IMI] IUBILEI M.D. 75.'[1] The endowment of the chapel is recorded in the books of Sta Croce in an entry dated 2 November 1575:

1575

Ricordo come sotto dì 2 di Novembre 1575 Messer Tomaso di Giovanni Risaliti* havendo edificato un altare intitolato la Trinità nel pilastro de' Salviati per limosina di detto Altare donò al Convento fiorini centocinquanta di lire 7 per fiorino sopra una casa posta nel popolo di San Simone nella Vigna vecchia, con suo vocaboli et confini, la qual casa il detto Messer Tomaso vendé a Gabriello di Pier Lioni cioè la metà che s'aspettava a lui per fiorini 200 o più. Rogato per mano di Ser Zanobi di Ser Domenico di Zanobi di Matteo Farsi sotto dì 20 d'agosto 1575 che di detti fiorini dugento ne rimase in mano al suddetto Gabriello di Pier Lioni per dover pagare al nostro Convento fiorini sette et mezo di lire 7 per fiorino ognanno in perpetuo per doversi far quegli obrighi come in detto contratto al quale si habbi relatione.

Et più sotto dì 2 detto del detto Messer Tomaso obrighò lasciare doppo la suo morte anzi si obligò allora et donò fiorini 250 al convento di lire 7 per fiorino per doversi pagare per li suoi heredi fra un anno doppo la notificatione della sua morte, rogato per mano del sopradetto sotto detto dì al quale si habbi rapporto.[2]

* obrigo della cappella de' Risaliti [in margin].

The painting of the *Trinity* by Girolamo Macchietti of this date was later removed and replaced with a version by Cigoli (Pl. 81). The inventory of the chapels in Sta Croce records this change in the altar-piece and the reason for it: 'La Tavola la dipinse Girolamo del Crocifissaio la quale fù poi levata via perchè non piaceva et poi l'anno 1592 fù messa

[1] Sinibaldi, 'Un disegno di Girolamo Macchietti', p. 88. [2] A.S.F. Conv. Sopp. 92, vol. 133, fo. 268v.

altra tavola da Lodovico Cardi.'³ The Cigoli version of the *Trinity* hung over the altar until the chapel was removed in 1869.⁴ Since then it has been in the Museo di Sta Croce.

Macchietti's painting has been lost, but its design has been preserved in the drawing of the chapel published by Sinibaldi. That this drawing accurately records the appearance of Macchietti's painting is substantiated by another drawing, a study for the dead Christ, to be found in the Uffizi under the attribution Orazio Sammacchini (Pl. 80).⁵ The study, in Macchietti's favourite medium of red chalk on rose-tinted paper and unmistakably from his hand,⁶ is identical with the Christ of the sketch in every detail but one: the left hand of God the Father passes under Christ's arm and lightly touches him on the side with open fingers. This more subtle treatment enhances the impression that Christ's body floats on the clouds without support. The conventional treatment of the Trinity with God the Father standing above, and sometimes supporting, his son on the cross,⁷ is rejected here in favour of a Pietà-like composition.

Raffaello Borghini's criticism of this picture was so strong that it may even have precipitated the decision to remove it and replace it with another version of the subject. He liked it less than any other of Macchietti's works: '...siccome troppo del vivo mi pare che abbia il Cristo morto in braccio a Dio Padre, ed esso Dio Padre troppo del fiero, di Girolamo Macchietti.'⁸ He makes the same criticism in his discussion of its artistic merits: '...il quale quanto soddisfa a tutti nell'altre opere sue, tanto pare che in questa si sia guasto; percioché il Cristo fa attitudine di vivo, ed il Dio Padre mostra troppa fierezza, ed i colori non son molto bene accomodati, né molto buoni.'⁹

BIFFOLI CHAPEL
Giorgio Vasari, *Descent of the Holy Spirit* (1568) (Pl. 36) *In situ*

Agnolo Biffoli, ducal treasurer and friend to Cosimo, inaugurated the chapels in Sta Croce. Vasari lent his personal prestige by painting the altar-piece and making announcement of it in the *Vite*.¹

The deed of the chapel dated 9 February 1566/7² is described in the contract of endowment:³

Cum sit quod alias et sub die viiii mensis februarii anni 1566 Mag.ᶜⁱ domini operarii fabrice et ecclesie Sancte Crucis de Florentia concesserint Mag.ᶜᵒ domino Angelo Nicolai de Biffolis, civi

³ A.S.F. Conv. Sopp. 92, vol. 362, unnumbered page.
⁴ Paatz, *Die Kirchen von Florenz*, i. 605.
⁵ Uffizi 1281F. 256×193 mm.
⁶ Compare with the studies for the Studiolo panel, the *Baths of Pozzuoli*, published by Marcucci, *Macchietti*, figs. 5–8 and Pouncey, *Contributo*, figs. 1–4.
⁷ High Renaissance examples of this subject are Albertinelli's painting, now in the Academy in Florence (reproduced in Freedberg, *Painting of the High Renaissance in Rome and Florence*, Cambridge, Mass., 1961, fig. 257); Ridolfo Ghirlandaio's ceiling of the Cappella dei Priori, Florence, Palazzo Vecchio (Freedberg, fig. 284); Granacci's tondo in Berlin (Freedberg, fig. 288).
⁸ Borghini, *Il Riposo*, 1584, p. 112.
⁹ Ibid., p. 189.

¹ Vasari–Milanesi, vii. 711. See above, p. 5.
² Apparently Biffoli would have preferred the fifth bay in this aisle, but because of their seniority the Asini were given the first option (see Asini Chapel).
³ The record of the original deed is missing from the book of the notary, Piero Gemmari (Notarile Antecosimiano G. 105).

Florentino ac generali thesaurerio Sue Excellentie Ill.^me, spatium et parietem in muro magistrali dicte ecclesie a latere settentrionali quatenus capit primus arcus in ordine veniendo versus portam de Bellaccis per quam patet aditus ad societatem Yesu, pro construendo capellam et alia edificia, et ornando dictam parietem pictura vel alio, prout eidem et suis heredibus et successoribus libuerit, iuxta tenorem dicte concessionis et cum provvisionibus, obligationibus et aliis de quibus constat per eorum deliberationem et decretum rogatum manu mei notarii infrascripti.[4]

This document makes it clear that the chapel had not been allocated previously but belonged to the convent itself.

A month after the deed was drawn (8 March 1566/7), Vasari, in Rome and evidently aware of Biffoli's impatience to begin work on the new chapel, wrote to Vincenzo Borghini: 'Saluti il signor dipositario generale col dargli nuove, che io torno presto per servillo ...'[5]

Another sixteen months later, on 22 August 1568, Biffoli endowed his chapel in a lengthy document[6] of which the *Ricordo* in the convent books gives the substance:

Ricordo come sotto dì 22 d'agosto 1568, il magnifico messer Agnol Biffoli fece il contratto della sua cappella, rogato per ser Piero dell'Orafo, cancelliere delli Operai in quel tempo, dove furono poste conditione etc. Depose in su' Nocenti fiorini 300, di lire 7 per fiorino, con conditione quando si troverrà da spenderli in tante terre, et non in case né botteghe si spendino col suo consenso, et non essendo lui, del fratello, et non essendo il fratello, dello spedalingo de' Nocenti existente per tempo; intanto tirassono i cinque per cento, che son scudi 15 in tutto. ... Al libro giallo segnato C, c. 216.[7]

The payment of 105 lire annually until 1582 can be found in the 'Libro Giallo C' (vol. 71, fo. 216); it continues in the 'Campione azzurro D' (vol. 72, fo. 27) to 1589.

Vasari records the installation of the painting and his payment, which is 25 per cent higher than usual (cf. Strozzi, Pasquali, Capponi Chapels in Sta Maria Novella, and Guidacci, Buonarroti Chapels in Sta Croce).

Ricordo, come il medesimo anno [1568] di Ottobre si messe su nella Chiesa di Santa Crocie una tavola, alta braccia otto, larga 5, drentovi: Quando viene sopra gli apostoli lo spirito santo coi sette doni. La qual tavola si fecie per Messer Agniol Biffoli, dipositario di Loro Alteze, che se n'ebbe scudi dugento cinquanta scudi 250.[8]

In two letters to Borghini during the summer of 1566, Vasari mentions a painting for Biffoli of *Christ Taking Leave of his Mother*.[9] Frey's suggestion that this might have been an earlier version of the Sta Croce altar seems unacceptable, since the subject does not fit the iconographical cycle of the altars, and the chapel did not belong to the Biffoli before February 1567.

[4] A.S.F. Notarile Antecosimiano G. 105, 22 August 1568, fos. 160 ff.

[5] Frey, ii. 313 f. [6] See note 3 above.

[7] A.S.F. Conv. Sopp. 92, vol. 133, fo. 203.

[8] Vasari, *Ricordanze*, p. 98; in Frey, ii. 880. We know the time that the altar-piece was completed still more precisely from a letter addressed to Vasari on 19 September 1568. It is a reply to a letter from Giorgio, dated 9 September, in which the artist reported that he had finished the painting of the Holy Spirit. Stefano Veltroni, author of the letter, is very flattering to Vasari in his enthusiasm for the new painting, which he had seen at an earlier stage of completion. 'Così la tavola misa in santa Crocie so' sicuro che sia la più bella tavola che voi abiate fatto, ché ancora che io la vedessi abozata, mi piacque infinitamente e la giudicai che così avessi a essere, perché non credo che se possi fare il più bello conponimento e inventione per una simil cosa.' Frey, ii. 405 f.

[9] Frey, 31 July, ii. 265, and 18 August, ii. 272.

The very precise programme for Vasari's painting, conceived as was usual by Borghini, has been preserved:

A volere disporre bene la parte di sopra della tavola dello Spirito Santo è necessario pigliar il concetto di questa inventione et quel che hanno a operare quei sette Angieli, che si veggono in aria. Sotto sono adunque questi: que' sette chiamati comunemente doni dello Spirito Santo, descritti da Esaia all' XI cap. con queste parole: 'Et regescent super eum spiritus Domini; spiritus sapientiae et intellectus; spiritus consilii et fortitudinis; spiritus scientiae et pietatis; et replebit eum spiritus timoris Domini,' che sono sette speciali gratie et effetti dello Spirito Santo, che nella chiesa di Dio sono abbondantemente sparsi, come ben si vede nella prima epist. di San Pagolo a' Corintii, al XII cap., che a' santi appostoli furono divise le gratie dello Spirito Santo a reggiere e governare il popol di Dio perfettamente, dove dice: 'Aliis quidem per spiritum datur sermo sapientiae,' et il medesimo quasi al XII de' Romani ed al IV degli Effesi. Veduto il concetto è necessario accomodare la pittura in modo che la lo esprima il più intelligibilmente et il più vagamente che possibil sia. Però prima generalmente vorrei fussino accomodati di sorte che gli apparissi che e' discendon dal cielo con lo Spirito Santo, del quale e' sono ministri e guardiani delle gratie sue come che debbino infondersi anche loro e spargere le proprietà loro nel quore di quei fedeli raunati quivi insieme et arricchirgli di quelle gratie delle quali e' sono fatti dispensatori. Però gli vorrei in atto che con una mano, se non con ambedue, dico così perchè certi ne haranno una occupata, mostrassino di sparger sopra i fedeli come se fussino fiori, fiammelle di fuoco et la maggior parte doverrebbano guardare giù basso inverso gli Appostoli, ma pure sarà sopportabile, se alcuno guarderà verso lo Spirito Santo, poiché e' bisogna anche haver rispetto alla pittura, che per variare vien più bella et più vaga: e questo sia quanto al generale. Quanto poi al particulare, la bellezza di questo concetto apparirebbe eccellentemente se la pittura istessa con la proprietà degli abiti, colori et qualche contrasegno proprio et gentile havessi forza di fargli conoscere per quel che e' sono, senza che vi bisognassi o parole o altro comento. Il che non harebbe a essere troppo difficile per essere questo nome de' sette doni molto spesso nella notizia de' fedeli il il luogo del profeta assai celebre et noto. Et pur ci sforzeremo d'aiutargli un poco.

È adunque lo Spirito Santo di *Sapientia*, il quale dona quella cognitione dei secretissimi concetti divini et totalmente soprahumani, della quale furono perfettissimamente ripieni: prima la gloriosissima Vergine senza haver pari alcuno, di poi i Santi Appostoli, che n'hebber pochi. Questo lo vestirei di color d'oro, e per ornamento vorrei che havessi nel petto uno sole: et in capo gli metterei una corona di razzi d'oro pur come d'un sole et è il luogo suo il primo da la man destra.

Il secondo è lo spirito d'*Intelletto*. Io so che sopra queste distintioni si dicono dai Santi dottori cose divine et d'altissimi concetti, ma accomodandosi al proposito già proposto del servitio et commodo della Chiesa di Dio et di quelle parti che miracolosamente andarono in quel santo collegio appostolico, crederrei che sì come per il primo si intendeva la cognitione di misteri altissimi, così per questo si potessi pigliare il grande amore et affetione delle cose divine et celesti, et dispregio insieme delle cose humane et terrene perché il saper solo non basta se non vi si aggiugne l'affetione della mente e del cuore et però lo vestirei di color rosso come di fuoco e in capo adatterei per ornamento certe aliette, come gnene metterei anchora a' piedi, nel modo che si usa a Mercurio: et se corona vi andassi et agevolmente fra quelle aliette si accomoderebbe, gnene farei di stelle come d'argento, et il suo luogo il primo da man sinistra.

Il terzo lo spirito del *Consiglio*, che è la gratia del ben governare e reggere le anime; il che fecìono divinamente, predicando, admonendo, esortando ecc. Questo lo vestirei di colore mistiato, come meglio tornassi et in mano gli porrei uno scetro; et la corona sarebbe di fiori di più sorte, et questo va a man destra, dietro al primo.

Il quarto della *Forteza*, che fu in que' primi nostri fondatori perfettissima et sempre è necessaria,

ma ben fu allhora necessarissima, tanto hebbono da esercitarla per l'infinite persecutioni, che gli hebbero. Questo lo dipignerei armato, et perché la vera fortezza dei christiani consiste nel soppor- tare, vorrei che havesse dalla sinistra uno scudo cor' une croce et lo coronerei di palme, et è il suo luogo alla sinistra et accanto allo Intelletto.

Il quinto della *Scientia*, che è la vera cognitione dell'opere di Dio in questo basso mondo et non s'ingannaron intorno all'esser delle creature, et questo vorrei che havessi la veste di colore azzurro et nella sinistra mano un libro et la corona di gemme et di pietre pretiose, et va dalla destra dietro al Consiglio.

Il sesto lo spirito di *Pietà*, nel quale si comprende quel che appartiene alla religione et culto divino: però lo vestirei di veste sacerdotali, di color verde, et nella sinistra mano gli metterei uno calice o uno turibolo, come meglio tornassi, et la corona mi piacerebbe di spighe di grano mescolate con gigli, et è il suo luogo a sinistra dopo la Fortezza.

Il settimo lo spirito di *Timor di Dio*, che è quel mazzo di tutte le virtù, che si rinchiude et si lega insieme, nella una mansuetudine et humiltà di cuore che produce il suavissimo riposo dell'anime nostre. Lo vestirei di color di terra o bigiccio et se commodamente si potessi gli metterei una crocetta in mano et la corona sua farei d'ulivo, et questo viene nel mezzo di tutti.

Questa inventione, per essere nuova, ogni volta che sarà accomodata bene et con certe gentilezze che habbino del vivo et insieme del proprio, piacerà, a mio giuditio, assai e farà honore a chi l'ha fatta e piacere a chi la vedrà. Et quel che io dico nuova, intendo non più messa in opera in questa historia et non nuova che la sia di ghiribizo o di proprio capriccio, perché è vecchia et fondata sulla santissima scrittura vecchia et nuova et è propria et grave et da satisfare allo universale.[10]

Vasari followed Borghini's programme for the iconography of the upper zone rather closely. The Gifts of the Holy Spirit are, from left to right: (1) *Wisdom*, with the rays of the sun on his chest and behind his head; (2) *Counsel*, holding a sceptre and crowned with flowers; (3) *Piety*, holding a censer, wearing a crown of grain mixed with lilies; (4) *Fear of God*, kneeling in the centre, holding a cross and crowned with olive; (5) *Knowledge*, holding a book and wearing a crown of precious stones; (6) *Fortitude*, who is armed with a shield and crowned with palm branches, which he also holds in his hands; and (7) *Understanding*, wearing a winged crown studded with stars. The order is that suggested by Borghini, except that Vasari reversed the positions of the Spirits of Knowledge and Piety. By the addition of this upper zone Vasari and Borghini have been able to transform a subject which calls for direct narrative into a complicated intellectual puzzle requiring a verbal programme in order to be comprehended.

The execution of the lower zone of the Biffoli panel is remarkably dry and lifeless, even for Vasari's late period. Certain of the heads so closely resemble the insipid square-jawed types of Stradano that his participation alongside Vasari is very probable. The upper zone is painted with considerably more delicacy and liveliness, possibly by Naldini, or by Vasari himself. The existence of a *modello*, in fact almost a *cartonetto* (Pl. 37),[11] indicates that the master was free to turn over most of the execution to his workshop.

Borghini's indifference to this altar-piece is probably deserved. He remarked in passing

[10] Transcribed from B.N.F., Miscellaneo, ii, X, 114, pp. 576 ff., by Scoti-Bertinelli, *Giorgio Vasari scrittore*, pp. 231–4. This document dates from after September 1567.

[11] In Bologna, Pinacoteca Nazionale, no. 1651. Silverpoint on sepia paper, heightened with white, 450×305 mm. The late Walter Vitzthum very kindly pointed out to me this unpublished study.

that Vasari had made the Queen of Heaven no more than twenty years old, whereas she must have been fifty at least.[12] He clearly disliked the composition altogether, for he commented tersely on its artistic qualities, noting that the figures were badly ordered, and that the seated old man (to the left of the Virgin?) had little grace in his pose.[13]

COMPAGNIA DELLA SS. CONCEZIONE CHAPEL

The 1439 Inventory of Chapels describes this chapel, beside the Porta de' Bellacci, as dedicated to Saints James and Philip and belonging to the descendants of Guido Machiavelli (see Appendix, Doc. 1). The organ, designed by Vasari and given by Duke Cosimo, was placed here above the door.

This bay was the ultimate location for Alfonso della Casa's altar dedicated to the Immaculate Conception, which had originally been situated in the last bay of the right aisle, beside the Bruni tomb (see Serristori Chapel). In his will, dated 1492, della Casa had provided that if his altar were ever moved the endowment should pass from the Convent of Sta Croce to the monks of Sta Maria degli Angeli.[1] When it was decided to reorganize the nave chapels in a cycle representing Christ's Passion, the altar of the Immaculate Conception had to be moved. Lodovico Serristori was allocated the bay in which the della Casa altar was located. It was proposed that the della Casa altar be transferred out of the nave to the site that was later allocated to the Risaliti family, next to the Salviati Chapel, or else to the corresponding site in the right transept.[2] Papal permission was obtained to make the transfer without loss of the endowment in September 1570,[3] but Sta Maria degli Angeli objected that the new site was not an honourable one and the case was brought before the Archiepiscopacy of Florence. After hearing the testimony of two officials from the Convent, of Francesco da San Gallo and of Giorgio Vasari, the tribunal ruled that the proposed site in the left transept was acceptable.[4]

A few years later, when Gregory XIII had succeeded Pius V, the case was again presented to the pope. A new papal brief was issued on 25 January 1574 in which the pope

[12] Borghini, *Il Riposo*, 1584, p. 111.
[13] Ibid., p. 189.

[1] A.S.F. Conv. Sopp. 92, vol. 112. This lengthy document is the legal record of the dispute over the relocation of della Casa's altar kept by the court notary. In the course of the hearing the entire history of the decision to remove the altar as part of the renovation is reviewed. The full text was transcribed and appeared as Doc. P of the Appendix of my dissertation *Counter-Maniera Art in Florence* (Harvard University, 1967).
[2] Ibid.: 'Sexto dicit et ponit quod si dictum Altare a dicto loco removeatur et construatur in pilastro inter Cappellaniam de Salviatis et navem Ecclesie existentem a manu sinistra ab ingressu Ecclesie, ubi nunc reperitur tabula Sancte Brigide, sive in alio pilastro contra sito, inter Cappellaniam de Castellanis et aliam navem a manu

dextra ab ingressu, ubi est ostium schale cloace nuncupate, per quam datur accessus ad loca sublimia et tectum Ecclesie . . .'
[3] A *spoglio* of the Bull is preserved in A.S.F. Spogli, vol. 65, p. 255ᵛ.
[4] A.S.F. Conv. Sopp. 92, vol. 112, fos. 30 ff: 'Ideo auctoritate apostolica nobis commissa et qua fungimur in hac parte, eisdem Dominis Operariis ut pro decentiori eiusdem Ecclesie ornamento tantum, altare sub Invocatione Conceptionis prefatum de loco in quo ad presens situm existit, ne series facti in eadem Ecclesiam impediatur, transferendi et amovendi illudque in pilastro eiusdem Ecclesie, inter Cappellaniam de Salviatis et navem Ecclesie a manu sinistra ab ingressu ubi nunc reperitur tabula Sancte Brigide, tamquam in loco honorifico, sine dictorum fratrum et conventus preiudicio . . .'

again submitted the matter for arbitration to the Archbishop of Florence and his vicar,[5] who was Sebastiano de' Medici. Sebastiano heard the arguments, and then on 2 May 1575 made a visit to Sta Croce to inspect the site himself. He refused to make an immediate ruling,[6] but after consideration he evidently proposed that the altar be moved to the sixth bay in the left aisle. A few days later, representatives of the Machiavelli family appeared to oppose this decision, which would transfer another altar into their bay.[7] They were given opportunity to prove their case, but they failed to produce the evidence. On 17 May 1575 it was ruled that the altar should be transferred to the position between the Asini Chapel and the door, opposite the Cavalcanti Chapel, and that it should be constructed without detriment to the tombs and the rights of the Machiavelli.[8]

Some time between this date and 1580, the chapel became the responsibility of the Compagnia della SS. Concezione. On 17 July of that year the Provinciale di Toscana of the Franciscan order reported to the *Operai* that the confraternity of the Conception had offered to build an altar similar to the Cavalcanti Chapel opposite, but more richly ornamented. They requested special consideration when it came to the endowment in view of the fact that so many people were coming to this shrine every Sunday and expressing their devotion with monetary contributions.[9] On 7 August the agreement was finalized (see Appendix, Doc. 15, para. 5).

The following March, the *Operai* addressed a letter to Grand Duke Francesco enumerating their objections to a plan to move the altar of the Conception from its position beside

[5] A.S.F. Conv. Sopp. 92, vol. 112, fo. 36ᵛ: 'Nos itaque huiusmodi supplicationibus inclinati, fraternitati tue, frater Archiepiscope, seu discretioni tue, fili vicarie, per presentes commictimus et mandamus quatenus in premissis facias prout tibi videbitur. Non obstante voluntate predicta ac constitutionibus et ordinationibus apostolicis ac domus et ordinis predictorum iuramento confirmatione apostolica vel quavis firmitate alia roboratis statutis et consuetudinibus, ceterisque contrariis quibuscumque. Datum Rome apud Sanctum Petrum sub anulo Piscatoris, die XXV Ianuarii MDLXXIIII, Pontificatus nostri anno secundo.'

[6] Ibid., fo. 37ᵛ: 'Die lune secunda mensis Maii MDLXXV Idem R.dus Dominus Vicarius Iudex Executor et Commissarius apostolicus predictus accessit ad locum ubi est situm dictum Altare Conceptionis et in Ecclesia Sancte Crucis de Florentia, et in specie vidit, consideravit dictum Altare ac inspexit omnia et singula predicta que videnda erant circa huiusmodi negocium sibi commissum, hisque visis dixit se adhuc non esse resolutum quid sibi agendum sit in huiusmodi negocio, sed velle predicta melius et maturius considerare.'

[7] Ibid., fo. 38ʳ.

[8] Ibid., fo. 39ʳ: '. . . et propterea dictum Altare de loco in quo ad presens situm extitit transferendum et amovendum esse illudque infra Cappellaniam familie de Asinis et portam dicte Ecclesie ad manum sinistram dicte Ecclesie qua peragitur ad Ecclesiam Sancti Ioseph et supra quam fuit destinatus locus organorum, et prope et penes quem locum ad presens reperiuntur sepulchra nobilis familie de Machiavellis et e contra Altare Annuntiationis Beate Marie de Cavalcantibus . . . Et hec omnia sine preiudicio sepulchrorum et iurium dicte nobilis familie de Machiavellis et non alio modo, et hec omni meliori modo.'

[9] A.S. Croce, vol. 426, fo. 27: 'Molto Mag.ᶜⁱ Sig.ʳⁱ Duolmi assai non potere essere stamani con Vostre Signorie molto Magnifiche rispetto all'esser chiamato da S.A. a Pratolino; nondimeno confidato nella loro solita verso di me amorevolezza vengo con questa a mettere in considerazione tre cose. Prima, che dovendosi esporre a loro dal molto Eccellente Sig.ʳ Giovan Batista delli Asini come la Compagnia della Concezzione si esibisce e obliga a far l'altare con simili e più ricchi ornamenti di quello che è dirimpetto a' Cavalcanti, le voglino anche haver considerazione alla dotazione di detto altare per il convento et frati, acciò sì come ogni Domenica con le letanie et processioni vanno a quel luogo per eccitare et augmentare la divozione ne' popoli, così con qualche provento perseverino di bene in meglio, del che era promessione da altri di volerlo fare se tale altare li fussi concesso . . . Di Santa Croce, i XVII di Luglio MDLXXX. / Di Vostre Signorie molto Magnifiche [in his own hand] / Affetionatissimo Servitore / Frate Hieremia provinciale di Toscana'.

the door into the middle of the bay. The door which was there would be walled up. According to the *Opera*, if this door were closed off, the same thing would have to be done to the one opposite the Cavalcanti Chapel, the Cavalcanti altar moved, and small new doors cut beside the old ones. Evidently the *Opera*'s arguments won out, for the chapels and doors were not changed, except that the Compagnia did construct its new chapel.

ASINI CHAPEL

Giovanni Stradano, *Ascension* (Pl. 43) *In situ*

Inscribed on rock in foreground: 'IOANES STRATENSIS FLANDRUS PICTOR FACIEBAT 1569'

Appendix, Docs. 9, 10, 11, 12, 13.

The Asini Chapel was perhaps the oldest in Sta Croce: according to one version of the Inventory of 1439, it was transferred from the old church in 1295 (see Appendix, Doc. 1, no. 10). Prior to Vasari's renovation the chapel was located on the front of the *tramezzo* in the left aisle (see Fig. 2, no. 10), and was decorated with frescoes of the martyrdom of St. Mark, which Vasari attributes to Stefano Fiorentino.[1] During the flood of 1557 the chapel had been damaged: the altar-piece had had to be repainted and other repairs made (Appendix, Doc. 12, p. 181).

On 21 December 1566, after the rood screen had already been torn down and the old Asini Chapel already presumably demolished, Marco degli Asini was informed by the *Operai* that within six or eight days he must decide whether he wished to rebuild the chapel or concede the site to others (Appendix, Doc. 10). If he did not wish to rebuild his chapel in the fifth bay which had been allocated to him because it was the nearest unoccupied bay to the former Asini Chapel, that site would be given to Agnolo Biffoli (Appendix, Doc. 13). Six weeks elapsed before Marco served formal notice of his decision to accept the *Operai*'s offer (Appendix, Doc. 10), during which time Biffoli was allocated the seventh bay instead (see Biffoli Chapel).

Marco then proceeded to have the chapel built, and by 1569 the painting was completed and a plaque was placed under the altar, inscribed with the date and the name of Marco degli Asini. When the Simone branch of the Asini family saw the new chapel and the plaque they were infuriated and wrote a letter of complaint to the *Operai* (Appendix, Doc. 9) in which they claimed: (1) that the Marco branch of the family had not been the patrons of the old chapel because they were not the descendants of Francesco and that only the Simone branch had the right to build the new chapel: (2) that the *Operai* had not informed them about the possibility of constructing a new chapel; and (3) Marco had taken down the old inscriptions, had put up new ones bearing only his name, and had added his wife's arms to the family arms, thereby excluding altogether the Simone branch of the family.

In response to these allegations the *Operai* appealed to the Convent for clarification as

[1] Vasari–Milanesi, i. 450. See Hall, 'The *Tramezzo* in Santa Croce, Florence, Reconstructed', p. 327.

to who had actually owned the old chapel. Frate Risaliti signed an affidavit on 24 June 1570 (Appendix, Doc. 11) declaring that the two tombs of the chapel had always been considered to belong to the entire Asini family; that members of Marco's line were buried in them; and that Marco had always shared the expenses of maintaining the chapel with his brother Niccolò, especially in repairing the damage of the recent flood.

Marco was then asked by the *Operai* to answer the charges made by Simone's sons. He replied (Appendix, Doc. 10): (1) that the chapel and the tombs had always been held communally by the family and that he had always shared in the expenses of maintaining them; (2) that it was not his responsibility to inform the other branch of the family of the *Opera*'s offer, but (3) that when Giovambatista, Marco's son, asked Niccolò and Simone verbally if they wished to share the expenses of the new chapel each replied that he could not; (4) furthermore, three years had gone by since construction of the new chapel had been begun and during that time Francesco and Niccolò had had ample opportunity to raise any objection they might have had.

The *Operai* then replied to Niccolò and Francesco (Appendix, Doc. 12), employing the same arguments as had Marco and Frate Risaliti to deny their allegations.

The Simone branch, however, was not apparently willing to drop the matter, for some time later Marco appealed directly to the Grand Duke (Appendix, Doc. 13). After reviewing the allegations and the response to them, and stating that he and the *Operai* were still being molested by his relatives, he requested that Niccolò and Francesco be assigned another site in the church in which to build their own chapel. It appears that by calling their bluff, Marco effectively silenced Niccolò and Francesco, for we hear no more from them, and the plaque installed by Marco can still be seen today under the altar. The chapel was eventually endowed by Marco with the sum of 300 florins, according to the Inventory of Chapels.[2]

Borghini does not reveal much about his evaluation of Stradano's altar-piece, except that he makes several minor criticisms in both discussions of it, and is somewhat restrained in his praise:

Quanto al misterio dell'Ascensione, dice la Scrittura sacra, che il Redentor del mondo, essendo apparito agli apostoli, ed avendo alquanto ragionato con esso loro, fu veduto da quelli levar in aria; e da una chiara nuvola essendo coperto, sparì loro davanti, ed incontanente vennero due huomini vestiti di bianco, e parlarono seco. Ora se in cotesta tavola fossero i due angeli, vestiti di bianco, a favellare con gli apostoli, che apparvero, poi che Cristo si alzò da terra, del rimanente mi piacerebbe molto.[3]

He comments with regard to the style:

Tutto piace (rispose il Michelozzo) fuor che l'attitudine de' due agnoli nell'estremità del coro, i quali mostrano spavento, dove doverebbono mostrare allegrezza: e la figura bassa, che si vede mezza, mostra posare in su un piano molto basso, rispetto al piano, dove posano l'altre figure.[4]

[2] A.S.F. Conv. Sopp. 92, vol. 362. 'Il Sig.ʳ Cavalier Marcho dell'Asini ha lasciato al nostro conto scudi 300 per dir quattro messe la settimana al suo altare, e sua madre scudi 100 per tante messe la settimana al detto altare, et ci è tenuto come per testamento alle ricordanze.'

[3] Borghini, *Il Riposo*, 1584, p. 114.

[4] Ibid., p. 189.

GUIDACCI CHAPEL

Giorgio Vasari, *Incredulity of Thomas* (1572) (Pl. 39) *In situ*

The chapel was founded by two brothers, Tommaso and Francesco Guidacci, who lived in Rome. Girolamo Guidacci, acting on their behalf, endowed it in 1574.[1] The date of the painting, which has been given by Paatz and others as *c.* 1570,[2] is revealed by a series of letters to and from Vasari exchanged between October and December, 1572. At the time the references in the letters begin, the chapel was apparently already completed and the painting very nearly so. Vasari wrote to Vincenzo Borghini in Poppiano on 18 October asking for his assistance on the matter of iconography:

... Ō bisognio di vedervi e di parlarvi per molte cose, massime che quelle figure che sono in la tavola del Guidaccio, che una che s'era fatta per l'Umanità e l'altra per la Divinità; ānno bisognio, volendole far come la S.V. desidera, d'aver qualcosa che si conoschino, o in mano o per il capo o altrove. Le son fatte, e seggano e stan bene, ma i contrassegni ci bisognia. Vorei, avendo tenpo, che la S.V. mi mandassi qualcosa, perchè questo Ogni Santi, se gli ornamenti et di questa e del Buonarroti sarà messi d'oro, le potranno andar su.[3]

Borghini replied at great length the next day, 19 October, in a letter which discussed only the attributes of the two allegorical figures in the upper zone of the altar-piece:

Quanto alle due figure, a me pareva già più d'uno anno havervi detto quello che allora m'occorse a questo proposito, et sono così fatto, che quando ho un concetto, detto che io l'ho, mi fugge, et quando lo rivoglio, talhora mi ritorna a mente e talvolta no, come m'intervien hora di questo, che non mi sovviene quel che io havea allora disegnato. Ma diciamo la cosa come sta et forse ci tornerà. San Pagolo dichiara la fede con due cose, che hanno in sé o son composte di due cose et qualità contrarie: cioè una Speranza che è in effetto uno invisibile che si tocca, io lo dico così grossamente, che *sustantia rerum sperandarum*[4] par che voglia dire una cosa sussistente et in essere di quello che si spera, et è come dire nella imaginatione. Questa la potreste far così: la prima cosa le vesti verdi, se siate in tempo — l'alie ad ambedue, che questo sta bene, et l'havete fatte o le potete fare. Questa io la fingerei femina cioè come una Virtù. Gli farei in una mano fiori, che è la propria insegna et per le medaglie et per tutto della Speranza, et dall'altra [mano] frutti et pomi, o glene farei una ghirlanda in testa; et questa mi contenta ragionevolmente, perché si vede la speranza nel fiore, la sustantia nel frutto. A questa altra fia il Duolo, perché quel che non si vede è appunto il contrario della pittura, che è tutta degli occhi et di cose visibili. Io fighurerei la prima cosa mastio, cioè angelo, perché San Paolo il chiama argumento ['evidence' in K J V] et così è anche in greco, che vuol dire una cosa soda et certa et torna tropo bene a San Tommaso, che volse toccar con mano, né se ne stette alle parole di coloro. Hora egli ha da esser mastio, et vorrei che la differenza apparisse, che i capegli lunghi a quella et questo ricciuto, et la faranno facilmente; ma il dargli contrassegno di cosa che non si vegga et si tocchi con mano, in pittura mi riesce difficile, ché

[1] One version of the 1596 Inventory of Chapels (A.S.F. Conv. Sopp. 92, vol. 175, Insert, p. 9) has the following entry: '18. La Cappella a canto alla detta e intitolata in S. Tommaso Apostolo fu fondata dai Sig.ri Guidacci di Roma, e per detti agitò Girolamo Guidacci.' The *Ricordo* of the endowment can be found in Conv. Sopp. 92, vol. 133.

[2] Paatz, *Die Kirchen von Florenz*, i. 580. Marc'Antonio

Vasari recorded the painting in Vasari's *Ricordanze* incorrectly under the year 1569. (Frey, ii. 885.) P. Barocchi (*Vasari Pittore*, pp. 65 and 144) quotes Marc'Antonio's entry and apparently accepts his date.

[3] Frey, ii. 705.

[4] Hebrews 11: 1. Borghini shares the traditional opinion, rejected by modern scholarship, that Paul was the author of the Letter to the Hebrews.

come disse quel galante huomo: cosa che non sia veduta, non si può dipignere, se non fussino gli starnuti [*sic*]. etc. Delle cose a proposito io ne so, ma non si possan dipigner; se si mettesse la fenice rinascente dalla cenere, harebbe qualche proposito, perché nella cenere non si vede quel bello animale et pur vi è in virtù; ma come si può dipignere, et poi harebbe bisogno di comenti. Se si havesse a dipignere il contrario, sare' cosa facile, che se gli [*gli si*] darebbe uno specchio, ove si vede una cosa, et non vi è. Ma qui bisogna una cosa, che vi sia et non apparisca. Io per quel che mi occorre lo vestirei di che color voi volete et vivi al possibile e sopra gli darei un velo, che quasi lo coprissi tutto; come facessi in capo a quella madonna, che andò a Città di Castello, et se in mano gl[i]e ne facessi uno, come sciugatoio, sare' forse bene, che sarebbono questi velo quello non apparentium [= 'not seen', KJV] di San Pagolo figurato il me' che si può. Et se a piedi chi facessi qualche nugoletta, che i piedi vi si perdessino dentro, non sare' male. Questo è quel che io so dire: vedete hor voi quel che sapete fare.

Di lettere non mi so risolvere, se forse vi paresse, o nel lembo della vesta, o dove vi paresse che me' tornasse, accennar così alla prima: SVBS. SPER.,[5] alla seconda: ARG. NON APP.[6] Boetio quando figurò la Filosofia, in quel de Consolatione, gli fece tessuto nel lembo della veste, se ben mi ricorda, un π et un θ, che volea intendere Pratica et Theorica etc. [*sic*].

Io ho ripensato a questo medesimo et non truovo altro più di quello che ho detto, in modo che ho anche altro che dir, et mi vi raccomando da cuore.

Da Poppiano a 19 di Ottobre 1572.

Vostro
D. Vinc.°[7]

In another letter written only six days later, on 25 October, Vasari told Borghini that he had finished both the Buonarroti altar-piece (see Buonarroti Chapel; Pl. 40) and this one.[8] Both patrons had been charged Vasari's standard price of 200 scudi, plus a charge of 18 scudi 16 soldi payable to the wood-worker.[9] By 1 November Vasari had already departed for Rome, and wrote to Borghini to expect payment from the Guidacci.[10] And finally, on 20 December, Borghini wrote to Vasari telling him that he had seen the two paintings installed in Sta Croce and that he thought the Buonarroti *Christ Carrying the Cross* to be a greater success, largely because of the way the light fell.[11]

The chapel had formerly belonged to the Barbigia family and in it had been placed Donatello's *Crucifix*.[12] The Barbigia are not mentioned in the 1439 Inventory of Chapels, however, and therefore almost certainly did not commission the Donatello, as Bocchi had stated. At the time of the 1439 Inventory this bay appears not to have been allocated.

When the Guidacci were assigned the chapel, Donatello's *Crucifix* was placed in a wooden tabernacle, designed by Vasari, and removed to its present location in the Lodovico Bardi Chapel (see Appendix, Doc. 14, second paragraph).[13]

According to Moisè, the Guidacci had owned a chapel on the rood-screen.[14] It is not

[5] 'SUBSTANTIA SPERANDARUM'.
[6] 'ARGUMENTUM NON APPARENTIUM'.
[7] Frey, ii. 706 f.
[8] Ibid., ii. 710.
[9] See letter to Leonardo Buonarroti, 31 October 1572 quoted in Buonarroti Chapel entry.
[10] Frey, ii. 715–16.
[11] Letter quoted in Buonarroti Chapel entry.
[12] Mencherini's version of the 1596 Inventory of

Chapels states: 'L'antica cappella de' Bardi sotto il titolo di S. Lodovico di Tolosa, e privilegiata quotidiana v'è stato collocato il Crocifisso di Donatello, il quale era nella cappella dei Barbigi, dov'è ora la cappella de' Guidacci', p. 30, no. 24.
[13] This paragraph, which had been published by Moisè, is translated by Janson, *Donatello*, ii. 9.
[14] Moisè, *S. Croce di Firenze*, p. 421, and Paatz, *Die Kirchen von Florenz*, i. 594, following him.

mentioned in the 1439 Inventory of Chapels, but it might have been founded after that list was made. Rosselli also does not mention such a chapel in his description of the *tramezzo*, but, for want of other sources, he had had to depend largely upon the early Inventory.

Representations of the *Incredulity of Thomas* were still rather rare at this time. Vasari has grouped ten of the Apostles symmetrically around the central pair of Thomas and the Risen Christ, placing Peter, probably with his brother Andrew, in the lower right corner. Behind the Apostles on the left, looking out, is a head without a halo which is evidently a portrait, perhaps of Tommaso Guidacci. Floating above are the two allegorical figures about which Borghini advised Vasari at such great length. According to Vasari's letter, Borghini had originally proposed that these figures represent Humanity and Divinity, that is, the two natures of Christ, which would have been a theologically appropriate commentary on a Resurrection appearance of Christ. A year or more later, when the picture was nearing completion and Vasari asked Borghini to describe how these figures should be treated, the iconographer decided to transform the figures into allegorical representations of a quite different concept. Taking as the central focus of the painting not Christ's Resurrection, but Thomas's deficient faith, Borghini suggested turning the figures into representations of the nature of Faith. He therefore recommended that the allegories be made to represent the two qualities described in 'St. Paul's' definition of faith in Hebrews 11 : 1 : 'Faith is the substance of things hoped for, the evidence of things not seen.'

Vasari must already have painted the figures when he received his friend's letter, for he did not take the suggestion that the second should be a male angel. Vincenzo's suggested attributes for the figures do appear, however. The figure on the right, the 'Substance of Things Hoped For', holds flowers in one hand and an apple in the other; rising from her back can be seen a wing which was clearly added after the figure had been painted, to conform with the Prior's suggestion. The figure on the left, the 'Evidence of Things not Seen', holds a very thin veil over her head. Apparently Vasari did not bother to add the inscriptions recommended by Borghini, without which no one could hope to decipher the meaning of the allegories. Vasari was apparently more concerned with completing the picture for All Saints' Day than with communicating Borghini's complex ratiocination.

The preparatory study in the Uffizi (Pl. 41)[15] shows a liveliness in the poses of the figures which is lost in the painting.

This painting appears to have been executed with less haste than most of Vasari's late works, and without the assistance of the workshop. In contrast to the contemporaneous *Christ on the Way to Calvary* for the Buonarroti Chapel, this is spatially one of Vasari's more successful altar-pieces, but it is atypical in that it lacks the strong upper zone he usually preferred. The ascending staircase behind the central group was probably introduced to satisfy Vincenzo Borghini's requirements that no important activity be repre-

[15] Uffizi 630F. Published in Florence, Gabinetto Stampe e Disegni degli Uffizi, *Mostra del disegno italiano di cinque secoli*, Firenze, 1961, pp. 54 f., fig. 63 (cata- logued by Anna Forlani); also ibid., *Mostra di disegni del Vasari e della sua cerchia*, no. 44, catalogued by P. Barocchi.

sented in the centre of an altar-piece which would distract attention from the Mass celebrated before it.[16]

After first complimenting the composition and colour of the painting, Raffaello Borghini severely criticizes it:

Non passate più avanti (rispose interrompendolo il Michelozzo) perchè io ho inteso, che San Tommaso e San Piero fanno male attitudini, che intorno alle figure non è molto artificio, che i panni sono mal composti, et che alcune figure, che posano in sul medesimo piano delle colonne, sono poco men alte di esse colonne . . .[17]

BERTI CHAPEL

Santi di Tito, *Supper at Emmaus* (Pl. 104) *In situ*

Inscribed on base of column, lower left: 'SANCTES TITIUS F. 1574'.

The Inventory of Chapels identifies the chapel fully:

Alla Capella de' Berti, fondatore Antonio di Piero Berti et li suoi figliuoli; et ci danno f. 12 di lire 7 l'uno, l'anno, et ½ barile d'olio per la lampana. La tavola che v'è dipinto quando Cristo fu conosciuto nel rompere il pane da Cleofas et Luca, et la dipinse Santi di Tito.[1]

The record of this endowment, dated 6 October 1581, can be found among the *Ricordi* of the convent,[2] and the account of payment in the Debitori e Creditori.[3] The tomb in front of the chapel is inscribed with Antonio di Piero's name and bears the same date as the painting: 1574.[4]

Before Vasari's renovations there was a door in this bay referred to in the early sources as the door of the Via delle Pinzochere. Beside the door was the Trecento chapel of a branch of the Baroncelli family dedicated to S. Gherardo da Villamagna (Appendix, Doc. 1, no. 12; Fig. 2, no. 12).[5] Vasari mentions a painting by Giovanni da Milano, dating from about 1364, for this altar.[6]

Borghini, as is to be expected, approved of this altar-piece and praised both it and the *Resurrection* for the Medici Chapel beside it for their observance of scripture and for their chaste quality (*onestà*).[7] In commenting upon its formal qualities, he noted its remarkably sensuous beauty, which I have attributed to his recent Venetian experience:

. . . perciocché vi sono colori bellissimi, e le figure graziose, e la disposizione molto considerata. Io credo, che Santi in questa tavola volesse mostrare (soggiunse il Michelozzo) che egli quando

[16] See Pasquali Chapel.
[17] Borghini, *Il Riposo*, 1584, p. 188.

[1] A.S.F. Conv. Sopp. 92, vol. 362.
[2] A.S.F. Conv. Sopp. 92, vol. 134, fo. 7r.
[3] A.S.F. Conv. Sopp. 92, vol. 72, fo. 102: account in the name of Antonio di Piero Berti, 1582–95.
[4] A.S.F. MS. 618, p. 70.
[5] Paatz, *Die Kirchen von Florenz*, i. 607.
[6] Vasari–Milanesi, i. 584. Eve Borsook's attempt to associate the Trecento drawing for a Baroncelli Chapel in Sta Croce (preserved in A.S.F.) and a fresco fragment by Taddeo Gaddi (preserved in the Museo di Sta Croce) has proved mistaken: 'Notizie su due cappelle in S. Croce a Firenze', *Rivista d'Arte*, xxxvi (1961–2), pp. 89 ff. See my article, 'The *Tramezzo* in S. Croce, Florence, Reconstructed', which associates the A.S.F. drawing with a different Baroncelli Chapel on the front of the rood-screen (see Appendix, Doc. 1, no. 21 and Fig. 2). [7] Borghini, *Il Riposo*, 1584, p. 116.

vuole, sa ben colorire; ma che più attende al disegno, che a' bei colori: pur quella figura vestita d'azzurro, è tenuta alquanto grande a proporzione dell'altre.[8]

A pen drawing of this composition is attributed to Santi di Tito in the Uffizi (7752F), but it is more probably a study after the painting.

MEDICI CHAPEL

Santi di Tito, *Resurrection* (c. 1574) (Pl. 101) *In situ*
Inscribed on sword-blade, lower left: 'SANCTES TITIUS F'.

Very little is known about the founding of this chapel. The Inventory of Chapels reads:

> Alla Cappella de' Medici, la fondò messer Francesco di [*lacuna*] de' Medici, canonico fu in S.ta Maria del Fiore, et perché morì, la finì il Rosso di [*lacuna*] de' Medici, et messer Bastiano di [*lacuna*] de' Medici, vicario dell'Arcivescovo di Firenze et Cavaliere di Santo Stefano.[1]

The chapel was evidently never endowed, since there is no record of it, nor can the account be found among those of the other chapel owners in the books Debitori e Creditori. The inscription on the tomb in front of the chapel differs confusingly from the Inventory in that it mentions a Philip instead of Sebastian as the founder: 'PHILIPPUS MEDICES ET ROSSUS F.S. ARAM CHRISTO RESURGENTI DICARUNT SEPULCRUM AVTEM SIBI POSTERIBUSQUE DORMIENTIBUS PONENDUM CURARUNT A.S. 1574.'[2]

This is the only date we have in connection with the chapel and it is usually given as that of Santi's undated painting as well.[3] Comparison with the *Supper at Emmaus* (Pl. 104) for the Berti Chapel reveals a similar concern with decorative effect and dramatic illumination which suggests that this painting was done at about the same time, shortly after the journey to Venice. It was certainly done before 1576 when, as we see in the *Raising of Lazarus* for the chapel of the Compagnia del Gesù Pellegrino-Tempio in Sta Maria Novella (Pl. 105), he had already lost interest in decorative effects.

In his preparatory drawing (Pl. 103),[4] Santi's dependence upon Bronzino is more direct than in the final version. Here the two standing soldiers dominate the lower zone, and although they are reversed, they resemble Bronzino's pendant soldiers closely. In the drawing Santi has followed Bronzino's model for the banner Christ holds, but in the final version he has reversed its swirl so that it appears filled with a rush of air as Christ rises from the ground. The angel who sits on the tomb has been given identifying wings, in accordance with literal regard for scripture.

Though Borghini found no fault with Santi's picture *qua* altar-piece, he somewhat surprisingly criticizes certain aspects of its style. After admitting that this was one of Santi's best paintings, he goes on: '. . . nondimeno quell'attitudine di Cristo, che pende tanto in

[8] Ibid., p. 188.

[1] A.S.F. Conv. Sopp. 92, vol. 362.

[2] A.S.F. MS. 618, p. 70.

[3] Paatz, *Die Kirchen von Florenz*, i. 581.

[4] Uffizi 7687F. Louvre, 1936, may be a study for the sleeping soldiers in the lower right corner.

sulla banda manca, ha un non so che, che gli toglie parte di grazia: ed il colorito potrebbe esser più vivo e più vago.'[5]

DA VERRAZZANO CHAPEL

Battista Naldini, *Entombment of Christ* (Pl. 67) *In situ*

Inscribed to right of crown of thorns: 'BAT. NALDINI 1583'.

The Inventory of Chapels gives the following information:

Alla Cappella de' Verrazzani, fondatore Francesco di Giovanni Battista da Verrazzano, morto in [*cancelled*: Francia] Sivilia, et lasciò che gli heredi suoi facessino una Cappella in Santa Croce di Firenze, con la sua dote. Lodovico suo fratello l'anno 1587 fondò et esequì tutto. La tavola fu dipinta da Batista Landini detto Batista del Puntormo.[1]

The tomb in front of the chapel bore this inscription with the date of Francesco's death: 'LUDOVICO IOANNIS BATISTE A VERRAZZANO CIVIS FLORIS SUMPTIBUS FRAN-CISCI SUI FRATRIS HANC ARAM FIERI FECIT QUI ANNO 1579 DIE XVII SETTBIS SIBILIE OBIIT CUIUS OSSA ANNO MDLXXX FLORENTIA TRANSLATA FUERE.' It was dedicated to St. Louis.[2] The endowment by Lodovico was recorded by the Convent on 25 May 1587,[3] eight years after Francesco's will and four years after the altar-piece was finished.

The aisle chapels nearest the façade must have been the last to be appropriated, this one preceding the Alamanneschi Chapel by three or four years.

The date inscribed on the painting was mistakenly reported by Paatz as 1575.[4] This, in conjunction with Raffaello Borghini's report that Naldini was working on this painting at the time of his writing, has led to the hypothesis that Naldini began the picture in the mid-1570s, then left it unfinished when he went to Rome and completed it on his return. This is obviously impossible, since the chapel was not begun until Francesco da Verraz-zano's death in 1579. It is also clear from Borghini's report that, as he himself said, the painting was very nearly approaching completion. Borghini had certainly seen it, and not just a drawing, for he describes the colour as well as the composition.[5]

A number of preparatory drawings for the altar-piece are preserved in the Uffizi. They are red-chalk studies, made in the studio from live models for the various figures. 657S is a drawing of a young male model which was transformed by Naldini into the woman seated at the lower right.[6] 17817F (Pl. 69) is a study of two of the background figures who are preparing the tomb.[7] 17810F is a study for the pose of Christ (Pl. 68),[8] and 7487F a study of Christ's hand (Pl. 70).[9] 17814F (Pl. 71) is a study for the man facing away at the

[5] Borghini, *Il Riposo*, 1584, p. 188.

[1] A.S.F. Conv. Sopp., 92, vol. 362.
[2] A.S.F. MS. 618, p. 71, and Rosselli (MS. 624), pp. 287 f.
[3] A.S.F. Conv. Sopp., 92, vol. 134, fo. 24ᵛ.

[4] Paatz, *Die Kirchen von Florenz*, i. 581.
[5] Borghini, *Il Riposo*, 1584, p. 618.
[6] Traces of white chalk, 287×434 mm.
[7] 410×270 mm.
[8] 400×250 mm.
[9] 180×140 mm.

right who holds up Christ's arm.[10] Each of these has been incorporated in the final composition without change.

ZANCHINI CHAPEL
Agnolo Bronzino, *Christ in Limbo* (Pl. 25) Museo di Sta Croce
Inscribed on sword in woman's hand, lower right: 'MDLII OPERA DEL BRONZINO FIORE.'

Giovanni Zanchini endowed his chapel in his will drawn on 17 October 1554;[1] the note in the books of the convent records the substance of this document:

Ricordo oggi questo dì 26 di gennaio 1556 come Giovanni di Piero Zanchini ciptadino fiorentino fece suo testamento sotto dì 17 d'ottobre 1554, rogato ser Bartolomeo Finiguerra notaio al palagio del podestà, et lasciò al nostro convento e 4/5 cioè e quattro quinti d'una bottega a uxo di coiaio, posta in sul Canto de' Pecori di Firenze, con sua vocaboli e confini . . . l'à donata e lasciata im perpetuo al nostro Convento per legiptima dote della cappella in detta chiesa, la quale bottegha tiene oggi a ppigione rede di Bartolomeo di Matteo Coiai e compagni e paga ogn'anno scudi sedici d'oro in oro, e quali sopradetti oblighi cominciono adì primo di Febraio 1556.[2]

The account for this endowment in the name of Rede di Bartolomeo di Matteo coiai shows an annual payment of 120 lire.[3]

When Bronzino's painting was installed in June 1552 opposite Salviati's *Deposition* in the Dini Chapel (Pl. 24), Vasari received two letters remarking upon the comparison of the two altar-pieces. Minerbetti wrote on 1 July: 'El Bronzino finalmente dette fuora la tavola del Zanchino, la quale fa tanto paragone a quella del Salviati, che là la caccia via, non a juditio mio, ma di chi più sa. Sonvi e popoli ogni dì già otto giorni; et chi dice una, chi un'altra cosa. Io non ho potuto intendere pareri. Li saprò et scriverò.'[4] Borghini, of the opposite opinion, as one might expect, wrote on 20 August:

Hora hora hora si è partito da me quel vostro cugino che sta al Monte et hammi in nome vostro visitato, et habbiamo insieme ragionato a dilungo delle tavole vostre, del Bronzino et del Salviato. Né vi dico nulla di più che io mi vi scrivessi per l'ultima, perché sono nella medesima opinione né mi vi credo ingannare dentro né son solo; et se altri vi ha scritto altrimenti, io sono certo, che voi, quando vedrete, sarete dalla mia, benché voi la vedete hora in spirito et la giudicate. . . . Et quando voi vedrete poi, che io ho compagni al mio giuditio, io voglio, che voi mi tegnate da qual cosa, che Dio vel perdoni. Voi m'havete, vi so dirio, per una volta lavato il capo in su que' disegni. Io per me fui vicino a spiritare, quando io lessi quella parte. A Dio, messer Giorgio.[5]

[10] 410×250 mm.

[1] A.S.F. Notarile Antecosimiano, F371 (Testamenti) fos. 252–4[v]. The chapel is mentioned and the name of a notary, Ser Lorenzo da Bibbiena. (I owe this information to the generosity of Edward Sanchez.)

The only notary of this date called Lorenzo da Bib-biena is Lorenzo Balduccini (1528–59) B 456–64, but I have not been able to find any Zanchini documents among his protocols.

[2] A.S.F. Conv. Sopp. 92, vol. 133, fos. 150[v]–151[r].
[3] A.S.F. Conv. Sopp. 92, vol. 71, fo. 123.
[4] Frey, i. 329.
[5] Ibid., p. 332.

Vasari informs us that Bronzino included several portraits from life, among them Pontormo, Giovambatista Gelli, Bacchiacca, Costanza da Sommaia, wife of Giovambatista Doni, and Camilla Tebaldi del Corno.[6] The exquisite rendering of surfaces, especially flesh, creates an effect which is sensuously appealing in the extreme. For this reason, Raffaello Borghini found this painting to be in bad taste:

Di già abbiamo noi ragionato (rispose il Vecchietto) quanto mal fatto sia le figure sacre fare così lascive. Ora di più vi dico, che non solamente nelle chiese, ma in ogni altro pubblico luogo disconvengono ... Perciò quanta poca laude meriti il Bronzino in cotesta opera, voi medesimo, dilettandovi nel rimirare quelle donne lascive, il confessate: ed io son sicuro, che ciascuno che si ferma attento a rimirare questa pittura; considerando la morbidezza delle membra, e la vaghezza del viso di quelle giovani donne, non possa fare di non sentire qualche stimolo della carne: cosa tutta al contrario di quello, che nel santo tempio di Dio far si doverebbe.[7]

A similar attitude of puritanism caused the altar-piece to be removed from the church in the nineteenth century. It was displayed in the Museo di Sta Croce until the flood of 1966, when it was seriously damaged and removed for restoration.

A preparatory drawing for the male figure about to touch Christ's foot is preserved among the drawings at Windsor Castle.[8]

[6] Vasari–Milanesi, vii. 109 f. [7] Borghini, *Il Riposo*, 1584, p. 109 f.
[8] A. E. Popham and J. Wilde, *Italian Drawings at Windsor Castle.* London, 1949, cat. no. 143, pl. 34.

APPENDIX OF DOCUMENTS

THE documents in this section are previously unpublished, except for Doc. 3 and portions of Doc. 14. They are presented chronologically, regardless of whether they refer to Sta Maria Novella or Sta Croce. Some refer specifically to individual chapels (e.g. Docs. 6 and 16 concern the Zati Chapel, and Docs. 9, 10, 11, 12, and 13 the Asini Chapel) but they have been included in this section rather than in the Catalogue because they reveal the methods used in settling disputes and thereby provide useful information on the division of responsibility in a joint undertaking such as this renovation project.

The documents are drawn from four Florentine archives:

A.S.F. Archivio di Stato: Conventi Soppressi, 92 (Sta Croce), 102 (Sta Maria Novella), Corporazioni Soppresse.

B.N.F. Biblioteca Nazionale, Manoscritti.

A. S. Croce Archivio di S. Croce in the church of S. Croce. Preserved here are the books of the *Opera* di Sta Croce.

A.S.M.N. Archivio di S. Maria Novella in the church of Sta Maria Novella. The holdings of the library have been published by Stefano Orlandi, O.P. in his *'Necrologio' di S. Maria Novella*.

Document 1

Inventory of Chapels, Sta Croce, 1439

A comparison of six versions:

 (A) A.S.F. MS. 619, fo. 1.
 (B) A.S.F. MS. 618, fos. 1 ff.
 (C) A.S.F. Conv. Sopp. 92, vol. 175, Insert.
 (D) P. Saturnino Mencherini, *Santa Croce di Firenze* (Memorie e documenti), Florence, 1929, pp. 22 ff., from a manuscript in the Oliveriana Library, Pesaro, no. 1687.
 (E) A. S. Croce, vol. 450, f. 2 ff. (dated 1596).
 (F) A.S.F. Conv. Sopp. 92 vol. 363, fos. 1 ff.

Version A is the earliest, perhaps even the original (the script dates from the first half of the fifteenth century). Other versions are copies from the late Cinquecento or later.

(A) Chappelle, altari e sepolture di S. Croce.

(B) Stratto di tutte le Cappelle, e Sepolture nel modo che si trovavano l'anno 1439 nella Chiesa di S. Croce di Firenze, copiate dagl'inventarii antichi di detta Chiesa.

> Operai di S. Croce del 1439
> Antonio di Tommaso di Giovanni Peri
> Paolo di Zanobi da Diacceto
> Iacopo di Giorgio Berlinghieri
> Ghino di Jacopo di Ser Francesco
> Niccolò di Filippo di Bancozo
> Giovanni del Maestro [*lacuna*]
> Proveditore di detti Signori Operai Ser Giovanni Pagnini

(C) Registro delle Cappelle che esistevano nella Chiesa di S. Croce e di S. Francesco de' Molto Reverendi Padri Minori Conventuali dalla sua fondazione che seguì il 5. di Maggio 1295 fino all'Anno [*lacuna*]

(D) Cappelle della chiesa di S. Croce dell'anno 1439.

(E) Qui di sotto si scriveranno tutte le cappelle quali si trovavano nella chiesa di S. Croce di Firenze l'anno 1439 con i lor titoli e padronati cavate dal libro del 1439 tenuto per ser Giovanni Pagnini proveditore delli SS.ri Operai di S. Croce quali erano allora:

> Antonio di Tomaso di Giovanni Peri
> Paolo di Zanobi da Diaceto
> Jacopo di Giorgio Berlinghieri
> Ghino di Jacopo di ser Francesco
> Niccolò di Filippo di Bancozzo
> Giovanni del Maestro

(F) Al nome di Dio amen

> Qui appresso saranno tutte le Cappelle, et sepulture che sono nella Chiesa et Chiostri di Santa Croce della Città di Firenze et i Padroni di dette Cappelle et sepolture, et prima.

1 (A) La chappella dell'altare maggiore è intitolata nella Croce; è di tutta la famiglia degli Alberti. L'altare di detta chappella è della famiglia degli Alamanni.

(B) La cappella del'altar maggiore è intitolata nella croce. È' di tutta la famiglia degl'Alberti. L'altare di detta è di tutta la famiglia degli Alamanni.

(C) La cappella dell'altar maggiore è intitolata nella croce. È' di tutta la famiglia degl'Alberti. L'altare di detta è di tutta la famiglia degl'Alamanni.

(D) La cappella dell'altar maggiore è intitolata nella S. Croce: è di tutta la famiglia degli Alberti. L'altare di detta cappella è di tutta la famiglia degli Alamanni.

(E) In prima la cappella dell'altare maggiore di S. Croce, e intitolata nella Croce, è di tutta la famiglia degli Alberti. L'altare di detta cappella è di tutta la famiglia degl'Alamanni.

(F) Cappella Maggiore di Santa Croce titolata nella Croce, di tutta la famiglia delli Alberti. L'altare di detta Cappella è delli Alamanni. Francesco d'Alamanno Alamanni detto Boccaccino.

2 (A) La chappella allato in verso la tramontana e intitolata nella 'Sunzione di nostra Donna è della famiglia de' Tolosini.

(B) La cappella del'Annuntiata è di tutta la famiglia de' Tolosini: appartiene, dice il libro del 1441, a Tommaso di Lionardo Spinelli.

(C) La cappella del'Annunziata è di tutta la famiglia de' Tolosini: appartiene, dice il libro del 1441, a Tommaso di Lionardo Spinelli.

(D) La cappella dell'Assunzione della Madonna è di tutta la famiglia de' Tolosini. Nel lib. del 1441 si dice di Tommaso di Leonardo Spinelli.

(E) La cappella dell'Assuntione della Madonna è di tutta la famiglia de' Tolosini. Appartiene, dice il libro del 1440, a Thomaso di Lionardo Spinelli.

(F) Cappella dell'Assumptione di nostra Donna di tutta la famiglia de' Tolosini, sonne hoggi Broglione di Giovanni Tolosini. Appartiensi a Tommaso di Leonardo Spinelli.

3 (A) La chappella seguita in verso la tramontana e intitolata nella Vergine è di Johanni d'Amerigho Benci e tutta la famiglia.

(B) La cappella della Vergine a canto alla sopradetta è di Giovanni di Domenico Benci.

(C) La cappella della Vergine a canto alla sopradetta è di Giovanni di Domenico Benci. [Added in a later hand] in oggi appartiene al Signore Senatore Capponi.

(D) La cappella superiore a quella e intitolata *La Vergine*: è di Giovanni d'Amerigo Benci e di tutte le famiglie Benci.

(E) La cappella, quale è allato alla sopradetta, e intitolata nella Vergine, è di Giovanni di Domenico Benci, et delli altri della famiglia de' Benci.

(F) Cappella della Vergine, allato alla sopradetta, di Giovanni d'Amerigo Benci ènne hoggi Giovanni d'Amerigo Benci et figliuoli di Miniato di Bertoldo Benci.

4 (A) La chappella seguita intitolata in S. Antonio da Padova è della famiglia da Ricasoli cittadini fiorentini.

(B) La cappella acanto a detta, di S. Antonio da Padova, è della famiglia de' Ricasoli, quelli sono cittadini di Firenze: Albertaccio e fratelli, Galeotto di Bettino e fratelli, e Bindaccio di Granello.

(C) La cappella a canto a detta, di S. Antonio di Padova, è della famiglia de' Ricasoli, quali sono cittadini di Firenze: Albertaccio e fratelli, Galeotto di Bettino e fratelli, et Bindaccio di Granello.

(D) La cappella di S. Antonio da Padova è della famiglia dei Ricasoli, i quali sono cittadini di Firenze, Albertaccio e i fratelli, Galeotto di Bettino e fratelli, e Bindaccio di Granello.

(E) La cappella allata alla sopradetta, e intitolata in S. Antonio da Padova, è della famiglia de' Ricasoli, i quali sono cittadini di Firenze, Albertaccio e i fratelli, Galeotto di Bettino e fratelli, e Bindaccio di Granello.

(F) Cappella di Santo Antonio da Padova delli Arricasoli, attiene a' sotto scritti figliuoli di Albertaccio, cioè Antonio Galeotto di Bettino et Antonio suo figliuolo, Bindaccio di Granello, et Andrea et Agnolo suoi figliuoli.

5 (A) La chappella allato a detta e intitolata ne' Sancti Marteri è di Francesco di Messer Alesandro de' Bardi e sua ereda.

(B) La cappella acanto a detta, di S. Lorenzo e di tutti i Martiri è di Francesco di M. Alessandro de' Bardi e de sua discendenti.

(C) La cappella a canto a detta, di S. Lorenzo, e di tutti i Martiri è di Francesco di M. Alessandro de' Bardi e de sua descendenti.

(D) La cappella allato verso tramontana e intitolata in S. Lorenzo e tutti i martiri, è di Francesco di M. Alessandro de' Bardi e suoi discendenti.

(E) La cappella allata alla soprascritta verso tramontana, e intitolata in S. Lorenzo e tutti i martiri, è di Francesco di messer Alexandro de' Bardi, e dei suoi descendenti.

(F) Cappella de' Martiri, allato alla sopradetta, di Francesco di messer Alessandro de' Bardi, ènne hoggi madonna Nanna di Francesco d'Altobianco et 3 fanciulle piccole di Bardo di Francesco.

6 (A) La chappella allato a detta e intitolata ne' Confessori è d'Ubertino d'Andrea de' Bardi e suorum e Tommaso di Jacopo de' Bardi.

(B) La cappella acanto a detta di S. Silvestro et i Confessori è d'Ubertino d'Andrea de' Bardi e del suo lato, e Tommaso di Iacopo de Bardi.

(C) La cappella a canto a detta di S. Silvestro et i Confessori, è d'Ubertino d'Andrea de' Bardi, e del suo lato, et Tommaso di Iacopo de' Bardi.

(D) La cappella allato alla suddetta e intitolata in S. Silvestro et i Confessori, è di Ubertino d'Andrea de' Bardi e del suo lato e Tommaso di Iacopo de' Bardi.

(E) La cappella allato alla soprascritta e intitolata in S. Silvestro e i Confessori, è di Ubertino d'Andrea de Bardi e del suo lato e Thomaso di Jacopo de Bardi.

(F) Cappella allato alla di sopra, titolata ne' Confessori, di Ubertino di Andrea de Bardi.

7 (A) La chappella nel chanto allato a detta e intitolata nella Vergine Maria è della Compagnia delle Laude della Vergine Maria.

(B) La cappella del canto rimpetto alla porta della Sagrestia e intitolata nella V.M. delle Laude di detta Compagnia. Hoggi posseduta dagli eredi del S.r Giovanni Niccolini.

(C) La cappella del canto rimpetto alla porta della Sagrestia è intitolata nella V.M. delle Laude di detta Compagnia. Hoggi è posseduta dagl'Eredi del Signore Giovanni Niccolini.

(D) La cappella nel canto è intitolata nella Vergine Maria delle Laudi; è di detta Compagnia, oggi posseduta dagl'eredi del Sig. Giovanni Niccolini.

(E) La cappella del canto dirimpetto alla porta del'andito della sacrestia e intitolata nella Vergine Maria delle Laude, è di detta Compagnia. [Added in a different hand:] Oggi posseduta dalli heredi del Signore Gio. Niccolini.

(F) Cappella nel canto, titolata nella Vergine Maria, della Compagnia delle Laude.

8 (A) La cappella allato a detta in testa e intitolata in Sancto Lodovicho è di Bartolomeo di Gualterotto de' Bardi e discendenti di Bartolaccio de' Bardi.

(B) La cappella allato alla detta che è in testa alla croce della chiesa e intitolata in S. Lodovico è di Bartolomeo di Gualterotto e descendenti de' Bardi di Vernio.

(C) La cappella che è allato alla detta che è in testa alla croce della chiesa e intitolata in S. Lodovico, è di Bartolomeo di Gualterotto, e descendenti de' Bardi di Vernio.

(D) La cappella allato è intitolata in S. Lodovico; è di Bartolomeo di Gualterotto e discendenti di Bartolomeo Bardi di Vernio.

(E) La cappella allato alla sopradetta, quale è in testa alla croce della chiesa, e intitolata in S. Lodovico, è di Bartolomeo di Gualterotto, e descendenti de' Bardi di Vernio.

(F) Cappella di Santo Lodovico.
Di Bartolomeo Gualterotti et descendenti di Bartolaccio; ènne: Bartolomeo di Lorenzo di Totto Gualterotti, e figliuoli di Bernardo di Bartolaccio, Andrea di Giovanni d'Andrea et figliuolo, cioè Giovanni d'Andrea di messer Bindo, Giovanni di Sozzo da Vernio et Sozzo suo nipote, Francesco di Filippo de Bardi.

9 (A) La chappella ch'è in sulla regi di sopra allato alla porta de' Guardi e de' Machiavelli è intitolata nei Sancti Jacopo e Filippo.

(B) La cappella allato alla Porta de' Bellacci di S. Iacopo è de' descendenti di M. Guido Machiavelli.

(C) La cappella allato alla Porta de' Bellacci, di S. Iacopo e Filippo è de' descendenti di M. Guido Machiavelli.

(D) La cappella allato alla porta de' Bellacci e intitolata in SS. Iacopo e Filippo è de' discendenti di M. Guido Machiavelli.

(E) La cappella allato alla porta de Bellacci e intitolata in S. Jacopo e S. Filippo, è de' descendenti di Messer Guido Machiavelli.

(F) Cappella di san Iacopo et san Filippo: de' descendenti di messer Guido Machiavelli: ènne hoggi:

Guido di Boninsegna ⎫
Totto di Boninsegna ⎬ Machiavelli
Giovanni di Lorenzo Machiavelli
e figliuoli d'Agnolo di Lorenzo Machiavelli.

10 (A) La chappella che [lacuna] ch'è accanto alla detta di sotto e intitolata in Sancto Marcho, è della famiglia degli Asini e discendenti d'Asinino.

(B) La cappella acanto alla detta di S. Marco è padronato di tutta la famiglia degl'Asini.

(C) La cappella allato alla detta di S. Marco è padronato di tutta la famiglia degl'Asini. [In a later hand:] Fondata nel 1231 e traslatata nella nuova chiesa nel 1295, sotto il titolo S. Marco, ma nel 1569 fu permutata nel titolo del'Ascensione del N.S.J.C.

(D) La cappella allato a questa e intitolata in S. Marco, è patronato di tutta la famiglia degli Asini.

(E) La cappella allato alla soprascritta e intitolata in S. Marco è padronato di tutta la famiglia degl'Asini.

(F) Cappella di san Marco, allato a quella di sopra. Della famiglia delli Asini. Ènne hoggi: Niccolò di Francesco delli Asini et figliuoli, Piero di Francesco degl'Asini.

11 (A) La chappella che dirimpetto alla detta in sulle regi è intitolata in Sancto Piero Apostolo, è di Nicholò di Bocchino e discendenti, stava a casa da Sancta Lucia de' Magnioli.

(B) La cappella che è a rimpetto alla detta di S. Piero Apostolo è de' descendenti di Niccolò di Bocchino, sta da S. Lucia de Magnoli.

(C) La cappella che è rimpetto alla detta di S. Piero Apostolo, è de' descendenti di Niccolò di Bocchino, sta da S. Lucia de' Magnoli.

(D) La cappella allato e intitolata in S. Piero Apostolo è dei discendenti di Niccolò di Bocchino, oggi de' Rimbaldesi.

(E) La cappella, quale è a dirimpetto alla predetta e intitolata in S. Piero Apostolo, è de' descendenti di Niccolò di Bocchino stava da S. Lucia de Magnoli.

(F) Cappella dirimpetto alla sopradetta, di San Piero Appostolo. Di Niccolò di Bocchino, stava da Santa Lucia, hoggi appartiene a Giovanni di Niccolò di Bocchino, sta da Santa Lucia.

12 (A) La chappella ch'è allato alla porta va nella Via delle Pinzochere e intitolata in Sancto Gherardo di Valenza è di Inghilese di Simone Baroncelli.

(B) La Cappella allato alla porta che va nella via delle Pinzochere, è della Famiglia de' Baroncelli; intitolata in S. Gherardo di Valenza.

(C) La cappella allato alla porta che va nella Via delle Pinzochere è della Famiglia de' Baroncelli, intitolata in S. Gherardo di Valenza.

(D) La cappella allato alla porta, che va in via delle Pinzochere, è della famiglia de' Baroncelli; è intitolata in S. Gherardo da Valenza.

(E) La cappella allato alla porta che va nella Via delle Pinzochere è della famiglia de' Baroncelli et è intitolata in S. Gherardo di Valenza.

(F) Chappella di santo Nardo da Valenza. Di Inghilese Baroncielli; ènne hoggi: Inghilese di Simone, Giovanni Baroncelli e figliuoli.

13 (A) La cappella ch'è allato alla chappella dell'altare maggiore e intitolata in Sancto Francesco è di messer Ridolfo de' Bardi e discendenti, è in verso mezzodì.

(B) La cappella a lato al'altar maggiore, di S. Francesco, è di tutta la famiglia di M. Ridolfo de' Bardi.

(C) La cappella allato all'altar maggiore, di S. Francesco, è di tutta la famiglia di M. Ridolfo Bardi.

(D) La cappella allato all'altar maggiore è intitolata in S. Francesco; è di tutta la famiglia di M. Ridolfo de' Bardi.

(E) La cappella allato all'altare maggiore e intitolata in S. Francesco è di tutta la famiglia di M. Ridolfo de' Bardi.

(F) Cappella allato alla [cappella] maggiore, titolata in san Francesco. De' descendenti di messer Ridolfo de' Bardi; ènne hoggi: Ridolfo et Giovanni di Tommaso de' Bardi.

14 (A) La chappella séguita e intitolata in Sancto Johanni Batista e Vangelista è di tutta la famiglia de' Peruzzi, fanno solenne festa di detto santo.

(B) La cappella a lato alla detta, di S. Giovambatista e S. Giovanni Evangelista, è di tutta la famiglia de' Peruzzi.

(C) La cappella allato alla detta, di S. Giovanni Batista e S. Giovanni Evangelista, è di tutta la famiglia de' Peruzzi.

(D) La cappella allato e intitolata a S. Giovanni Battista e S. Giovanni evangelista, è di tutta la famiglia Peruzzi.

(E) La cappella allato alla sopradetta e intitolata in S. Giovanni Batista e in S. Giovanni Evangelista, è di tutta la famiglia de' Peruzzi.

(F) Cappella di santo Giovanni Batista et del Vangelista. Di tutta la famiglia de' Peruzzi:

> Niccolò di Rinieri di Niccolò
> Luigi di Giovanni di Rinieri
> Niccolò et ⎫
> Bartolomeo ⎰ di Conte et fratelli
> Donato di Bonifatio Peruzzi
> Antonio di Giotto Peruzzi

15 (A) La chappella alla detta e intitolata in tutti gli Apostoli è di Nicholò e Bernardo di Domenico Giugni [In a later hand:] de' figli et di Filippo di Niccolò.

(B) La cappella acanto alla detta, di tutti gl'Apostoli, è di tutta la famiglia de' Giugni.

(C) La cappella a canto alla detta, di tutti gli Apostoli, è di tutta la famiglia Giugni.

(D) L'altra cappella che segue e intitolata in tutti gli Apostoli, è padronato di tutta la famiglia de' Giugni.

(E) La cappella allato alla sopradetta e intitolata in tutti gl'Apostoli, è padronato di tutta la famiglia de' Giugni.

(F) Cappella di santo Andrea Appostolo.

> Di Niccolò et ⎫
> Giovanni ⎰ di Giovanni del Bellaccio, hoggi ne sono
> e figliuoli, ⎰
> Antonio di Andrea di Giovanni del Bellaccio.

16 (A) La chappella allato a detta e intitolata in Sancto Andrea è di Nicholò e Giovanni di Bellaccio e suorum.

(B) La cappella a canto alla detta, di S. Andrea Apostolo, è di Niccolò di Giovanni del Bellaccio et suorum.

(C) La cappella a canto alla detta, di S. Andrea Apostolo, è di Niccolò di Giovanni del Bellaccio et suorum. [In a later hand:] Fu ereditata da casa Calderini, e poi dalla casa Riccardi che al presente possiede.

(D) L'altra vicina è intitolata a S. Andrea apostolo; è di tutta la famiglia de' Bellacci, e nel libro antico vi dice: *di Niccolò di Giovanni del Bellaccio, et suorum.*

(E) La cappella allato alla sopradetta e intitolata in S. Andrea Apostolo, è di tutta la famiglia de' Bellacci. [Added in the margin:] Anzi appare al libro anticho di dove n'è stato copiato questo vi dice a detto numero 16 et a carte una, seconda faccia, essere di Nicholò di Giovanni del Bellaccio et suorum.

(F) Cappella titolata in tutti gl'Appostoli.[1] Di Niccolò di Bernardo di Domenico Giugni, hoggi ne sono: Niccolò di Domenico Giugni, Galeotto di Bernardo di Domenico et fratelli.

17 (A) La chappella segue e intitolata negl'Agnoli è della famiglia de' Velluti.

(B) La cappella acanto alla detta, intitolata negl'Angeli, è di Donato di Michele Velluti e di Stoldo di Biagio Velluti. Oggi del Senatore Girolamo Morelli.

(C) La cappella a canto alla detta, intitolata negl'Angeli, è di Donato di Michele Velluti. [In a later hand:] In oggi della casa Morelli.

(D) La cappella vicina è intitolata negli Angioli; è di Donato di Michele Velluti e di Stoldo di Biagio Velluti, ossia del Senatore Girolamo Morelli.

(E) La cappella allato alla soprascritta e intitolata nelli Angeli è di Donato di Michele Velluti, e di Stoldo di Biagio Velluti. [Added in a different hand:] Oggi del Senatore Girolamo Morelli.

(F) Chappella degl'Agnoli. Hoggi appartiene [a] Donato di Michele Velluti.

18 (A) La chappella è in testa della croce e intitolata nella Nunziata, è di Giovanni e fratelli di Piero Bandini Baroncelli.

(B) La cappella allato alla porta della Sagrestia che fa testa alla croce della chiesa, intitolata nell'Annunziata, è di Giovanni e fratelli di Piero Bandini Baroncelli.

(C) La cappella allato alla porta della sagrestia che fa testa alla croce della chiesa, intitolata nell'Annunziata, è di Giovanni e fratelli di Piero Bandini Baroncelli. [In a later hand:] In oggi appartiene al Signore Marchese Giugni Niccolini e Marchesi del Bufalo.

(D) La cappella in testa alla crociera della chiesa è intitolata nella Nunziata; è di Giovanni e fratelli di Pietro Bandini Baroncelli.

(E) La cappella allato alla porta del'andito della sacrestia e in testa della croce della chiesa, e intitolata nella Nunciata, è di Giovanni et fratelli di Piero Bandini Baroncelli.

(F) Cappella titolata nella Nuntiata. De' descendenti di Piero Bandini. Hoggi ne sono Giovanni di Piero Bandini et Guasparri fratelli.

[1] The correct order of chapels 15 and 16 (given in A, B, C, D, and E) is reversed in F.

19 (A) La chappella allato a detta e intitolata in Sancto Antonio Abate è dei discendenti di Michele di Vanni Chastellani.

(B) La cappella a canto alla detta, di S. Antonio Abate, è de' descendenti di Michele di Vanni Castellani.

(C) La cappella a canto alla detta, di S. Antonio Abate, è de' descendenti di Michele di Vanni Castellani.

(D) La cappella vicina è intitolata in S. Antonio abate; è dei discendenti di Michele di Vanni Castellani.

(E) La cappella allato alla sopradetta e intitolata in S. Antonio Abbate è de' descendenti di Michele di Vanni Castellani.

(F) Cappella titolata in Santo Antonio Abbate. De' descendenti di Michele di Vanni Castellani, hoggi messer Francesco di messer Matteo, Antonio di Niccolò, Giovanni di Michele, Simone di messer Vanni Castellani.

20 (A) La chappela è lungho el muro in sulle regi di sotto e intitolata in Sancto Bastiano, è de' figliuoli di Nicholò di Guido della Foresta.

(B) La cappella allato al muro della sopradetta in su le reggi, di S. Bastiano, è dei figliuoli di Niccolò di Guido della Foresta.

(C) La cappella allato al muro della sopradetta in su le reggi, di S. Bastiano, è dei figlioli di Niccolò di Guido della Foresta.

(D) La cappella allato al muro della sopradetta e intitolata in S. Bastiano, è de' figlioli di Niccolò di Guido della Foresta.

(E) La cappella allato al muro della sopradetta in sulle reggi e intitolata in S. Bastiano, è de' figliuoli di Niccolò di Guido della Foresta.

(F) Cappella di san Bastiano. De' figliuoli di Niccolò di Guido dalla Foresta et de' Franzesi per metà; hoggi ne sono: Guido di Niccolò di Guido et fratelli, Antonio et fratelli di Niccolò Franzesi.

21 (A) La chappella è dirimpetto alla detta e intitolata in Sancto Martino, è delle rede di Piero di Jacopo Baroncelli.

(B) La cappella a dirimpetto alla sopradetta, di S. Martino, è delle rede di Piero di Jacopo Baroncelli.

(C) La cappella a dirimpetto alla sopradetta, di S. Martino, è delle rede di Piero di Iacopo Baroncelli.

(D) La cappella dirimpetto alla sopradetta e intitolata in S. Martino, è padronato degli eredi di Piero di Iacopo Baroncelli.

(E) La cappella a dirimpetto alla sopradetta e intitolata in S. Martino è padronato delle redi di Piero di Jacopo Baroncelli.

(F) Cappella di san Martino. Rede di Piero di Iacopo Baroncelli, hoggi:

Iacopo
Giovanni } di Piero Baroncelli
Sandro

22 (A) La chappella è più giù lungho el muro e intitolata nel Volto Santo, è di Francesco di Lorenzo Cigliamochi.

(B) La cappella che è più giù allato al Coro, del Volto Santo, è di Francesco di Lorenzo Cigliamochi.

(C) La cappella che è più giù allato al coro, del Volto Santo, è di Francesco di Lorenzo Cigliamochi.

(D) La cappella che è più allato al coro, e intitolata nel Volto Santo, è di Francesco di Lorenzo Cogliamochi [*sic!*].

(E) La cappella che è più giù allato al coro e intitolata nel Volto Santo, è di Francesco di Lorenzo Cigliamochi.

(F) Cappella del Volto Santo. Di Francesco di Lorenzo Cigliamochi, hoggi di Francesco di Lorenzo Cigliamochi.

23 (A) La chappella è in sagrestia intitolata nella Natività di Nostra Donna e di Sancta Maria Maddalena, è di Messer Francesco Rinuccini e suoi discendenti.

(B) La cappella di Sagrestia, della Natività della Madonna e di S. Maria Maddalena, è delle rede di M. Francesco Rinuccini.

(C) La cappella di sagrestia, della Natività della Madonna e di S. Maria Magdalena, è delle rede di M. Francesco Rinuccini.

(D) La cappella di Sagrestia è intitolata nella Natività della Madonna e in S. Maria Maddalena; è dell'erede di M. Francesco Rinuccini.

(E) La cappella di sacrestia è intitolata nella Natività della Madonna, et in S. Maria Magdalena, è delle rede di Messer Francesco Rinuccini.

(F) Cappella in sacrestia, titolata [nella] nostra Donna. Rede di messer Francesco Rinuccini.

Giovanni di Simone
Francesco et
Filippo et } di Cino Rinuccini
Iacopo

24 (A) La chappella nel primo chiostro cioè la schuola, e intitolata nella Natività di Nostra Donna, fu de Guidalotti, ogi è di Michele di Lodovicho de Banchi.

(B) La cappella nel primo chiostro e intitolata nella Natività della Madonna è di tutta la famiglia de Guidalotti, che è sotto la cappella de Bandini, oggi si domanda la Compagnia della Capanna.

(C) La cappella nel primo chiostro e intitolata nella Natività della Madonna, è di tutta la famiglia de Guidalotti che è sotto la cappella de Bandini, oggi si domanda la Compagnia della Capanna.

(D) La cappella nel primo chiostro è intitolata *La Natività* di Nostra Donna; è di tutta la famiglia de' Guidalotti, è sotto la cappella de' Bandini, oggi si domanda la Compagnia della Capanna.

(E) La cappella nel primo chiostro, e intitolata la Natività di Nostra Donna, è di tutta la famiglia de Guidalotti; è sotto la Cappella del Bandino. Hoggi si domanda la Compagnia della Cappanna.

(F) Cappella de' Guidalotti, nel primo chiostro. Natività di nostra Donna. Appartiene oggi: figliuoli di Michele di Lodovico di Banco, Iacopo di Michele di Banco.

25 (A) La chappella di sopra in detta schuola e intitolata in Sancto Francesco, è della Compagnia di Sancto Francesco.

(B) La cappella di sopra a dirimpetto all'ultima soprascritta, e intitolata in S. Francesco, è della Compagnia di S. Francesco.

(C) La cappella di sopra a dirimpetto all'ultima sopradetta e intitolata in S. Francesco è della Compagnia di S. Francesco.

(D) La cappella di sopra dirimpetto all'ultima sopradetta e intitolata in S. Francesco, è della Compagnia di S. Francesco.

(E) La cappella di sopra a dirimpetto al'ultima soprascritta e intitolata in S. Francesco, è della Compagnia di S. Francesco.

(F) Cappella di sopra al'ultima scritta dirimpetto, titulata in San Francesco et della [co]mpagni[a] di San Francesco, di detta Compagnia.

26 (A) La chappella ch'è nel primo chiostro e risponde in sul verso è intitolata in Sancto Francesco; è di Giovanni di Nicholò di Lodovicho de' Cerchi e non degli altri.

(B) La cappella tra i 2 Chiostri, intitolata in S. Francesco, è di tutta la famiglia de' Cerchi.

(C) La cappella tra i 2 chiostri intitolata in S. Francesco, è di tutta la famiglia de' Cerchi.

(D) La cappella tra' due Chiostri, intitolata in S. Francesco, è di tutta la famiglia de' Cerchi.

(E) La cappella tra' duo chiostri, intitolata in S. Francesco, è di tutta la famiglia de' Cerchi.

(F) Cappella di san Francesco, tra' dua Chiostri, della famiglia de' Cierchi; hoggi ne sono Giovanni di Niccolò di Lodovicho de' Cierchi.

27 (A) La chappella nella infermeria è intitolata in Sancto Bartolomeo Raffragano; è di Charoccio degli Strozzi e discendenti. Rinieri d'Antonio degli Strozzi.

(B) La cappella dell'Infermeria, intitolata in S. Bartolomeo Raffragano, è de' descendenti di Caroccio Strozzi.

(C) La cappella dell'infermeria, intitolata in S. Bartolomeo Raffragano, è de' descendenti di Caroccio Strozzi.

(D) La cappella dell'infermeria è intitolata in S. Bartolomeo; è de' discendenti di Caroccio Strozzi e discendenti di Ranieri d'Antonio degli Strozzi.

(E) La cappella dell'infermeria è intitolata in S. Bartolomeo Raffragano; è de descendenti di Caroccio Strozzi.

(F) Cappella nell'Infermeria, di San Bartolomeo. Descendenti di Charoccio Strozzi, sonne hoggi e figliuoli di Lionardo et Charoccio d'Antonio di Lionardo d'Antonio degli Strozzi.

28 (A) La chappella è sotto l'altare maggiore di chiesa e intitolata in Sancto Nicholò, è della famiglia de' Buonaccorsi stanno a Fano. Àll'a fare Bernardo d'Antonio de' Medici e fratelli e figliuoli di Piero da Meleto.

(B) La cappella sotto l'altar maggiore, intitolata in S. Niccolò sotto le volte, è della famiglia di Bettino Buonaccorsi, stanno a Fano.

(C) La cappella sotto l'altar maggiore, intitolata in S. Niccolò sotto le volte, è della famiglia di Bettino Buonaccorsi, stanno a Fano.

(D) La cappella sotto l'altar maggiore, intitolata in S. Niccolò sotto le volte, è padronato della famiglia di Bettino Bonaccorsi.

(E) La cappella sotto l'altar maggiore intitolata in S. Niccolò sotto le volte, è padronato della famiglia di Bettino Buonaccorsi, stanno a Fano.

(F) Cappella di san Niccolò sotto le volte. Della famiglia di Bettino Buonaccorsi si stanno a Fano, àlla a fare Bernardo di Antonio de' Medici et fratelli. Bernardo d'Antonio de' Medici, Giovanni di Bernardo Bettini Buonaccorsi.

29 (A) La chappella sotto le volte in verso la tramontana è intitolata nella Croce; è della Compagnia della Disciplina e Croce.

(B) La cappella sotto le volte e intitolata nella Croce è della Compagnia della Disciplina detta la Compagnia del Iesù.

(C) La cappella sotto le volte, intitolata nella Croce, è della Compagnia della Disciplina, detta la Compagnia del Iesù.

(D) La cappella sotto le volte, intitolata nella Croce, è della Compagnia della Disciplina (oggi detta del Gesù).

(E) La cappella sotto le volte è intitolata nella Croce, è della Compagnia della Disciplina, detta la Compagnia del Jesù.

(F) Cappella sotto le volte titolata nella Croce. Della Compagnia della Disciplina.

30 (A) La chappelletta sotto la sagrestia è intitolata nella Assunzione di Notra Donna; è di Francesco di Bartolo sevaiuolo.

(B) La cappella sotto le volte intitolata nel'Assuntione della Madonna, è di Francesco di Bartolo sevaiolo.

(C) La cappella sotte le volte intitolata nell'Assunzione della Madonna, è di Francesco di Bartolo sevaiolo.

(D) La cappella sotto le volte, intitolata nell'Assunzione della Madonna, è di Francesco di Bartolo settaiolo (Galigario).

(E) La cappella sotto le volte e intitolata nell'Assuntione della Madonna, è di Francesco di Bartholo seuaiuolo.

(F) Cappella sotto le volte. Assuntione di nostra Donna. Di Francesco di Bartolomeo setaiuolo, sta da ogni santi, hoggi ne sono Fra' Francesco Grassi, appartiene alla compagnia della Croce di sopra. Una sepultura in detta Cappella.

31 (A) La chappella è nel primo chiostro, è della Compagnia di Sancto Bartolomeo e intitolata in Sancto Bartolomeo.

[(B), (C), (D), and (E) No entry.]

(F) Cappella di san Bartolomeo, che è nel primo chiostro, ragunasi la compagnia di san Bartolomeo.

32 (A) La chappella in sul chiostro primo nel capitolo nuovo à fatto fare messer Andrea de Pazzi è intitolata . . .

[(B), (C), (D), (E), and (F) No entry.]

33 (A) La chappella ch'è all'entrare nel dormitorio de' novizi è intitolata in Sancto Cosma e Damiano; fece fare Cosma de' Medici detto dormitorio e cappelle e l'andito innanzi alla sagrestia.

[(B), (C), (D), (E), and (F) No entry.]

34 [(A), (B), and (C) No entry.]

(D) Il suddetto estratto fu copiato dall'inventario dell'anno 1439, che si conservava nell'Archivio dell'Opera. Lo scrittore fu il Baccelliere fra Raffaello della Fonte, fiorentino di S. Croce l'anno 1597, essendo provveditore dell'Opera Francesco di Piero Covoni.

[(E) and (F) No entry.]

Document 2

Extracts from the Records of the Opera di S. Maria Novella, *noting the demolitions and renovations planned by* Vasari

Preserved in Vincenzio Borghigiani, 'Cronaca', iii 391-2 (A.S.M.N.)

RAGGUAGLIO

Della restaurazione o riordinazione interiore della chiesa di S. Maria Novella fatta da Cosimo I e principiata l'anno 1565.

E prima si noterà le demolizzioni che furono fatte, cioè:

1. La Cappella de' Magi allora di padronato de' Fedini, situata allato la Porta grande di verso levante.
2. La Cappella di S. Maria e S. Lorenzo della famiglia Giuochi, situata in cantonata, tra la porta laterale a levante, a la prima arcata.
3. La Cappella di S. Maurizio, che stava nella 2^{da} arcata.
4. La Porta del fianco a levante nel mezzo della 3^{za} arcata fu rimurata.
5. Il Sepolcro di Beato Giovanni di Salerno, e quello della Beata Villana situati nel piano della 4^{ta} arcata furono levati.
6. Tutto il Ponte, e tutte le Cappelle che vi erano sotto, e sopra.
7. Tutto il Coro, situato avanti la Cappella Maggiore, (8.) con l'altare aderente al muro di esso Coro per di fuori, intitolato della Nunziata, già eretto dal P. M.ro Pantaleoni.
9. Il Sepolcro di Messer Bartolomeo Rimbertini Vescovo di Cortona, posto alla muraglia maestra di contro a detto Altare: ed il Sepolcro del Vescovo Aldobrandino Cavalcanti situato lì oltre, fu trasferito altrove. Siccome da altro luogo quello del Vescovo Visdomini.
10. Lo Altare di S. Maria Maddalena Penitente situato di là dalla Pila de' Regnadori verso mezzodì.
11. Il Sepolcro del Vescovo di Fiesole, M. Jacopo Altoviti, che stava allato di detto Altare.
12. Il Sepolcro del Podestà da Panzano, che succedeva a suddetto di verso il Ponte, amendue di marmo al muro.

13. Il Sepolcro della Beata Giovanna Fiorentina situato sceso di poco lo scalino del Ponte al muro.
14. La Cappella della Trinità posta a ponente nell'arcata di contro la Porta del fianco suddetta stata rimurata.
15. La Cappella di S. Ignazio Martire de' Benintendi, posta nel piano dell'arcata, che ne succedeva di verso la Piazza nuova.
16. La Cappella antica di S. Vincenzio Ferrerio posta tra le due porte appiè della chiesa, a ponente della Porta Maggiore.

NUOVITA

Cosimo I dopo di avere sgombrato le tre Navate dal Coro, e dal Ponte che le occupavano nel mezzo, ed impedivano all'occhio la vista libera, e vaghezza del magnifico tempio, volle che gli Altari si rinuovassero, e rimodernassero con architettura di pietrame, e che uniformi si corrispondessero da un' Arcata all' altra per tutto il corso della chiesa; onde si prese l'appunto, non che di ricercare il consenso delle Famiglie Padrone delle Cappelle, che furono demolite come sopra; ma di ritruovarne altre, che a loro spese riedificassero le nuove, nel modo, che l'era determinato, secondo il disegno del celebre Giorgio Vasari Architetto, e Pittore Aretino di gran nome: e a tenore d'una sua Istruzione diretta in carta agli Operai da esso deputati Soprintendenti a' Proveditori di detta Restaurazione, la detta Istruzione del Duca Cosimo contenevea quanto appresso.[1]

Tirar l'Altare (maggiore) innanzi, et alzarlo con le sue appartenenze. Fare il Coro doppio per i Frati, assettarlo, non levando le Spalliere, nè alterando la Cappella, nè dipinture, come sarà giudicato dal'Ingegnere, col far l'entrata dietro alle Cappelle, che si possa di dormitorio venire in coro, servirà, che i Frati non siano visti.

Levar il Ponte, mantenendo ai Padroni le loro Sepolture et il luogo, e dando loro un altro luogo per la Cappella, secondo che parrà al'Ingegnere.

Levare il Coro, mettendovi panche per il popolo, come sarà giudicato.

In ogni arco far una Cappella e non più, nel modo che sarà giudicato dal'Ingegnere, che sono dodici archi.[2]

Ridurre la Cappella de' Giuochi, secondo il modello che sarà disegnato, lasciandovi la memoria di detta Casato, che è già spento.

Far l'andata all'Organo dalla Cella del Sagrestano, che è poca poca spesa, e fatti senza rompere mura, o levarlumi o altro.

Di quattro Altari, che sono sul Ponte, ridurgli tutti sotto un titolo, in un altro Altare.

L'Ingegnere abbia autorità, bisognando, di levare o tramutare Sepolture, Sepolcri, o porte per comodità di questa Opera, dando a quei tali simile, o più degno luogo.

[1] Baldovinetti (n.p.) has a shortened version of this document beginning with the following paragraph; it is substantially the same as the version given here. Similarly, V. Fineschi transcribed a version of it in his *Memorie istoriche degli uomini illustri del convento di S. Maria Novella di Firenze*, Florence, 1790, pp. 22 f.

[2] Baldovinetti has retained a longer reading: 'In ogni arco fare una Cappella honorata col disegno che ne farà l'Architetto, i quali Archi sono XII e dalla Concessione del sito si caverà buona somma di denari, con i quali si potrà rinborsarne l'Escita delle spese.'

Copia estrata dall'Originale esistente nell'Archivio di Sindicheria, Zibaldone dell'Opera segnato numero 6, foglio 8.

Document 3

Letter from the Operai *of Sta Croce to the Duke, reporting on the removal of the rood-screen and old choir, 21 July 1566*

A. S. Croce, vol. 426, fo. 51. Transcription by Moisè, *S. Croce di Firenze*, pp. 122 ff.

Illustrissimo et Eccellentissimo signor Duca.

Ricercando il debito nostro ragguagliare Vostra Eccellentia di quello habbiamo seguito fino al presente circa l'assetto della chiesa di Santa Croce, con somma riverentia gli narriamo come habbiamo levato tutto il tramezzo et cappelle, eccetto quelle della Foresta lungo il muro di verso i chiostri, sulla quale s'è posto l'organo comodamente, e senza alcuno suo impedimento, che per esser vecchio se ne dubitava. Dipoi habbiamo levato parte dei legnami del coro, et abbassato il muro sino a quel segno che Vostra Eccellentia Illustrissima fece fare, salvo però che mezza la facciata dinanzi dalla parte di settentrione, quale s'è messa in terra tutta per veder come tornava; et inoltre, perchè così era necessario, quando bene si habbia abbassare il legname del coro; perchè le piane vi sono murate dentro tanto spesse che ad ogni modo è forza smurarlo tutto. Et per quanto apparisce per quella parte che s'è tutta messa in terra, quando detto coro si levasse del tutto, apparirebbe bellissimo et magnifico tempio, et tutto il corpo della chiesa saria sanza comparatione molto più bello et dilettevole all'occhio; e questa è opinione universale di ciascuno che l'ha vista, e particolarmente di più architettori et periti, et a noi molto satisfà. Rimettendo pur tutto al prudentissimo et sapientissimo giuditio et al parere di quella. Advertendo Vostra Eccellentia Illustrissima che sia molto ben considerato, che, tirato l'altar maggiore innanzi quanto si può, et accresciuto alquanto le scalee, et levato una scaletta di dietro che non sarà più necessaria, s'acquista circa braccia quattro di spazio, tanto che la cappella resterà capacissima per ricetto de' frati; et di già si è provato con tutti i lor frati che sono sessanta, e ci avanza luogo et le voci ci si sentono benissimo, et non punto meno che nel coro vecchio. Et quando si levasse la tavola che è molto grande, la cappella appareria maggior, e con più grazia, et si guadagneria la vista di tutte quelle finestre maggiori che sono molto belle, e li frati potriano veder levare il Sacramento, e in sull'altare si potria mettere uno ciborio o un Crocifisso, come hanno Santo Spirito, la Nuntiata et Santo Piero Maggiore, e risparmierebbesi spesa. Attenderemo adesso quello che dall'Eccellentia Vostra Illustrissima ne sarà comandato, prontissimi tutto eseguire, et con desiderio aspettandone la risposta, a cagione sappiamo quanto habbiamo a seguire secondo

l'intenzione di quella. Alla quale, non occorrendo altro, di cuore ci raccomandiamo bacian-doli le honoratissime mani.

Di Fiorenza il giorno 21 luglio 1566.
Di Vostra Eccellentia Illustrissima
Fedelissimi Servitori
Operai della fabbrica e Chiesa di Santa Croce

[Cosimo's reply :]
Se il coro si può mettere nella cappella maggiore, lievisi del tutto il coro dov'è hora.

Thomaso de' Medici C. de Mand.
28 luglio 1566

Document 4

Letter from the Operai *of Sta Croce to the Duke, requesting marble for the altar table February 1566/7*

A. S. Croce, vol. 429, fo. 10.

Ill.ᵐᵒ et Excell.ᵐᵒ S. Duca

Gli operai della fabrica et chiesa di Santa Croce, humili servi di V. EX. Ill.ᵐᵃ, con somma reverentia expongono a quella come, essendo finito el choro di detta chiesa, desiderano si potessi offitiare la capella maggiore. Et perchè, secondo ci ha referto Messer Giorgio Vasari, quella per sua bontà et amorevoleza si era offerta di donarci una pietra di marmo di Seraveza per far la tavola di detto altare maggiore da collocarsi su 4 balaustri, ci è parsso, con ogni debita reverentia, ricordarllo a V. Ex. Ill.ᵐᵃ. Et perchè possa havere notitia della grandeza di quella, troviamo che quella vi è di presente è lunga braccia 7 et larga 3²/³. Ma per occupare mancho luogo, li architectori et Giorgino et li frati anchora che se n'hanno a servire, dicono che basteria fussi larga 2½ o al più 2/3, et che della lungheza si può poco diminuire, pur tuctavolta non daria noia quando fussi braccia 6½ vel circa. Et perchè ci è anchora necessario un ciborio sull'altare, del quale ne ha facto un modello detto Giorgino, quale ha relapsato in mano di Maestro Batista Botticelli, preghiamo quella anchora ci voglia aiutare in tale opera, essendo le forze nostre debole, ricevendo tutto per dono et gratia di V. Ex. Ill.ᵐᵃ et per l'honore di Dio et tal chiesa. Et non occorrendo altro, a quella di cuore ci rachomandiamo et li baciamo le honoratissime mani.

[Cosimo's reply:]
Si farà cavare e si farà venire.
Thommaso de' Medici C. de mandato, 23 di febraio 1566.

Document 5

Verdict of the magistrate in the case of the Alberti Family v. the Operai *of Sta Croce concerning the Alberti's rights of patronage to the pavement of Sta Croce where the choir had been, 26 August 1567*

A.S.F. Magistrato Supremo, 1330, no. 164

Molto Magnifici et Illustrissimi Signori:

Egli è solito di quelli, i quali hanno poca ragione in una causa et non hanno fondamenti, per li quali possino mostrare la loro intentione et oviare al'obiectioni che se li fanno, di cercare d'inculcare la verità con la moltitudine delle parole et cose impertinenti, chiamando cose vane le ragioni del'altra parte alle quali con difficultà possono rispondere. Onde non è meraviglia se li signori operai di Sta Croce havendo tolto a difendere causa così ingiusta, et contro il comun parere di tutta questa Città, cercano con vanità levar via i saldissimi fondamenti della chiarissima et nobilissima Famiglia degl'Alberti con le risposte date alle ragioni dedutte per li medesimi Signori Alberti; alle quali risposte singularmente et particularmente et a ciaschuna d'esse replicherebbano gl'Alberti, se cognoscessero esser tali che meritassero replicationi; Ma perchè la causa pende avanti a persone dottissime, et giuditiosissime le quale ben cognoscano qual sia la verità, et quali sieno le Cavillationi; Imperò per non perder tempo nelle cose vane, consultamente le lascia andare. Et pigliando solamente duoi Capi ne' quali consiste tutto questo negotio, brevemente n'occorre replicare quanto apresso cioè:

Il primo Capo adunque è che le cose ecclesiastiche (secondo gl'operai di Sta Croce) non si possino possedere da i laici, et conseguentemente che gl'Alberti non possino far fondamento nel'antichissima possessione del solo del coro di Sta Croce. Questo fondamento è tanto debole quanto è contro la decisione comune di tutti i dottori Civili et Canonisti, i quali unitamente concludano che quanto al'uso et memoria le cose ecclesiastiche possono essere possedute da' laici. Sì come questo et altre cose in favore degl'Alberti et contro gl'operai, deduce largamente et dottamente al solito l'eccellentissimo Messer Giovambatista degl'Asini in un consigl[i]o fatto in questa causa a favore degl'Alberti, quale si produce avanti alle signorie vostre Magnifiche.

Inoltre non solamente questo è chiaro di ragione, ma anche si vede osservare continuamente il medesimo in tutte le chiese di questa Città, conciò sia che si vede ogni giorno concedersi a' laici nelle chiese il sito delle Cappelle et de' sepolcri, il qual sito sì come è posseduto da i laici, così anche quanto al'uso ne sono interamente padroni, non si possendo senza loro licentia in quel sito sepellirvi altri nè mettervi da altre persone cosa alcuna senza loro espressa volontà. Il che non li sarebbe concesso di fare se non possedessero et non fussino Padroni di tal sito almeno quanto al dominio utile, et questo è chiarissimo et si è osservato, et osserva in tutte le chiese di questa Città.

Apparisce adunque che di ragione et secondo la consuetudine le cose ecclesiastiche possono esser possedute da i laici almeno quant'al'uso et Dominio utile, et però potendosi possedere, et essendo gl'Alberti in antichissima et lunghissima possessione del solo sopra detto (come s'è mostro nel'Informazione fatta per gl'Alberti, né si vede gl'operai negarlo), ne succede la chiarissima conclusione, che essendo in Possessione, devono essere in quella mantenuti, et non molestati senza causa alcuna come indebitamente fanno gl'operai.

Con questa conclusione solamente considerando diligentemente il tutto si lievano via tutti i fondamenti per gl'operai di Sta Croce, et in particolare il secondo capo del quale di sopra si faceva mentione, il quale è che il solo fussi concesso solamente alla Famiglia degl'Alberti per l'effetto del coro, et che perciò, essendo levato il coro, et così cessando la causa, cessi l'effetto, et consequentemente, che levato il Coro degl'Alberti non habbino più che fare nel solo. Imperò che essendo gl'Alberti in antichissima Possessione del sudetto solo in tutto et per tutto, insieme con le cinque conietture delle quali s'è detto altrevolte, hanno la presuntione urgente in loro favore di tutto il solo, la quale presumptione è di tale efficacia, et opera tanto, che pretendendo gl'operai che il solo fussi concesso agl'Alberti per l'effetto solamente del coro, lo devino provare havendo contro di loro la Presuntione del tutto, mediante la possessione degl'Alberti di tutto il solo.

Et benché questo bastassi a gl'Alberti, et che agl'operai s'appartenessi, come si è detto di sopra, il mostrare che il sito fussi concesso agl'Alberti per l'effetto solamente del coro; nondimeno acciò che la verità apparisca, et che le signorie vostre Magnifiche sieno chiarissime, il solo in tutto appartenersi agl'Alberti non solamente per l'effetto del coro, ma per ogni altra cosa che in quel luogo havessero voluto fare, si mostra chiaramente per l'infrascritte urgentissime ragioni.

Imperò che se il solo fussi stato concesso agl'Alberti per l'effetto del coro, necessariamente ne sarebbe seguitato, che da quel poco luogo in poi, i'nel quale erano apposti li sedili et scanni del coro, i' nel restante del vacuo che vi rimaneva, gl'Alberti non havessero havuto che fare, et nondimeno apparisce il contrario, così per le linee di marmo apposte sotto alle scalee, come anche per le sepolture degl'huomini et donne degl'Alberti, le quali sarebbano state unitamente messe insieme, et non da capo et da piedi se lo spazio, et solo da le sepolture degl'huomini et donne compreso non fussi stato degl'Alberti.

Questo medesimo più chiaramente si mostra perché se tal vacuo fussi stato degl'operai, in tanto così lungo tempo harebbano concesso il luogo per le sepolture a molte persone, sicome hanno fatto intorno intorno et per tutto il restante della chiesa; onde non l'havendo fatto, manifestamente appare, che non lo potevano fare.

Inoltre se il solo, et vacuo da li sedili in poi, come di sopra, non si fussi appartenuto agl'Alberti ma a gl'operai, quando il generale Sansone fu sepolto in quel solo anzi nel mezzo di quel vacuo, non accadeva nè faceva di bisogno che per mettervi quel corpo né havessero li frati di Sta Croce ottenuto licentia da la Famiglia degl'Alberti, et di tal licentia fatto memoria nel sepolcro. Et però, essendo stata impetrata et data tal licentia dagl'Alberti, bisogna per forza confessare che il solo fussi concesso agl'Alberti in tutto et per tutto, et non per l'effetto del coro solamente.

Ultimamente questo medesimo apparisce per l'ossa del Cardinale degl'Alberti messe da loro in nel mezzo del solo mentre che il Coro si disfaceva et publicamente, et palesemente; il che se non havessero possuto fare gli sarebbe stato proibito dagl'operai. I quali non l'havendo fatto, vengano tacitamente a havere approvato il fatto degl'Alberti.

Agiugnesi ancora alle cose suddette quello che si diceva, che il coro quanto agl'operai, et agl'Alberti non era levato, et la risposta data per gl'operai è vanità perché trattandosi il negotio del coro intra gl'Alberti et gl'operai di Sta Croce et essendo loro i contraenti si hanno a considerare solamente le cose fatte infra di loro, et di loro consenso et voluntà, et l'altre cose fatte dal Principe senza pregiuditio del terzo non hanno a essere in consideratione come se fatte non fossero.

Per il che finalmente si conclude, gl'Alberti non dovere esser molestati nella loro pacifica et lunga possessione, et gl'operai come temerarii litiganti dovere esser condennati nelle spese.

Document 6

Letter from the Operai *of Sta Croce to Duke Cosimo reviewing the status of the* Zati *Chapel, 6 February 1568/9*
A. S. Croce, vol. 429, fo. 12

Illustrissimo et Eccellentissimo Signore Duca

Li Operai di S. Croce devotissimi servi di V. Eccellenza Illustrissima, con somma reverenza espongono a quella qualmente già sono più anni venendo a morte Andreuolo di Niccolò Zati fece suo testamento nel quale lasciò herede universale Alessandro suo unico figliuolo all'hora di minore età e quello gravò di fare una Cappella in S. Croce in certo tempo già decorso più anni sono. Nella construttione della quale e tavola et ornamenti dovessi spendere f. 800 d'oro di moneta e f. 400 simili per la dotatione d'essa et così in tutto f. 1200. Del'anno 1565 Il Signore Commissario Apostolico trovando non essere adempiuto tal legato trasse da detto Alessandro il quinto di contanti et li fece dilatione per quattro anni a fare e finire tal Cappella con il consenso de' frati senza far noto cosa alcuna alli Operai et con conditione che non la facendo in detto tempo cadessi in pena di f. 200 quali cedessino in augumento di tale dotatione come n'apparisce publico instrumento, qual tempo è maturo. Onde più volte per il debito del nostro ufficio e desiderio teniamo che tal chiesa si vadi ornando di dette Cappelle secondo l'ordine datone altra volta da V. Eccellenza Illustrissima, l'habbiamo fatto chiamare e fattoli parlare a qualchuno di noi, et espostoli tal desiderio nostro et debito suo, et la pena nella quale incorre. Niente di manco non possiamo condurlo a pigliare il luogo, o vero sito di tal Cappella, et dare principio a tal impresa, et ancor che l'authorità nostra s'estenda pure assai secondo li ordini, ci è parso non usarla senza farlo prima sapere a V. Eccellenza

Illustrissima la quale ne comanderà la volontà sua et noi saremo pronti a esequire quanto quella comanderà, alla quale di cuore ci raccomandiamo, et il Signor Iddio la feliciti et esalti.

[The Duke's reply, in a different hand:]

Facciano pure il debito loro ché S.E. lo concede

Lelio Torelli VI Febraio 68.

Document 7

Letter from the Compagnia di Gesù Pellegrino to the Duke, informing him of their desire to found a new chapel in Sta Maria Novella, March 1568/9

A.S.F. Corporazioni Religiose Soppresse, 910, no. 11, fos. 33–4.

Jesus MDLXVIII

Essendoci fatto intendere da Bartolomeo di Bernardo Gondi come uno delli Hoperai di Santa Maria Novella che sua excellenzia Illustrissima haveva concesso a'm^{ci} Minorbetti la cappella dove essi hanno le loro sepolture libera vacua et spedita, acciò che vi facessino una cappella nel modo del'altre, però essendovi la sepoltura della Beata Villana, di che noi col Tempio siamo Padroni, ci richiede che si levi di quivi quanto prima, d'onde consultato tal negozio con tutto il corpo della compagnia, et ragionato di fare uno altare a detta Beata in essa chiesa dirimpetto a quello di Santa Caterina, o altrove insieme con detta compagnia del Tempio, o soli, richiedendocene con molta istanzia Sua Excellenzia Illustrissima et assai de'nostri principali fratelli di questa casa, parve a tutti XII li ufficiali, ché solo dua furno aggiunti per arroti, di eleggere quattro de'nostri fratelli sufficienti a praticare la traslazione di detto corpo, e fare detta cappella. Però fu da loro nominato di pari e concordevole volontà aprovati da detti ufficiali:

Messer Alessandro d'Ottaviano de'Medici

Messer Francesco di Girolamo Lenzoni

Jacopo di Francesco Pitti

Cristofano di Giovanni Spini

Tutti in solido, con l'autorità che si dirà apresso, quale fu letta e publicata prima a tutto il corpo della casa e benissimo considerata per ciascuno videlicet:

Concedano detti Padri, Capitani, Proveditori et consiglieri con tutto il corpo della nostra compagnia di pari consenso autorità e balia, a'sopradetti quattro eletti e deputati quanto tutto l'intero corpo della compagnia, salve però le cose infrascritte, sopra la traslazione del corpo e sepoltura della Beata Villana, posta al presente in Santa Maria Novella dirimpetto alla cappella de'Pasquali, di padronato di questa compagnia insieme con quella del Tempio, et per conto di tale trasmutazione, trattare e negoziare in nostro nome tanto

con l'Illustrissimo et Excellentissimo Signor Duca nostro, quanto con li huomini e deputati del Tempio, et con li hoperai di detta chiesa di Santa Maria Novella et ogni altra persona che accadessi. Ancora fare per tal conto, bisognando, una nuova cappella in essa chiesa, nel modo et luogo che parerà ai sopradetti deputati. Possino altresì per tal conto risquotere o fare risquotere da qualsivogli debitore di nostra compagnia, deliberare et porre vanti secondo che a lloro piacerà, con questa condizione non di manco, che qualunque deliberazione da farsi per loro circa le sopranominate cose o ciascuna di esse, si debba prima aprovare in corpo di nostra compagnia e dapoi sortisca il suo intero effetto.

Così fu mandato attorno il partito per la confermazione et approvazione di quanto di sopra et di là si contiene, nel corpo di ottantadue nostri fratelli presenti, et fu hauto per rato grato et fermo per sessantasette fave nere nonstante quindici bianche. Che nostro Signore Iddio gli illumini a fare quello che sia suo honore e reverenzia, et di questa Venerabile casa, con salute del'anime nostre.

Document 8

Letter from Lodovico Serristori to the Operai *of Sta Croce accepting their offer of the site of the Serristori Family Chapel, 19 May 1569*

A. S. Croce, vol. 426, fo. 6

Molto Magnifici et honorandi Signori

Io ho ricevuto una lettera delle Signorie Vostre offerendomi il sito della Cappella da farsi nel medeximo sito de'mia antenati, et intendo che i'nel lascio di Ristoro non si deve far fondamento alquno, che sia con Dio. Ringratio però le Signorie Vostre del'amorevol diligentia fatta usare, et non posso in modo alquno lasciar quel sito che fu sempre de'mia antenati, et che le Signorie Vostre mi offeriscono, et mi contenterò di farci la fabrica secondo il disegno, et in brevi giorni spero che potrò tornar di costà per la speranza che me ne danno i patroni, sì che non passerà a mio giuditio giugno, et allora non mancherò di far mio debito, et basciando le mani delle Signorie Vostre prego Iddio che le contenti. Di Roma, addì 19 di maggio 1569

Delle Signorie Vostre Molto Magnifiche

Servitore Lodovico Serristori.

Document 9

Letter from Francesco and Niccolò di Simone degli Asini to the Operai *of
Sta Croce concerning the new Asini Chapel built by Marco* [*1570*]

A. S. Croce, vol. 426, fos. 157, 158, 156

Dinanzi a voi, molto magnifici Signori Operai della Chiesa di Santa Croce, con reverentia espongano

Francescho et⎫ fratelli carnali et figlioli già di Simone di Francescho delli Asini, cittadini
Niccholò ⎭ fiorentini, in lor nome proprio et senza etc.

Et disseno et dicono come per molti et molti anni et da tanto tempo in qua che non è memoria in contrario, il casato et famiglia delli Asini ha tenuto una cappella nella Chiesa di Santa Croce, intitolata nel nome di S. Marcho, et con detta cappella due sepolture, l'una della quali haveva la tavola di marmo et l'altra di pietra, et una era drento nel sito della detta Cappella et l'altra fuori, et in una si seppellivano i corpi di mastii et nel'altra delle femmine. Le quali due sepolture insieme con la detta cappella son sempre state, havute, tenute et reputate delli descendenti di Francescho di Niccholò di Marcho degl'Asini, cioè di Niccholò, Piero overo Pieraccino et Christofano, figlioli di detto Francescho, sì come questo essere stato vero apparisce et con verità si può giustificare per i libri nei quali è tenuto conto delle cappelle e sepolture di detta Chiesa, i quali si producano et si depongano appresso il sagrestano di detta Chiesa et altra persona appresso la quale fussino. Et che mess. Marcho et mess. Giovanbatista infrascritti non sono delli descendenti di detto Francescho, essendo provato il contrario, che non farano in questo replica alcuna li comparenti. Et però non hanno li detti mess. Marcho et mess. Giovan Batista ragione alcuna di detta Cappella, sepolture et sito di Cappella.

Et che non obstante le cose predette, li prefati

Mess. Marcho et ⎫ hanno alli mesi passati, nel sito di detta Cappella, edificato un'altra,
Mess. Giovan Batista⎭ con impressione d'arme loro propria et particolare, per il che hanno voluto excludere dalla possessione di detta Cappella i proprii padroni et fondatori, cioè descendenti di detto Francescho, et per consequentia detti Francescho et Niccholò comparenti, contr'ogni debito di ragione, in preiudicio della casa loro, come veri descendenti [*cancelled*: della casa loro] di detto Francescho.

Et inoltre, per torre il lume del vero ai posteri, hanno fatto levare i fregi neri di marmo di dette sepolture donde detti comparenti vengono anchora affaticati molto più che non converrebbe loro se detti fregi non fussino tolti via, sendo che in quelli vi erono scolpite parole et altre cose per le quali si dimostrerebbe esser vero quanto di sopra è stato narrato. Anzi, che per divenire detti mess. Marcho et mess. Gio[va]nbatista infra poco spatio di tempo patroni senza contraditione che potessi loro esser fatta dalli descendenti di detti comparenti, hano fatto scolpire versi tali nella tavola di detta cappella, che in pochi anni

da quelli che verranno sarà tenuta sol et proprio patrone di detta cappella et sepolture, se dalle Magnificentie Vostre non si soccorre nelli infrascritti modi domandati.

Et però brevemente così narrato il fatto, domandorno et domandano per voi S.ri Operai dichiararsi et sententiarsi le cose predette essere state et esser vere, et la detta cappella intitolata in S. Marcho con le sepolture predette essersi appartenuta et appartenersi ai sopradetti comparenti come descendenti di Francescho degl'Asini et veri patroni di essa. Et consequentemente, sendo detta cappella stata distrutta in parte, dichiararsi et pronunptiarsi i ferramenti et spoglie di qualsivoglia sorte cavati di detta cappella, essersi appartenuti et tenersi ai detti comparenti. Et detti mess. Marco et mess. Giovan Batista esser condemnati a restituirli di detti comparenti che sono in essere, altrimenti la lor valuta et prezzo; et successivamente non haver possuto i detti mess. Marcho et mess. Giovan Batista fare edificare nel sito di detta cappella di S. Marcho edificarne quella che hanno edificato et che hoggi apparisce [essere?] senza il consenso, intervento o [volere?] di detti comparenti. Et sendo così hoggi edificata [*cancelled*: et tutto sendo seghuito di fatto] detta nuova cappella nel luogo predetto, et sopra di essa postavi l'arme propria di detto mess. Marcho et mess. Giovan Batista, et dalle sepolture predette tolto le tavole et i fregi, come è stato narrato. Et finalmente tutte le cose predette seghuite di fatto et non di ragione, domandorno et domandano detto mess. Marcho et mess. Giovan Batista esser dechiarati a non havere havuto actione et facultà di edificare la cappella predetta, maxime nel sito predetto, et havendola edificata non havere possuto sopra di quella mettere l'arme sua propria né anchora diversi [fregi?] che si veggono nella tavola sculpiti, né anchora haver possuto torre et far levare le tavole delle dette sepolture con i fregi di marmo, et perciò dechiararsi et dechiarato condennarsi detti mess. Marcho et mess. Giovan Batista a far riporre le dette tavole et fregi di dette sepolture, et a far levare l'arme lor propria posta sopra detta cappella, et inoltre dichiararsi non potere né dovere usare detta cappella come loro propria et in quella non havere padronaggio, ma restituirli la spesa che giustamente fu fatta, esser condennato a desistere di usar la detta cappella et sepolture come non descendenti delli propri descendenti di detto Francescho delli Asini, o almeno in ogni caso che il contrario si mostrassi, dechiararsi detto mess. Marcho e mess. Giovan Batista haver solo la participatione per una parte, refacendogli la rata della spesa che dalle Signorie Vostre sarà deliberato doversegli rendere, et per la detta rata detta cappella et sepolture appartenersi alli detti comparenti come patroni per l'altra parte, sempre compensando quelli commodi che si sono[1] presi mediante li ferramenti et altre reliquie della detta cappella destrutta et ogn'altro commodo, et successivamente a esser condennato a torne la detta sua arme et dovervi star l'arme comune a l'una e l'altra famiglia, et dovendo extinguere quelli versi che hoggi vi sono scritti o almeno farvi altra aggiunta in quelli modi che parrà alle Magnificentie Vostre, perché sia noto il lume della verità ai posteri.

[1] [In margin:] la destruzione di detta cappella, cioè.

Document 10

Letter from the Marco degl'Asini line to the Operai *of Sta Croce, refuting claims of the Simone degl'Asini line to the Chapel* [1570]

A. S. Croce, vol. 426, fo. 146

Per informazione delle SS VV si dice quanto appresso et prima

Che sotto dì 21 di dicembre 1566 fu facto partito che si facessi intendere a Messer Marcho degl'Asini che fra dì 6 o 8 si risolvessi se voleva rifare la cappella o concedere il sito ad altri.

Di poi sotto dì X di febraio apparisce partito della accettatione di Messer Marcho et di poi a poco a poco s'è condocta come appare.

Due cose s'allegano dalla parte adversa ambe notoriamente false, la prima che noi non siamo padroni della cappella ma loro soli; la seconda che non furno citati secondo la forma del rescritto di Sua Alteza.

Quanto alla prima si risponde la cappella esser stata sempre comune della famiglia degl'Asini insieme con le sepulture, come diceva l'inscritione vechia di quelle et ne faranno fede i frati et tutto Firenze, et utimatamente nella sepultura ehe era dentro alla cappella furno sepelliti Nicholò degl'Asini, fratello, et Ruberto degl'Asini, figliolo di Messer Marcho degl'Asini.

Di più proveranno questi Reverendi Padri come tutti gl'acconcimi et instauramenti che si sono fatti in detta cappella gl'hanno fatti Messer Marcho degl'Asini et Nicholò suo fratello oggi morto, et massime doppo la piena grande, et nel dossale del'altare et ne'paramenti era et è l'arme degl'Asini et de'Gualterotti, della qual famiglia è la moglie di detto Messer Marcho; ci s'aggiugnie anchora che tale cappella per tali acti possessorii era tenuta communemente da ogniuno [o] la maggior parte, particulare di Messer Marcho et della sua linea. Et che questo sia vero si prova anchora per la confessione della parte facta la passata tornata davanti alle SS VV Mag[nifi]ce quando disse che per più acti facti Messer Marcho haveva cercho di torre loro tale cappella, la quale confessione fatta in iuditio et dinanzi alle SS VV pruova perfectamente.

Per queste ragioni et altre che occorrendo si diranno per non infastidire, senza bisognio, le SS VV, prima pare che s'inferisca che Messer Marcho et la sua linea sia uno de' padroni, ma più presto solo padrone, et quando non fussi mai altro, non si può negare che non fussi in quasi possessione di detta cappella et però potette come uno de'padroni accettar l'offerta et fare detta cappella come ha facto.

Quanto alla seconda, dove dice non esser stato citato prima, si dice che non toccava a Messer Marcho a citarlo perché egli era citato et poteva accettare senza altro.

2° Si deve credere che anchora egli fussi citato, ma perché in tali casi si procede summariamente, non ne sia stata facta scrittura.

3° Si dice che quando bene le SS VV non l'havessino citato o notificatognene, che non si crede, Messer Marcho, anchora che non fussi tenuto, gnene fece sapere per vedere se voleva concorrere alle spese, et Nicholò degl'Asini, oggi conparente, disse et rispose a Messer Giovannbatista suo figliolo nello studio, che non voleva et non poteva concorrere et questo serva per positione et le SS VV gli faccino dare il giuramento perché e'confessi se è vero o nieghi.

4° Quando ciò non fussi seguito, si dice che sono già 3 anni passati che si stracciò il muro et si gittò il fondamento, et di poi publicamente si sono tenute le pietre in chiesa gran tempo et murato detta cappella con lung[h]eza di tempo. Onde habitando detti Francescho et Nicholò degl'Asini del continuo in Firenze et vicino a detta chiesa di Santa Croce dove s'è fatta tal cappella, hanno più et più volte veduto et potuto vedere et sapere che era fatta da Messer Marcho degl'Asini, et non hanno mai reclamato o detto cosa alcuna. Onde ne segue che quando non havessimo ragione alcuna sopra il padronato (il che, per le cose dette di sopra, si niegha) harebbano acconsentito che noi la rifacessimo et però s'harebbano pregiudicato a ogni ragione che potessino pretendere: perché chi vede e sta cheto, secondo che disponghano le leggi, s'intende consentire, il quale tacito consenso basta.

Document 11

Affidavit of Frate Risaliti concerning the past ownership of the Asini Chapel and Tombs. 24 June 1570

A. S. Croce, vol. 426, fo. 145

Fassi fede per me Frate Dionisio Risaliti al presente Guardiano di Santa Croce di Firenze come nella sepultura et per dire meglio nelle sepulture di huomini et donne della famiglia degl'Asini, le quali sono differente nel sotterrarsi, ché in una vanno li huomini et nel'altra le donne, vi si sono sotterrati i figliuoli et fratelli et altri della banda et linea di Messer Marco degl'Asini et sempre habbiamo tenuto noi che le sieno commune. Et similmente la cappella di detti Asini si appartenghi al detto Messer Marco per havere lui in tutti i bisogni di detta Cappella concorso alla spesa di tovaglie e altri bisogni appartenenti a detta cappella insieme con Niccolò suo fratello, et particolarmente l'Anno doppo la piena restaurò il dossale del'altare, fece una cortina all'Altare di detta Cappella et candellieri per detto Altare. Ancora hanno a uso di detto Altare un paliotto di Damasco incarnato con l'Arme di detti Asini et Gualterotti, fatta da detti di Messer Marco, et di tanto fo fede sottoscrivendomi di mia propria mano hoggi questa dì 24 di Giugno 1570.

Io frate Dionisio Risaliti come di sopra guardiano di detto convento, fo fede a quanto di sopra è scritto, anno mese dì ut supra, manu propria.

Document 12

Answer of the Opera *of Sta Croce to Francesco and Niccolò degl' Asini*

A. S. Croce, vol. 426, fo. 144

Risposta et eccezioni alla domanda fatta per Francesco et Niccolò di Simone degl'Asini dinanzi alli Mag:^{ci} S:^{ri} Operai di Santa Croce.

Prima s'accetta che la famiglia degl'Asini da tanto tempo in qua che non è memoria in contrario habbi havuto una cappella in Santa Croce con dua sepolture come in detta domanda si presuppone.

Quanto a quello che si dice esser sempre state, havute, tenute e reputate de' discendenti di Fran:^{co} di Niccolò di Marco degl'Asini:

Prima si niega et si dice tutto il contrario perché si è tenuto comunemente che la cappella vechia fussi delli ascendenti di messer Marco degl'Asini, e però per conto di tal grido fu egli dai SS. Operai principalmente ricerco se la voleva rifare conforme al rescritto di S. Altezza.

2° che è repugnante il narrato in se stesso, cioè che fussi della famiglia degl'Asini come si dice avanti, e di poi de'discendenti di Francesco di Niccolò di Marco.

3° si vegga il libro delle cappelle citato da loro perché prova lor contro, dicendosi in quello che la cappella era della famiglia degl'Asini non d'alcuno d'essi particulare.

4° si prova perchè si vede che ciaschuno pagava per la sua rata non per il tutto come per detto libro apparisce.

5° si dice che tra le partite descritte nel libro e l'edificazione della cappella vi corrono presso a cent'anni talché tal pagamento non potette essere per tal edificazione e maxime perché sarebbe cosa minima ancora che, come di sopra si dice, è per la loro portione solamente.

Item dove si dice che messer Marco e messer Giovannibatista hanno edificato un'altra cappella nel sito della vechia, si niega ancor che l'havessino possuto fare, perché la vechia era nel muro del tramezo hoggi destrutto, et questa è nel muro della chiesa molto più bassa inverso la porta principale concessa loro da'SS. Operai secondo l'ordine.

Quanto a' fregi neri, si levorno, perché non si poteva far altro atteso che venivano coperti più che mezi dalle scalee della nuova cappella e le potevano fare come hanno fatto e fanno gl'altri che hanno fatto cappelle non solo nella chiesa di Santa Croce ma nell'altre ancora, e non solo levare i fregi ma le sepolture ancora quando fussi stato di bisogno solo basta rifarle, imperò ancor che non fussino tenuti è stata sempre loro intenzione fargli nuovi, poi che come si proverrà quando bisogna n'è stato rubato una parte, e i nuovi si rimetteranno sì come erano i primi.

Circa alle parole scritte in detti marmi antichi, si dice che da quegli come dal'altre cose dedotte per loro, si mostra o l'ignoranza o la malizia imperoché in quelli conforme al libro delle sepolture diceva sepulchrum de domo Asinorum et il millesimo e non altro.

Di più si dice che tutto quello che è stato di bisogno in detta cappella vechia maxime dalla piena in qua in far ridipignere la tavola, far il dossale, candelieri, vela del'altare, predella, tovaglie e altro, sì come si è detto nel'informazione e provano i frati, sono stati fatti da messer Marco e Niccolò suo fratello.

Quanto all'inscrizione si dice che per quella non è detto, che fussi la cappella vechia più di messer Marco e suoi discendenti che degl'altri, anzi riferendosi alla vechia viene dichiarato dal'altre scritture e memoria, ma si dice bene che quando messer Marco havessi detto haver riffatta la sua cappella vechia, non harebbe fatto contr'alle leggi, né pregiudizio ad alcuno, imperoché essendone, com'è notorio, padrone almanco per la sua rata in comunione et havendo in qualunche minima parte la sua porzione la poteva chiamar sua, perché chiunche ha comunione in una cosa la può chiamar sua et s'intende per la sua participazione. Apparisce adunque che messer Marco poteva dire molto più nella inscrizione che non ha detto.

Al'altre impertinenze et ineptie non occorre rispondere perché da se stesse si dimostrano e questo ci occorre dir brevemente oltr'alle cose dette altra volta.

Document 13

Letter from Marco degl'Asini to the Grand Duke, forwarded by
the Operai *of Sta Croce*

A. S. Croce, vol. 426, fos. 1 and 143

Serenissimo Granduca

Mess. Marcho degl'Asini et Mess. Giovambatista suo filiolo humilmente espongano a Vostra Alteza come nel tempo che, di commessione sua, si disfece in Santa Croce il muro del tramezo et si cominciorono a rifare le cappelle, gli fu facto intendere se volevano rifare la loro cappella antica gli sarebbe dato il luogo, altrimenti si darebbe et non la volendo rifare s'intendessi dato a Mess. Agnolo Biffoli, come n'apparisce partito de'S.$^{\text{ri}}$ Operari di detta chiesa. Fattaci tale notificatione, facemo chiamare Nicholò degl'Asini nostro vicino e gli domandamo se voleva concorrere alla spesa, il quale rispose di no et di non havere il modo, per il che ci fu necessario fare tutta la spesa soli, et così in capo di tre anni e mezo s'è condotta, come ha potuto vedere et sapere Vostra Alteza alla giornata. Poi che l'è stata facta del tutto alquanti mesi, il medesimo Nicholò degl'Asini, quale non volse da principio concorrere, s'è mosso dinanzi a'medesimi Operai et dice tre cose: prima, che non fu citato da loro Signorie; 2°, che noi habiamo aggiunto una croce nella arme; terzo, che noi habiamo messa una inscritione in detta cappella. Alle tre obiectioni s'è risposto: et alla prima, che se gl'Operai non l'hanno citato, non debbe nuocere a noi, che sotto le spalle loro habiamo facta la cappella; secondo, si dice che se non fu citato dagl'Operai, fu niente di mancho ricercho da noi, et facendosi le citatione perché il citato

n'habbia notitia, essendogli detto da noi non era necessaria altra citatione; tertio, che essendo facta publicamente et durato anni tre et mezo, et essendo egli stato sempre in Firenze et non havendo mai recramanto [*sic* = reclamato], non possa oggi che è finita, in nostro preiuditio dire cosa alcuna.

Quanto alla seconda obiectione del'arme, si dice che, havendo speso del nostro, ci pare giusto potervi mettere l'arme a nostro modo.

Al terzo del'inscriptione, si replica che, essendo noi padroni almancho per il terzo del'antica cappella, habiamo potuto dire, come dice detta inscritione, d'haverla rifatta; et tanto più che tale inscritione tende più alla memoria del tempo che V.A. fece abbelire tal chiesa.

Et non ostante che si sieno più volte proposte queste et altre ragioni davanti a decti S.ri Operai, niente di manzo [*sic* = manco] non se ne viene a termine alcuno, anzi pare che ogni dì più si vadia difficultando, per l'onore segreto di qualchuno di loro. Onde c'è forza ricorrer a'piedi di V.A. et dolerci che essi Operai, i quali ci doverrebbano difendere havendola noi facta sotto la loro parola et in ogni evento quando la parte adversa havessi alcuna ragione, che non ha, ci sarebbano tenuti a'danni et interessi civanno difficultando la causa. Con pregare V.A. che commetta che noi non siamo più molestati nella nostra cappella, havendo tanta ragione, et a detto Nicholò et il fratello sia assegnato un altro luogo per farne un'altra, poi che si va vantando davanti ai decti S.ri Operai voler renderci i danari, a causa che non havendo hauto mai animo di spendere con tal malignità, non habbia uccellato et molestato noi, gl'Operai et tutto il mondo, che ne terremo obligo perpetuo con V.A., alla quale baciando la veste preghiano ogni felicità.

[Added below in a different hand:]

Li Operai lo spedischino, che ci pare habbi molta ragione.

Document 14

Memorandum from Vasari to the head of the Opera *of Sta Croce informing him of the work to be done, 29 December 1571*

A. S. Croce, vol. 426, fo. 14

Magnifico Messer Matteo Benvenuti

La S.V. averta di far aconciare quanto prima la doccia che è sopra l'archo che regie il tetto della capella di Michelagnelo Buonaruoti, perchè non infradici le mura.

Solleciti il Signore Pierantonio da Vernia che finischa l'ornamento di legniame intagliato et messo d'oro per il Crocifisso di Donato messo nella capella de'Bardi; et che non alteri o guasti il disegnio che si è dato loro di mia mano.

Facci che l'altare della Concettione si lievi, et si ponghi quanto prima dov'è hoggi l'altare della Visitatione delle pinzochere. Et quel si lievi et si pongha dove l'hanno

destinato i Signori Operai. Et l'altare de'Seristori si lievi, acciò che Lodovico Serristori non habbia scusa di non dar principio alla sua capella; et come non comincia, fatelo intendere a'Sig.^ri Operai, che gli faccino comandamento che se fra tanti dì non harà dato principio, che non habbia avere più ragione et si possa alogare a uno altro, ché così è la mente del Gran Duca.

Appresso, che a Bancho da Barberino si lasci murare la sua capella dove è l'epitaffio de'frati del capitolo, il quale si metta dalla porta della sagrestia; et che detto Bancho, volendo fare sepoltura dinanzi alla capella, possa muovere tutte le sepulture che gli danno noia, et che a sua spese le metta in chiesa quivi o più lontano, con l'intervento de'padroni di dette sepolture. Et che possa murare la porta che va sopra i tetti, et metterla di là nella capella de'Castellani, pure a sua spese; et che solleciti l'opra sua, *chè tutto è con ordini del Gran Duca, et vostro sono. Di casa, alli 29 di Dicembre 1571. Scadendo niente avisate. D.V.S. Il Vostro*

o dove li piaccia

Cavalier Giorgio Vasarii[1]

Document 15

Letter from the Operai *of Sta Croce to the Grand Duke Francesco objecting to a plan for further renovations in the church, 15 March 1580/1*

A. S. Croce, vol. 426, fos. 141 ff.

Ser.^mo Gran Duca Sig.^r et Padron nostro osservandissimo

Da maestro Hyeremia da Udine, Provintiale de'Conventuali di San Francesco in Toscana, ci è stato mostro un modello per levar l'altare della Santissima Concettione, che di presente si trova nella Chiesa di Santa Croce, allato alla porta di verso tramontana, dove è sopra l'organo di detta Chiesa, et collocarlo sotto l'organo, dove hoggi è la porta, et da parte di quella esposto che sopra di ciò li diamo informatione. Imperò ci siamo più volte ragiunati, et con ogni diligentia et maturo discorso il tutto considerato, et a V.A. Ser.^ma sopra di ciò ci occorre dire che levare il detto altare col metterlo in luogo più degno è opera pia, et da essere da ciaschuno caldamente favorita et augumentata, ma ci si rappresentano più inconvenienti et [*cancelled*: bruttezze] sproportioni che tal fabrica di Santa Croce ne riceverebbe.

Et in prima la felice memoria del Gran [Duca] Padre di V.A.S. ordinò che nelle cappelle da farsi in detta Chiesa si facessi tutti i misteri della passione di nostro Signore Yesù Cristo, cominciando dalla prima cappella de'Serristori inverso mezzogiorno, la cena del nostro Signore co'suoi apostoli, et finendo all cappella de'Biffoli, al dirimpetto, lo spirito santo et così sino a hoggi si è seguito tal modello et ordine, et fatto tutte le cappelle ecceto una.[1] Donde se tal altare si mettessi dove è fatto il modello, parrebbe cosa che non convenga a

[1] Words in italics are in Vasari's autograph.

vedere fra lo spirito santo et l'ascensione, la concettione di Nostra Donna, che renderebbe grande sconcertamento a tal ordine.

2° E sarebbe necessario, se tal cosa sequissi, chiuder la porta al dirimpetto, che va ne'chiostri di tal convento, dove si va nella cappella de'Pazzi, il che chiudendo dette 2 porte renderebbe gran [*cancelled*: bruttezza] disordine a tal Chiesa; oltre che in detta porta sarebbe necessario mettere l'altare della Annuntiatione della Vergine, de'Cavalcanti, cosa ancora inconsentata a vedere che fra la cena et Cristo che ora nel'orto, via [*sic* = vi] sia l'annuntiatione della Madonna, et così tutto l'ordine et modello antico si viene a interrompere et guastare.

3° E sarebbe necessario dipoi far dua porte in detta Chiesa, per entrare et uscire di quella, le quale bisogna fare allato delle cappelle et piccole, per non poter farle grande, che renderebbero bruttezza a detta Chiesa, oltre che, quando vi sarà gran populo, si farà gran confusione nel'entrare et uscire.

4° Nel chiudere le dette due porte si leverà gran bellezza alla detta Chiesa, oltre che si fa pregiuditio alla casata de'Pazzi et alla loro cappella, che viene a mancare della porta di mezzogiorno. Et questo è quanto ci è parso dire a V.A. Ser.^ma, rimettendoci sempre nel prudentissimo parere di quella, alla quale preghiamo ogni felicità et contento. Di Santa Croce, della nostra solita audientia, il dì 15 di marzo 1580.

Di V.A.Ser.^ma

Humil Servi

Li operai di Santa Croce.

5° Fin sotto dì 7 d'agosto 1580 ricerchi dagl'huomini di detta compagnia della Concettione, per partito fatto per noi, fu deliberato che si facessi una cappella di più, dove è hoggi detto altare, lavorata secondo che il luogo e la divotione in ciò richiede, la qual venissi dirimpetto alla cappella della Nuntiata de'Cavalcanti: la quale fatta che fussi, harebbe dato ornamento assai a detta Chiesa, per havere la detta cappella de'Cavalcanti simile al rincontro.

Document 16

Record of the agreement made between Zati and the Convent of Sta Croce, 18 June 1581

A.S.F. Conv. Sopp. 92, vol. 134 (n.fo.)

Addì 18 di Giugno 1581

Ricordo come havendo il convento et frati di Santa Croce di Firenze per debitore al loro campione giallo segnato C, a ²c. 248, messer Alexandro d'Andreuolo Zati, cittadino fiorentino, per conto d'un legato che fece l'anno 1551 il detto Andreuolo Zati suo padre

¹ The Alamanneschi chapel had not yet been appropriated.
² [In margin:] accordo fatto con Alessandro d'Andreuolo Zati — al campione giallo C, c. 336.

per suo ultimo testamento in detto anno quando morì, il quale lasciò il detto messer Alexandro Zati suo unico figliuolo et suo universale erede, per essere allhora in età manco che di diciotto anni, lasciò che quando havessi finiti li 18 anni, spendesse f. mille dugento, di lire 7 per fiorino, in fondare et fare una Cappella nella chiesa di Santa Croce, recipiente alla casa et famiglia delli Zati. Et perché pochi mesi sono, li detti frati lo costrinsero a dar loro conto et mostrare quanto lui havea speso et quanto ci era ancora da spendere per adempiere la voluntà di suo padre testatore, allhora lui mostrò alli detti frati che tra la spesa fatta sino a questo dì in fare fabricare la detta cappella et tra quelli ci era ancora da spendere nella pittura, ornamento, sepultura et lampada et altre cose per detta cappella, ascendono alla somma di f. ottocento simili, che glienne rimase nelle mani f. quattrocento, che hanno a servire per la dote di detta cappella: delli quali f. 400 — l'anno 1571 addì primo di febbraio, cominciò ad andare debitore al detto campione giallo di f. 20 per l'ufizziatura di detta Cappella l'anno, con carico a noi d'ufizziarla; et quando da lui sarà messa la tavola et finitola, sia obbligo alli frati tenervi il lume a spese loro, nel modo lo tengono alla cappella dei Dini in detta chiesa. Et perché l'anno 1577 addì 5 di luglio, il detto messer Alexandro Zati de' f. quattrocento ne dipositò f. trecento in sul Monte della Pietà, delli quali ne tiriamo li emolumenti, a tal che gliene resta nelle mani f. cento simili, delli quali deve andare debitore delli frutti a ragione di cinque per cento l'anno. Et perché li frati volevano che depositassi ancora li detti f. cento rimastili nelle mani, per fare il pieno di f. 400 — per dote di detta Cappella; et per havere il detto messer Alexandro questo dì 18 di giugno 1581 chiesto lor tempo ancora quattro anni da oggi, li detti frati di comune concordia gliene fecero grazia insieme con un'altra a detti padri chiesta, come qui appiè si dirà.

Et perché l'anno 1565 addì 10 di luglio li frati sopraddetti, insieme con li signori loro operai, gli fecero intendere che per havere lui finito il tempo di gran lunga dell'età di 18 anni, dovessi fare fondare et construire detta Cappella, et gli concessero certo tempo determinato: dove, per haver lui mancato et trasgredito al testamento di suo padre, il signor Commessario di Pias Causas lo condannò in nelle pene, come per il contratto rogato ser Agnolo del Favilla sotto suo dì. Et infra le altre pene, a doverci dare per agumento di dote di detta Cappella f. dugento simili, a doverceli pagare infra certo tempo, che in detto contratto apparisce, se non havea fondata o fatta fondare detta cappella: il che non havendo lui osservato et essendoli fatte più proroghe, come altra volta per un contratto rogato ser Piero dell'Orafo sotto suo dì, al quale ci rapportiamo, viene per tale suo difetto condannato in detti f. 200. Onde sendo lui, come di sopra, comparso avanti a li detti frati, quali in camera del Rev.do Padre Ministro et Provinciale, maestro Ieremia da Udine, dove erono ragunati li Rev.di maestri et padri insieme col Rev.do Guardiano, maestro Pagolo Palmieri, et col proccuratore frate Ottaviano Soldani da Poppi, il detto messer Alexandro si raccomandò loro di detta condannazione. Li quali tutti concordi deliberorno et li feceno libero dono della metà di detti f. 200 di che era condannato, et li altri f. cento li debba pagare loro o depositarli in sul Monte della Pietà da oggi a anni quattro, che sieno et stieno per fondo insieme con li altri della dote, dei quali in detti quattro anni non debba

O

pagarne li emolumenti. Ma se da oggi a quattro anni non harà sborsati o depositati in sul Monte sotto nome di detti frati, all'otta che saranno finiti detti quattro anni, li corrino et debba pagare li emolumenti di cinque per cento l'anno mentre li tenessi in mani. Et in caso che li frati, doppo li detti quattro anni, li volessino rispendere in beni stabili, il detto messer Alexandro allhora sia obbrigato a sborsarli loro, altrimenti ne possa essere astretto dalli detti frati. Et per fede dell'osservanza si sottoscriverà di sua propria mano.

Io Alessandro d'Andreuolo Zati sopradetto affermo quanto di sopra si contiene, e in fede ho sottoscritto questa di mia propria mano oggi questo dì diciotto di giugno.

INDEX

Page references in bold type indicate the principal of several references. Where the name of an artist appears in brackets in an entry for a place or building the references following are to works by that artist located there.

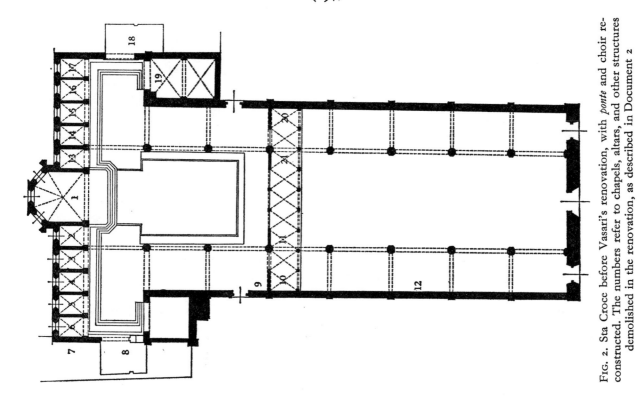

Fig. 1. Sta Maria Novella before Vasari's renovation, with *tramezzo* and choir reconstructed. The numbers refer to the chapel existing before the renovation, as listed in Document 1

Fig. 2. Sta Croce before Vasari's renovation, with *ponte* and choir reconstructed. The numbers refer to chapels, altars, and other structures demolished in the renovation, as described in Document 2

Fig. 3. Isometric projection of Sta Croce with *tramezzo*, before Vasari's renovation

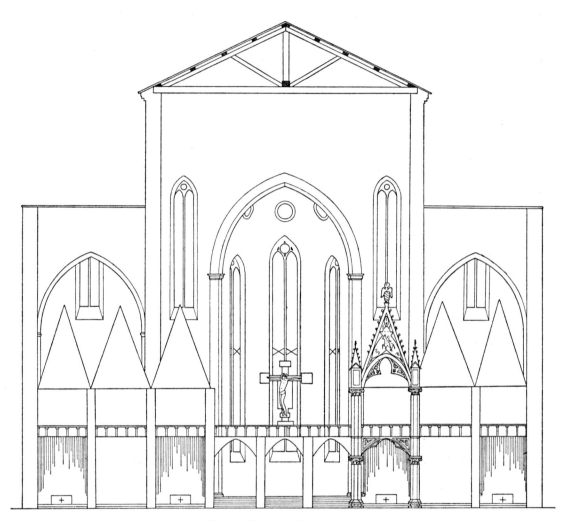

FIG. 4. Sketch of Sta Croce

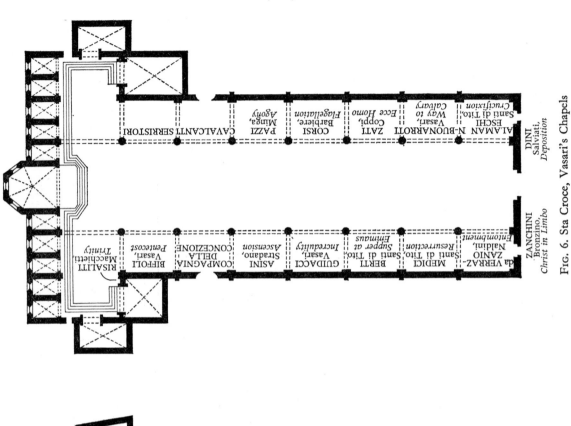

FIG. 6. Sta Croce, Vasari's Chapels

FIG. 5. Sta Maria Novella, Vasari's Chapels

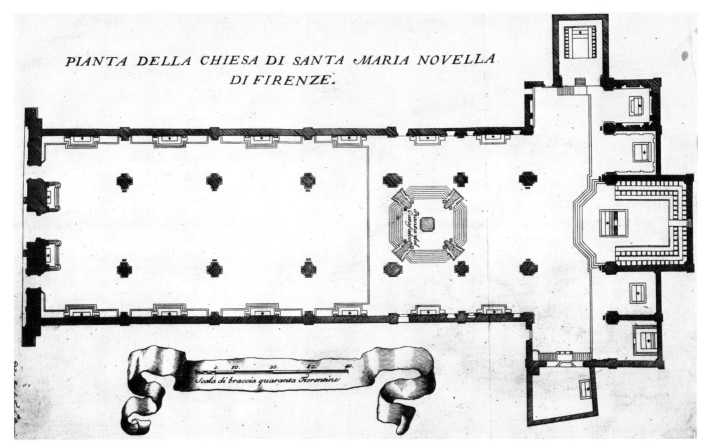

PIANTA DELLA CHIESA DI SANTA MARIA NOVELLA DI FIRENZE.

Scala di braccia quaranta Fiorentine

1. Plan of Sta Maria Novella, showing Vasari's church before the renovation of 1861

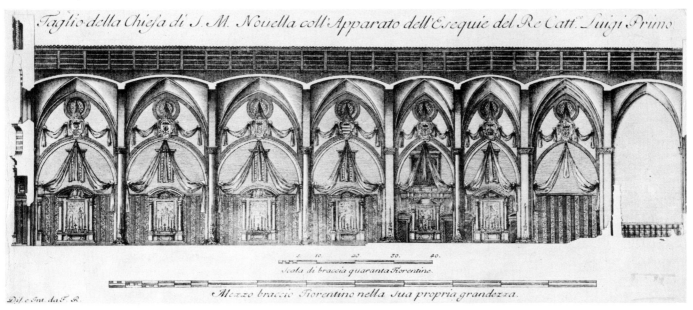

Taglio della Chiesa di S. M. Novella coll'Apparato dell'Esequie del Re Catt. Luigi Primo

Scala di braccia quaranta Fiorentine

Mezzo braccio Fiorentino nella sua propria grandezza

2. Elevation of Sta Maria Novella (1724), showing Vasari's (destroyed) tabernacles. Windows are draped with hangings for funeral of King Louis I of Spain

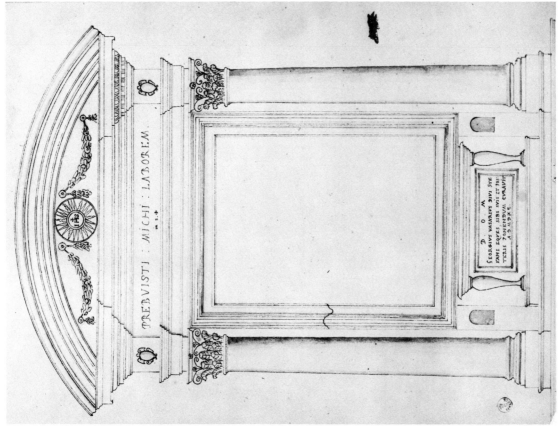

3. Sta Maria Novella, altar tabernacle designed by Vasari.
Drawing by Giorgio Vasari il Giovane, Uffizi 4682A

4. Sta Croce, altar tabernacle designed by Francesco da San Gallo.
Drawing by Giorgio Vasari il Giovane, Uffizi 4675A

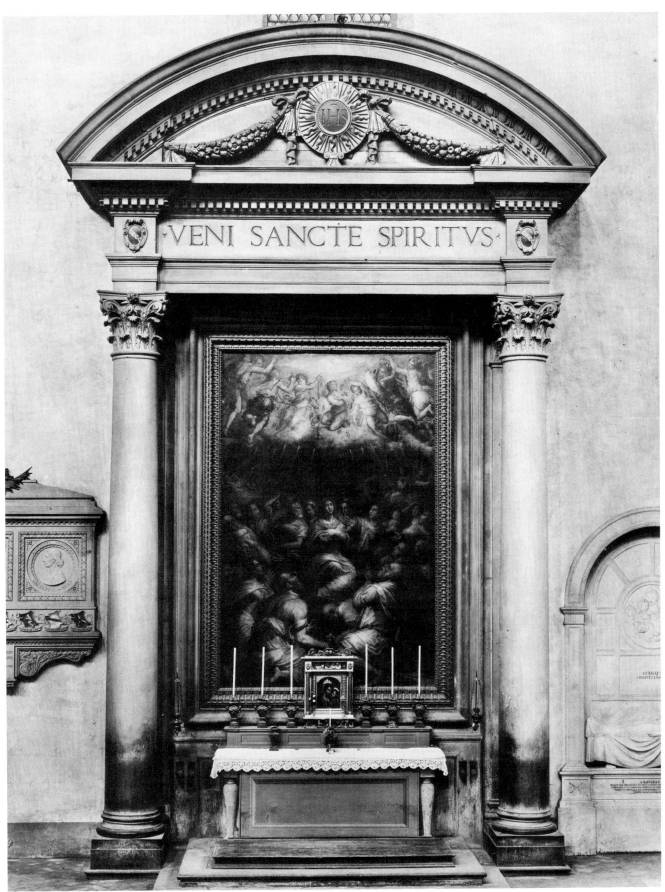

5. Sta Croce, altar tabernacle by Francesco da San Gallo (Biffoli Chapel)

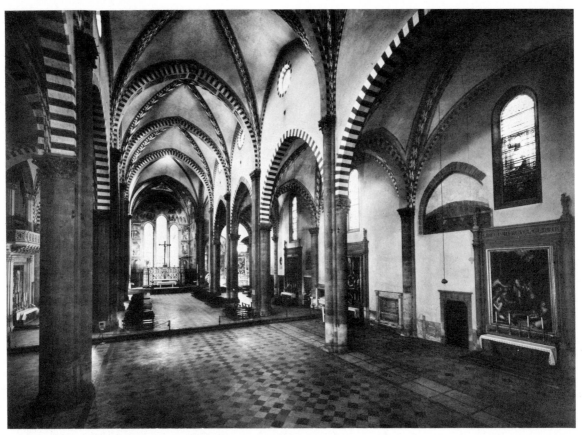

6. Sta Maria Novella, interior with neo-Gothic tabernacles in aisles

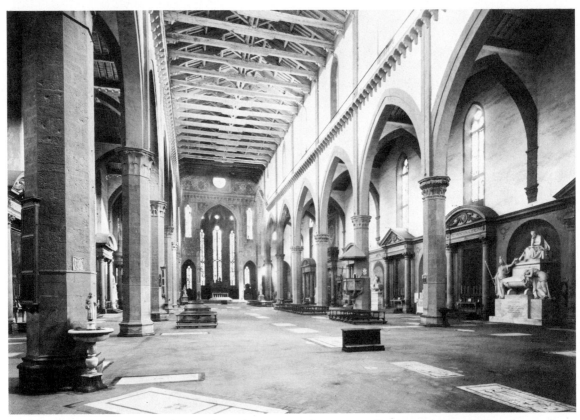

7. Sta Croce, looking east, showing continuous cornice connecting Vasari–San Gallo tabernacles

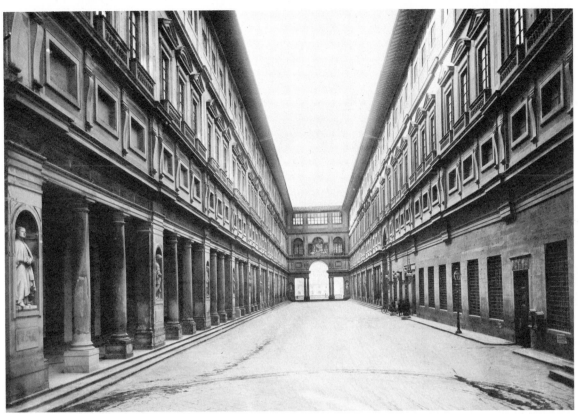

8. Giorgio Vasari, the Uffizi looking towards the Arno

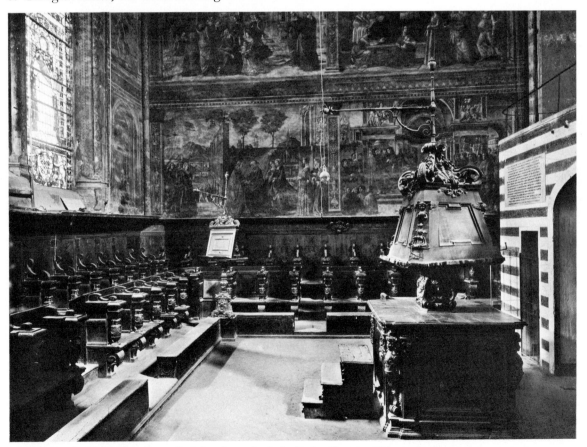

9. Sta Maria Novella, *Cappella Maggiore*, choir built by Baccio d'Agnolo (1490s), enlarged by Vasari

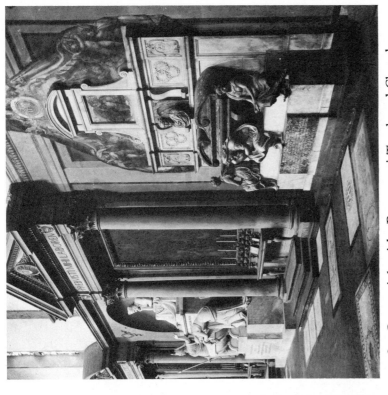

11. Sta Croce, right aisle. Buonarroti Tomb and Chapel

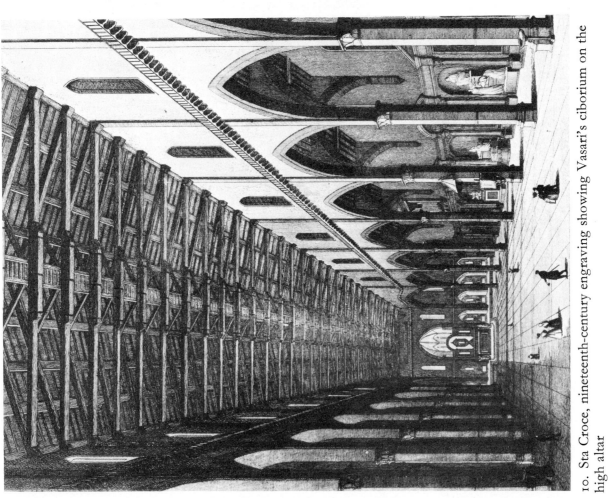

10. Sta Croce, nineteenth-century engraving showing Vasari's ciborium on the high altar

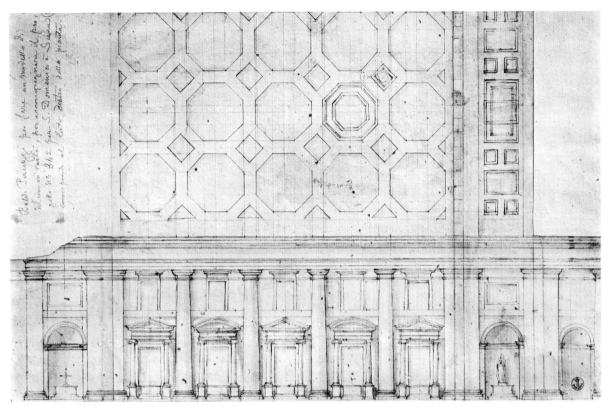

12. Baldassare Peruzzi, design for renovation of S. Domenico, Siena. Elevation. Uffizi 1575A

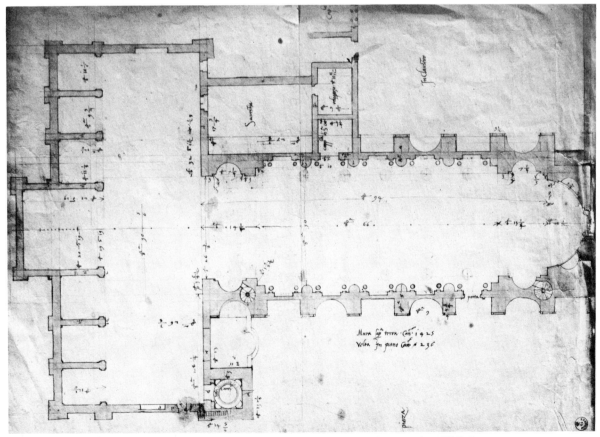

13. Baldassare Peruzzi, design for renovation of S. Domenico, Siena. Plan. Uffizi 342A

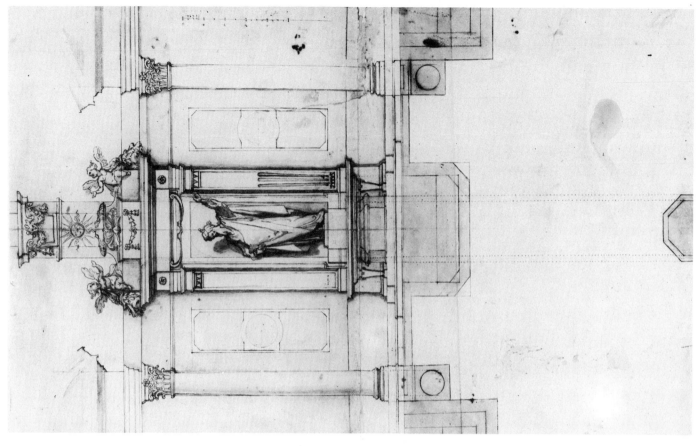

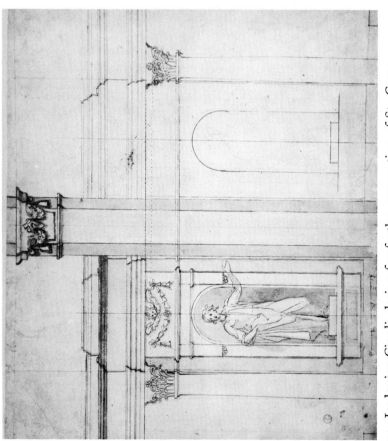

14. Ludovico Cigoli, design for further renovation of Sta Croce,
Uffizi 2611A

15. Ludovico Cigoli, design for additional tabernacles in aisle of Sta
Croce. Uffizi 1906A

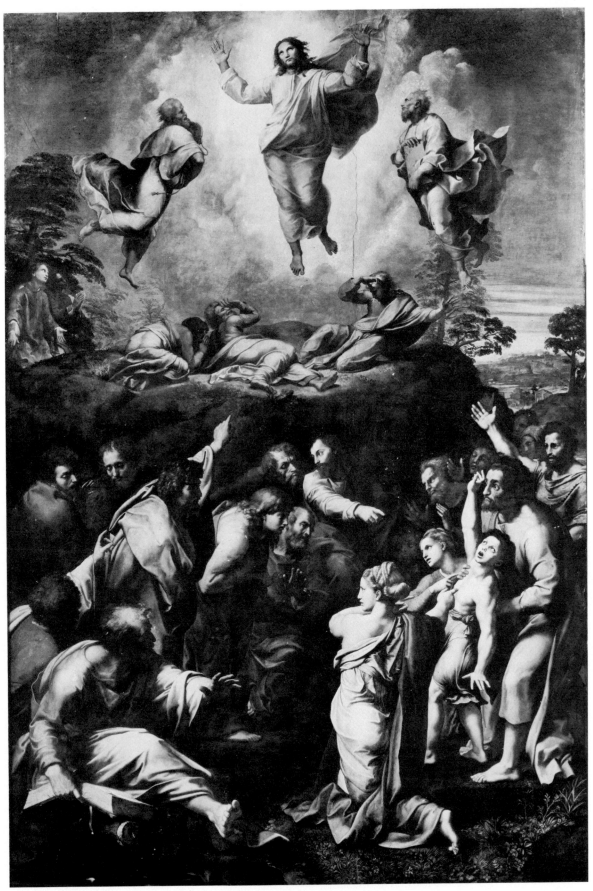

16. Raphael, *Transfiguration*, Vatican, Pinacoteca

17. Jacopo da Pontormo, *Deposition*, Florence, Sta Felicita

18. Giorgio Vasari, *Entombment*, Arezzo, Casa Vasari

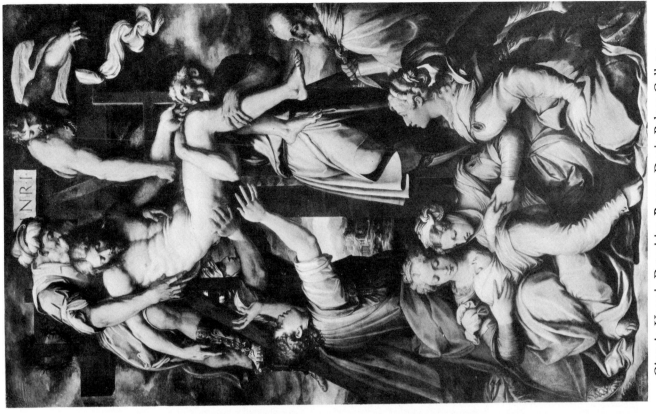

20. Giorgio Vasari, *Deposition*, Rome, Doria Palace Gallery

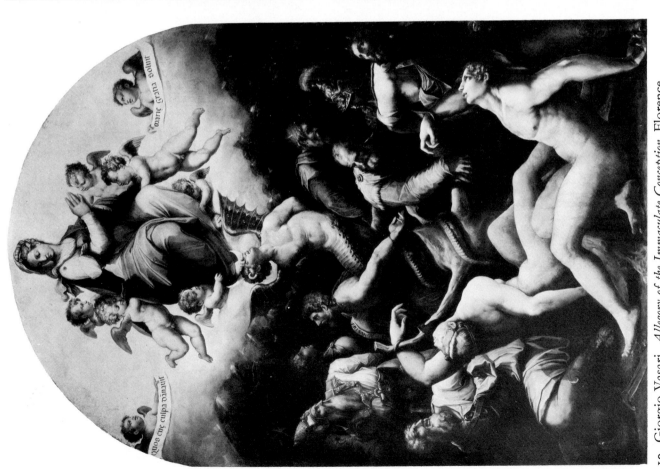

19. Giorgio Vasari, *Allegory of the Immaculate Conception*, Florence, SS. Apostoli

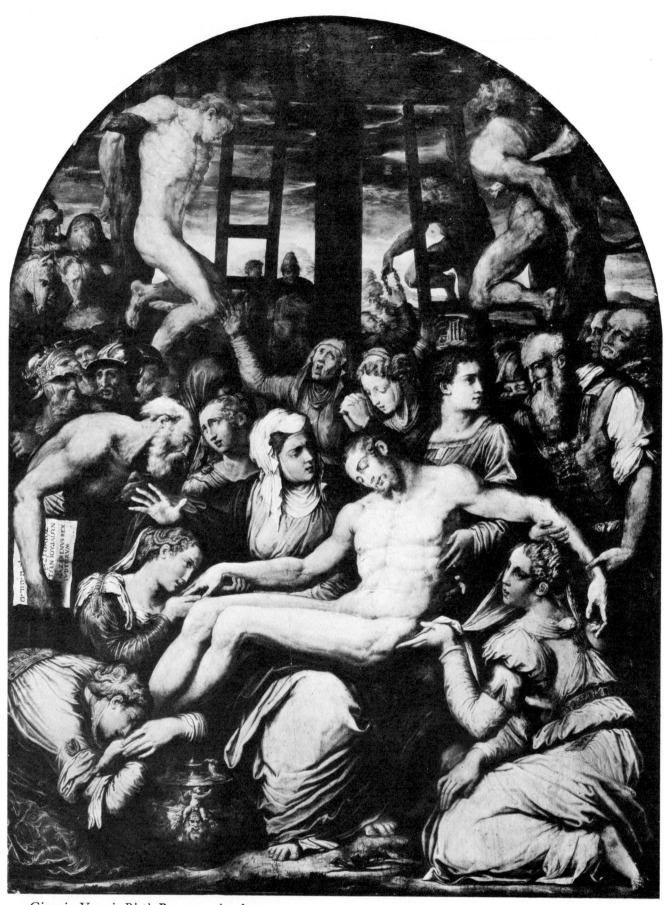

21. Giorgio Vasari, *Pietà*, Ravenna, Academy

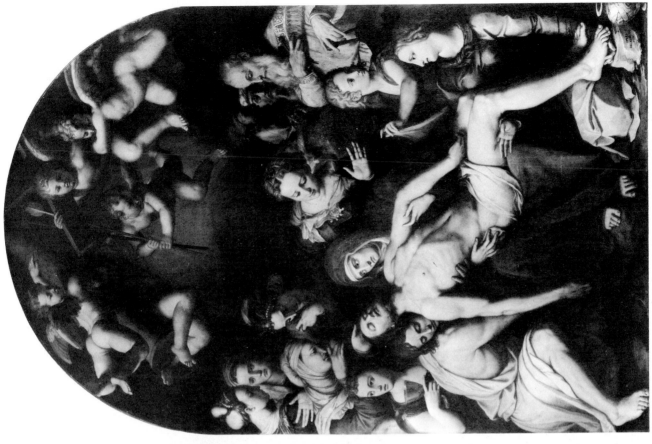

23. Agnolo Bronzino, *Pietà* Florence, Palazzo Vecchio, Chapel of Eleanora da Toledo

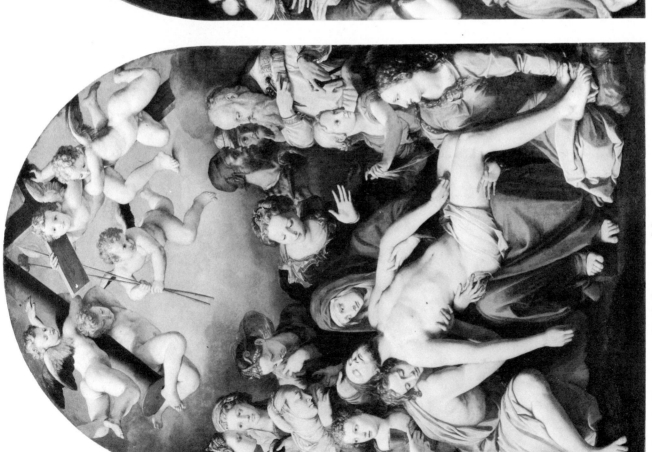

22. Agnolo Bronzino, *Pietà*, Besançon, Museum

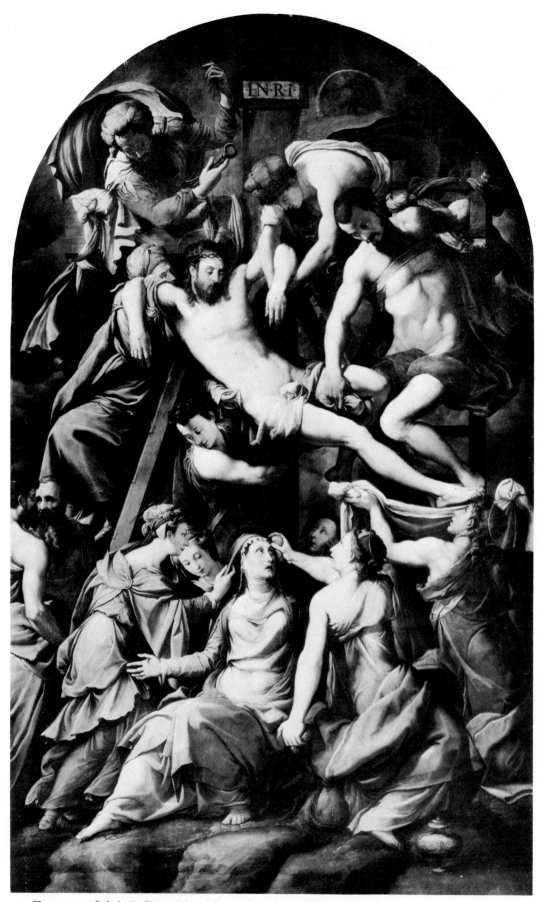

24. Francesco Salviati, *Deposition*, Museo Sta Croce (Dini Chapel)

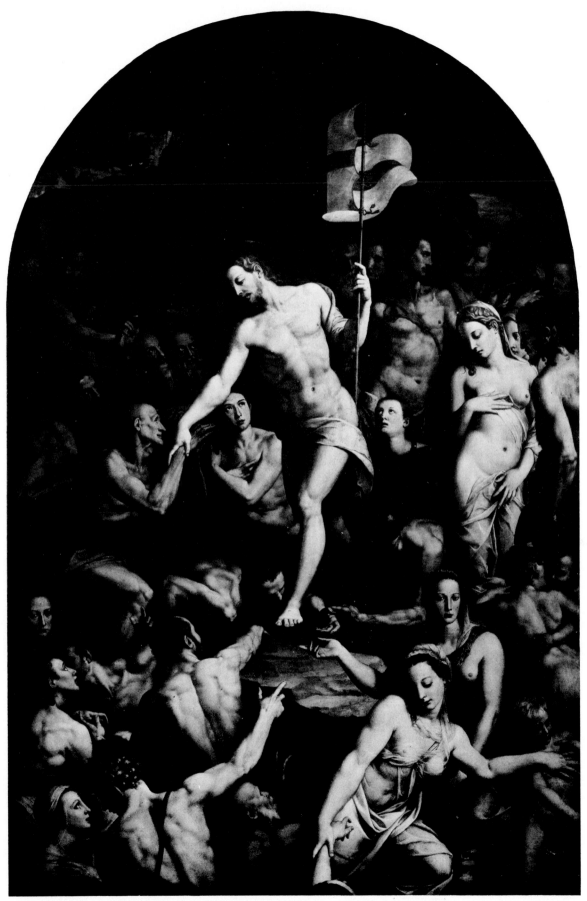

25. Agnolo Bronzino, *Christ in Limbo*, Museo Sta Croce (Zanchini Chapel)

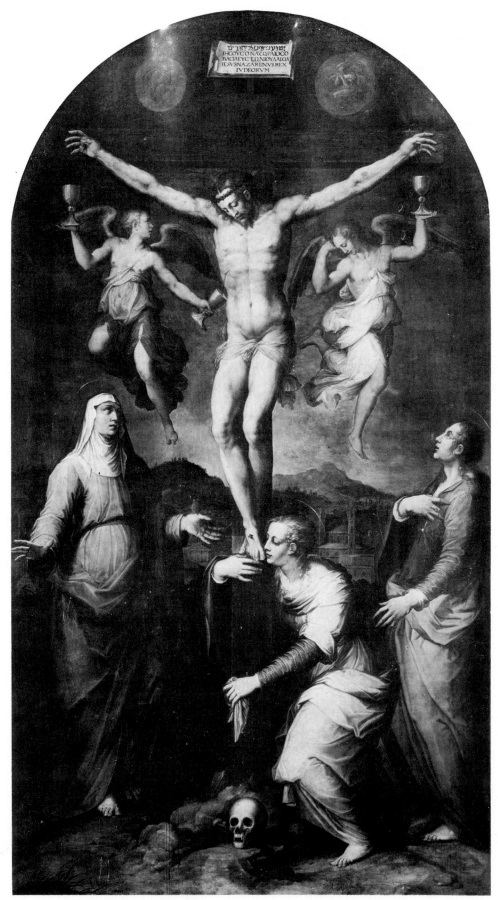

26. Giorgio Vasari, *Crucifixion*, Florence, Sta Maria del Carmine

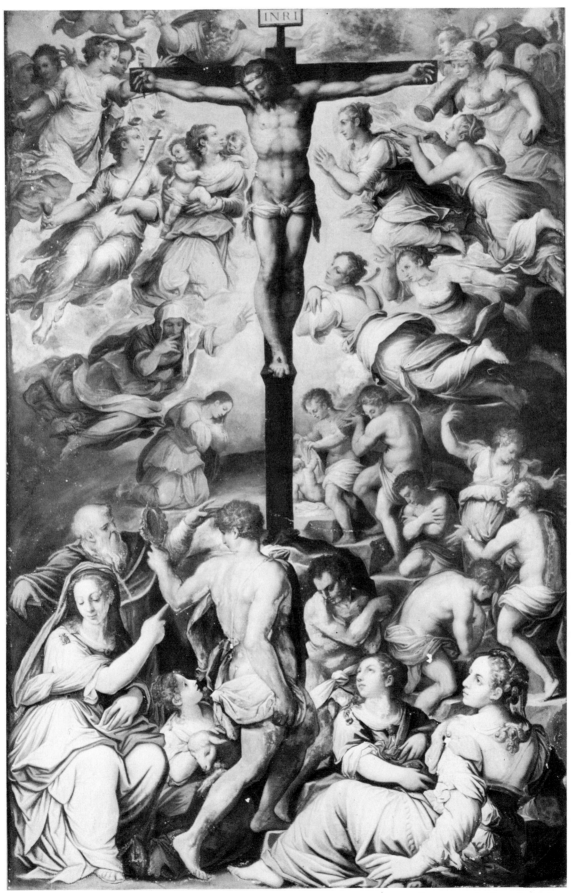

27. Giorgio Vasari, *Crucifixion According to St. Anselm*, Sta Maria Novella (Strozzi Chapel)

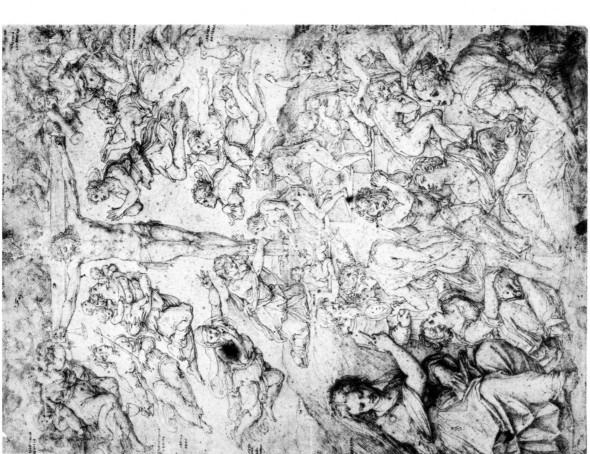

28. Giorgio Vasari, Study for *Crucifixion According to St. Anselm*, Uffizi 624F

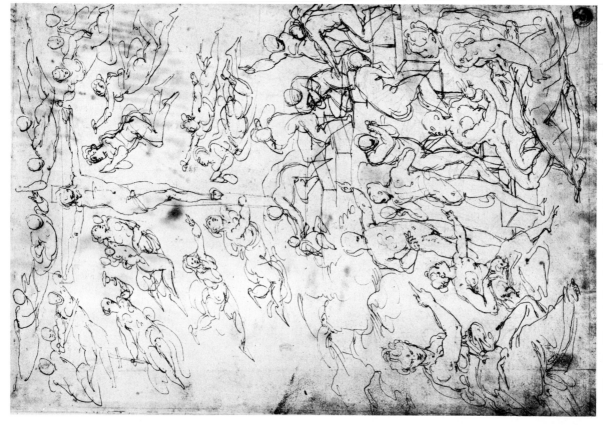

29. Giorgio Vasari, Study for *Crucifixion According to St. Anselm*, Uffizi 623F

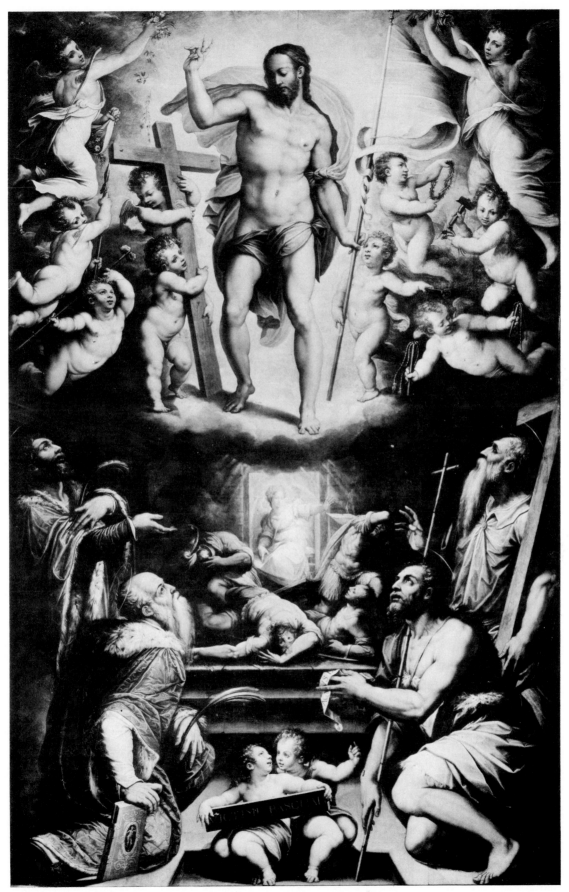

30. Giorgio Vasari, *Resurrection with Saints*, Sta Maria Novella (Pasquali Chapel)

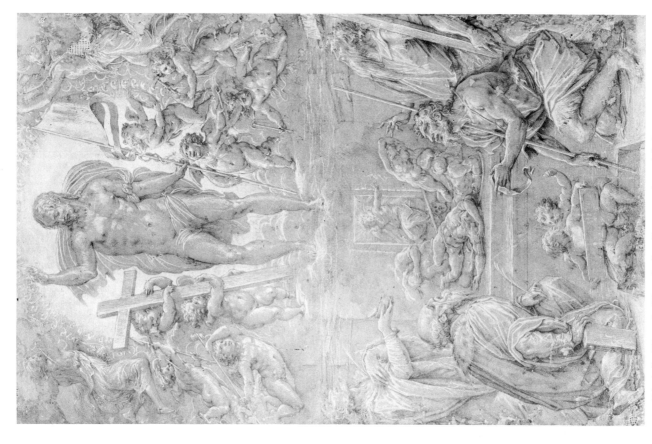

32. Giorgio Vasari, Sketch for *Resurrection with Saints*, New York,
Private Collection

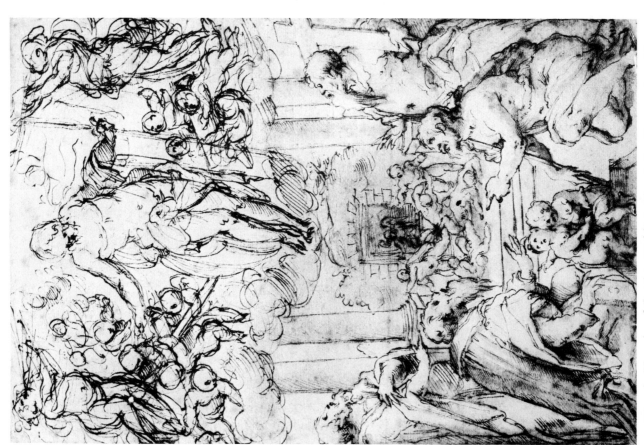

31. Giorgio Vasari and Battista Naldini, Sketch for *Resurrection with
Saints*, Lille, Musée Wicar 901

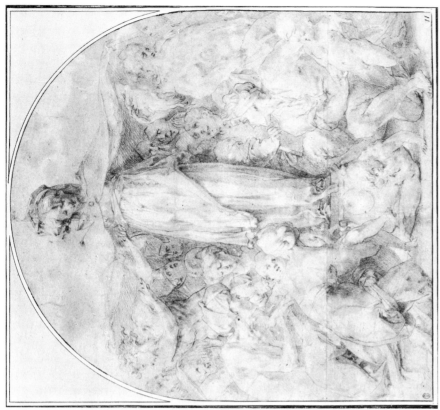

34. Rosso Fiorentino, Sketch for *Madonna della Misericordia*, Paris, Louvre 1579

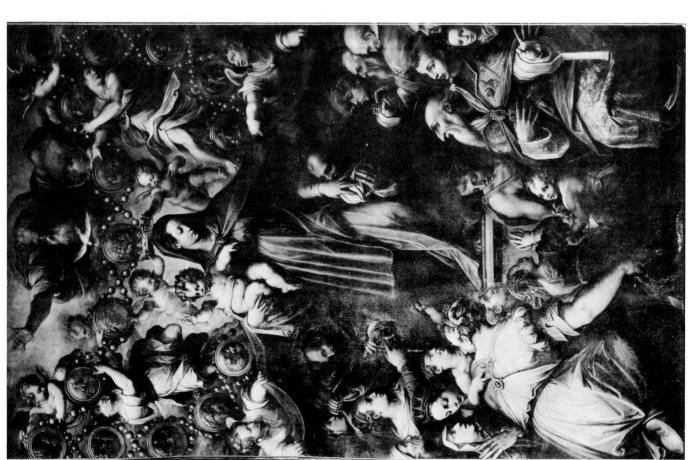

33. Giorgio Vasari (executed by Jacopo Zucchi), *Madonna of the Rosary*, Sta Maria Novella (Capponi Chapel)

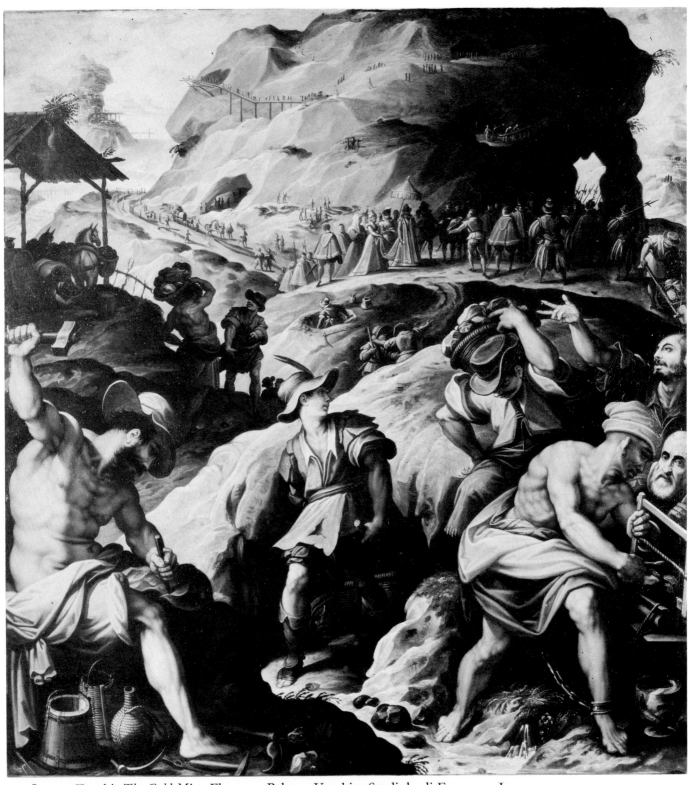

35. Jacopo Zucchi, *The Gold Mine*, Florence, Palazzo Vecchio, Studiolo di Francesco I

37. Giorgio Vasari, Sketch for *Descent of the Holy Spirit*, Bologna, Pinacoteca Nazionale 1651

36. Giorgio Vasari (and Assistants), *Descent of the Holy Spirit*, Sta Croce (Biffoli Chapel)

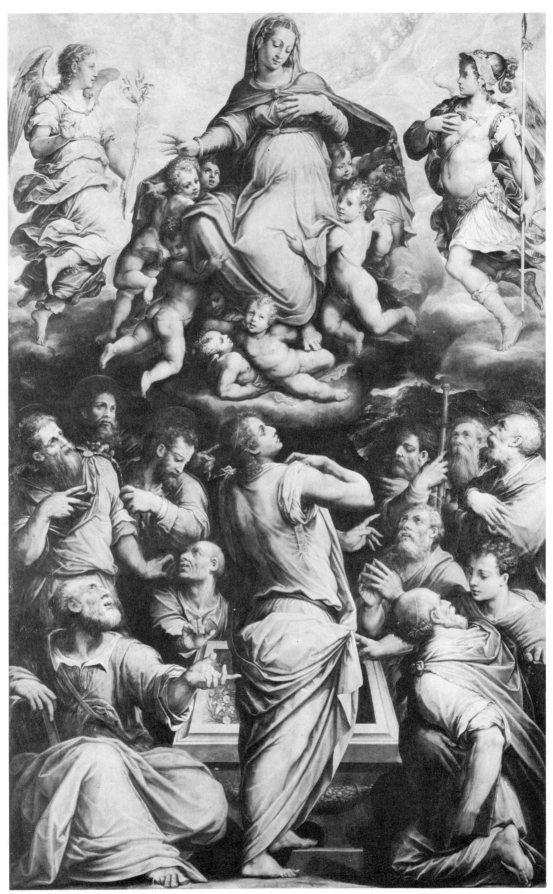

38. Giorgio Vasari, *Assumption of the Virgin*, Florence, Badia

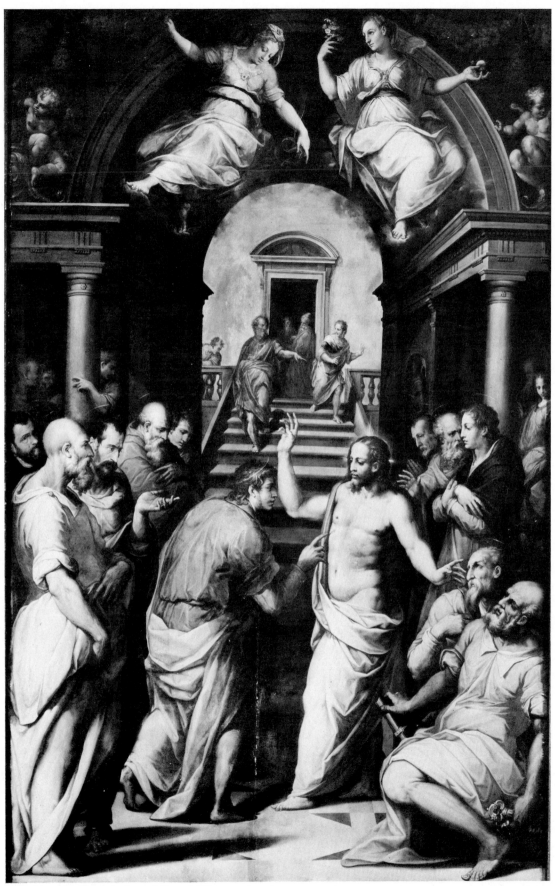

39. Giorgio Vasari, *Incredulity of Thomas*, Sta Croce (Guidacci Chapel)

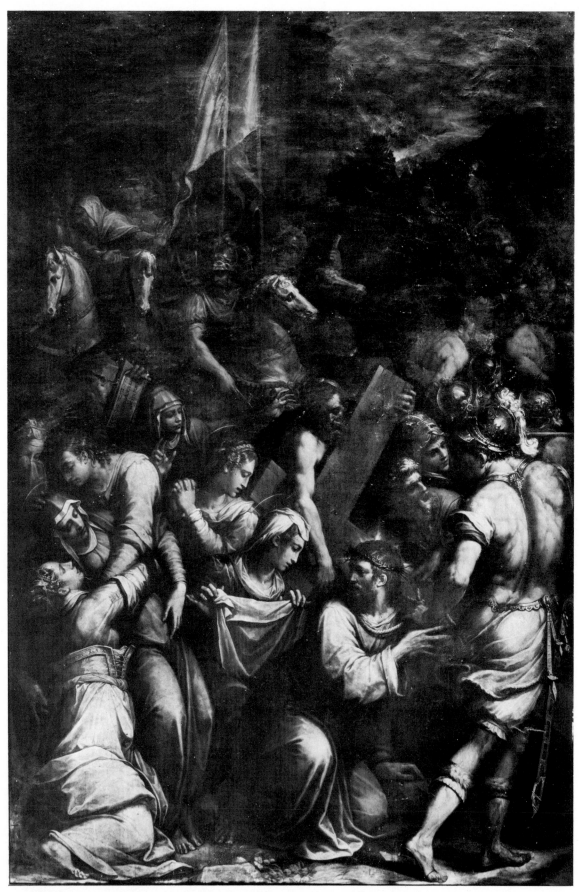

40. Giorgio Vasari, *Christ on the Way to Calvary*, Sta Croce (Buonarroti Chapel)

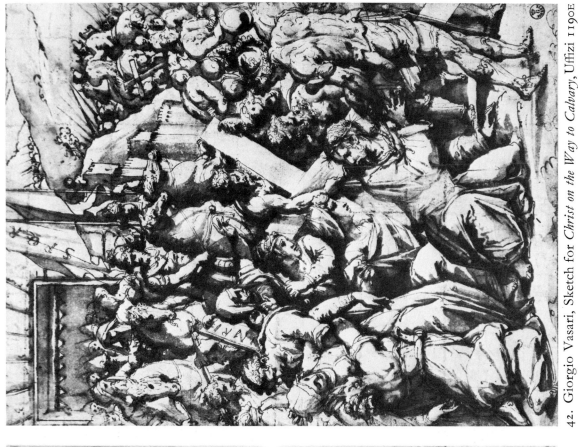

42. Giorgio Vasari, Sketch for *Christ on the Way to Calvary*, Uffizi 1190E

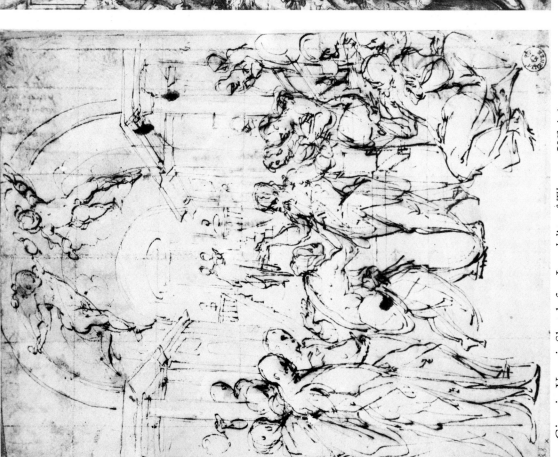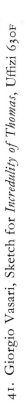

41. Giorgio Vasari, Sketch for *Incredulity of Thomas*, Uffizi 63OF

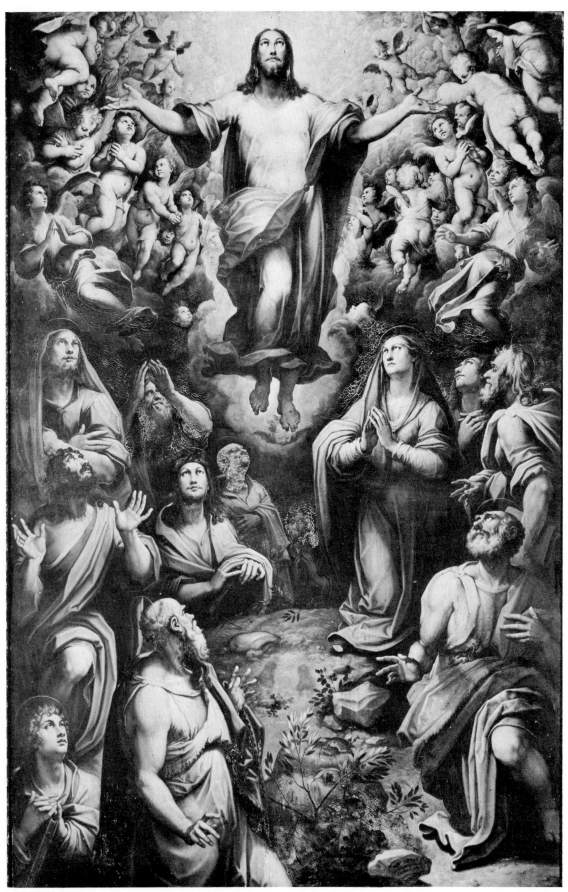

43. Giovanni Stradano, *Ascension*, Sta Croce (Asini Chapel)

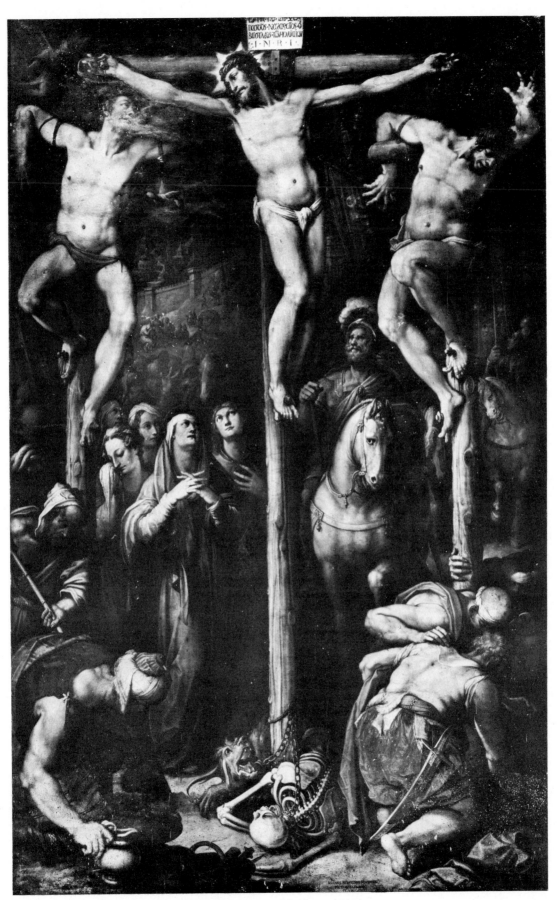

44. Giovanni Stradano, *Crucifixion*, Florence, SS. Annunziata

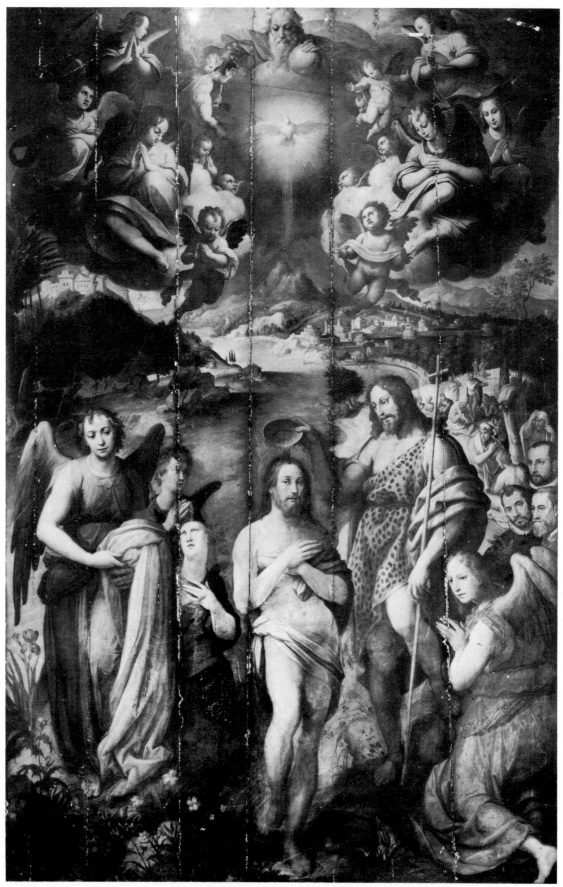

45. Giovanni Stradano, *Baptism of Christ*, Sta Maria Novella, Sacristy (Baccelli Chapel)

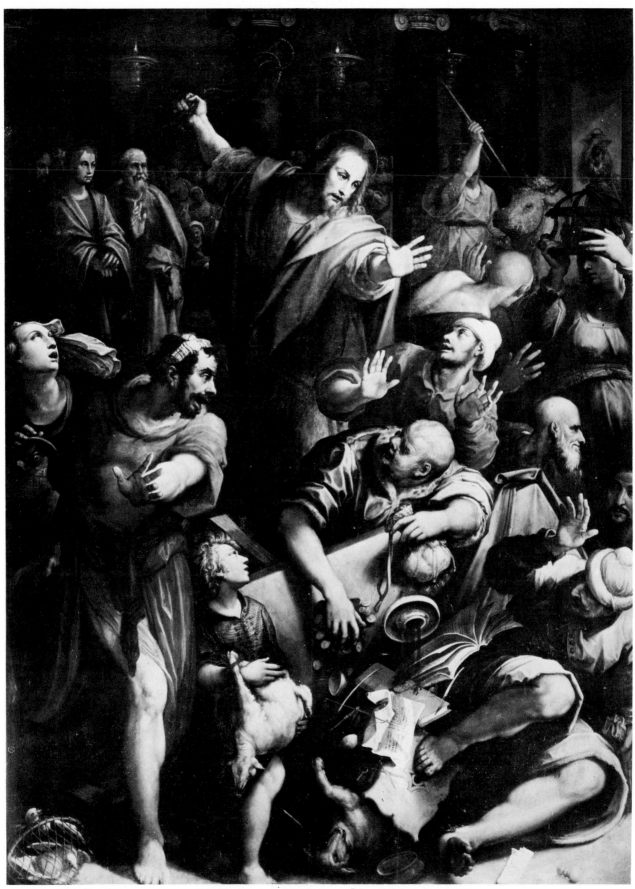

46. Giovanni Stradano, *Expulsion from the Temple*, Florence, St. Spirito

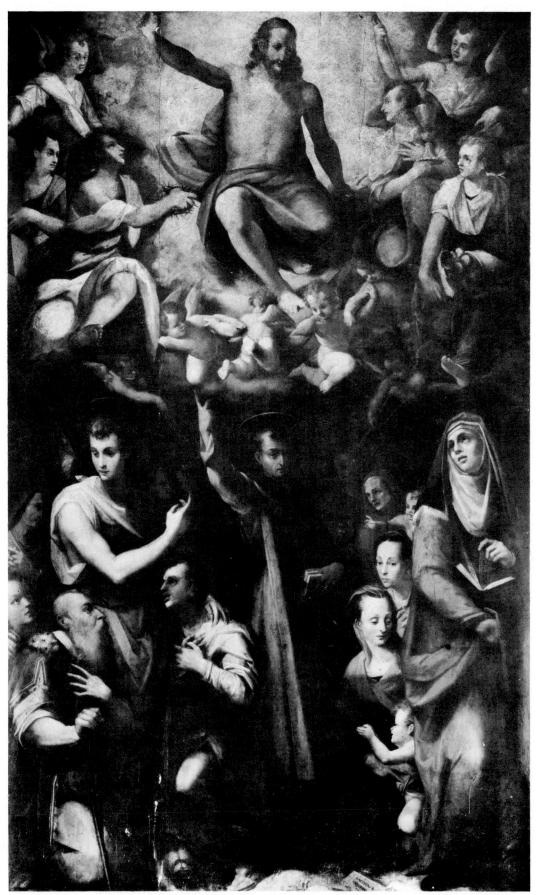

47. Jacopo Coppi, *Christ in Glory with Saints*, Sta Maria Novella (Attavanti Chapel)

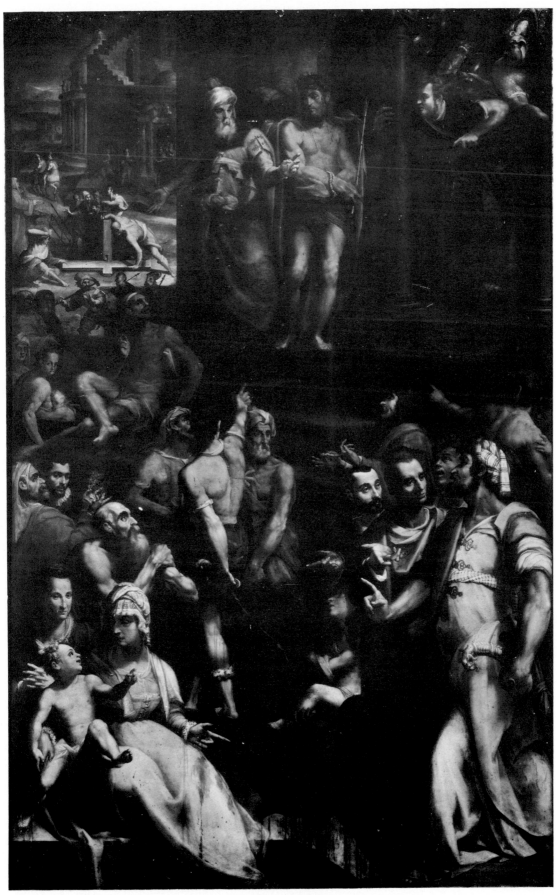

48. Jacopo Coppi, *Ecce Homo*, Sta Croce (Zati Chapel)

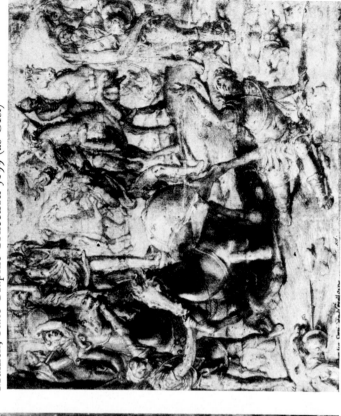

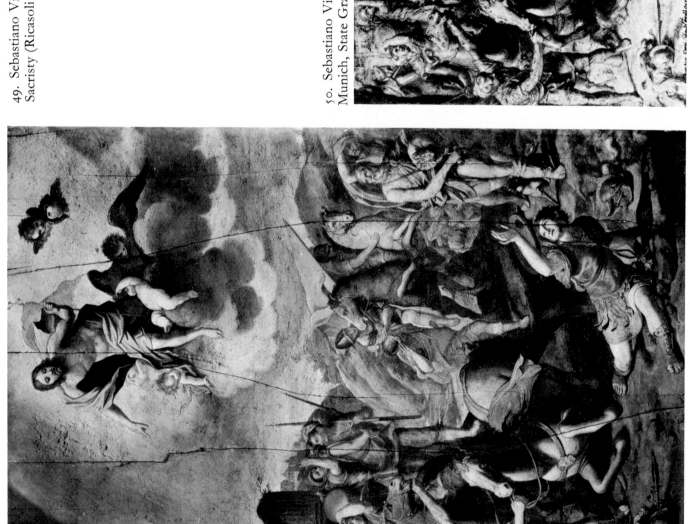

49. Sebastiano Vini, *Conversion of Saul*, Sta Maria Novella, Sacristy (Ricasoli Chapel)

50. Sebastiano Vini, Sketch for lower half of *Conversion of Saul*, Munich, State Graphic Collection 3099 (as Orsi)

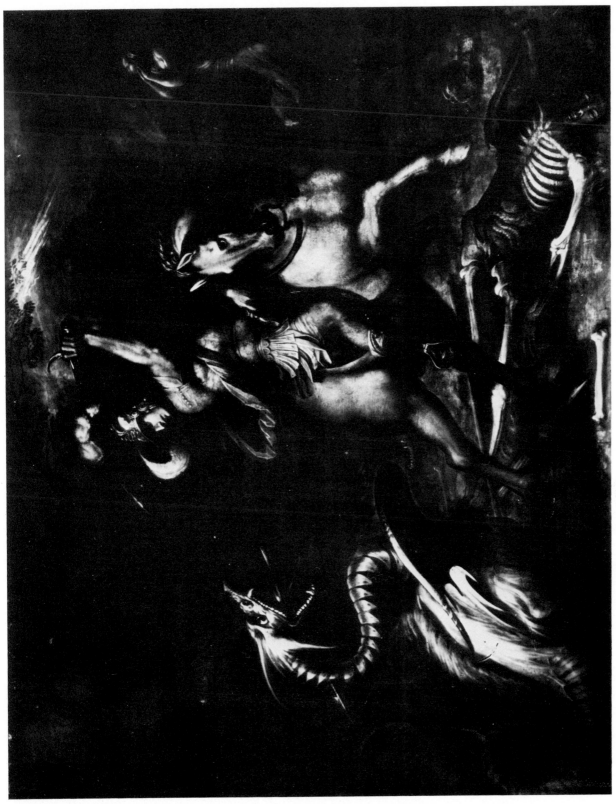

51. Giovanni Stradano, *St. George Killing the Dragon* (predella), Arezzo, Badia

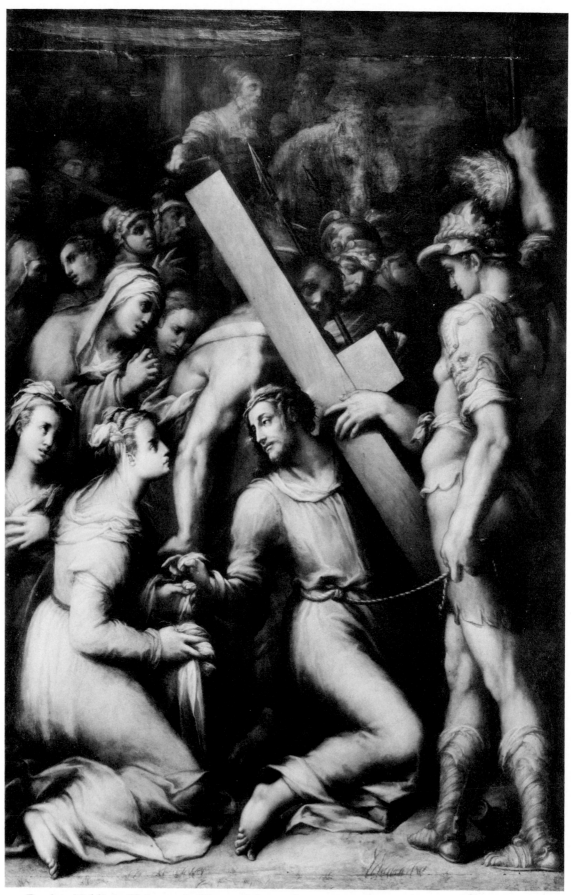

52. Battista Naldini, *Christ on the Way to Calvary*, Florence, Badia

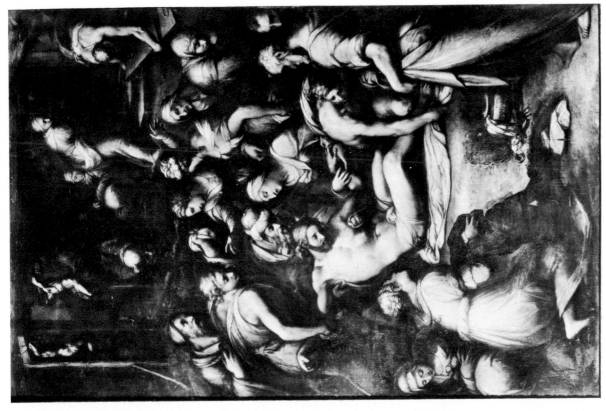

54. Battista Naldini, *Deposition*, Sta Maria Novella (Minerbetti Chapel)

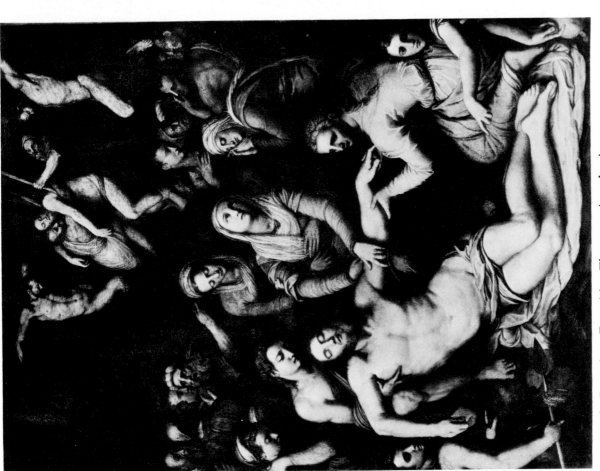

53. Agnolo Bronzino, *Deposition*, Florence, Accademia

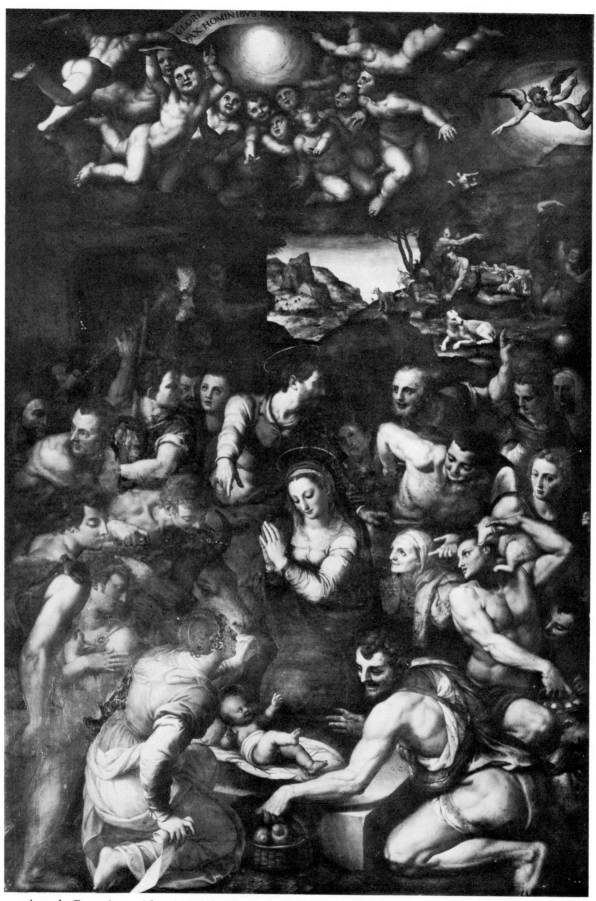

55. Agnolo Bronzino, *Adoration of the Shepherds*, Pisa, S. Stefano

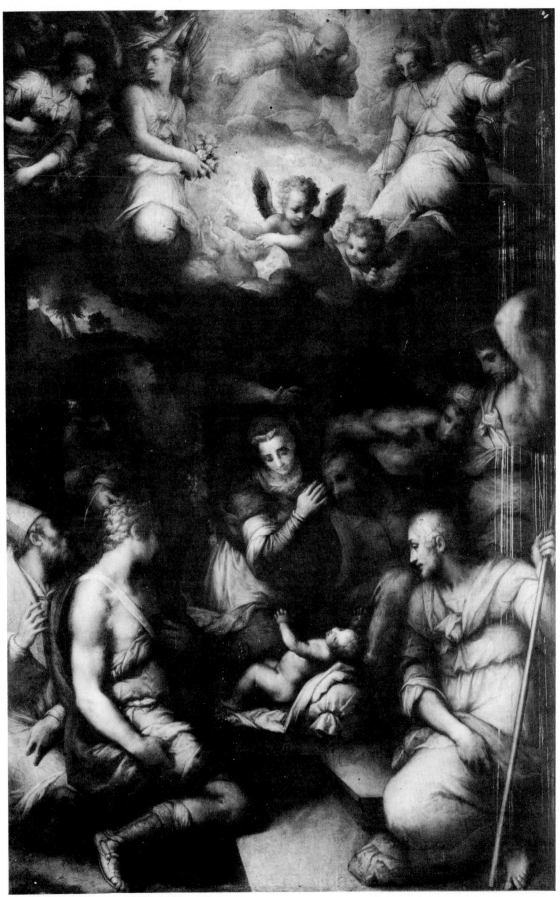

56. Battista Naldini, *Nativity*, Sta Maria Novella (Mazzinghi Chapel)

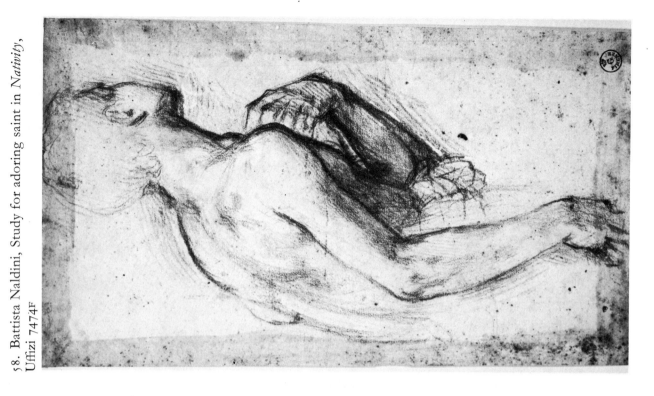

57. Battista Naldini, Sketch for *Nativity*, Uffizi 705F

58. Battista Naldini, Study for adoring saint in *Nativity*, Uffizi 7474F

59. Agnolo Bronzino, *Raising of Jairus' Daughter*, Sta Maria Novella (Gaddi Chapel)

61. Battista Naldini, *Modello* for lost Carmine *Assumption of the Virgin*, Oxford, Ashmolean Museum

60. Maso da San Friano, Sketch for Carmine *Assumption of the Virgin*, Uffizi 602F

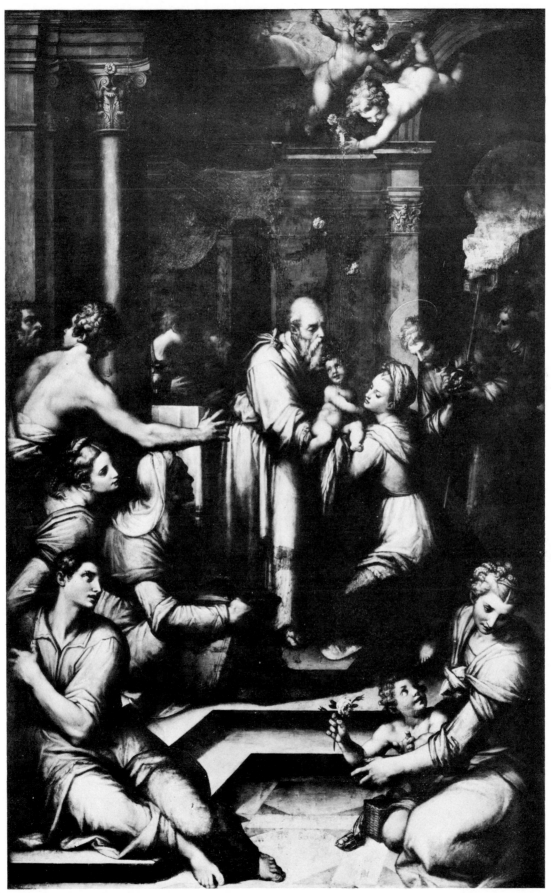

62. Battista Naldini, *Purification of the Virgin*, Sta Maria Novella (da Sommaia Chapel)

64. Battista Naldini, Study for woman, lower right, *Purification of the Virgin*, Uffizi 7447F verso

63. Battista Naldini, Study for head of woman, lower right, *Purification of the Virgin*, Uffizi 7447F

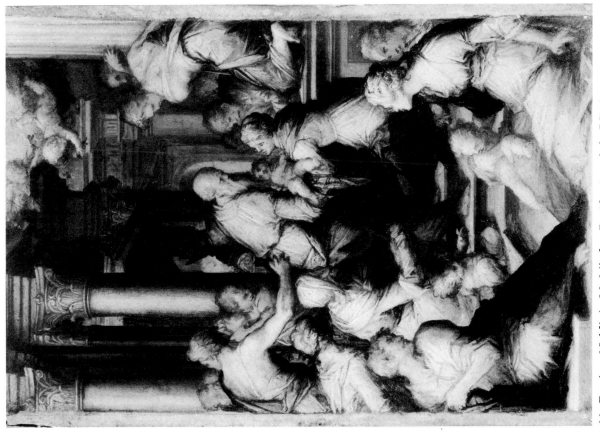

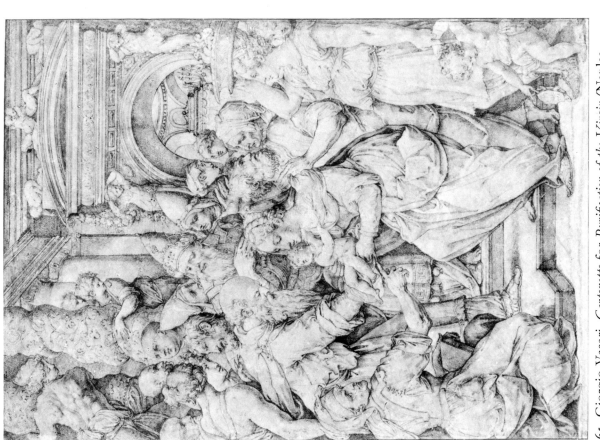

65. Giorgio Vasari, *Cartonetto for Purification of the Virgin* (Naples, Capodimonte), Paris, Louvre 2080

66. Battista Naldini, *Modello for Purification of the Virgin*, Private Collection

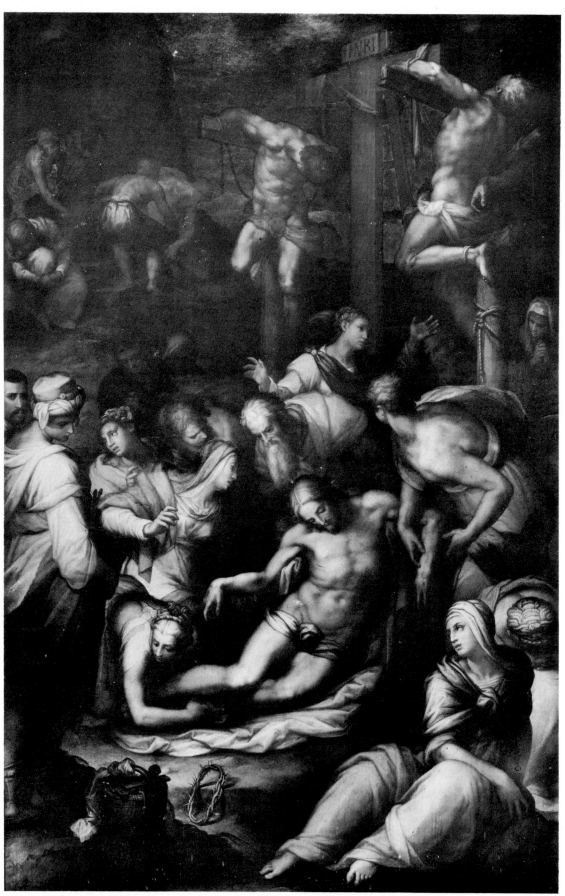

67. Battista Naldini, *Entombment of Christ*, Sta Croce (da Verrazzano Chapel)

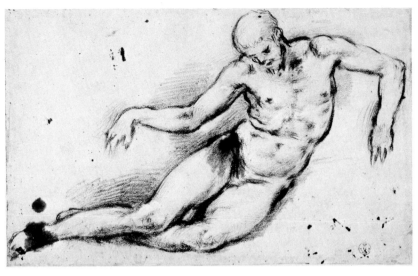

68. Battista Naldini, Study for Christ in *Entombment of Christ*, Uffizi 17810F

69. Battista Naldini, Study for figures lifting tomb-cover, *Entombment of Christ*, Uffizi 17817F

70. Battista Naldini, Study for Christ's hand in *Entombment of Christ*, Uffizi 7487F

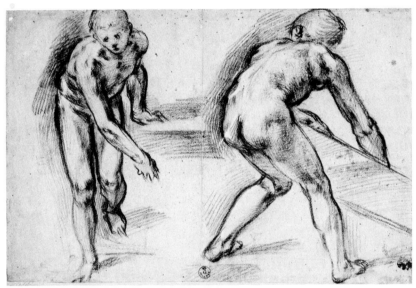

71. Battista Naldini, Study for figure holding Christ's arm in *Entombment of Christ*, Uffizi 17814F

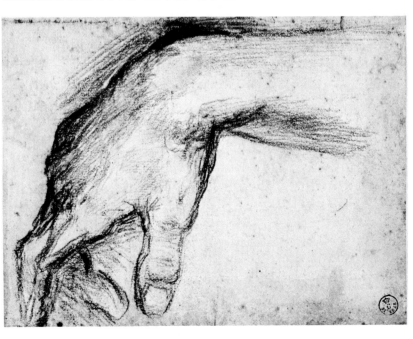

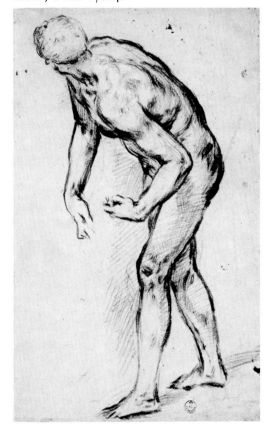

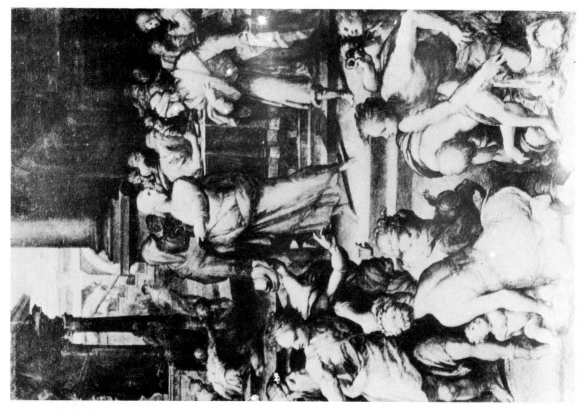

73. Battista Naldini, *Calling of Matthew* (*modello*), present location unknown

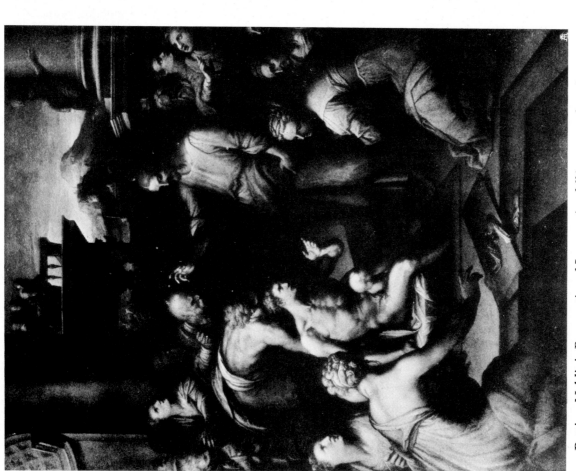

72. Battista Naldini, *Resurrection of Lazarus* (*modello*), present location unknown

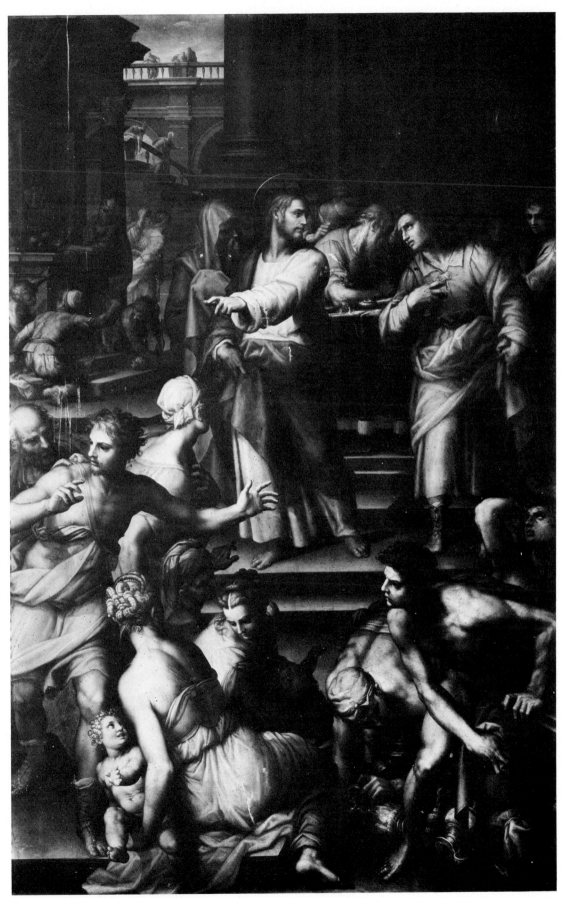

74. Battista Naldini, *Calling of Matthew*, Florence, S. Marco

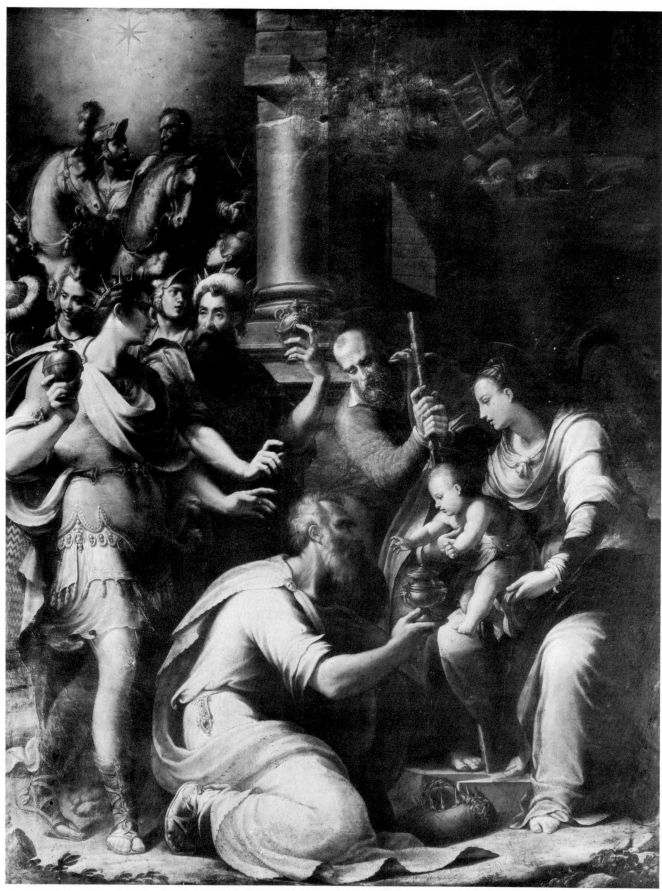

75. Girolamo Macchietti, *Adoration of the Magi*, Florence, S. Lorenzo

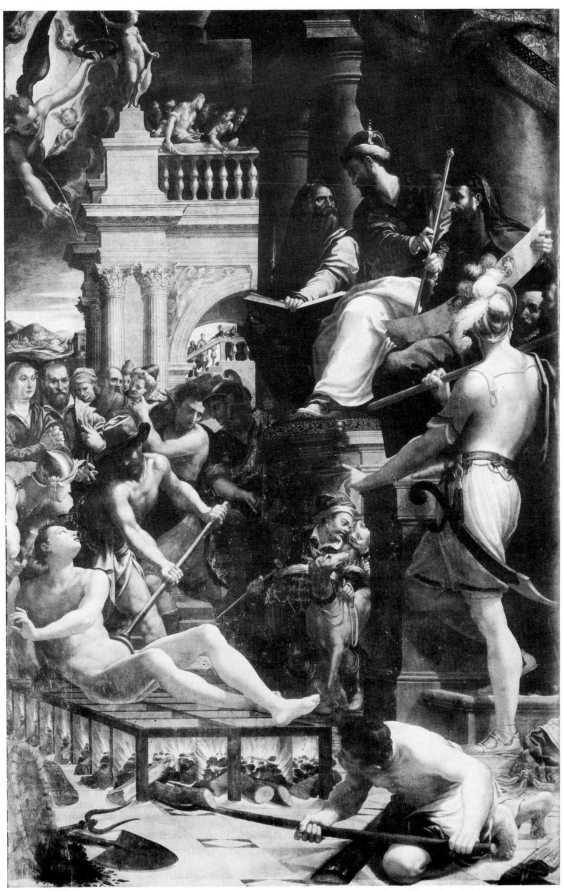

76. Girolamo Macchietti, *Martyrdom of St. Lawrence*, Sta Maria Novella (Giuochi Chapel)

77. Girolamo Macchietti, Self-portrait, Uffizi 1088F

78. Girolamo Macchietti, Study for the torso of St. Lawrence, *Martyrdom of St. Lawrence*, Uffizi

80. Girolamo Macchietti, Study for dead Christ in *Trinity*, Uffizi 12182F
(as Sammacchini)

79. Drawing after Risaliti Chapel showing Macchietti's
Trinity (lost), Uffizi 1647A

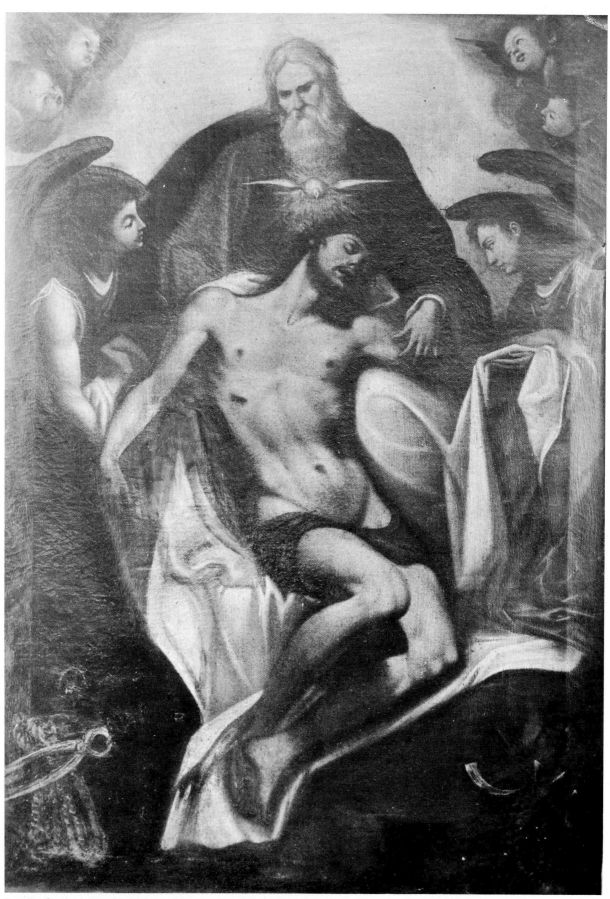

81. Ludovico Cigoli, *Trinity*, Museo Sta Croce (Risaliti Chapel)

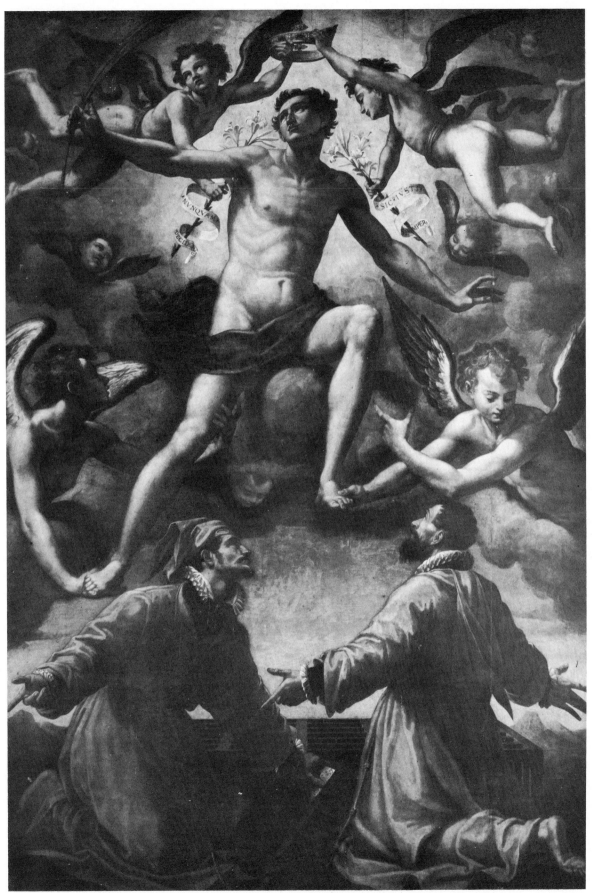

82. Girolamo Macchietti, *St. Lawrence in Glory*, Empoli, Collegiata

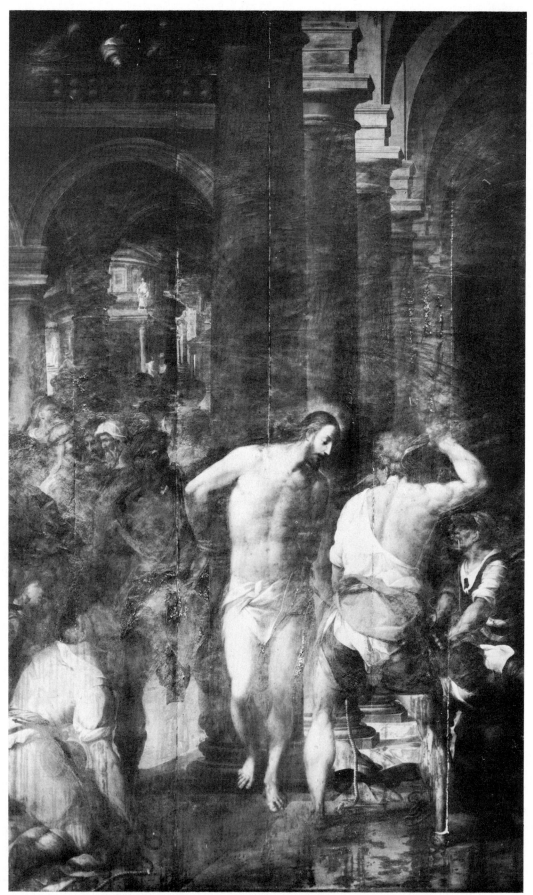

83. Alessandro del Barbiere, *Flagellation of Christ*, Sta Croce (Corsi Chapel)

84. Alessandro del Barbiere, Sketch for *Flagellation of Christ*, Paris, Louvre 198 (Baldinucci Collection)

85. Alessandro del Barbiere, Study for *Flagellation of Christ*, present location unknown

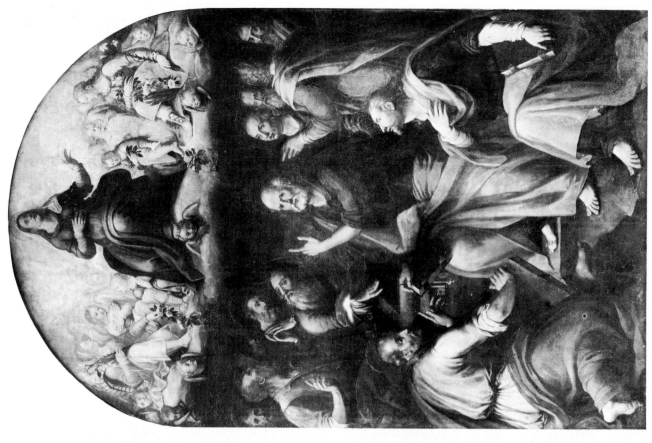

87. Andrea del Minga, *Assumption of the Virgin*, Florence, Sta Felicita

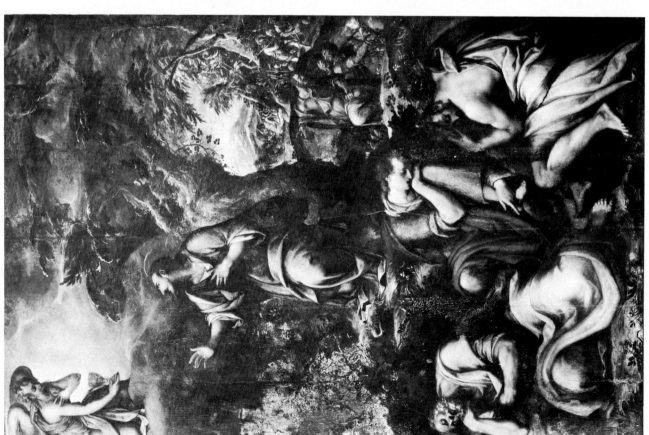

86. Andrea del Minga, *Agony in the Garden*, Sta Croce (Pazzi Chapel)

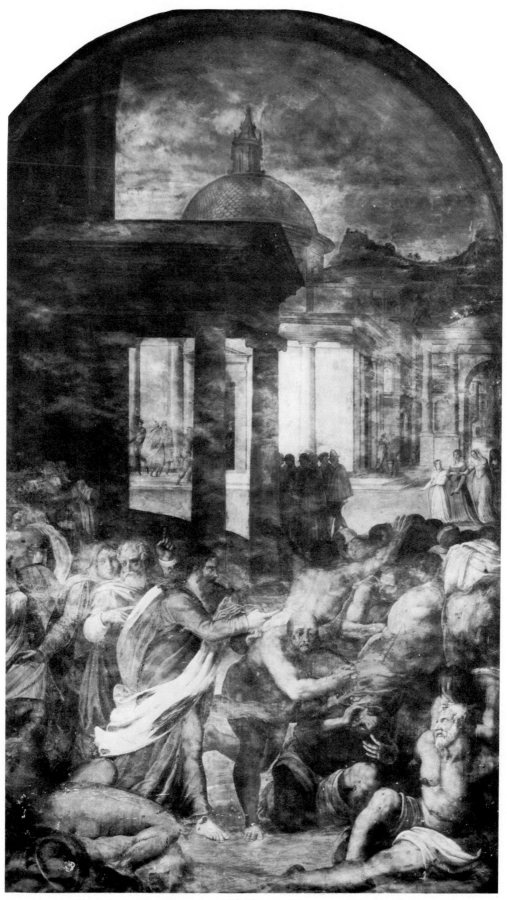

88. Alessandro Allori, *Expulsion from the Temple*, Florence, SS. Annunziata

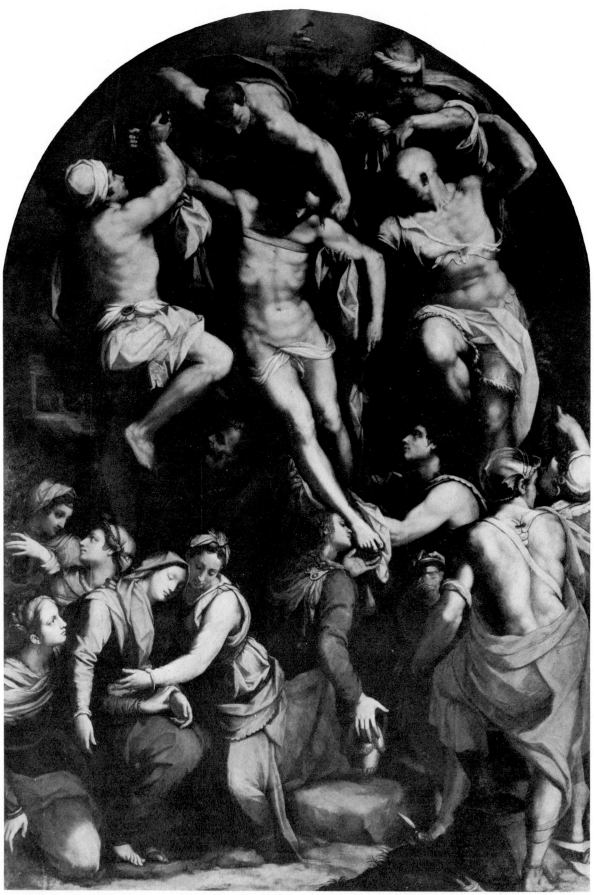

89. Alessandro Allori, *Deposition*, Museo Sta Croce

91. Alessandro Allori, Study for *Christ and the Samaritan Woman*,
Uffizi 10317F

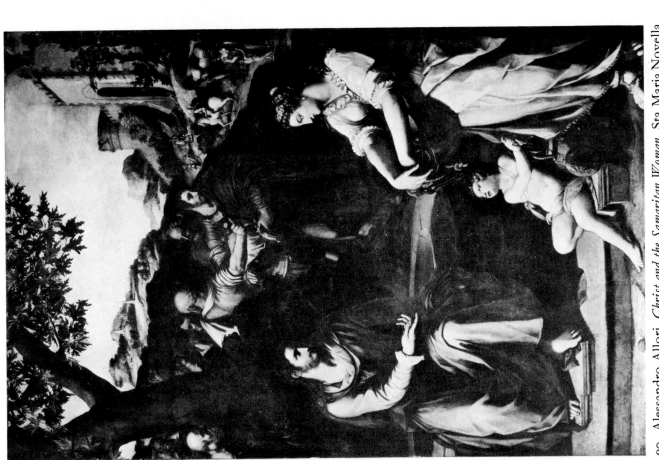

90. Alessandro Allori, *Christ and the Samaritan Woman*, Sta Maria Novella
(Bracci Chapel)

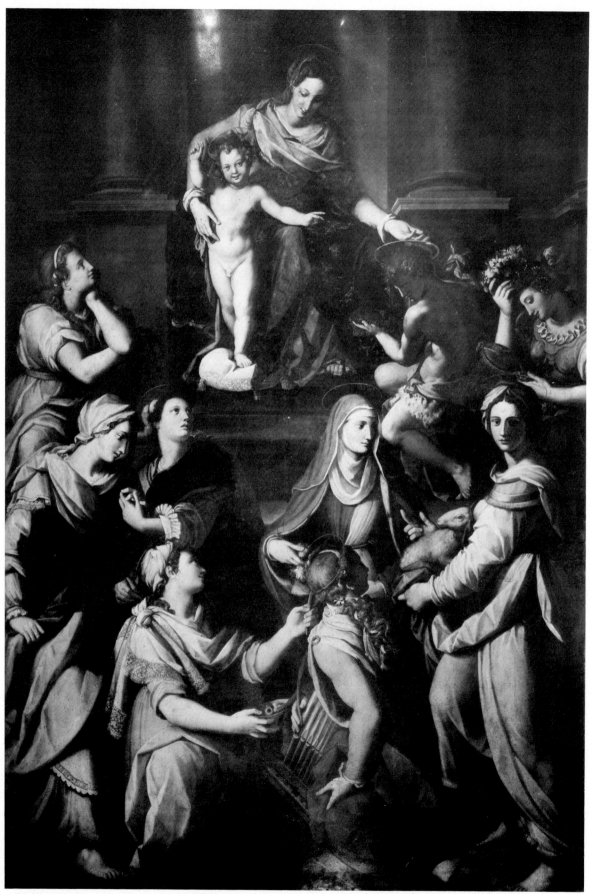

92. Alessandro Allori, *Sacra Conversazione*, Florence, Accademia (formerly Sta Maria Nuova)

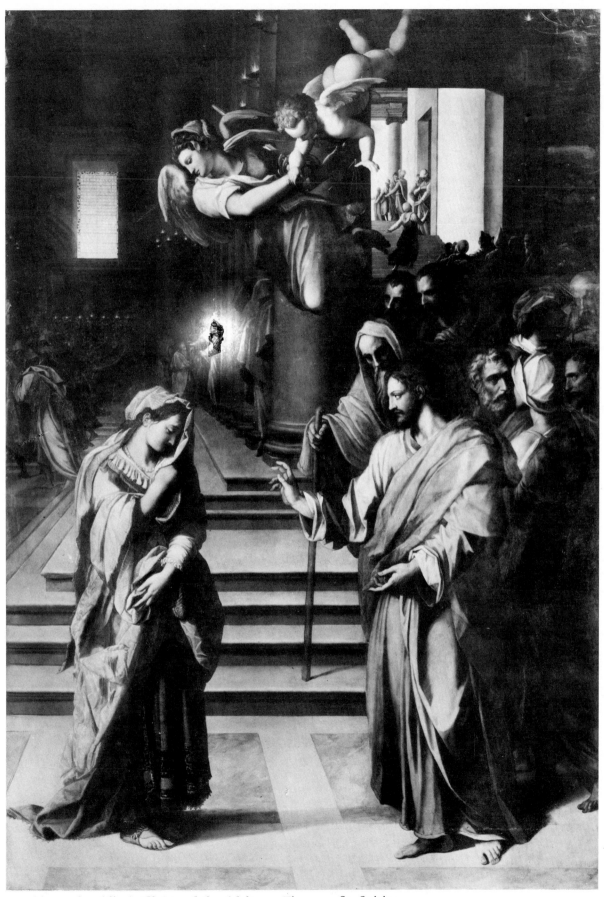

93. Alessandro Allori, *Christ and the Adulteress*, Florence, St. Spirito

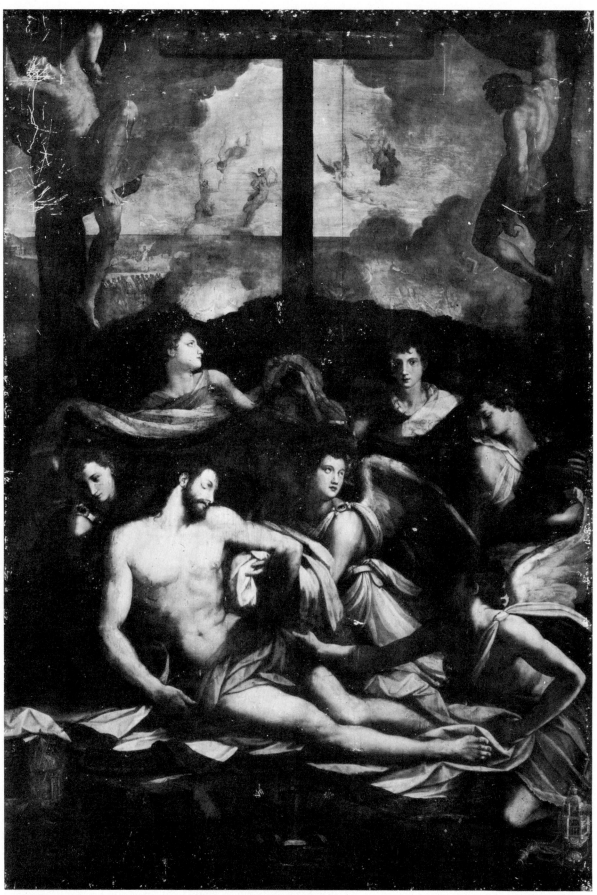

94. Alessandro Allori, *Deposition*, Florence, Sta Maria Nuova

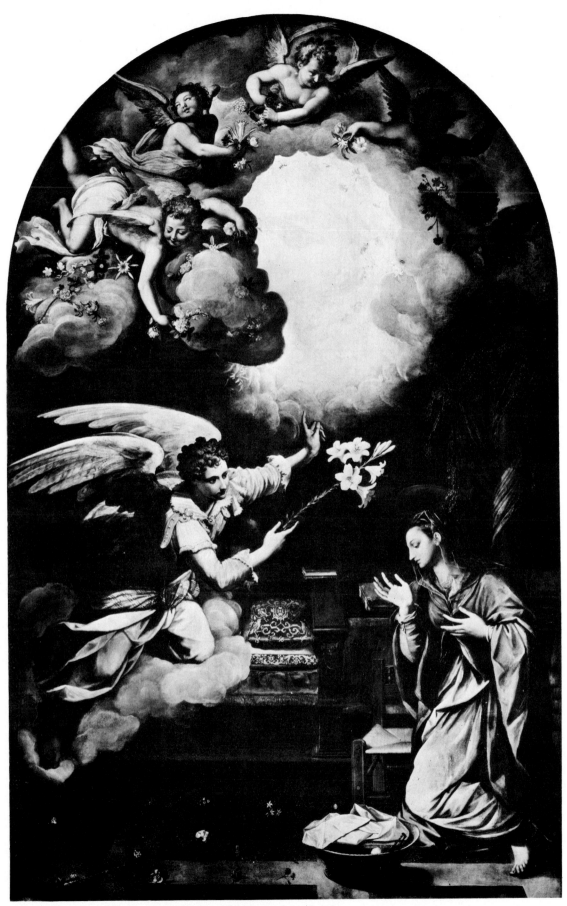

95. Alessandro Allori, *Annunciation*, Florence, Accademia

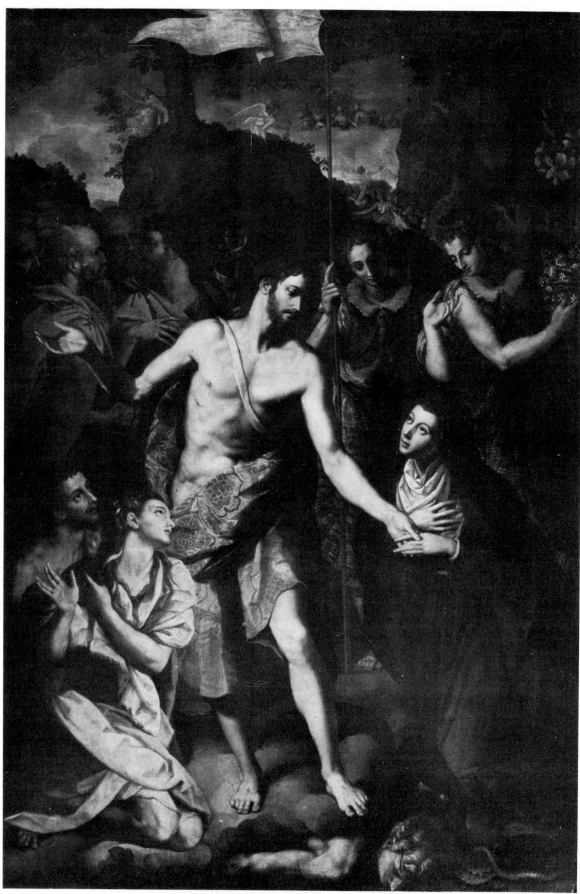

96. Alessandro Allori, *Christ in Limbo*, Florence, S. Marco

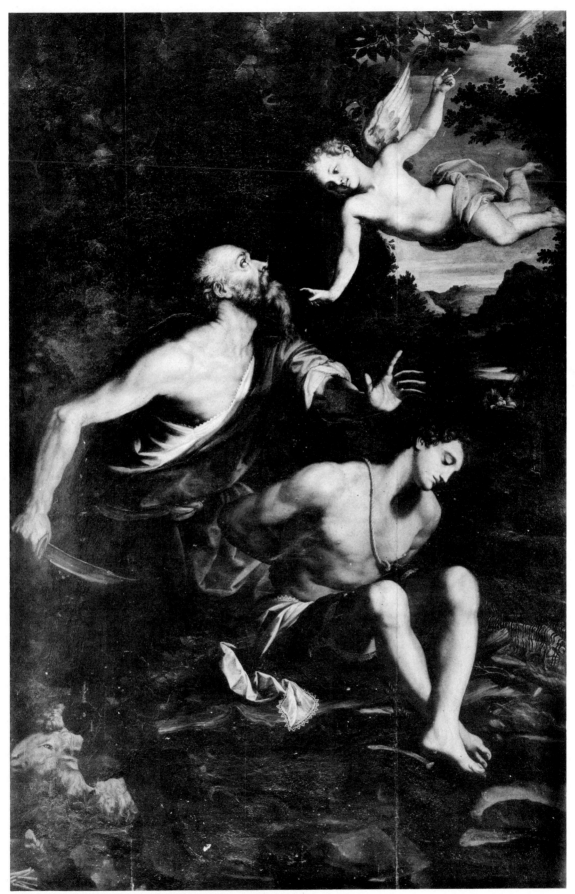

97. Alessandro Allori, *Sacrifice of Isaac*, Florence, S. Niccolò

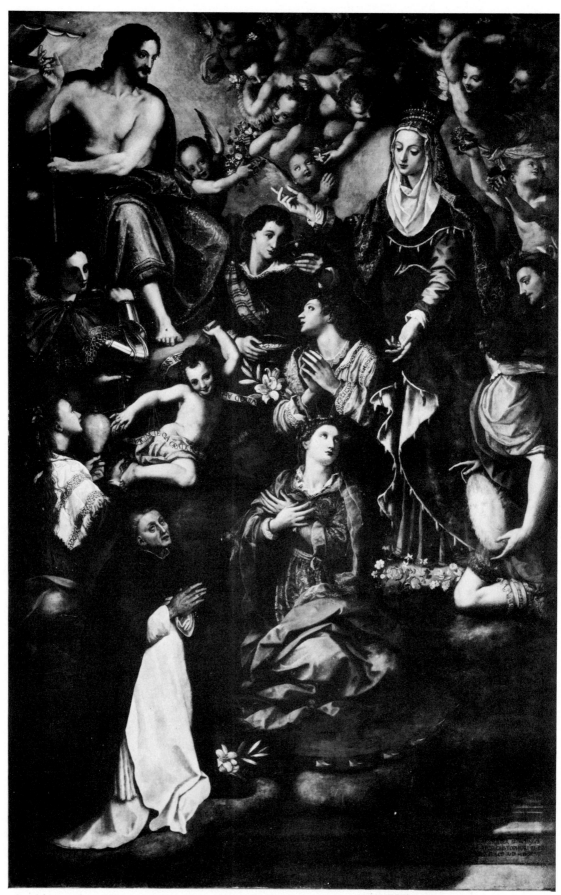

98. Alessandro Allori, *Vision of St. Hyacinth*, Sta Maria Novella (Strozzi Chapel)

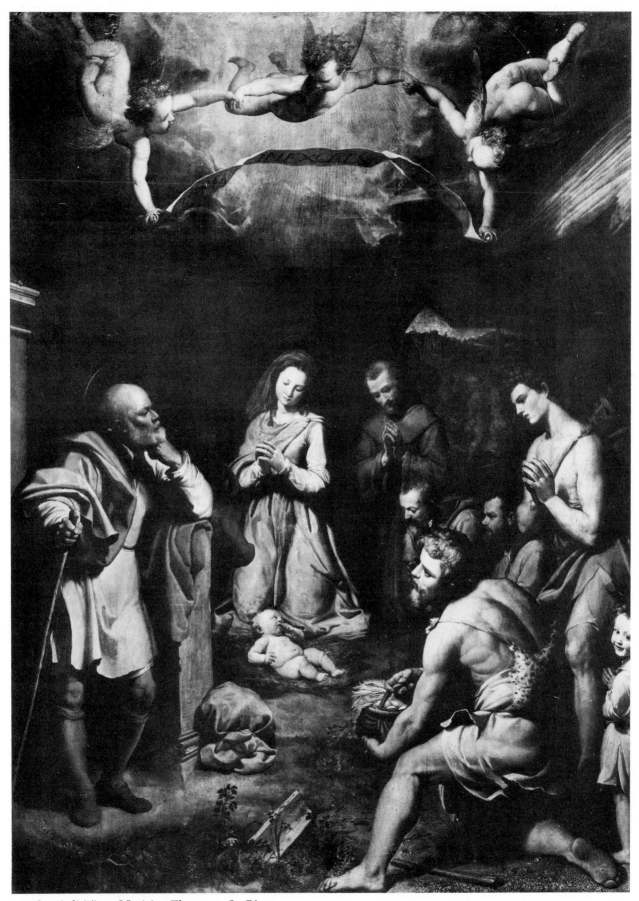

99. Santi di Tito, *Nativity*, Florence, S. Giuseppe

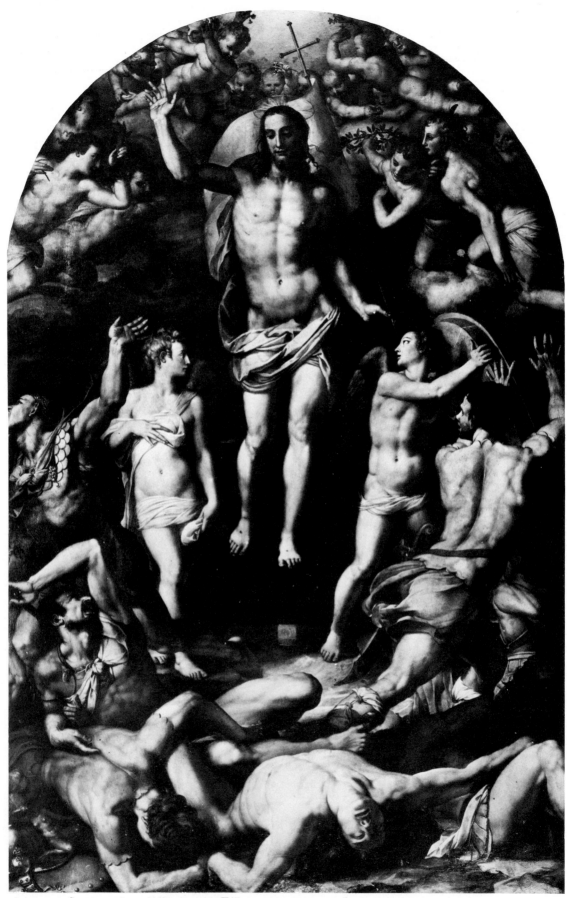

100. Agnolo Bronzino, *Resurrection*, Florence, SS. Annunziata

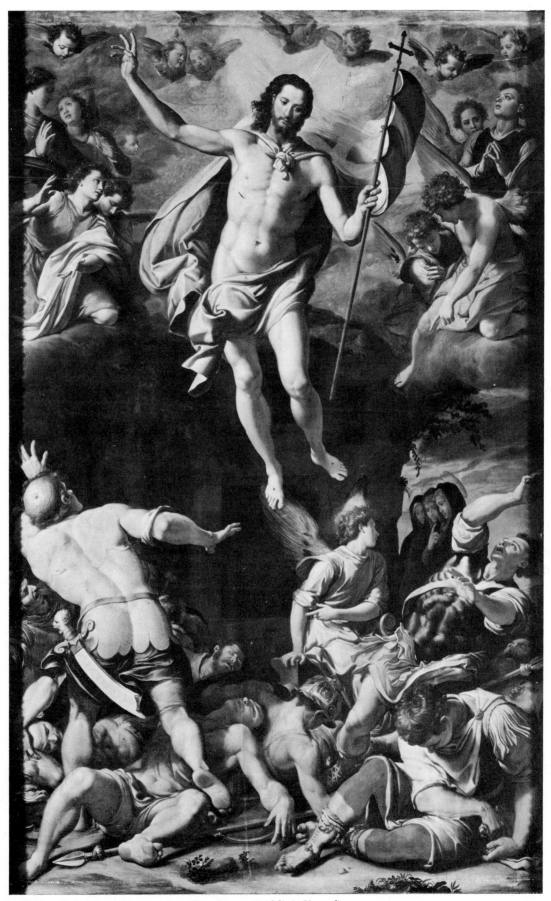

101. Santi di Tito, *Resurrection*, Sta Croce (Medici Chapel)

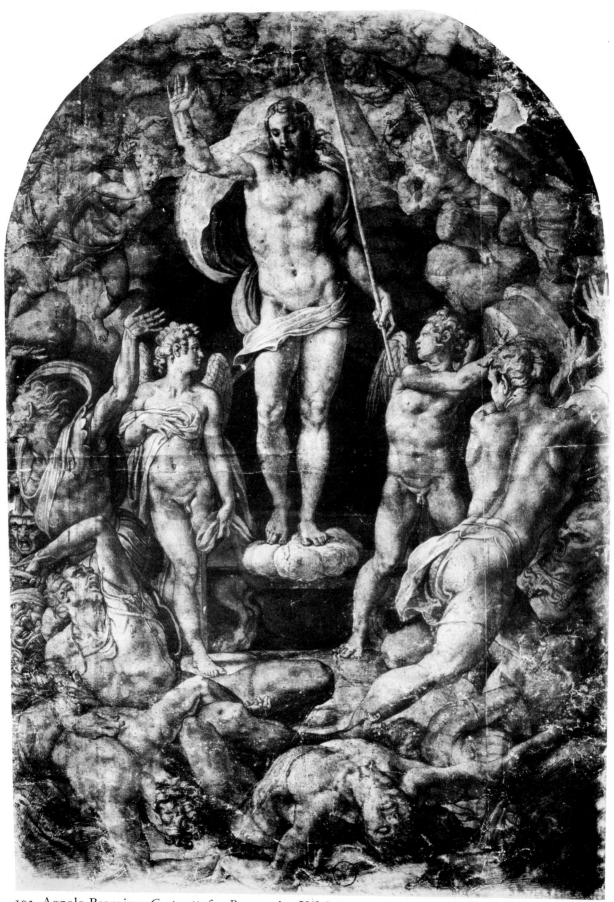

102. Agnolo Bronzino, *Cartonetto* for *Resurrection*, Uffizi 13743F

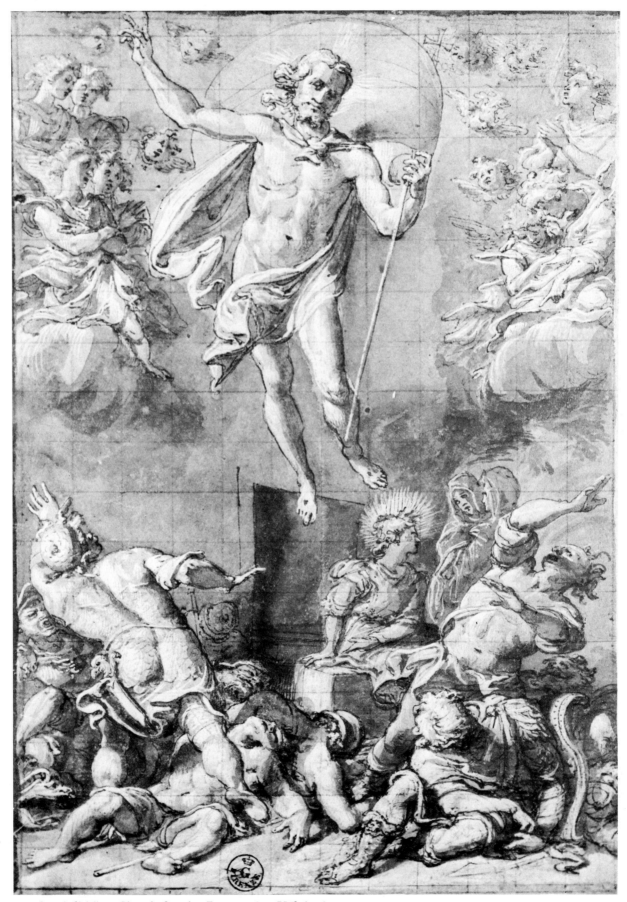

103. Santi di Tito, Sketch for the *Resurrection*, Uffizi 7687F

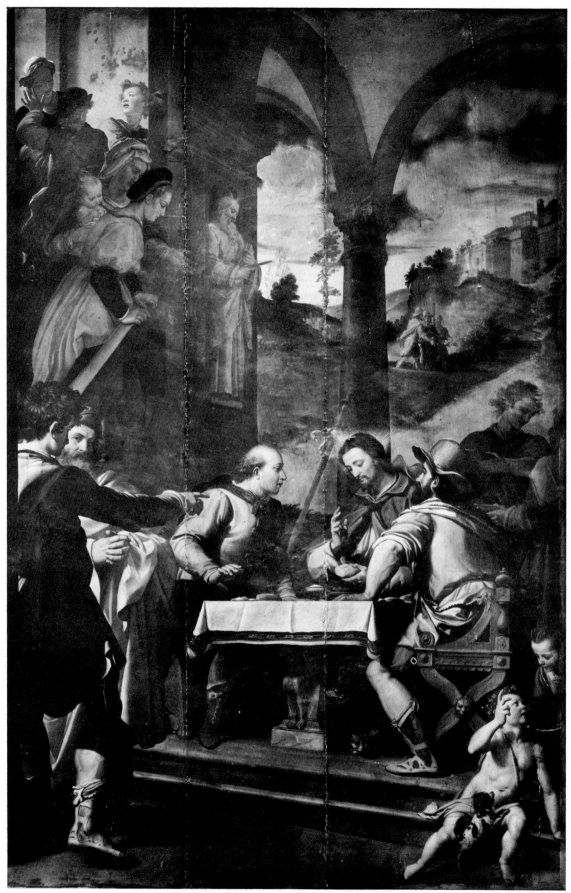

104. Santi di Tito, *Supper at Emmaus*, Sta Croce (Berti Chapel)

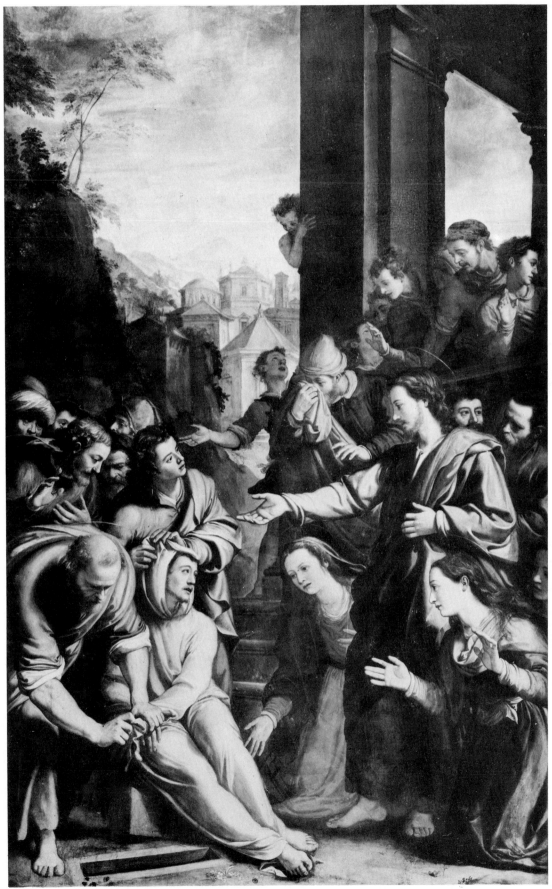

105. Santi di Tito, *Raising of Lazarus*, Sta Maria Novella (Compagnia di Gesù Pellegrino-Tempio Chapel)

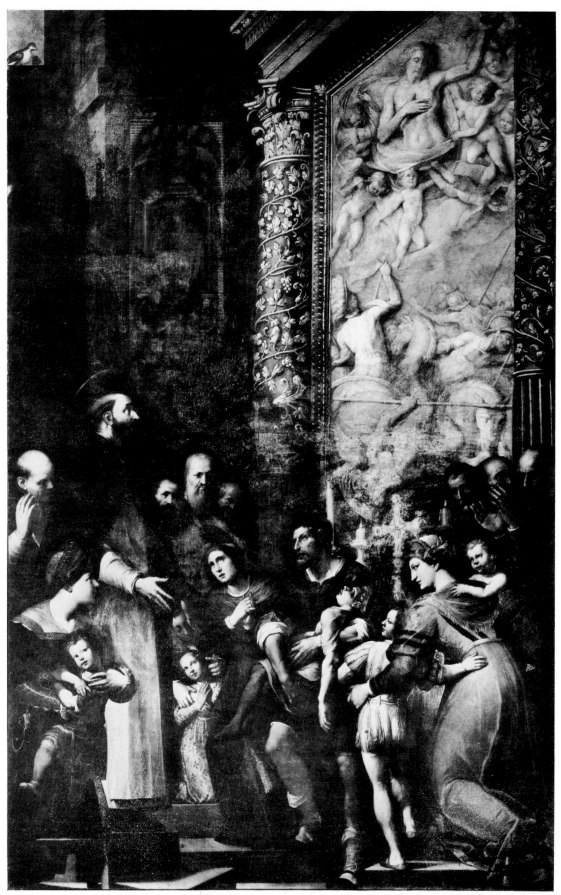

106. Jacopo Ligozzi, *St. Raymond* *Raising the Dead Child*, Sta Maria Novella (Ricasoli Chapel)

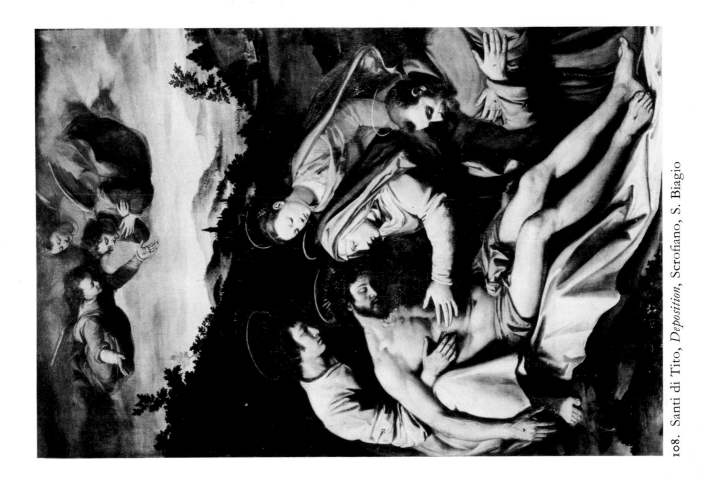

108. Santi di Tito, *Deposition*, Scrofiano, S. Biagio

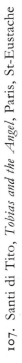

107. Santi di Tito, *Tobias and the Angel*, Paris, St-Eustache

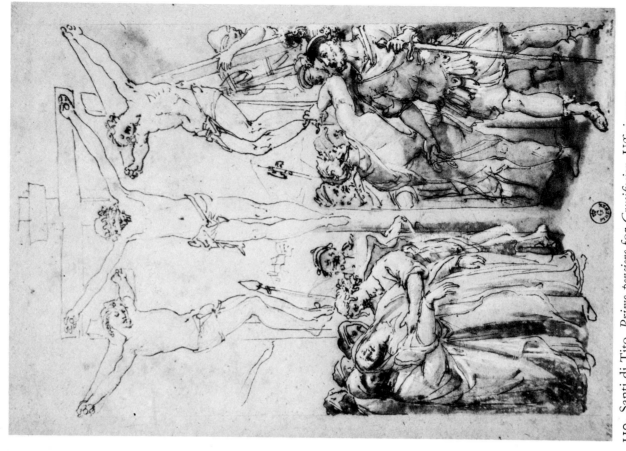

110. Santi di Tito, *Primo pensiero* for *Crucifixion*, Uffizi 773F

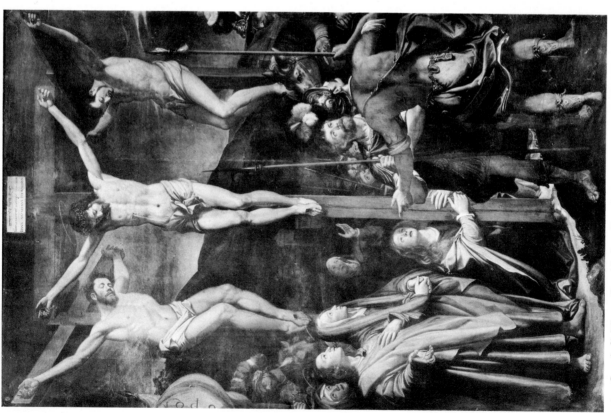

109. Santi di Tito, *Crucifixion*, Sta Croce (Alamanneschi Chapel)

111. Santi di Tito, Compositional sketch for *Crucifixion*, Uffizi 771F

112. Santi di Tito, Sketch for soldiers in *Crucifixion*, Uffizi 771F verso

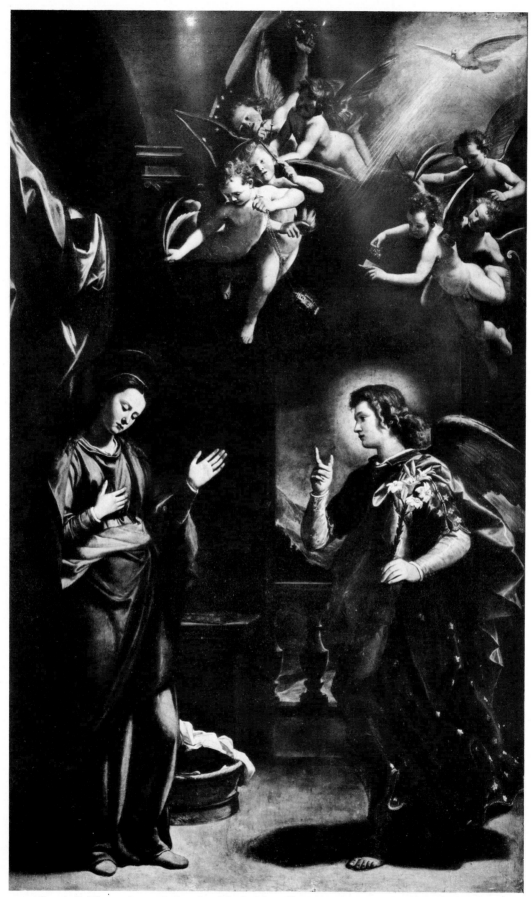

113. Santi di Tito, *Annunciation*, Sta Maria Novella (Mondragone–Vecchietti Chapel)